CITIES INTERR

CITIES INTERRUPTED

Visual culture and urban space

Edited by
Shirley Jordan and
Christoph Lindner

Bloomsbury Academic
An imprint of Bloomsbury Publishing Plc

B L O O M S B U R Y
LONDON • OXFORD • NEW YORK • NEW DELHI • SYDNEY

Bloomsbury Academic

An imprint of Bloomsbury Publishing Plc

50 Bedford Square	1385 Broadway
London	New York
WC1B 3DP	NY 10018
UK	USA

www.bloomsbury.com

BLOOMSBURY and the Diana logo are trademarks of Bloomsbury Publishing Plc

First published 2016

British Library Cataloguing-in-Publication Data
A catalogue record for this book is available from the British Library.

ISBN:	HB:	978-1-4742-2442-0
	PB:	978-1-4742-2441-3
	ePDF:	978-1-4742-2444-4
	ePub:	978-1-4742-2443-7

Library of Congress Cataloging-in-Publication Data
A catalogue record for this book is available from the US Library of Congress.

Typeset by RefineCatch Limited, Bungay, Suffolk
Printed and bound in Great Britain

CONTENTS

List of illustrations vii

List of contributors x

Foreword xiii
Ackbar Abbas

Acknowledgements xv

1 Visual culture and interruption in global cities 1
 Shirley Jordan and Christoph Lindner

PART ONE CRISIS AND RUIN

2 Why we love 'interruption': urban ruins, food trucks
 and the cult of decay 17
 Richard J. Williams

3 Rescuing history from the city: interruption and urban
 development in Beijing 31
 Jeroen de Kloet

4 Interrupting New York: slowness and the High Line 49
 Christoph Lindner

5 Sound, memory and interruption: ghosts of London's
 M11 link road 65
 David Pinder

PART TWO RESISTANCE AND RENEWAL

6 Suburbia, interrupted: street art and the politics of place in the Paris *Banlieues* 87
Gillian Jein

7 Looking at digital visualizations of urban redevelopment projects: dimming the scintillating glow of unwork 105
Gillian Rose, Monica Degen and Clare Melhuish

8 'Here we are now': Amsterdam's North–South metro line and the emergence of a networked public 121
Ginette Verstraete

9 Pop-up shops as interruptions in (post-)recessional London 141
Mara Ferreri

PART THREE BODIES AND SPACE

10 Interruption expanded: urban photography's perspicacious view 159
Hugh Campbell

11 Buildering, urban interventions and public sculpture 173
Bill Marshall

12 Interrupting the street 193
Shirley Jordan

References 211

Index 227

ILLUSTRATIONS

1.1	Jordi Colomer, *Anarchitekton Brasilia*, 2003.	4
1.2	Dionisio González, *Novaacqua-Gasosa II*, 2004.	6
1.3	Tuca Vieira, *Paraisópolis*, 2005.	7
2.1	Food trucks, Seattle, 2014.	25
3.1	Detail of Beijing scale model in the Urban Museum.	35
3.2	Xing Danwen, *Urban Fiction 0.2004*.	39
3.3	Xing Danwen, *Urban Fiction 0.2004*, detail.	39
3.4	Xing Danwen, *Urban Fiction 17.2004*.	40
3.5	Xing Danwen, *Urban Fiction 17.2004*, detail.	41
3.6	Hotel in Qianmen District before demolition in 2008.	43
3.7	Ou Ning, *Meishi Street*. Zhang Jinli writes a slogan on his house.	45
4.1	Future site of the High Line: building the West Side Line, c. 1933.	53
4.2	Billboard next to the High Line: Joel Sternfeld, *Landscape with Path: A Railroad Artifact*, 2011.	55
4.3	View from the High Line: rendering of Whitney Museum of American Art at Gansevoort, 2007 – in progress.	57
4.4	Luxury living at the High Line: rendering of 520 West 28th Street.	58
4.5	Rendering of the Lowline at Delancey Street, 2012.	60
4.6	'Pop Down': proposal for Mail Rail urban mushroom garden in central London, 2012.	61
4.7	Stills from James Nares, *Street*, 2011.	63
5.1	Interrupting the street: protesters prepare for the final evictions at Claremont Road, London, 28 November 1994.	67
5.2	Claremont Road, London, summer 1994.	67
5.3	'If my house was still there': A12 Eastway, London.	69
5.4	Walking the motorway.	74
5.5	Linear Park, Grove Green Road, London.	77
6.1	Pantin sign and Fred le Chevalier, September 2013.	91
6.2	*Grand Moulins*, July 2004.	93
6.3	BNP buildings, July 2014.	94

6.4	CCIP building undergoing renovation in 2015.	100
6.5	Da Cruz, CCIP building, September 2013.	101
6.6	CCIP building with swans, September 2013.	102
6.7	CCIP building, July 2013.	103
7.1	A billboard showing a digital visualization of a building under construction in Leeds, UK, June 2013.	106
7.2	Stickers on a visualization of the Leadenhall Building in London, December 2013.	112
7.3	A view of the exhibition 'Architectural Atmospheres: Digital Placemaking in the Twenty-first Century', held at the Building Centre in London in August 2013.	117
8.1	R. Vincken, *Arrow on Street. North–South line.*	129
8.2	Krien Clevis, *Station Rokin*, 2014.	131
8.3	Krien Clevis, *Tunnel Rokin*, 2014.	132
9.1	*Art in Store Fronts*, Mission District, San Francisco (April 2010).	143
9.2	Images of the open shop as appeared on the Make:Do blog (November 2010).	146
9.3	Granville Arcade 'before'.	148
9.4	Photograph of Meanwhile Whitechapel pop-up shop.	151
10.1	Abelardo Morell, *Brookline View in Brady's Room*, 1993.	161
10.2	Abelardo Morell, *Times Square in Hotel Room*, 1997.	164
10.3	Abelardo Morell, *The Chrysler Building in Hotel Room, NY*, 1999.	164
10.4	Abelardo Morell, *Boston's Old Custom House in Hotel Room, Boston MA*, 1999.	165
10.5	Thomas Struth, *6th Avenue at 50th Street, New York, Midtown*, 1978.	169
10.6	Thomas Struth, *West 44th Street, Theater D, New York*, 1978.	169
11.1	Still from *The Emerald Forest* (dir. John Boorman, 1985).	174
11.2	Still from *The Emerald Forest* (dir. John Boorman, 1985).	175
11.3	Nature/city contrast in buildering.	175
11.4	Ashley Holland, Guy's Hospital.	177
11.5	Builderer's grip.	182
11.6	Scaling a wall.	183
11.7	Bobby Gordon-Smith, Rock On Top of Another Rock.	186
11.8	*Els Mistos.*	187
11.9	Kamila Szejnoch, *Swing*, installation, memorial to the Berling Army Soldiers, Warsaw, 2008.	189
11.10	Statue of the Duke of Wellington, outside Gallery of Modern Art, Glasgow.	191
12.1	Beat Streuli, *Bruxelles 05/06 11*.	196
12.2	Beat Streuli, *Sint-Pieters Station, Ghent*, 2011.	198

12.3 Michael Wolf, *Paris Street View No. 28*, 2009. 204

12.4 Michael Wolf, *Paris Street View No. 9*, 2009. 206

12.5 Michael Wolf, *Paris Street View No. 27*, 2009. 207

12.6 Beat Streuli, *The Pallasades*, 2001. 209

CONTRIBUTORS

Akbar Abbas is a Professor of Comparative Literature at the University of California, Irvine. Previously he was Chair of Comparative Literature at the University of Hong Kong and also Co-Director of the Center for the Study of Globalization and Cultures. His research interests include globalization, Hong Kong and Chinese culture, architecture, cinema, postcoloniality and critical theory. He is the author of *Hong Kong: Culture and the Politics of Disappearance* (University of Minnesota Press, 1997).

Hugh Campbell is Professor of Architecture at UCD School of Architecture, Planning and Environmental Policy, Dublin. He is editor of *Architecture 1600–2000*, volume 4 of *Art and Architecture of Ireland* (Yale University Press, 2014). With Nathalie Weadick he curated Ireland's pavilion at the 2008 Venice Biennale, *The Lives of Spaces*. His current research focuses on the relationship between photography and spatial identity as manifested in architecture and in cities.

Monica Degen is a Senior Lecturer in Cultural Sociology at Brunel University, London. Her interdisciplinary work focuses on the sociology of the senses, urban cultures, the politics of the everyday, and the experience of design and architecture. She is the author of *Sensing Cities* (Routledge, 2008) and *The Meta-City Barcelona: Transformation of a Metropolis* (Anthropos, 2008).

Mara Ferreri is a Lecturer in Human Geography at the University of Durham, UK. She holds an MA in Visual Cultures, Goldsmiths College, and completed her doctoral thesis, titled 'Occupying Vacant Spaces: Precarious Politics of Temporary Urban Reuse', in the School of Geography at Queen Mary University of London. Among her research interests are temporary spatial practices in the city, cultural and socio-spatial dynamics of contested urban transformation, and conditions and experiences of urban precarity.

Gillian Jein is an academic in French Studies at Bangor University. Her research coheres around issues relating to the aesthetics and politics at stake in the

articulation of place in global cities, with an empirical focus on travel writing and visual practices. Her books include a co-edited volume, *Aesthetics of Dislocation in French and Francophone Literature and Art: Strategies of Representation* (2009) and a monograph, *Urban Crossings: Alternative Modernities in French Travel Writing, 1851–2000* (forthcoming, 2016). Her current project examines the cultural politics of spatial affect in practices of suburban renewal in France and has been funded by the British Academy and Modern Humanities Research Association.

Shirley Jordan is Professor of French Literature and Visual Culture at Queen Mary University of London. A specialist in contemporary women's writing and visual culture, she has recently worked on photography in autobiography, the photo-text and city photography. Her publications include *The Art Criticism of Francis Ponge* (1994), *Contemporary French Women's Writing* (2004) and a range of articles on contemporary photography which explore the poetics of scale, interruption and the street, focusing in particular on practitioners such as Stéphane Couturier, Valérie Jouve and Denis Darzacq.

Jeroen de Kloet is Professor of Globalization Studies and Director of the Amsterdam Centre for Globalization Studies (ACGS) at the University of Amsterdam. His work focuses on cultural globalization, in particular in the context of East Asia. In 2010 he published *China with a Cut – Globalisation, Urban Youth and Popular Music* (Amsterdam University Press). He wrote, together with Yiu Fai Chow, *Sonic Multiplicities: Hong Kong Pop and the Global Circulation of Sound and Image* (Intellect, 2013) and edited, together with Lena Scheen, *Spectacle and the City – Chinese Urbanities in Art and Popular Culture* (Amsterdam University Press, 2013). See also http://www.jeroendekloet.nl

Christoph Lindner is Professor of Media and Culture at the University of Amsterdam, where he writes about cities, globalization and issues of sustainability, urban citizenship and creative practice. His books include *Imagining New York City* (Oxford University Press, 2015), as well as the edited volumes *Global Garbage* (Routledge, 2016), *Inert Cities: Globalization, Mobility and Suspension in Visual Culture* (I.B. Tauris, 2014) and *Paris–Amsterdam Underground* (Amsterdam University Press, 2013).

Bill Marshall is Professor of Comparative Literary and Cultural Studies at the University of Stirling, Scotland, having previously held posts at the Universities of Southampton and Glasgow. His authored works include *Victor Serge: The Uses of Dissent* (1992), *Guy Hocquenghem* (1996), *Quebec National Cinema* (2001) and *André Téchiné* (2007). He has edited books on *Musicals – Hollywood and Beyond* (2000), *Montreal-Glasgow* (2005) and a three-volume Encyclopedia, *France and the Americas* (2005), which gave rise to his most recent monograph, *The French Atlantic: Travels in Culture and History* (2009).

Clare Melhuish is Research Associate in the UCL Urban Laboratory, conducting comparative research on university-led urban regeneration. From 2011 to 2013 she was Research Associate at The Open University working on the ESRC-funded project 'Architectural atmospheres: the impact of digital visualizing technologies on contemporary architectural practice'. She is an anthropologist specializing in architecture and urbanism, with a focus on the use of ethnographic and visual research methods, and has worked extensively outside academia as an architecture critic, author, curator and consultant. Her key areas of interest are Modern Movement and contemporary architecture, postcolonial urban aesthetics and heritage, and urban development policy and practice in the UK, France, the Gulf and the Caribbean.

David Pinder is Professor of Urban Studies at Roskilde University in Denmark. His research interests lie in utopia and modern urbanism, and in art, performance, mobility and spatial politics. His publications include the book *Visions of the City: Utopianism, Power and Politics in Twentieth-Century Urbanism* (Edinburgh University Press, 2005).

Gillian Rose is Professor of Cultural Geography at The Open University, UK. Her current research interests focus on contemporary digital visual culture and visual research methodologies. She is the author of *Doing Family Photography: The Domestic, The Public and The Politics of Sentiment* (Ashgate, 2010) and *Visual Methodologies* (Sage, fourth edition 2016), as well as a number of papers on images and ways of seeing in urban and domestic spaces.

Ginette Verstraete is Professor of Comparative Arts and Media and former Head of the Division of Arts and Culture at the VU University Amsterdam. She has written on cultural studies, media and globalization, intermediality and on mobility. Among her recent publications are a special issue of the *European Journal of Cultural Studies* (2009) on 'Media Globalization and Post-Socialist Identities' and the book *Tracking Europe: Mobility, Diaspora, and the Politics of Location* (Duke University Press, 2010).

Richard J. Williams is Professor of Contemporary Visual Cultures at the University of Edinburgh. He works on the visual representation of cities, and contemporary ideas of creativity and the city. His books include *After Modern Sculpture* (2000), *The Anxious City* (2004), *Brazil: Modern Architectures in History* (2009) and *Sex and Buildings* (2013).

FOREWORD: INTERRUPTING INTERRUPTION

Ackbar Abbas

One of the most immediately striking but ultimately misleading characterizations of globalization is to see it as 'time–space compression'. What is misleading is that the formulation suggests that the process has a clear directionality: time speeds up and space contracts. Such directionality does not take sufficiently into account the *volatility* of the global, and the way it has reshuffled the grids and coordinates of our world. Volatility produces something perhaps more accurately described as 'time–space *distortion*', where time turns anachronistic, and space anamorphic; a world that has lost its measure. Speed is no longer captured by Futurist images of bullet trains devouring space; it has greater affinities with the randomness of Brownian movement. As for global cities, they too have become so complex and dense that, like black holes, they are not directly perceptible. We can only speculate about what urban space has become through examining the visual and spatial *anomalies* it produces and the *bizarre* affective response it elicits. In other words, we see the global city only through its interruptions.

The problem, as this seminal volume demonstrates, is that interruption is not a simple procedure; it is something more complicated than putting on the brakes. Any car designer would tell you that brakes are not just about slowing down. Rather a car's realizable speed depends on its brakes, so that good brakes are what *allow* a car to go fast. Or take the example of urban preservation in cities like Shanghai. Is preservation a way of slowing down Shanghai's relentlessly rapid development, or does it not rather *participate* in the logic of development, as 'historic' districts and landmarks can also function like theme parks to attract global tourism? Another complication is that slowness-as-interruption can mean different things in different cases. Walter Benjamin spoke of the brief vogue in nineteenth-century Paris of taking turtles for a walk as the *flâneur's* protest against the rapid pace of city life. In global cities today, we find a different kind of slowness, whose emblem might be the figure not of the *flâneur*, but the *funambulist* or tightrope walker. The funambulist moves slowly because a false move could prove fatal. What these examples show is that interruption can have different motivations and surprising outcomes; it can even *facilitate* what it purports to hinder. And all

this suggests that if we are to think of it as a critical practice, we will need above all to *interrupt interruption*; that is to say, to reflect on what it can and cannot do.

A case in point is visual culture. One of the main critical objectives of visual culture has always been to interrupt and resist the spectacle, understood as ideology that has taken on a visual form. But as Debord's final comments on the spectacle make clear, what we have to deal with today is a mutated and elusive version of the spectacle: the spectacle that appears and disappears as information. What requires and defies analysis is not the visual form of the spectacle, but the informational, invisible and secret form; namely, a spectacle that is no longer spectacular. We cannot fight spectacle-as-information with a critique of visual ideology, when everything can be integrated into information, including critique. And when cities themselves become essentially spaces of information, what happens to visual culture and interruption as practices of resistance? What must we do differently?

This is the crucially important question this volume poses, and there is no single answer. Instead, the various authors invite us to think along with them. Nonetheless, one point seems clear. It would be false optimism to assume that interruption can expose the lie and give us the truth. What it can do, however, is to create 'noise'. Noise can take the form of protest, but also of artworks, performances, spatial constructions or theories. And noise can disrupt and disturb the smooth operation of the system, but also try to take it elsewhere. 'In dreams begins responsibility', W.B. Yeats once wrote; could it also be that it is in interruption that dreams of a better world begin?

ACKNOWLEDGEMENTS

This book developed from a two-year international research network jointly funded by the Arts and Humanities Research Council and the Netherlands Organisation for Scientific Research. We would accordingly like to thank the AHRC and NWO for their support. We are grateful to the Institute for Public Knowledge at New York University and the Institute of Modern Languages Research at the School of Advanced Study, University of London for hosting network meetings and conferences. Thanks are also due to our home institutions – Queen Mary University of London and the Amsterdam School for Cultural Analysis – which generously provided support throughout the project, as well as to the Amsterdam Centre for Globalisation Studies, which was an important partner in our work. Both editors are immensely grateful to Tijmen Klous for his outstanding editorial and research assistance. Most of all we would like to thank the authors whose chapters are collected in this volume. For their curiosity about interruption, for their rich contributions to workshops and conferences, and for the rewarding discussions with them that have fed into this collective endeavour we remain extremely grateful.

Shirley Jordan and Christoph Lindner

1 VISUAL CULTURE AND INTERRUPTION IN GLOBAL CITIES

Shirley Jordan and Christoph Lindner

What is interruption?

Cities are constantly undergoing change, their fabric shifting in small or seismic ways, some planned and some unplanned. Discourses and theories of mobility, acceleration and flow are often used to account for this change, particularly in the era of globalization. Key critical paradigms that attempt to capture and account for late twentieth- and early twenty-first-century urban evolution have shaped our understanding and, to some degree, our perception. David Harvey (1989) and Doreen Massey (1994) have written on the time–space compression involved in globalization; Saskia Sassen (1991) has popularized the concept of the global city as a transnational space of rapidly circulating capital; while Edward Soja (2000) has emphasized the spatiality of urban transformation under intensified conditions of globalization. Numerous studies seek to account for new and often overwhelming combinations of speed and scale. Manuel Castells (1996) has developed the concept of the 'space of flows' to describe the fast-paced networks of communication and power dominating the global information society; Arjun Appadurai (1996) has called attention to the sense of acceleration that accompanies the global flow of people, goods, services and data; and John Urry (2007) and Tim Cresswell (2006) have stressed the new forms of mobility that globalization facilitates and often necessitates. Meanwhile, more alarmist accounts of globalization and urban change have emerged from provocative thinkers like Paul Virilio and Jonathan Crary who warn, respectively, against the atomizing, anonymous speed-space of the accelerated city (Virilio 1997; 2007), and against late capitalism's relentless war on rest and sleep (Crary 2013).

This volume traces urban phenomena that cut across and complicate such discourses on globalization and cities. Building on a series of workshops organized in Amsterdam, Edinburgh, London and New York, it completes a trilogy of interrelated studies developed by a group of international scholars whose work on the visual culture of global cities has given rise to new thinking on violence (Lindner 2009), inertia (Donald and Lindner 2014) and, in the case of the current volume, interruption. In particular, *Cities Interrupted* brings together researchers in architecture, geography, urban planning, photography and art to explore some of the ways in which visual culture responds to, intervenes in, decelerates and critiques global conditions of urban speed and mobility.

In this introductory chapter, we wish to set the frame for the discussions that follow by sketching some of the key debates about interruption and exploring some preliminary examples that bring into focus core issues at stake in the volume as a whole. We begin, therefore, by addressing the question 'what is interruption'? Interruption, commonly understood, entails breaking in upon an action, bringing about a temporal rupture, creating an interval that draws attention to itself precisely as deliberately 'counter'. Interruption, as we understand it in this volume, entails a wide range of such temporal interventions, while also addressing the idea of spatial interruption in the built environment that calls attention to issues of ongoing urban development and restructuring. To say that cities are sites of permanent interruption might seem like a truism, for it is clear that interruption is the very stuff of the urban condition, made up as it is of competing drives and currents, endlessly reinvented obstacles and avenues, unceasing reinvention. Indeed, 'flow' itself may be seen to consist of a rapid succession of interruptions. And, while 'interruption' has been harnessed as an analytic tool for thinking about, say, documentary photography (Roberts 1998), the concept has not yet received close attention in either urban studies or cultural studies.

One reason for this is that interruption is something of a slippery, capacious concept. It is that very slipperiness, however, that makes it both attractive and appropriate for our purposes as we set out to test its critical potential. As will become clear, the case studies in this volume all address the term, each asking, in their own way, pressing questions about the nature, effects and effectiveness of interruption. The latter is a key issue for all contributors. To what extent does a given interruption have 'teeth' as a means of stymying, in however small a way, the overwhelming tsunami of globalization? Does some of what we like to think of as interruption in fact contribute to the race towards an ever-accelerating global future? Does interruption resist or reinforce what it critiques? Who really wants interruption, and in what context?

Interruptions are often unpredictable and are brought about by a vast range of agents. Their most salient and immediately conspicuous forms are embodied, for example, by global terror, which has transformed the architectural map of many cities (think, for instance, of New York after 9/11) and found its way into visual

culture in innumerable fashions. One might also cite the economic interruptions in flows of capital as a result of the global financial crisis, or interruptions effected by provisional failures of systems and infrastructures, such as the blackout in Lower Manhattan following Hurricane Sandy in 2012 or the massive disruption of European air travel following the eruption of Iceland's Eyjafjallajökull volcano in 2010.

Interruptions can also result from carefully managed State-induced changes. One unusual, highly ironic and visually spectacular example was the recent clean-up of Beijing in readiness for the November 2014 Asia Pacific Economic Cooperation (APEC) summit. Air pollution, a serious health hazard in Beijing, is part and parcel of its narrative of growth. Habitually at dangerous levels, the thick smog is a dominant feature of the city environment. As Beijing prepared to receive over twenty world leaders and geared up for the summit, the authorities orchestrated an interruption in the ongoing pollution of the city in order to improve air quality and avoid the embarrassment of foreign dignitaries having to wear face masks. The operation of factories, construction sites and even crematoriums was restricted in order to minimize emissions and 'interrupt' smog-producing activities. Factories within 200 kilometres of the city centre closed. It was forbidden to light fires. The use of cars was restricted. A six-day holiday was declared and attempts were made to lure city dwellers out of town by offering free entry to museums and other attractions so that the city centre would feel less populated. This short-lived but telling interruption in what is the ecological disaster of Beijing was all the more important given that APEC promotes green growth and environmental protection. How paradoxical that a global city – by definition characterized by the density of its production activities and priding itself on being a thrusting, throbbing hub – should, in order to showcase itself, grind to a halt. A remarkable visual phenomenon was brought about by the government's decision briefly to re-cast the city as clean. The smog-less sky was newly revealed, in a hue that was wryly referred to by city dwellers as 'APEC blue'.

Our emphasis in this volume is deliberately placed on less obvious and less explosive instances of interruption. We have sought out quieter 'pockets' of resistance, to use a metaphor coined by John Berger (2001), and smaller spaces of contestation associated with or brought about by visual culture. Looking at cities such as Amsterdam, Beijing, Doha, London, New York and Paris, chapters discuss variously how unruly bodies interrupt cityscapes; how everyday spaces may be transformed into sites of interruption; how street art seeks to push back against the homogenization of urban space and the flattening of cultural difference. We explore how new aesthetic and technical practices in urban photography self-consciously put the urban environment on hold; how installation art and performance may undermine or conversely reinforce the totalizing visions of architecture and urban planning; how post-industrial urban ruins are revivified in order to decelerate the global flows that produce them; as well as how visualizations

of urban redevelopment oscillate between smoothness and friction in their surface engagements with the city. To bring these sorts of concerns into sharper focus, we turn briefly to consider two examples of what we mean by interruption. Both are artistic responses to architecture and urban planning, and both demonstrate in key ways the kinds of thinking that interruption can generate and the challenges involved in its interpretation.

Anarchitekton

A solitary man runs through the streets holding aloft a cardboard maquette of a building mounted on a stick, like a placard. In Barcelona, Bucharest, Osaka and Brasilia he performs this puzzling urban ritual carrying scale models of real high-rise edifices, either already built or unfinished, that are emblematic of the city in question, or of its suburbs, and against which his performance is set like a miniature echo. This is the pseudonymously named Idroj Sanicne, a character who acts out street interventions devised by architect and visual artist Jordi Colomer and whose global architectural runs are captured on film, brought together and projected in galleries for Colomer's *Anarchitekton* project[1] (2002–2004; Figure 1.1).

Colomer's small architectural dramas stop traffic, turn heads, generate curiosity and questions, and induce a pause in everyday urban flow. They may be read – and are intended – as interruptions, disruptions, spaces of intervention. Colomer's gloss on our idea of interruption includes the notion of contagion: he speaks of

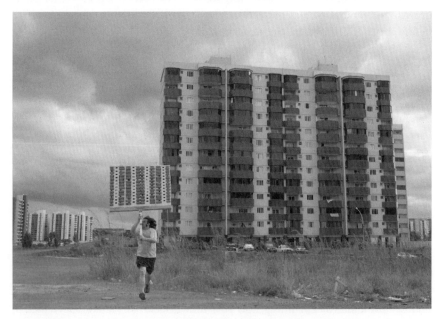

FIGURE 1.1 Jordi Colomer, *Anarchitekton Brasilia*, 2003. Courtesy of the artist.

'contaminating the streets' with a new kind of imagination and estrangement that prompts critical questions, inducing us to keep on seeing and interrogating architecture and urban planning. Released from their massive materiality, the buildings are rendered newly portable, strangely mobile and uncomfortably fragile. They are returned to the world of ideas from which they originated, and are made freshly available for attention and debate.

The interest of this example for our purposes is its ambiguity and the way in which it is snagged between competing interpretations. On the one hand, the performances have the energy and urgency of street demonstrations; the maquette or effigy brandished aloft on a wooden stick seems like a form of grass-roots protest against the violence that architecture can do – a cry against the contagion and creeping homogeneity of global modern and postmodern design. One wonders if, when the running stops, the model building might be symbolically destroyed, sacrificed, set on fire. On the other hand, these performances also have an almost self-avowed, self-deprecating futility that renders them absurd or even comical. Colomer's man is running hard – sometimes at full pelt – against the global tide, yet at the same time emulating globalization's flow and speed. He is alone. He is going nowhere in particular and, with such an unfocused, unformulated, ephemeral sense of protest, is doomed to failure. Worse perhaps – and this is deliberate – the performance even lays itself open to being interpreted as something of an advertisement for contemporary architecture and planning. Is Colomer's running man in fact, bizarrely, not struggling against but instead promoting to its inhabitants the built environment through which he runs? Is this a procession dedicated to something sacred rather than a demonstration against a negative force? One thinks of how, in early Soviet Russia, people carried architectural maquettes through the streets. The idiom provided by the maquette belongs to events characterized by both celebration and protest. Colomer's interruptive gestures, interminably re-played in the silent looped videos that were screened simultaneously in the multi-projection gallery exhibitions that took place in Brazil and France in 2003, seem uncomfortably caught between outrage and celebration. Perhaps the clue is in the title, an anagram that draws together 'architecture', 'anarchy' and 'marathon', unpicking the cityscape but with no apparent programme in mind.

This spectacle is emblematic of the way in which several of the interruptions brought about via visual art in the current volume, although springing from a desire to protest, may become difficult to read *as* protest and instead get dragged along in, and ultimately serve to bolster, the hurtling forces of neo-liberal globalization. Think of the pop-up shops that turn bourgeois (Ferreri, Chapter 9); graffiti absorbed into the mainstream global art world (Jein, Chapter 6); or the street photography that mingles with other images in the street to become confused with advertisements (Jordan, Chapter 12). Interruption has only temporary force and may dissolve into or be co-opted by the very conditions it seeks to resist. Some

of the case studies in this volume disconcertingly suggest the emergence of a deceptive form of interruption, one that appears to spring up in order to work 'against the grain' of globalization and its forces, but that is in fact complicit with those forces – an interruption that is cooperative rather than subversive.

Colomer's running projects seem to exemplify the inevitable exhaustion of small protests, deeply and energetically felt but poor in resources, deprived of clear direction, and ultimately ineffectual. Their upshot seems to be a confirmation that it is not possible to find effective ways to undercut, interrupt and contest major urban development projects. The most that such interruptive pockets can achieve is, like this volume, to ask us to think again, harder, perhaps differently about the urban environment that surrounds us.

Digital favela

A further perspective on our paradigm of interruption is provided by architect and photographer Dionisio González, who grafts the materials and the idiom of the global city onto Brazil's favela structures in sharply clever and ambitious digitally manipulated images (Figure 1.2). Threading before us like frozen, frontal travelling shots, his large-scale panoramic images of the favela's façade have a disconcerting density. The habitual heterogeneity of favela building material and the haphazard, organic growth of the overall structure by irregular accretions are surreally interwoven with high-end architectural designs and materials, so that modules using smoked glass, sculpted concrete and beautiful wood are grafted on to and meld with the crude and makeshift breeze block, corrugated iron and slipshod cement. González thus provokes a mutual interruption of two worlds and a reflection on the speed and nature of development and planning in each built environment. Like Jordi Colomer's work, that of González is spectacular and surprising, inviting fictions full of humour, irony and social critique. These environments have stairs that seem to go nowhere, and a dream-like quality.

Favelas, some of the global city's defining spaces, are in themselves seen as potentially interruptive parallel environments, peripheries whose messy

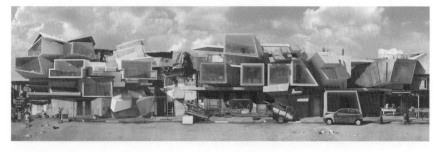

FIGURE 1.2 Dionisio González, *Novaacqua-Gasosa II*, 2004. Courtesy of the artist.

horizontality rivals the obsessively sleek verticality of the global centre. There is in these images a concentrated allusion to the socio-spatial inequalities inherent in the centre/periphery relations of São Paulo and Rio de Janeiro, and to the range of problems that this relationship involves. Affluence is sutured in; the wrong materials are used; the wrong shapes, angles and properties. The conjunction of the labyrinthine favela structure and the sleek and desirable matter of the postmodern global city seems to blend the hauntings, desires and antagonisms that construct the favelas conceptually (and comparatively) from both the outside in, and the inside out.

González's treatment of the favela, taking sharp account of its relationship to the vertical architecture of affluence, stands in contradistinction to the dominant image of the global megalopolis as a divided city characterized by extreme spatial segregations between the urban rich and the urban poor. Such an image of the city has been reinforced in recent studies of the global slum and the phenomenon of megacities by thinkers like Mike Davis (2006) and Lucia Sá (2007). In the Brazilian context, that image of division is perhaps best illustrated by Tuca Vieira's widely reproduced photograph of the Paraisópolis favela in São Paulo (Figure 1.3). Showing the razor-sharp edge dividing the low-rise sprawl of the favela and the high-rise clustering of fortified luxury living, the photo comments powerfully on the severity of urban separation. González's digital favelas emerge from, and respond to, the same divided world. Rather than accentuating such a condition of

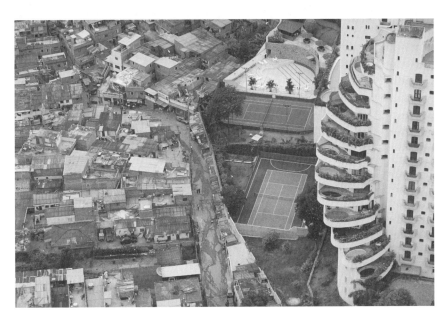

FIGURE 1.3 Tuca Vieira, *Paraisópolis*, 2005. Courtesy of the artist.

separation, however, his work experiments in aesthetic and spatial terms with intermixing those two worlds and dissolving their constructed boundaries.

From the outside, the favela can be seen as incoherent, threatening, amorphous and un-navigable. As such, it serves as a metaphor for the mass of its inhabitants, who almost seem to secrete this habitat organically like a carapace. González's photographs thus bring into mutual interruption two perspectives: one that is comfortable with the favela and one that finds it psychically disturbing, rather in the manner of Jameson's (1991) and Baudrillard's (2010) seminal records of dizziness and disorientation in response to the architectural spaces of Los Angeles' famous Bonaventure hotel. Jameson's description of hyperspace as 'transcending the capacities of the individual human body to locate itself, to organize its immediate surroundings perceptually, and cognitively to map its position in a mappable external world' (Jameson 1991: 44) resonates with outsider responses to this structure.

Grafting sleek and orderly elements onto the favela is a good visual joke for two reasons. First, there *is* no master plan for the favela, at least conventionally speaking. Second, the favela expands and reshapes precisely through the accretion of second-hand materials and heterogeneous scraps that are cast-offs from the affluent centre. Interruption is inherent too in the characteristics of the image itself, which is an unstable conjunction of competing categories. Here, art photography, documentary photography and the crisp fictional idealism of architectural design cut across and interrogate each other. The images look by turns like realist records of teeming favela structures, and by turns like confident architectural plans, typically focusing on built structure and not on signs or experiences of dwelling. Indeed, people in these images are uncannily evacuated in favour of an emphasis on design, producing an almost surreal interruption in the flow of the lived environment. This interruption is deliberately effected by González as part of his critique of centralized planning for favela-dwellers.

In terms of this critique, González's project interrupts with a very specific purpose, as opposed to that of Colomer described above. His work is intended as an intervention in debates about slum clearing and redevelopment projects on the one hand, versus in situ upgrading on the other, and stems from a deep concern for living conditions on the periphery of global cities. González points the finger at a real interruption of the favela, the now infamous Cingapura low-cost housing project in São Paulo, an example of corrupt and failed urban planning that was singled out for especially damning treatment in a recent report on global slum upgrading and human rights (Un-Habitat 2013). Here, the São Paulo favelas – notably those visible from the city's highways – were demolished to make way for high-rise blocks whose visual language was consistent with the vertical aspirations of the centre, but that disrupted the community networks and social structures of the favela and that nobody wished to inhabit. The towers now languish in a state of decay.

One of the most fascinating aspects of these photographs is that they are in fact authentic designs for in situ upgrading, as became clear in the exhibition of González's work at the *Interdictory Spaces* exhibition in Paris in 2008, where some of the photographs were accompanied by 3D plans to reveal the coherence of their structure and inner arrangements. González's interruptive experiments stand in opposition to a global vocabulary of verticality and homogeneity, and seek to further the explicit Millennium Development Goal of improvement rather than clearance of global slums.

Visualizing interruption

The above examples of interruption effected by the intersection of architecture and art in globalized urban space illustrate our interest in unruly practices that deflect, divert, decelerate or put on hold, and thus create the conditions for considering not only the object of interruption (what has been interrupted) but also the agent of interruption (who or what is causing the interruption). Reflecting this interest, we have divided our case studies in this volume into three interrelated categories: 'Crisis and Ruin'; 'Resistance and Renewal'; 'Bodies and Space'. These are not hermetic categories but rather tendencies and centres of interest. The examples of Colomer and González outlined above suggest a certain fluidity whereby works of interruption can cut across the various categories in telling ways. This fluidity extends not only to the organization of the current volume, but also to the individual chapters and case studies, each of which, as we elaborate next, privileges in various ways the idea of visualizing interruption.

Just as video and photographic art are integral to the mixed-media and mixed-mode creations of street running and favela design explored above, so several contributors to this volume consider the interruptive value of lens-based art. In the chapters that follow, specialists in film and photography examine how speed and flow are explicitly foregrounded in these media, and how a range of techniques are harnessed as ways of defamiliarizing or commenting on the urban. In particular, the chapters by Hugh Campbell and Shirley Jordan are specifically attentive to the medium of photography – so closely associated since its inception with recording cities – as inherently interruptive and stilling of flow; '*arresting*' as Barthes has it (Barthes 2000: 91). In Chapter 10, Campbell focuses on the urban environment stripped of its inhabitants; and in Chapter 12, Jordan addresses images of city dwellers excised from, and then woven back into, urban environments in innovative forms of display. Both chapters push beyond the most obvious instance of photographic interruption – the idea of the shutter click producing a frozen moment – to explore how recent practice with both analogue and digital images interrupts differently, creating expanded interruptions, temporal pockets, telling iterations of interiority that mark departures from more familiar instances of urban photography.

In addition, Campbell and Jordan consider how globalization shapes the urban scenes and objects photographed. This involves exploring how recent photographic experiments dialogue with the known potentialities of the medium as they set up new experiences to reflect on a shared emerging consciousness of a globalizing world. There is a concern too – also addressed in Chapter 7 by Gillian Rose, Monica Degen and Clare Melhuish in relation to architectural renderings of urban redevelopment projects – with how images of the global city loop back into the city's fabric and are displayed there, deliberately difficult to read, the crux of their function lying in that very illegibility.

In addition to an interest in stilling, a related concern with deceleration runs through this volume's engagement with urban visual culture. This is consistent with, and contributes to, what is a gradually coalescing interest in the meanings of slowness and slow practices in a global context (Honoré 2004; Koepnick 2014). In Chapter 4, Christoph Lindner builds on an extended reading of New York's High Line elevated park, which he understands as an iteration of slow urbanism, to explore how James Nare's extraordinary slow motion film *Street* (2011) furnishes a lyrical, revelatory view of the global street and its differentiated temporalities. In Chapter 12, Jordan suggests that Beat Streuli's slow-motion videos of the street also reveal the city in ways that are not available to the human eye at faster tempos, and open up spaces for new apprehensions of urban co-presence. David Pinder likewise underscores the value of slowness, tracing the leisurely paced re-discovery of an environment currently dedicated to the pursuit of speed – a six-lane motorway – with the aid of an experimental sound walk entitled *LINKED* (Chapter 5). Pinder's chapter sets this politically motivated walking project against the ongoing flow of the road, bringing about a sequence of interruptions which exchange the amnesiac highway for the layers of memory and experience that constitute lived space and that are intriguingly made available through sound. Here, walking and witnessing as artistic practice offer powerful ways of engaging with urban restructuring, injecting affect, and acknowledging it as the missing dimension in large-scale developments.

Other more visually spectacular kinds of activist art that also involve slow and deliberate re-calibrations of the relationship between cities and human bodies are analysed by Bill Marshall in his appraisal of buildering (Chapter 11). Marshall shows how this sub-cultural practice of urban climbing produces in the climber a new and especially tactile apprehension of the city and makes available previously unimagined places, spaces, interstices and perspectives. These in turn renew the city for those who look upon the sharply innovative visual records of the climbing experience in still or moving images. Our fascination for the incongruous body grasping or sitting aloft public buildings, sculptures and statues is testimony to a deeply felt, collectively shared sense of the need for what Robert Klanten and Matthias Hubner (2010) refer to as 'urban interventions' that cut across the prescribed order pre-written into urban space, however open-ended the meaning of such gestures patently remain.

Together, these chapters point to the subtle ways in which interruption repeatedly calls attention to the public/private dichotomy of city life (the public in the private and the private in the public) and strains towards the restoration of some degree of intimacy that seems achievable only by putting on hold the velocity and mobility of globalization. De Kloet's reading of urban planning in Beijing, through competing meanings of the scale model and through a documentary film on demolition of the Qianmen *hutong* (alleyways) to make way for a shopping street, explores precisely such interruptions (Chapter 3). De Kloet sets the complexity of intimate stories, as revealed in works of visual culture, against the smooth utopian fiction of progress underpinning a gigantic maquette of the evolving city housed in the Beijing urban museum. He shows, for example, how the alternative scale models made by artists such as Xing Danwen contest the ideology of architectural maquettes, mimicking their idiom, but interrupting their assumptions and letting in mess. The tiny human figures whose activities inject into the plan elements of puzzling or disturbing intimacy open it up suggestively to the layers of human experience that, in its sanitized emptiness, it deliberately refuses to map. Use of miniature figurines has been on the rise in recent years among a range of artists and urban photographers such as Isaac Cordal (see Chapter 12) and their potential for powerful interruptive gestures is considerable. Commentators on this trend are explicit about its value as a response to both the speed and scale of globalization and to an escalating personal sense of being unsettled and fragile (Valli and Dessanay 2011).

The fantasies of urban living developed by planners and architects are analysed too by Rose, Degen and Melhuish, who focus on an especially complex type of image: the high-definition, computer-generated digital visualizations of large-scale redevelopment projects that are displayed on the hoardings of today's urban building sites (Chapter 7). Here visual culture, at its most insidiously seductive, is squarely in the service of the market. The authors analyse the visual qualities of these images and delineate the processes of layering and negotiation that their production necessitates and that takes place between the various agents involved. One of the most notable features of these visualizations is their persistent erasure of labour: none is depicted, while the labour involved in the images' production is also made to dissolve. Rose, Degen and Melhuish suggest three strategies for interruptive readings of such images: resisting, deglamourizing and networking. The latter, most far-reaching tactic gave rise to a 2013 London-based exhibition in which the visualizations' layers were separated out to expose the methods they use to produce idealistic worlds of leisure and to challenge the visions they project.

Urban renewal and gentrification in the specific context of Paris's *banlieue* is the context for Gillian Jein's study of art-based interruption (Chapter 6). Drawing on Jacques Rancière's politics of aesthetics, Jein considers street art as snagged between protest traditions and capitalist spectacle and analyses the way in which the graffiti-laden structure of derelict buildings situated on the Canal de l'Ourcq in

the commune of Pantin became a key visual cultural site as the area was progressively re-appropriated and re-framed by the centre. The case study reveals sharply how aesthetic experience is integral to the (re)distribution of power and to processes of social and political exclusion. For Jein, the shared public 'canvas' of the buildings' surfaces constitutes a site of everyday micro-interruptions that seek to fend off renovation, yet whose impact in the last analysis is not truly counter-cultural.

A further contested development, that of the catastrophically disruptive Amsterdam North–South metro line, is studied by Ginette Verstraete (Chapter 8). Verstraete traces the troubled history of the line since it was first planned in the 1950s, through interruption of its construction in the late 1970s, to resumption of the project some twenty years later within a new 'networked' landscape. Particularly attentive to the way in which social media platforms became intricately bound up in controlled mediation and self-promotion as the long discredited construction project continued, she gives a detailed account of the dense mesh of creative production in, around, and about the construction site. Aestheticization, celebration of the project's visibility as spectacle, a raft of participative cultural events and a variety of interventions in public space above ground constitute a powerful case study of the intersections between mobility, place and media. Here urban visual culture – orchestrated from the top down by powerful interest groups and presented as participative – is powerfully harnessed to work with, rather than against, the commercial grain and to ensure public support on the ground.

For Mara Ferreri the epitome of temporary urban interruption in the wake of the 2007–8 financial crisis is found in the somewhat smaller-scale, if widespread, phenomenon of pop-up shops. Chapter 9 analyses the re-claiming, for social and artistic uses, of some of the commercial spaces lying fallow in East London and considers the position of such projects within the wider dynamic of urban culture. Ferreri examines the shops' celebratory aesthetic and their range of uses. Through close analysis of encounters at the shop front, she analyses conflicting responses on the part of those who 'fill' and those who are enticed into these newly appropriated places, as well as the ways in which the shops re-articulate the urban imaginary by reclaiming the spaces of decline and promising opportunities for slow, newly authentic community encounters. She situates their apparent interventionist thrust in contradistinction to the pop-up shop as a commercially oriented marketing vehicle. Ultimately, however, her chapter asks whether such provisional pockets of apparently countercultural transformation may be seen to interrupt, or instead to provide ballast to the existing global dynamic of interurban competition and place branding.

In the first of this volume's case studies, Richard Williams further pursues the task we have set ourselves in the current chapter, submitting the concept of interruption to vigorous scrutiny and placing it at the forefront of his analysis (Chapter 2). Williams pinpoints the contradictions and blind spots that he detects

in the widespread academic attraction to (or even nostalgia for) the idea of interruption. In the process, he identifies its rootedness in 1960s' counterculture, describes its aesthetics, and predicts its future. The material instances of interruption that he references include the ruin and the food truck, the latter seen as powerfully revealing of the modalities and meanings of urban interruption since 2008. Williams ultimately asks how good the idea of interruption is to think with. When does it cohere and reveal something essential about the global city? Conversely, when does it fragment into inadequacy, peel away from reality, and reveal itself as a fiction? Like its companion chapters in this volume, and like the volume as a whole, Williams' study not only describes interruption but also demonstrates the intricate and often conflicted intellectual engagement that academics from a range of disciplines have with the concept. One thing at least is clear: at once unsettled and unsettling, interruption has emerged as a key critical concept for our understanding of global cities. Studying its embodiment or enactment in various forms of visual culture is one powerful way of teasing out the complicated and competing investments that are inherent in urban change.

Note

1 *Anarchitekton* is also a compound term referring to the Greek *architekton* (designating both architect and urbanist); to the *Architectones* (plaster architectural models of a city still to come made by Kazimir Malevich and stemming from Suprematist formal principles); and *Anarchitecture* (the group founded by Gordon Matta-Clark in 1974 that promoted anarchy in architecture and attempted to reveal social problems through art).

PART ONE

CRISIS AND RUIN

2 WHY WE LOVE 'INTERRUPTION': URBAN RUINS, FOOD TRUCKS AND THE CULT OF DECAY

Richard J. Williams

In the humanities, we love the 'interruption' of capital's flows, especially the greatest products of capital, its cities. How we love dystopias, whether we are students of latter-day Detroit, consumers of so-called ruin porn, fans of J.G. Ballard's ecstatic fiction, or the many who follow Guy Debord in the simultaneous critique and celebration of the 'spectacle'. However, our attraction to these things also misleads us. What I show in the following is how our desire to see capital fail – which is mostly the good old cult of the picturesque – blinds us to other discourses, equally valid, it seems to me, in which the city ruin still represents opportunity and security. So this chapter presents an alternative to the gloomy view of cities that prevails in the pages of the *London Review of Books* and its counterparts across the world. It is also an attempt to define 'interruption' in material terms through the figure of the so-called food truck: a much discussed consumer trend that, however ephemeral-seeming here, embodies, in all its contradictions, what we mean by the term 'interruption'. More of that later.

The concept of interruption is largely academic. As Shirley Jordan and Christoph Lindner explain elsewhere in this book, 'interruption' attempts to explain a cluster of urban phenomena that are widely perceived, understood and consumed, but that have no generally accepted label. The kinds of things they describe may exist in the field of culture: an outdoor screening of a film, or an artist's projection on a disused building for example. They may be *ad hoc* performances, such as flash-mobbing. They may be political interventions, such as the Occupy movement that achieved such worldwide attention in 2011.[1] Or they may be small-scale,

bottom-up consumer phenomena such as guerrilla gardening, or food trucks (discussed later). The contemporary art world has arguably taken up the interruption as its principal *modus operandi*. Its income may still be produced by the sale of conventional items of painting and sculpture, but contemporary art announces itself to the world by interrupting its surroundings; Tate Modern, in common with many contemporary art spaces around the world, has essentially dismissed its collections to a supporting role, in favour of the colossal interruptions staged by the Turbine Hall (Fer, Hudek, Nixon, Potts and Stallabrass 2001). The interruption has become conventional wisdom in many ways. We shop or dine in 'pop-ups'. Our parks and recreation spaces, like New York's much celebrated High Line, are interruptions, designed to make us pause and reflect. Our architecture, especially the architecture of cultural spaces, has long cultivated an aesthetic of disruption rather than affirmation; we ask, seemingly, that our buildings interrupt our flow, rather than help us maintain it. We consume 'ruin porn' of various kinds, such as the now iconic photographs of Detroit by Yves Marchand and Roland Meffre or exhibitions such as Brian Dillon's *Ruin Lust*, held at Tate Britain in 2014.

And then, outside of the rather high-minded academic thinking on disruption, we can find any amount of material advocating something analogous to interruption as a means of producing capital returns. Look at the business sections of any bookstore and you will find books on 'creative' disruption, proposals to interrupt all kinds of flows of production and consumption in order to produce new paradigms of the same. In the world's business schools, 'disruption' of work, of capital flows, of ideas or traditions is a given, as if the students of the Paris '68 events had somehow taken over the corporate world.[2] The much-reported success of Silicon Valley in the mid-2000s has been much discussed as a paradigm of disruption, an attitude as much as anything that supposes rupture instead of wholeness, breaks instead of flow.[3] ('Disruption' has its physical manifestations too. Mountain View, Cupertino and Menlo Park, the geographical poles of Silicon Valley, constitute a highly fragmented urban landscape, incapable of perception as a whole. That is an argument that will have to wait.)

But capital's most efficient and impressive modern spaces, what Manuel Castells famously termed the 'space of flows', rarely get interrupted, except by war or acts of God (Castells 1996: 404). Cultural interruptions occur, by and large, in landscapes that are already themselves interrupted. The sites that get interrupted, you might say, are typically the inner areas of established cities, areas colonized by artists and other workers in the so-called creative industries. Since the late 1960s in the industrialized world, these landscapes have become tiresomely familiar: former factories and warehouses located by rail lines and port facilities, now scattered with coffee bars and lofts. They have a look that scarcely needs description. This landscape is, wherever found, a contrived set of disjunctions rather than flows –

old versus new, industrial versus domestic, big versus small, decayed versus reformed. These landscapes are everywhere, and regardless of the informality of their surfaces, they tend to be highly orchestrated. 'Oakland First Fridays' (2014), a monthly art event in the northern Californian city of Oakland, is a good example. Beijing's 798 art zone is another, a synthesis of every conceivable form of cultural interruption, on a mind-boggling scale.

The space of interruption (if we can call it that) is an essentially ruined space. The sociologist Sharon Zukin's (1982b) seminal book *Loft Living* described a mode of living parasitical on the failed spaces of capital. This mode colonized abandoned spaces of industrial storage and production, but in a way that made only minimal changes, in so doing preserving the memory of what went before. 'Authenticity', a term Zukin (2009) used later on, became prized; real estate agents sought out and promoted 'original features', however much they jarred with the new residential uses of buildings; a new aesthetic cult emerged.

The spaces of interruption were, and are, inescapably melancholy. One typically thinks of late-nineteenth- or early twentieth-century industrial architecture, sometimes magnificently scaled, but redolent of labour, discipline and loss.[4] These things came to be prized, along with, arguably, an accompanying sense of space that proceeded from the evacuation of industry. Industrial buildings and zones were empty-feeling; none of the replacement activities could fill them with equivalent life. The sense of plenitude, of congestion engendered by the industrial city, would never return, and its new colonists recognized and even prized that fact. It seems to me they *liked* the emptiness. Even in the most successfully regenerated parts of industrial cities, the melancholy persists, through design or association or a combination of both. Robert Harbison's (1977) poetic exploration of urban space, *Eccentric Spaces*, dates from the late 1970s, but is still relevant to this question: we seek out the melancholy, he says, for example by visiting the old port of London, precisely because it is disused. The live equivalent in Rotterdam holds no interest (Harbison 1977).

The location of cultural facilities in these places became a topic of considerable academic interest. In the field of geography, David Harvey argued that culture-led regeneration did nothing for the citizens of the areas in which it occurred. A now standard work of this kind, Harvey's *Cities of Hope* (2000) describes a hollowed-out, segregated, violent Baltimore behind the buffed-up brickwork of the Inner Harbor. *Cities of Hope* had a cultural counterpart not long afterwards, in the David Simon-scripted TV series *The Wire* (2002–8), which brought a broken, hopeless Baltimore to screens worldwide. There cannot have been many city-attuned academics, anywhere, who weren't also *Wire* fans.

Broaden the academic question out a little to consider the reference points routinely used by academics in the humanities when they need some urban theory (I include myself in this): Marc Augé, Friedriech Engels, Karl Marx, Georg Simmel, Siegfried Kracauer, Mike Davis, Ed Soja and David Harvey already mentioned – a

roll-call of urban dystopians if ever there was one. This trans-generational literature speaks to the 'end' of the city in diverse ways. The gentrified inner city is a highly policed space of exception, we might say, having picked up Giorgio Agamben (1998), or a 'heterotopia' if we have looked at Michel Foucault (1996) again. However we look at it, the city is going to hell. 'Interruption' is a perfect manifestation of this dystopian, essentially anti-urban worldview. 'Interruption' supposes both an antagonistic place in relation to the urban surround, and the urban surround itself as interrupted. To put it another way, we cultivate 'interruption' because we have become essentially antagonistic to the cities that surround us. And we celebrate the city when it is itself interrupted by economic or other kinds of failure – we cultivate its ruins, not its monuments. This is a global tendency among the educated, although it has a particularly strong expression in England, as I argued in 2004: the disdain for the urban has roots in the early nineteenth century, and the present-day taste for ruins is a straightforward continuation (Williams 2004: 107–28).

What's wrong with dystopianism?

The dystopian worldview works perfectly well in the academy, and specifically those academic disciplines (geography, sociology, various kinds of cultural studies) that buy into it. But it falls apart as soon as we move outside. (It actually falls apart as soon as we experience the puzzlement of students from any place where the city unambiguously represents opportunity – but that is another story.) What I set out in the rest of this chapter are a few of the ways in which 'interruption' fails as a means of describing cities. It is, and will certainly remain, an important idea in the humanities, and more broadly in the world of culture. However, 'interruption' may also be misleading. The purpose is not, I should stress, to dismiss 'interruption' from our vocabulary, but to refine its definition. Set in context with other ways of thinking, it is to my mind an exercise in fantasy, a sort of science fiction. It colours the way we understand the materially existing city, but is essentially a product of the imagination. What I set out in the following draws from demographic statistics, and some readers will infer a correlation between growth and quality (or to put it another way, a growing population is a good thing). That is broadly correct. The reason is that of the concepts of 'interruption' we have in play, almost all of them are underpinned by an imagination of decline, whether economic or popular. The stats I draw on are a corrective. The logic of interruption does not bear much relation to the lived reality of cities now, and even the financial crash of 2008 did not produce much of a pause in the general process of urbanization or re-urbanization. So the culture of interruption is a poor indicator of the actual state of cities, as if what we say or think about cities, and how we experience them, are actually two different things.

The great inversion

During the past five years a lively pro-urban secondary literature on cities has emerged. In what it advocates, it is not dissimilar to what lonely urbanists described in the 1990s, from Aldo Rossi (1982) to Richard Rogers (1996) to (in a marginally different form) the New Urbanists (Talen 1999). However, it differs from that earlier (in some cases, much earlier) literature in that it describes not aspiration, but statistically supported change. The evidence for change is incontrovertible, and sometimes dramatic. These books point to some remarkable phenomena of the past decade: re-urbanization of the most unpromising places, population growth, new pieces of infrastructure, light rail in particular. Los Angeles, for much of the twentieth century one of the most car-oriented cities on earth, has become by some margin the most densely populated urban region of the US, surpassing New York in 1990 (Soja 2014). This has not solely been a US phenomenon, however: most northern European cities have experienced something similar. In the UK, London's population is now 8.2 million, close to its historic high (1939) and well up on its historic low of 6.7 million (1988). Manchester's population has grown 19 per cent in its urban core since 2001, a positively Victorian rate of growth (*Economist* 2012). Even longstanding basket cases such as Belfast or Liverpool have experienced growth of between 5 and 10 per cent during the past decade. Population growth is only one measure of a city's health. For contemporary, pro-growth commentators it is a good one, but that view would have been anathema to decision makers in the mid-twentieth century who would have seen congestion as a problem (see Hall 1996).

This recent urban literature is advocacy of a kind, but also an account of a process that is fully in train; while it is not shy of identifying problems associated with the new trends, it is also straightforwardly pro-city. It does not advocate garden cities or urban de-congestion; congestion is a positive. Key books include Ed Glaeser's *Triumph of the City*, a Harvard economist's take on the same phenomenon, which holds New York's revival over the past twenty years as a model (Glaeser 2012). Bruce Katz's *Metropolitan Revolution* is a fine example too, an account of research on the re-urbanization of American cities based on a decade's worth of research done by the Washington DC-based Brookings Institute (Katz 2013). In the UK, a number of writers have presented the city as a conduit to 'happiness', however defined: Leo Hollis (2013) is a good example, perhaps drawing on the popular philosopher Alain de Botton's (2006) earlier speculations.

A theme of all the American literature is the key role of information technology, and social media in particular. It elaborates work done by the University of California Berkeley's erstwhile professor of planning, Manuel Castells (1996), who argued in the 1990s that communications networks would produce density, not the reverse (Castells' sometime colleague Melvin Webber (2005) had argued in the mid-1960s that technology would mean the dissolution of the conventional

city). The conventional wisdom now is that technology not only produces nodes and hubs, to use Castells' terminology, but that it actually produces *more* face-to-face communication. Not only does technology, the argument goes, produce more communication *per se*, but the complexity of new forms of work requires plenty of face-to-face work: coaching, for example, which can only be done effectively in person. Hence the attraction of physical clustering, which one might have thought these technologies would abolish. As Glaeser wrote, 'ideas cross corridors and streets more easily than continents and seas' (2012: 36; see Katz 2013: 21–2).

The mainstream media understands these things reasonably well. The *Financial Times* picked up on the US story well before it was reported elsewhere, giving plenty of attention to *The Great Inversion* and the other books (Gapper 2013). The *Economist* went as far to declare recently that the inner-city problem, a cause of such anxiety in the 1980s, had been effectively 'solved', citing tumbling crime rates down by 70–80 per cent, immigration and (citing the experience of Manchester, UK) urban organic farms in Moss Side (*Economist* 2012). It is the suburbs that are now crime-ridden dystopias. No doubt the picture is more complex, but broad trends are irrefutable. Crime is down, and growth is up, in terms of both capital and population. Nobody, for the time being at least, thinks we are going back to an anti-urban future.

Among the more even-handed treatments of the city is Alan Ehrenhalt's *The Great Inversion and the Future of the American City* (2013), which describes the turnaround in the fortunes of (largely) American cities since the 1990s. The story is simple: since the Second World War, most American cities saw precipitous drops in their populations, and the growth of suburban or ex-urban regions, with poor infrastructure and little sense of urbanity. That process, Ehrenhalt argues, has been substantially reversed. In Chicago, the author's hometown, and a reference point throughout, the city is coming to resemble a traditional European city in terms of its demography. It could be 'Vienna or Paris in the nineteenth century, or, for that matter, Paris today. The poor and the newcomers live on the outskirts. The people who live near the centre are those, some of them black or Hispanic, but most of them white, who can afford to do so' (Ehrenhalt 2013: 3–4).

The racial dimension Ehrenhalt reports as symptomatic of the process. It is more than a simple influx of wealth, more a reversal of longstanding demographic trends. He cites Vancouver, the economic capital of Canada's British Columbia, as the North American city that has gone furthest in this reversal of direction: a 'forest of slender green condo skyscrapers' the city sees as many people commute out from its centre as inwards; 'new public elementary schools' have opened in recent years. It is a process that if anything, Ehrenhalt notes, has been 'too successful' (2013: 5): the city of residence has squeezed out the city of work, to the point at which it is no longer economically feasible to build office accommodation downtown.

The evidence across the border in the United States is also compelling, with rapidly growing urban populations in, for example, Lower Manhattan where the local population rose from 15,000 to 50,000 in the period 2001–8 (especially striking given the ruinous physical condition of this part of the city following 9/11) (Ehrenhalt 2013: 7). There are also compelling accounts of population growth in cities such as Phoenix and Houston, where there never were traditions of urban living in the first place (there is a gently amusing account of Phoenix citizens enjoying light rail for the first time) (Ehrenhalt 2013: 196–8). The anti-urban imagination has been replaced by an urban one, Ehrenhalt argues, to the point where the young now aspire to live in cities or something like them, and where they may not, as in previous times, see a driver's permit as a signifier of adulthood (Green and Naughton 2014). It is as if, quoting another urban historian Donald Olsen, the 'nineteenth century city [has been] reborn' (in Ehrenhalt 2013: 25). The whole process has been ongoing for a decade or so, but as Ehrenhalt reported in an interview with me, before 2010 there was relatively little media interest in the American city, and few people – Glaeser being a notable exception – had tried to describe it as a general phenomenon. It was more of a 'surprise' than it ought to have been (Williams 2014).

I am not going to interrogate Ehrenhalt's data here because they are based on non-partisan sources. Further corroboration, if needed, comes from the state of the real estate markets, which have seen intense capital growth in city centres since 2008 (at the time of writing, the *average* cost of a property in San Francisco was over $1 million, which was according to figures from the US Census Bureau for 2012, around twenty times the median household income for the United States as a whole) (Noss 2013). The upward pressure on real estate values has been much reported, along with the severe challenges it imposes on residents. Putting those aside for the moment, what the price data shows is a clear preference for cities.

'Interruption' meets the great inversion

So how does this inform 'interruption'? For the British left, the city was an inconvenient fact. As H.G. Wells once reportedly said on leaving a Fabian meeting in London, gesturing to the modern buildings all around, the city was 'a measure of the obstacle, of how much there was to be moved if there were to be any change' (in Williams 1973). In spite of the propensity of cities everywhere to vote for left-of-centre candidates, until 1997 the British left was by definition anti-urban. If you experienced municipal socialism in the north of England in the 1970s, you experienced urban government that paradoxically saw itself as a means to its own abolition. Manchester systematically reduced its central city population to near zero, and as late as 1985 saw its task as assisting the area's continued decline – it saw no long-term future for the city *per se* (see Williams 2004: 201). Like Liverpool,

Sheffield, Bradford and Leeds, it saw itself as the product of a discredited and outmoded capitalism. It was the task of government to see that it faded as quickly as possible. Something of this anti-urbanism still remains on the academic left, which means, in practice, that the humanities sometimes find it easier dealing with cities of the imagination, rather than of reality.

This is a gross generalization, of course. But there is something in it: think how often humanities scholars equate growth with catastrophe. Think of Mike Davis's (1998) work on Los Angeles, a global, not just American pole of growth. The city is a 'disaster' (social, ecological, seismic – you name it). Or consider the now well-established slum-city genre, of which Suketu Mehta's *Maximum City* (2004) is an example: the developing world megacity presented as a delicious horror to be consumed, far away, in a comfortable armchair.

Concretely, when 'interruption' meets 'the great inversion', there is no dialogue: the terms represent mutually exclusive worldviews, the one dystopian and anti-urban, the other growth-oriented and pro-urban. Each side claims to represent the city, as it were – but the object of the city in each case is different, and no dialogue is possible. I have experienced this countless times in teaching, especially with students from outside the Anglo-American context. The humanities' understanding of 'city' and what might be understood as the 'business' understanding of the city are mutually unintelligible.

These are caricatures, albeit ones widely in use. On the one hand there is the culture of interruption, underpinned by the cult of the ruin, and a vague belief in the city's imminent demise. On the other hand is the caricature of the urban booster: the urbanite and his or her colleagues, extrapolating from their own metropolitan situation. Their understanding of the city is underpinned not by imagination so much as statistical evidence. They can, as Ed Glaeser (2012) says in the unrepentantly pro-city subtitle to his book, point to evidence that cities ('our greatest invention') make us 'richer, smarter, greener, healthier and happier'. The city boosters present the city as a smooth surface on which growth can be, literally, projected: the statistical trends point relentlessly upward; the trajectory is smooth. Those imperfections – the abandoned buildings and decay – read differently from the boosters. They are no longer imperfections in the fabric, *memento mori* to remind us of the folly of human action, but opportunities for development. There is, arguably, a third position that sees a new, more nuanced, status for the place of ruins in cities, but I will leave that for others to make.[5]

Meet the food truckers

But are these positions so different? It is helpful, I think, to have the corrective of the latter position for, if cities were indeed the wastelands they were held out to be, then no one would be moving to them. But it is a false dichotomy in many ways,

for the individual instances of interruptions are also legible as contributing to the urban economy. The new urban economy in fact tolerates what might in another context be called interruption. As has been much discussed lately, it tolerates huge disparity of wealth, hyper-accumulation in certain favoured locations, and no accumulation in others. As the urbanist Richard Florida put it in the title of an article for *Atlantic*: the 'world is spiky' (Florida 2005: 48).

The dichotomy is also false when cultures of consumption are taken into account. An interruption might be taken to be an antagonistic act, one opposed to the commerce of its surroundings. Such ruptures may also, as business schools worldwide have theorized, be the result of intentional processes of creative disruption: means to creating new consumer paradigms. The difference between antagonistic acts and acts of commercially driven disruption may be very difficult to tell apart, perhaps impossible. The culture of the San Francisco Bay Area is a case in point: here, the most disruptive technologies have probably been produced by the technology companies of Silicon Valley, not the area's artists, who increasingly see their task as one of simple resistance to change. A key emblem of this interrupted city has become, arguably, the food truck.

The motorized kitchen has a history as long as the automobile itself but its recent, mostly American, iteration is a product of the post-recessionary city. An object of much critical fascination, it has been accompanied by a boom in highly aestheticized forms of food criticism, in which the object of attention is, to all

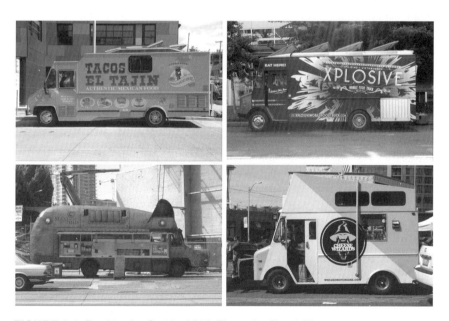

FIGURE 2.1 Food trucks, Seattle, 2014. Photos by Cheryl Gilge.

intents and purposes, indistinguishable from art (*Lucky Peach*, a sort of *Artforum* of food launched in 2011, is a good example).

The food truck is a perfect object in this case. It not only has the requisite look of austerity (it looks cheap) but also, we could say, performs an interruption in urban space. Its attraction is that of the carnival, albeit on a small scale: it rolls into town (or the school yard, or parking lot) and temporarily interrupts daily life. It does this partly through food: its contemporary iteration is big on spectacular culinary fusions, all colour and strong flavours. And it does it through the social life it temporarily engenders: the trucks are physical spectacles in themselves, and they make places out of non-places, while the inevitable lines to be served provide an opportunity to socialize (waiting in line is indeed part of the experience). The waiting and socializing usually have some ancillary support: buskers, music groups, etc. The overall effect of the food truck is unique, but it draws on a number of precedents from the 1960s: it resembles any number of temporary, performative, participatory actions in the realm of art.

Arte Povera would be a good comparator. Initially an Italian tendency defined by the art critic Germano Celant, it became an international label describing an art of intentionally poor materials and austerity, a riposte to the 'rich' art of the museums. The New York-based critic Lucy Lippard's book *Six Years* (1997) surveys the late 1960s' and early 1970s' art scene and contains any number of possible precedents for the food truck's aesthetics. And as she makes clear in the introduction and postscript, the aesthetic of these projects had an explicit politics too. To make an art of poor materials, a temporary, informal, low-key art was a form of cultural resistance. To engage with this stuff was to engage with the low, rather than the high, the street, not the museum, the mass of people, not the elite. Something of that rhetoric survives in the food truck, and it does not greatly matter if customers recognize it or not. The radical aesthetics of the 1960s have, one way or another, become part of the wider culture.

The contemporary food truck dates from 2008 or so. Sharon Zukin (2009) describes an important iteration of it in her *Naked City* where it stands for 'authenticity' and since then, newspapers, news magazines and food websites have routinely reviewed the food truck scene in major US cities, while a significant industry developed around supplying food trucks and their equipment. Margins remained tiny, and the business precarious, but it had become by the time of writing a plausible career choice (see Davidson 2013).

A good indicator of the food truck's status was the successful mainstream movie *Chef* (dir. Jon Favreau, 2014). No work of art, it nevertheless says succinctly what the food truck stands for.[6] The lead, played by Jon Favreau, is a successful chef at a high-end Los Angeles restaurant. Altercations with the restaurant's owner (Dustin Hoffman) and a sadistic online review lead to his departure and, after several further moves, the purchase of a food truck specializing in Cuban sandwiches, leading in turn to business success and then marital reconciliation.

In *Chef*, the food truck stands for many things. First, it offers a kind of authenticity that transcends money. Its dreadful condition requires labour to bring it up to scratch: the hard, but unalienated work of the refurbishment is pictured as both a reward in itself and a therapeutic tool. The truck is, second, a figure of authenticity. The food made in it is the Cuban sandwich, a simple, cheap and highly calorific treat available to all. Third, the truck is a counter-cultural vehicle. In a key scene, Favreau finds himself in contravention of a set of city ordinances (an occupational hazard of the food truck business, especially on the East Coast). The cop books Favreau, but not before having himself photographed with him, posting the results on social media, and in so doing giving the truck an invaluable publicity boost. At the same time the confrontation draws a large crowd, who soon rally in support of Favreau against the police. Without overstating the case, the episode places the food truck in an antagonistic relationship with authority. It is a vehicle for resisting authority and, ultimately, changing it. Finally, the truck is a therapeutic vehicle. Through buying and refurbishing the truck and setting up a business, Favreau restores a flagging relationship with his son and, ultimately, his ex-wife, whom he remarries at the end of the movie. It's too neat to be believable, but the idea of the truck as therapy *does* tie up with other ways the culture has been presented. Reading around such organizations as Off The Grid, for example, and the proposition is less business or retail, than therapy: through Off The Grid events, people and communities are psychologically healed and self-improved. The truck is not only good for you in terms of what it sells, but it is putatively good for you by means of its very existence.[7]

So when was interruption?

The food truck for me is emblematic of what this book means by 'interruption', and for many others too: it is representative of the peculiar changes that have been wrought on cities since 2008.[8] Like Occupy, it borrows the language of 1960s' counterculture to create a pause in the flow of the everyday. It has undoubted capacity to create social interaction of a new kind. But it is also a particular kind of business proposition that assists in developing capital flows as much as it might temporarily divert them. As we have seen, the rise of the food truck parallels the return of the city, which is real, and has produced astonishing capital growth in recent years. We should be careful what we mean by 'interruption', therefore, because by most measures, urban growth in terms of people and physical development is running at unprecedented rates. Judging by financial and demographic data, cities have barely been 'interrupted' at all by the events of 2008.

What the food trucks, and 'interruption' more generally, might tell us, however, is something about the quality of that growth. If cities are getting bigger demographically, and attracting more and more capital, the growth is not evenly

spread. The popularity of Thomas Piketty's 2014 book *Capital* indicated a broad awareness of what has come to be known as inequality. It is not my job here to criticize inequality, nor to offer a solution – but it is to say that 'interruptions' tend to occur in unequal places or, to put it another way, that the physical interruptions we see in cities, their 'holes', are often the physical manifestation of inequality, of the tendency of capital to cluster, and that cultural phenomena such as food trucks are a cultural response to inequality. They cluster in those zones left behind by capital in what might otherwise be favourable conditions. And if anything, the food trucks and allied phenomena celebrate the interruptions of the cities they inhabit: those cultural interruptions draw attention, as they always have done, to the interruptions produced by the flows of capital, and that has, of itself, become a tiresomely familiar aesthetic. For many of us in the most capital-intensive part of the world, interruption is the desired aesthetic. Irrespective of the morality, we cultivate inequalities. We want difference, contrasts, 'crunchiness', the cognitive dissonance so often sought, however perversely, by the privileged. These things ultimately define interruption. And when was it? Well, I think the 'when' coincides with the 'when' of the food truck, so from 2008 to the time of writing. It has become a powerful aesthetic. But it will, like everything, have a limited lifespan. In the long run, in tougher times, it may come to look like decadence.

Notes

1 I chose not to discuss Occupy in detail here. For more on it see Chomsky, N. (2012) *Occupy*, New York: Penguin. See also David Runciman's critique of the movement: Runciman, D. (2012) 'Stiffed'. *London Review of Books*, 34, 20, 25 October 2012, 7–9.

2 'Creative disruption' is beyond the scope of this chapter. For a brief summary of the current state of the field in business studies see Kay, J. (2014) 'Innovation Disrupted by Warring Gurus', *Financial Times*, 19 August 2014, http://www.ft.com/cms/s/0/0f599a20-26d0-11e4-bc19-00144feabdc0.html#axzz3B7i1cBxe [Accessed online 21 August 2014].

3 For a sharply critical take on 'disruption' and its history, see Shuelvitz, J. (2013) 'Don't You Dare Say Disruptive', *New Republic*, 15 August 2013, http://www.newrepublic.com/article/114125/disruption-silicon-valleys-worst-buzzword [Accessed online 25 August 2014].

4 The term 'urban memory' could also be used here. For more on that, see Crinson, M. (ed.) (2005) *Urban Memory: History and Amnesia in the Modern City*, London: Routledge.

5 In short, the desire to keep ruins as repositories of the imagination. See the debates around the St Peter's Seminary in Cardross, Scotland, and the Ministry of Defence building in Belgrade, Serbia. Both ruins have their advocates.

6 An alternative view of *Chef*: Lane, A. (2014) 'Movies', *New Yorker*, 9 May–17 June 2014, http://www.newyorker.com/goings-on-about-town/movies/chef-2 [Accessed 25 August 2014].

7 Off The Grid is 'about bringing communities together through amazing shared food experiences': http://offthegridsf.com/ [Accessed 25 August 2104].

8 For Nicole Archer of the San Francisco Art Institute, the food truck is the locus of creativity in the Bay Area. As a creative space, it surpasses anything, she thinks, in the art or technology sectors. Unpublished interview with Nicole Archer, San Francisco, July 2014.

3 RESCUING HISTORY FROM THE CITY: INTERRUPTION AND URBAN DEVELOPMENT IN BEIJING[1]

Jeroen de Kloet

Today I live in the pictures I make and I, along with my compatriots, can imagine our future by bending down to examine tiny models of buildings. This, perhaps, is another reality of the 'fantasies' which govern our contemporary life.

XING DANWEN 2009

[Totalitarian] regimes have discovered the political means to integrate human beings into the flow of history in such a way that they are so totally caught up in its 'freedom', in its 'free flow', that they can no longer obstruct it but instead become impulses for its acceleration.

HANNAH ARENDT 2005: 121

Soft powers

The main exhibition piece in the Beijing Urban Museum, located close to the south-east corner of Tiananmen Square, consists of a big scale model, or maquette, of the city of Beijing. At times a colourful lightshow highlights the north–south axis that defines the city, starting from the Temple of Heaven in the south of

Beijing, passing Tiananmen Square and the Forbidden City leading up to the Olympic park. As such, the cheerfully illuminated history is a history that is compressed and mapped onto a simple line, leading from religious and Dynastic times to communist landmarks, to arrive finally into a cosmopolitan utopian future. History is represented in the museum, as I will show in more detail later, as a neat and tidy line; it is constitutive of an authoritative discourse that helps to legitimize the ruling powers. It brings to mind Hannah Arendt's words, that 'modern thought has replaced the concept of politics with the concept of history' (2005: 121). In particular the end point, the Olympic park, is of interest here, since more so than the other landmarks, it plugs the country smartly into a narrative of globalization and cosmopolitanism.

The Urban Museum is very much a display of progress and development; it presents the changes in Beijing as a carefully planned process that legitimizes its current state, while simultaneously pointing towards a promising future. As such, the museum is part of the soft power tactics mobilized by the nation-state (Nye 2004), a notion that refers to the cultural politics through which nation-states brand themselves for their citizenry and the world at large. Through an analysis of the display in the museum, the movies that were on show there in the Olympic year of 2008 and the ideological role of the maquette, I aim to dig deeper into the different tropes through which Beijing, as the capital of an allegedly rising global power, is presenting itself.

The observation that countries use culture to promote themselves is neither original nor new. The question of how they do so, through what narrative modes and representations, is more urgent and implies a shift from the theoretically rather weak notion of soft power towards the idea of governmentality, a term that, according to Foucault, mediates between power and subjectivity and that allows scrutiny of the close relationship 'between techniques of power and forms of knowledge, since governmental practices make use of specific types of rationality, regimes of representation, and interpretive models' (Brockling, Krasmann and Lemke 2010: 2). Governmentality refers to the everyday techniques through which individuals organize and govern themselves as an implicit condition of their citizenship (Ouellette and Hay 2008: 473). In the first part of this chapter I aim to analyse the specific types of rationality, regimes of representation and interpretative models that are mobilized by the Beijing Urban Museum.[2]

The debates raised thus far also beg a further question: what are the possibilities of criticality when culture has become so much part of the working of the nation-state? In the context of this book, I would like to translate the question of critique in terms of the notion of interruption. Given that there is no utopian outside to the system, that critique is only possible from within – or, in the words of Foucault, that 'resistance is never in a position of exteriority in relation to power' (1978: 95) – then the interruption of the workings of power can constitute a moment of critique. How could one interrupt the neat and steady line that runs from south to

north Beijing, and what visual tactics are possible to disrupt the narrative of progress and development as articulated in the ubiquity of shiny white scale models in China?

In the second and third part of this chapter, I want to focus on two distinct tactics of interruption, one related to the use of scale models in China, and one that disrupts the south–north axis. The first consists of the artwork of Beijing-based artist Xing Danwen, and specifically her Urban Fiction series. The second is located on that axis, south of Tiananmen Square, and involves the 2007 documentary *Meishi Street* by Ou Ning, on the demolition of the Qianmen *hutong*, that had to make place for a glamorous and deeply Sinified shopping street.

When translating the key concept of this volume – interruption – in Chinese, two words come to mind: first, *zhongduan* (中断), which means to make a break in continuity or uniformity. The second possible translation is *ganyu* (干预), which suggests interference or intervention. When a conversation is interrupted, for example, one uses the word *zhongduan*; but for a stone in the river that redirects the flow of the water, the word *ganyu* is used. Thus, the two words conjure up quite a different set of associations: to make a break in a process is not quite the same as to intervene in it. The first refers to destruction, the second to intervention. In my analysis, I read the art work of Xing Danwen as tactics of intervention, tactics that make the scale models analysed here less utopian and more ambivalent; as such, these are tactics of, to use an old concept, 'defamiliarization', they render the utopia as presented in scale models as uncanny worlds full of danger and dismay. The documentary of Ou Ning instead represents an act of disconnection, of making a break, an attempt to upset the inevitable. It depicts the fights of a tenant against his forced removal and the demolition of his house, prompted by the authorities. I read both cultural expressions as tactics to interrupt what is portrayed in authoritative discourse as the development and progress of the city; both interrupt the sanitized and shiny surface of China's frenzied run towards a global future.

Urban dreams

In this section, I should like to probe two elements in particular: the representation of a sanitized history, as exemplified by both the narratives constructed in the regular exhibition as well as by the branding of the south–north axis in Beijing; and the subsequent propagation of a sanitized future, as exemplified by the extensive use of scale models by the museum, but also by real estate developers and local authorities.

In its regular exhibition, the museum presents Beijing's growth as if it were a carefully crafted process, with the Chinese Communist Party as its great omnipresent planner:[3] 'In Spring 1953, the municipal urban planning agency proposed two master plans for the construction of the city. Both plans covered a

20-year period; there were no fundamental differences in the urban layout. The demographic projection in the plans was 4.5 million, and total land area was 500 square kilometres.'

The text continues explaining the six principles that were drafted in the same summer of 1952, the first one of which reads like Orwellian double speak: 'It is not advisable to demolish the historic heritages left on ancient sites nor to preserve all of them because this might restrain the city's development. At present the latter choice is suggested.' Just as the commitment to progress motivated the choice for the demolition of cultural heritage sites, so the same commitment produces another contradictory statement regarding the need for sustainable development: 'Because Beijing suffers from water shortage, dry climate and storms, it is advisable to ameliorate the natural conditions and industrial development is to be promoted.' It also clearly explains why the government has to be located in the centre of the city: 'The central government should be located in the central area of the city making it the moral center for people nationwide.'

The exhibition continues to explain subsequent planning periods up to today; the texts are accompanied by maps of Beijing through which the growth of the city becomes visible. In recent years the preservation of the centre becomes more prominent, as part of the Protection Plan for Beijing as a Historical and Cultural City that states 'We shall protect the traditional grid layout of the city, and preserve as much as possible the characteristics and features of the old streets and alleys.'

In the museum, old Beijing is rebuilt in a big wooden maquette. The use of wood signifies naturalness; these are the original and traditional roots of the city. But the central piece of the museum is one floor higher. It is a gigantic scale model of Beijing, which materializes the outcome of the plans and erases all pains, struggles and demolitions that accompanied it. The city is rebuilt up to its important areas, located outside the third and fourth ring road. The rest of the city is printed on a lit glass floor, where the visitors walk (see Figure 3.1). This adds to the technologized and sanitized atmosphere the scale model itself already evokes. It gives the visitor a sense of command over the city, as he or she can now walk so quickly from the third to the fourth ring road. At the same time it presents the city as under the command of the authorities, which have not only designed the city so carefully, but also this museum.

It comes as no surprise that the Central Business District (CBD) of the main maquette is duplicated, and a second one stands right next to the big one, presenting the CBD in greater detail, including its iconic CCTV building designed by 'starchitect' Rem Koolhaas. The message seems to be clear: just as the wooden maquette of old Beijing one floor down signifies a glorious past, so does the highlighting of the CBD baptise a global capitalism with Chinese characteristics.

We witness in the museum a representation of History with a capital 'H'; it is an example of historicism, which Walter Benjamin in his essay *On the Concept of History*, written in 1940, explains as being in line with the ruling powers. In his

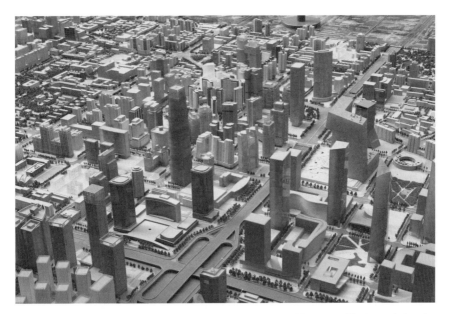

FIGURE 3.1 Detail of Beijing scale model in the Urban Museum. Photograph by the author.

words: 'With whom does historicism actually sympathize? The answer is inevitable: with the victor' (Benjamin 2003: 391). For Benjamin, it is dangerous to see the past as coherent, as a continuum; its so-called 'cultural treasures', like the Forbidden City, merely hide or camouflage the tensions, barbarisms and violence that constitute these treasures. Instead, the past is fragmented, its elements are time and again rearranged with snapshots from the present, 'the past can be seized only as an image that flashes up at the moment of its recognisability, and is never seen again' (Benjamin 2003: 390). The Urban Museum suppresses vigorously any alternative or fragmented version of history, its historicism is overwhelming.

The 4D movie theatre in the museum (4D since the chairs also move) strengthens the celebration of progress to an even more epical dimension. In addition to a movie on the Beijing Olympics, three further movies narrate the history of Beijing: one its past, entitled 'City of Eternity', one its present, entitled 'Today's Beijing', and one bridging the past towards the future, entitled 'New Beijing'. These movies, like the texts, are constitutive of a historicism in which past, present and future form a seamless upward continuum.

In 'City of Eternity', we see a map of the city of old Beijing, with its grid-like street plan, juxtaposed on the image of the Forbidden City. The voiceover, an authoritative masculine voice, explains that: 'Along the side of the main north–south avenue were many alleys extending from east to west in a symmetrical pattern. This kind of open street lay-out has been adopted up to now.'

A connection to the world outside is made when the visit of Marco Polo is hailed as follows: 'It attracted many merchants from all over the world, including Italian traveller Marco Polo, who all thronged to the gates of this oriental city. In his travel journal, Marco Polo extolled the grandeur of this city as the most magnificent on earth.'

Interestingly, one crack in the narrative appears towards the end of the almost ten-minute long movie. It concerns the construction of the *hutong*, or alleys, that are currently partly being demolished. The voiceover narrates, while drawn images are combined with real footage from the *hutong*: 'The residential areas (. . .) had narrow and overlapping lanes due to careless planning.' But the movie swiftly returns back to its celebration of Beijing, and ends with showing how in this 'unparalleled urban masterpiece' the bells from the Drum and Bell tower still echo over Beijing 'as they did hundreds of years ago'. It ends with the hyperbolic claim that 'Having experienced many vicissitudes of life, this immortal city, under the aegis of providence, is composing even more glorious chapters shaping its history to come.'

The other movies merely reinforce a similar narrative. In 'Today's Beijing', both the imagery as well as the language smack of a scientism in which grid lines, computer animations and all sorts of statistical figures (such as the amount of railway track increasing from 198 km in 2008 to 561 km in 2015) present Beijing as something that can be measured, calculated and predicted. In 'New Beijing', we see, in a highly sophisticated animation, a parade of the architectural highlights of the city, in which especially the Central Business District is portrayed. This time there is no voiceover, only a *Star Wars*-like soundtrack that strengthens the utopian, polished character of the movie. Significantly, in all movies, the north–south axis is presented as the key to and epicentre of the real Beijing, it connects the past with the present and the future.

While the prominence of the north–south axis in the promotion of Beijing can be explained by a desire to write a teleological history of the city, in terms of planning and progress, the maquette serves the ideological function of presenting a clean and smooth future. In the Beijing Urban Museum, the maquette covers Beijing within, approximately, the third ring road. Outside the borders, the map of Beijing is printed on the illuminated floor on which the visitors walk. This evokes a sense of control over the city, as well as a desire to start looking for one's own home. The city is literally beneath one's feet, the display thus creates a sense of both control and mastery, as well as of a utopian gesture towards a sanitized future.

The maquette is not just the key piece in the Urban Museum, it is strikingly popular all over China, and seems to me partly constitutive of the free flow of history that Hannah Arendt refers to in the opening quote of this chapter. Like the movies, the maquette promises a smooth transition from the past through the present towards the future. Through it, real estate developers present fantasies of urban living to the rising middle class, just as city governments use it to forge a coherent picture from an incoherent and conflicting past and present. Somehow,

in China the maquette seems to be both more prominent as well as more ideological when compared with its uses in other localities. Yomi Braester argues that detailed scale models in China are not so much a professional tool to sell an idea, nor do they just imply predictability and control of the design. Instead:

> in post-socialist China, scale models present readymade utopia. The government seems to believe that the ideal city is made of modular pieces and that its vision is rendered incarnate in maquettes (…) The official use of scale models on a grandiose scale promotes an urbanistic utopia, a neoliberal apotheosis of the consumerist city, a harmony at the converging fields of politics, economics, and planning.
>
> **BRAESTER** 2013: 68

The future of an alleged Asian – if not Chinese – century is presented as a miniature sanitized fantasy, generally devoid of people, consisting of shiny surfaces.

The presentation of history in the Urban Museum shows that China's modernization is *both* inevitable and contingent. Here we can trace an uncanny alliance with the discourse on globalization that operates on what Amy Skonieczny (2010: 3) terms 'a logic of contingent inevitability'. These two terms are often thought of as opposites, but instead should be conceived of as mutually constitutive. As she writes (Skonieczny 2010: 4–5), 'In this understanding of globalization, contingency does not challenge the dominant discourse of globalization, but is instead productive of it and actually displaces resistances by opening space for indeterminacy that does not ultimately threaten globalization's teleological trajectory.' China's progress is constructed as both an inevitable outcome of modernization and globalization, as well as being contingent upon the benevolent rule of the Party. The logic of contingent inevitability inspires Skonieczny, resonating closely with the main thrust of the current volume, to recognize 'the postcolonial concept of *interruption* as more appropriate in conceptualizing resistance to teleological processes of globalization' (Skonieczny 2010: 4, emphasis in original).

Intervention

Xing Danwen does not stand alone in using scale models of cities in her art work; other artists like Cao Fei and Zhong Kangjun (Braester 2013) mobilize scale models in their work, and one can also think of cinema like Jia Zhangke's *The World* and *24 City*. According to Braester, such art works contest the utopia as presented in scale models. In his words:

> the artworks show the unsavoury consequences of the scale model as a self-sufficient totality: a totally modular city that can be freely taken apart and

reassembled. The artists embrace an antitopian strategy that challenges the mimetic relationship between the model and the material city; they envision and visualise the future city as a spectacle that both depends on its encapsulation in model-like form, and acknowledges its inherent inviability.

BRAESTER 2013: 73.

Rather than presenting an antitopian strategy, in my view the work of Xing Danwen does something quite different, it interrupts and intervenes in the utopian fantasy presented by the scale model; it adds a critical edge to it, which is not necessarily antitopian.

A scale model is soft, peculiar, a tiny construction and a fragile one, hence the fences constructed around it. However, it points towards a future construction that is made of solid steel or concrete. The hardness of the latter is erased, what is left is a soft fantasy pointing at a smooth utopian future. What the work of Xing Danwen does is not so much break that smooth surface, or turn it into an antitopia, but rather subtly intervenes in it. One characteristic of scale models is the general absence of people (of course, there are exceptions to this rule). Xing Danwen makes big scale models, but always adds a scene with people in it. Sometimes these scenes are dramatic, sometimes they are merely mundane or banal.

These interventions inject the sanitized and soft fantasy of the scale model, a fantasy primarily directed to the upcoming urban middle class of China, with large doses of humanity, and this injection inevitably conjures up possibilities of pleasure, violence, loneliness and despair. Or, as Xing explains on her website: 'The models of these new living spaces are perfect, clean and beautiful but they are also so empty and detached of human drama. When you take these models and begin to add real life – even a single drop of it – so much changes' (Xing 2009). The works add the concrete, hard and harsh realities that the future holds to the softness of the scale models. Rather than stopping or breaking the lines towards the future, her work flips and twists these lines.

Figure 3.2, from the work *Urban Fiction*, presents to us the Jianwai Soho district, located in the heart of the Central Business District of Beijing, designed by the Melbourne-based LAB, Architecture Company. Indeed, the artist uses maquettes of existing real estate projects; some are already completed, others were in the making or being prepared when she made the work. When looking more carefully, we see a scene taking place on the rooftop of the building. In the work, it is often in the in-between, liminal spaces of the city, those that are located in between the private and the public, like rooftops and balconies, where human drama occurs (for a further reflection on the importance of rooftops in the Asian city, see Chow and de Kloet 2013).

When we zoom in and look more carefully, we are witnessing a fight between a man and a woman (see Figure 3.3). The woman has just stabbed the man with a big Chinese knife. Judging from their clothes, both belong to the young and hip

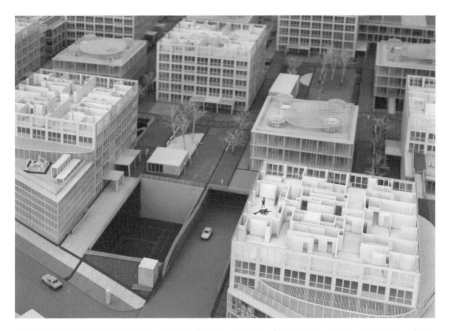

FIGURE 3.2 Xing Danwen, *Urban Fiction 0.2004.* Original in colour, courtesy of the artist.

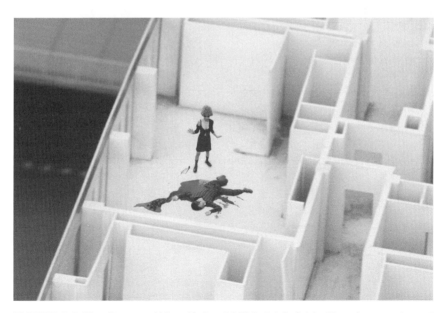

FIGURE 3.3 Xing Danwen, *Urban Fiction 0.2004*, detail. Original in colour, courtesy of the artist.

urbanites for whom these buildings are built. The sanitized future has become a murder scene; we as spectators are invited to build our own story around these two characters. Were they a couple, and was he having an affair? Or does she have a lover one floor above their apartment? Could it be that he has been stalking her for a long time? The whiteness of the buildings, hinting at a clean and tidy future, is interrupted here by the red blood. The desired and celebrated middle-class Chinese subjectivity that is so ubiquitously present in the media, and to which real estate developers pitch their projects, is confronted in this work with an uncanny mirror. The future also promises to bring violence and despair among the upcoming middle classes of China.

But it is not only despair: the future also holds pleasure, although even that pleasure remains ridden with ambivalence, and already holds a promise of danger. In another work we see a scale model, this time rather unusual, by night (Figure 3.4). Here, the intervention to the image is that we can see a woman watering her plants on her balcony. The ambivalence comes from the total absence of other signs of human life; the work thus evokes a sense of solitude, of being alone in the city, of estrangement with the harsh and concrete structure of the skyscraper.

Figure 3.5 portrays again the SOHO towers where we see a woman, alone, standing on the rooftop.

FIGURE 3.4 Xing Danwen, *Urban Fiction 17.2004*. Original in colour, courtesy of the artist.

The smoothness of the scale model is violently disrupted by this imminent attempt at suicide. Again, we as viewers are merely left with questions: We wonder if she will indeed jump? And why would she jump from such a beautiful building? Is she living there, or did she travel there on purpose? The shiny surface of the scale model, somehow already made more threatening in the darkness, loses its innocence.

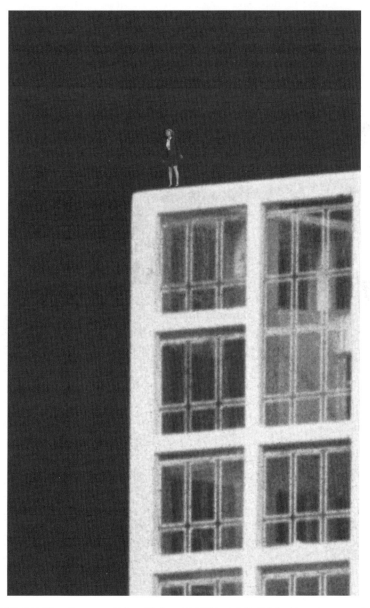

FIGURE 3.5 Xing Danwen, *Urban Fiction 17.2004*, detail. Original in colour, courtesy of the artist.

The whiteness of scale models underlines their innocence, their purity, the utopian fantasy they embody. As Xing Danwen herself states, 'today I live in the pictures I make and I, along with my compatriots, can imagine our future by bending down to examine tiny models of buildings. This, perhaps, is another reality of the "fantasies" which govern our contemporary life' (Xing 2009). Her reference to these models governing everyday life already points at their power. The object speaks back, but it does so with an ideological, authoritarian voice, one that directs rather than liberates, one that contains rather than opens up. Its voice is furthermore being disrupted and challenged by the hard realities of everyday life. The layers of dust that inevitably settle on scale models, also in the Urban Museum, are symptomatic for their unworldliness; they once held the promise for a better world, but that moment has passed by quickly.

Finally, the model is turned, through the intervention made by the artist, into a stage of desire, solitude, murder and despair. This interruption also turns the scale model itself into something less innocent, or better, more guilty, than local governments and real estate developers may have wished for. The interruption speaks back to the object itself. The whiteness of the maquette is to be mistrusted, the green lanes, shiny windows and neat and tidy balconies, all devoid of human life, now carry a sense of danger. These are not innocent maquettes, these are guilty maquettes.[4]

Breaking

When we leave the Urban Museum, now with some feelings of mistrust towards the scale model that is on display, we can walk in five minutes to Qianmen, the new glamorous shopping street in Beijing. Figure 3.6 is taken in 2008, in one of the side alleys south of Tiananmen Square. It is an old hotel where people are idling their time away; its desolate atmosphere makes it feel as if one is entering right into a movie of Jia Zhangke. In that Olympic year, Qianmen district was refurbished in a Chinese way: the whole neighbourhood was torn down to be replaced by a shopping street that was reminiscent of a Chinatown setting. Apart from that absurd ambition – the idea of creating a Chinatown in the midst of Beijing seems quite preposterous – the process of demolition of yet another old *hutong* neighbourhood attracted considerable attention from both activists and filmmakers. The project feeds into the narrative that old Beijing is being swept away for the Olympics, at the expense of courtyard houses and their social infrastructure (Broudehaux 2007). This narrative is seductive, as it validates the assumed rich traditional lifestyles of the Beijingers, just as it conveniently portrays the government as in total control. The narrative is also, as I will show later, problematic in its overly simplistic juxtaposition of the state versus the people.

As I have shown above, the process of destruction is rendered invisible in the Urban Museum, in the grand narrative of History; Beijing smoothly glides towards

FIGURE 3.6 Hotel in Qianmen District before demolition in 2008. Photograph by the author.

a prosperous future. What the documentary *Meishi Street* (2006) by Ou Ning, in cooperation with Cao Fei, does is recuperate the voices of protest that accompanied this destruction, and in doing so, tries to break the smooth narration of History.[5] This is not so much intervention as an attempt at cutting, at breaking. In this interruption of China's embrace of a global capitalism with Chinese characteristics, Ou Ning mobilizes an aesthetics of positioned realism, in line with the trend over the past decade in Chinese documentary making that has recently been analysed by Luke Robinson (2013). The new style of documentary making is characterized by what is termed *xianchang*, being on the scene, or on-the-spot realism (*jishi zhuyi*) – it is a subjective style, an embrace of the contingent (Robinson 2013). The documentary can be seen as part of the new documentary movement of China, in which the introduction of the digital video in the 1990s served as its central material and aesthetic foundation (Berry and Rofel 2010; Kim 2012). As Ou Ning explains:

> With the mobility and flexibility of individual shooting, the scope of these independent documentaries extends across the entire spectrum of customs and daily social life in China: from the decline of state-run heavy industry to the harsh life of prostitutes, from the protest of urban residents against the forced demolition and eviction from their homes to the democratic elections held in the countryside.
>
> in **KIM** 2012: 190–1

The tactics of interrupting are strikingly different from what we have seen with Xing Danwen in their contingent realism and antagonistic visual politics. The documentary is part of a wider project, the Dazhalan Project, which is sponsored by the German Federal Cultural Foundation, and involves ordinary citizens in using and producing their own media materials (Guo 2012).[6] The documentary

revolves around Zhang Jinli, an inhabitant of a restaurant in the *dazhalan* area in Beijing, an old area that is scheduled for destruction before the Beijing Olympics to make place for a more glamorous shopping area. He refuses to move and is entangled in an array of protests, ranging from petitions to slogans on his house.

Zhang is what is known as a 'stuck-nail tenant' (*dingzihu*): an epithet for those inhabitants of condemned neighbourhoods who, either for sentimental reasons or in an attempt to maximize the financial compensation paid for relocation, refuse to leave their homes until the last possible moment (Robinson 2012: online).

The contingency of Ou Ning's interruption in China's march towards the future consists of choosing a deliberately subjective point of view, by giving Zhang Jinli a camera that he can use to shoot the gradual demolition of his neighbourhood. These aesthetics of positionality and immediacy point unequivocally to the violence that comes with the urban renewal policies of the local authorities. As such, they present a break in the smooth narrative as presented in the Urban Museum, since they confront us with the violence that accompanies the construction of the north–south axis.

The propaganda of the authorities is shown through the banners that are placed in the neighbourhood with texts like 'strengthening city management, building a pleasant home together' and 'Demolition and removal in strict accordance with promoting the preservation of local character', texts that read like a parody given the ruins that often surround the banners. We see how Zhang Jinli posts letters to Chairman Mao on his house, on which he writes: 'Dear Chairman Mao, the Xuanwu district government is illegally forcing the eviction of my family on March 14!' He also alludes to the policies of the current government that centre on harmony when he writes on a banner, 'The creation of a harmonious society is a major policy of the government and people! Forced demolition and removal violates national laws.'

He thus appropriates the communist language and gestures to its history; in doing so he opposes the local authorities with their own language. What the film does, in the words of Robinson, is to '[capture] the experience of people at best marginalized by, at worst excluded from, this process: those left behind by modernity, or at least stranded in its wake, desperately struggling to stay afloat' (2012: online). It forces a break in the narrative of progress, a break that is contingent upon the subjective experiences of one house owner. As such, the movie fits into a wider trend in which new media are used to challenge the working of both state and market. As Matthew Erie (2012: 52) argues: 'in reform-era China, both cyberspace and real property are undergoing a transition from commons to privatization via the tropes of closure, harmony, and modernity. At the same time, netizens, bloggers, citizen journalists, and *dingzihu* are generating networks of support and alternative knowledge production.'

The power of the camera serves to archive the area for the future; it captures what is on the verge of disappearance. Over the course of the documentary, Zhang

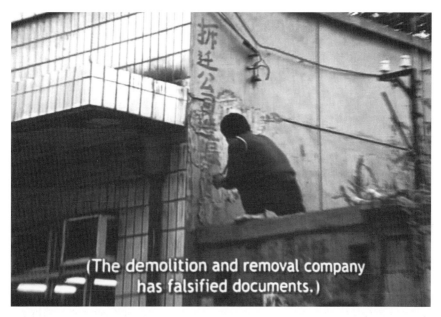

(The demolition and removal company has falsified documents.)

FIGURE 3.7 Ou Ning, *Meishi Street.* Zhang Jinli writes a slogan on his house. Courtesy of the artist.

Jinli becomes more and more eager, so it seems, to use the camera, as well as more skilled. As Robinson writes:

> His filming thus evolves into a form of counter-surveillance – an attempt by the weak to hold to account those in power – a point nicely conveyed when, in the film's final scene, officers from the Urban Management Bureau (the *chengguan*) arrive with a camera to document the razing of Zhang's home, only to find themselves, in turn, captured on video.
>
> **ROBINSON** 2012: online

This battle of the cameras reminds us of the work of Ai Weiwei: in his *So Sorry*, for example, he also shows how the police film him, and he, in turn, films them. But whereas Ai Weiwei has the global media to back him up, which empowers his gaze, Zhang Jinli is on his own, the documentary merely documenting the inevitable process of demolition and forced removal.

Despite all its merits and potential for articulating a critique that is as contingent as it is personal, the documentary also raises a host of questions. Starting from my own experience of watching the movie, the main protagonist Zhang Jinli becomes more and more pushy, he is more like a megalomaniac character that, in conjunction with the intrusive aesthetics of reality TV, renders resistance ambivalent – adding more ambivalent layers to what at first seems like a clear-cut

David versus Goliath narrative. Its point-of-view aesthetics also leaves many questions unanswered, such as how many residents share his views? Is his resistance driven by a desire to preserve the neighbourhood, or to secure a higher financial compensation? When I watched the movie in Beijing in the summer of 2008, one girl in the audience stood up, and asked Ou Ning: 'You present one side only, I was one of the inhabitants, and was quite happy to leave.' Later when I talked to her, she explained to me in a shopping mall located at the east end of the fourth ring road, close to her new home, that: 'The government has built a commune especially for them somewhere near this mall. They can buy the apartments that are far better than where they are living with a very low price. . . . In fact, the old neighbourhood would move together into the same place, so we will still be neighbours even if we move to the new place.'

The flip side for the deliberate choice by Ou Ning for a subjective narration is that it flattens out ambivalences and tensions, which produces one overarching question: Whose interruption are we analysing here? Who benefits from this interruption, and who does not? In her oral history account of the Dazhalan area, Harriet Evans concludes with the observation that 'the stories that I have discussed here are not ones of explicit contestation of state power, any more than they are stories of victimization and marginalization' (2014: 703). The documentary of Ou Ning *does* present a story of contestation, which, however admirable, runs the danger of neglecting other residents' tactics of survival and contestation.

The politics of interruption thus involve a politics of inclusion and exclusion, something that over the course of watching the documentary becomes clear as well, as some owners leave eagerly, whereas others stay – and the rationale between these differences is obscured due to the dominant voice of Fang Jinli. More is being obscured, since the final editing is done by Ou Ning alone, not involving Zhang Jinli, and when watching the documentary it is often unclear who shoots a given fragment; is it Zhang Jinli, or is it one of Ou Ning's team members? Chris Berry and Lisa Rofel (2010: 146) argue that this 'strategic ambiguity about the filmmaker's position' offers a way to circumvent government censorship. The vagueness regarding authorship proved to be advantageous for the director (Shen 2014: 19). At the same time it renders more ambivalent and unclear the question of whose point of view we are taking.

At the end of the movie, we see how the house is finally torn down. Slowly and quietly, Zhang Jinli starts to cry. The words of Luke Robinson are worth quoting at length here, as they capture the meaning of this ending so well:

Whoever is behind the camera moves in slowly for a close-up, and pauses; and then, unexpectedly, the screen goes black. The noise of the demolition continues on the soundtrack, but we can no longer see either Zhang or his tears. In cutting away, the documentary seems to concede its own failure as a public intervention, but in refusing to visualise Zhang's final collapse of composure – in leaving us

with only the aural traces of his livelihood's destruction – *Meishi Street* not only acknowledges his individual investment in everything we have just seen, but also accords him a degree of respect that has consistently been denied him by officialdom. At this moment, the objective and the subjective, the private and the public, the personal and the political, are finally united. There may be very real limits to independent documentary's capacity to effect social change in China, but perhaps it is at these points of affective conjuncture, almost at the boundaries of documentation itself, that Ou's 'alternative archive' finds its ultimate rationale.

ROBINSON 2012: online

The break the documentary forces is mostly an affective break, one that causes pain and tears, it is a break that makes the south–north axis, like the scale models, lose its innocence and clarity. How can we ever feel comfortable on and with this axis, now that we know the pains and violence it has caused?

Interruption

What I have shown in this chapter are two tactics of interruption. Xing Danwen intervenes (*ganyu* (干预)) in the display of a smooth and sanitized fantasy of the future, and thereby forebodes or predicts the concrete realities that will inevitably come out of the smooth fantasies as materialized in the scale model. The other forces a break (*zhongduan* (中断)) in the south–north axis: the work of Ou Ning shows the violence and destruction that underpins this axis and, as such, points at the violence that accompanies China's frenzied march towards the future.

We witness here a complex straddling between time, space and interruption. The works that I have discussed in this chapter intervene in idealized versions of the future and they forge breaks in the smooth transition from past to present to future, which we have seen on display in the Urban Museum of Beijing.

If we see contingency and inevitability as interwoven constituents of a dominant discourse of globalization [and, in the case of China, its modernization – JdK], it is in the interruption posed by incompletely erased traces of alternative historical trajectories that resistance to this logic happens. . . . These interruptions may be brief, but at the time are potent enough to reveal temporarily an alternative trajectory, an alternative future from what is otherwise assumed to be inevitable.

SKONIECZNY 2010: 13–14

As such, these works interrupt the authoritative discourse of progress. For this, they use different tactics. When theorizing interruption, the city and globalization,

it is important to be as specific as possible about what kind of interruption, at which location, with which implications and producing which modes of in- and exclusion. This asks for a deeply contextual approach, in which we read context as 'a force field in which multiple and contradictory temporalities and forces operate simultaneously' (Vitali 2010: 142).

Xing Danwen causes trouble in the utopian paradise called future, Ou Ning forces a break in the narrative of progress and prosperity that captures dominant discourses in and on contemporary China. Both objects are a far call from what we have witnessed in the Beijing Urban Museum. We are left with ambiguity and uncertainty, about the past, the present, as well as the future. Things are not as they seem anymore, the past appears like a pile of debris (cf. Benjamin 2003), the future as filled with alienation, dismay and violence. While president Xi Jinping tours the world with his Chinese Dream, in these art works and this documentary, the dream evaporates quickly, is shattered into pieces. We are left with a desire to pick up these pieces, reorganize them, and construct a different and more inclusive dream.

Notes

1 Here I paraphrase Prajensit Duara's seminal work *Rescuing History from the Nation: Questioning Narratives of Modern China* (1995).

2 Here I run the danger of aligning the notion of governmentality directly to the nation-state, whereas for Foucault, it is not a single body like the state, but rather a whole variety of authorities that manage the conduct of citizens in different sites (Rose, O'Malley and Valverde 2006). In the current study, we can think of a complex network of different actors, ranging from local and national authorities to museum directors, museum personnel, scale model makers, academics, et cetera. To analyse such a complex network behind the production of the displays presented in the Urban Museum would require a new full-scale study.

3 Quotes are taken from pictures of the permanent exhibition that I took on 18 April 2008.

4 Here I draw on the notion of guilty landscape by Dutch artist Armando, who used it as a title of a series of his works. The concept refers to the landscapes that have witnessed all sorts of violence, including those committed during World War II.

5 The documentary somehow resonates with Ou Ning's earlier work, conducted with Cao Fei and the U-Teque collective in Guangzhou, titled the *San Yuan Li* project. Whereas the latter employs an avant garde aesthetics in which the director is in control of the gaze, *Meishi Street* makes use of a documentary realist aesthetics, also in giving away control over the camera to a local inhabitant.

6 See http://www.dazhalan-project.org/introduction-en/introduction-en.htm

4 INTERRUPTING NEW YORK: SLOWNESS AND THE HIGH LINE

Christoph Lindner

Slow New York

This chapter critically examines the history and design of the High Line, a highly popular linear park on Manhattan's West Side involving the creative greening of abandoned elevated railway tracks. My argument is that the park's revivification of urban-industrial ruins constitutes a double interruption of the global city. At one level, the High Line's landscape urbanism enables new forms of spatial and visual incursion into the globalized cityscape that deliberately disrupt familiar, everyday urban experiences. At another level, the High Line marks the re-introduction of mobility into a space of interrupted transit in the form of a defunct elevated railway system. It is a mobility, however, designed around detour and delay, rather than speed and destination, and in this respect comprises an experiment in slow urbanism aimed at countering, while simultaneously contributing to, the accelerated urbanism of globalization.

In developing this argument, I pay particular attention to the ways in which aesthetics and memory, as well as industrial heritage and transport infrastructure, are used in the High Line design and its various spin-off projects, such as the QueensWay and the Lowline, to refigure the perambulatory conditions of the street. It is this refiguring of the street, I also argue, that enables a practice I call 'retro-walking'. Let me therefore explain that I use the concept of retro-walking to refer to three interrelated practices: first, retro-walking as a nostalgic return and a conscious retracing of steps; second, retro-walking as a form of reflexive critical-spatial analysis; and third, retro-walking as a stylistic, performative practice connected to the generic urbanism of globalization and inherited from the leisure

strolling traditions of the *grand boulevards* of urban modernity (Scobey 1992; Frisby 2001). The chapter concludes by drawing parallels between the High Line and James Nares' slow-motion installation film *Street* (2011), arguing that both projects belong to a larger trend in urban visual culture involving the creative production of slow spots.

Like all of the work in this book, this chapter is the result of an extended discussion between the authors over a period of several years. Thus the intellectual impetus for this chapter should be the debates and exchanges that took place in meetings (both formal and informal) in New York, London, Amsterdam, Edinburgh, Berkeley, Paris and elsewhere. To a large degree, that is the case. For instance, the understanding of interruption I outline here is indebted to Richard Williams' ideas, developed in relation to the popular street phenomenon of the food truck, that the space of interruption is 'an essentially ruined space', and that, in the era of neoliberal globalization, interruption is frequently the desired aesthetic of urban renewal (Chapter 2). Similarly, Ginette Verstraete's chapter on the urban-aesthetic disruptions caused by the building of a new subway line in Amsterdam (Chapter 8) resonates with my discussion of repurposing railways and 'un-ruining' abandoned infrastructure, as does David Pinder's chapter on audio memory-walks across disappearing neighbourhoods in East London (Chapter 5). I also share Gillian Rose's interest in the 'sensorily seductive, atmospheric visions of urban life' that architecture can produce (Chapter 7), as well as Gillian Jein's concern, explored via Parisian street art, with the ways in which everyday creative practices can decelerate or re-route dominant urban flows (Chapter 6).

While these intellectual connections and influences are important to acknowledge, a more significant moment in the development of this chapter took place during a workshop at New York University in 2013, at which we organized a site visit to the High Line in connection with this book project. Walking along the elevated walkway while reflecting on interruption, I was struck by how the site brought together the various strands of thinking that I had been developing in relation to the project's core concern with the interrelations of visual culture and urban space in global cities. The High Line is a site I had been visiting for many years, and which I had been writing about since before it opened (Lindner 2008), but this was the first time that my perambulatory experience of the park had led to such a moment of realization and recognition.

Obviously, New York looms large on the High Line, but so too does globalization as a transformative force in the space and culture of cities. Just as importantly, the High Line is a space designed around – even designed *as* – aesthetic, durational encounter. My point is that, as I realized during the walk, the High Line is a site where the urban, the global, the aesthetic and the creative commingle in a particular way that we might call interruptive, in the sense of a strategic intervention in urban space designed to produce an intensification or defamiliarization of experience. Unlike the spontaneous urban wanderings advocated by Situationist

psychogeography through the counter-cultural practice of the *dérive* and its embracement of spatial estrangement (Debord 2008), the High Line's interruptive experience is scripted and occurs in the context of a controlled and planned environment. In the following discussion, I return to the space of the High Line to think through its interruptive potential and do so in relation to what I see as the key factor behind its success as an engine of urban renewal: its refiguring of the street.

Elevated street

Writing in 2013 about plans to develop the defunct Bloomingdale rail line in Chicago into an elevated linear park, Amita Sinha notes the proliferation of such projects in the wake of the High Line's success. Echoing most commentators, she understands the growing phenomenon of the elevated linear park as reflecting the desire to 'reclaim marginal sites with derelict infrastructure in post-industrial cities whose manufacturing base has shifted elsewhere' (Sinha 2013: 113). What is somewhat different about Sinha's reading, however, is that she goes on to make an explicit link in her analysis between the trend of the elevated linear park and the rise of slow living movements:

> Slow food and slow city are recent reactionary trends to fast food and fast-paced urban life with a bearing on design of contemporary public parks. The slow food movement advocates . . . sociable eating at a calm, unhurried pace. Its influence on the urban landscape is seen in the popularity of community gardens, nowhere more so than in Detroit where their growth into urban farms in vacant lots has created the productive public park, in the process transforming industrial urbanism into agricultural urbanism. The slow city movement promotes leisurely rhythm of public life marked by conviviality. The anomie and standardization of globalization and corporate culture are countered by cultivating a sense of place and place making through local cuisines and arts and crafts.
>
> **SINHA** 2013: 117

Because they are designed around core values shared by the slow food and slow city movements – namely, decelerated practices aimed at improving quality of life and promoting urban sustainability and community – elevated linear parks like the High Line and planned projects like Chicago's Bloomingdale Trail can be understood as 'slow landscapes' in Sinha's thinking. These sites 'where nature is calming and attunes the body's rhythms to its own, creating a sense of quiet, offer respite from the hurried pace of the city' (Sinha 2013: 117). The aim, she argues, is to create 'sensuous and pleasurable experiences' that redefine 'the idea of beauty in

terms of the strangely familiar' (Sinha 2013: 117), effectively evoking the realm of what Anthony Vidler (1994) terms the architectural uncanny.

Like Sinha, I understand the High Line as an iteration of slow urbanism designed around an aesthetics and spatiality of defamiliarization. Although I would hesitate to trace such a direct line of influence from slow-living movements to the rise of the elevated park, I do agree with the broader idea that both constitute deliberate counter-responses to the ever-accelerating pace of life in the era of globalization. What I seek to add to this line of thinking is the idea that, as illustrated by the High Line, the creative production of slowness in global cities is predicated on – and ultimately helps to sustain – the culture of speed it resists or, at the very least, modulates.

There are certain tensions, then, to be found in the history of the High Line's reclaimed infrastructure, given that the building of the elevated railway in New York City in the early twentieth century was designed in accordance with the modernist vision of urban planning to unclutter the streets for pedestrians, while unlocking new forms of rapid transit and separating traffic functions into different levels (Lindner 2015: 165–7). The High Line is therefore situated in a space that helped to produce urban modernity's early articulation of today's multi-levelled, multi-rhythmic city, as well as that city's initial culture of speed. By conspicuously preserving the form of the elevated railway while rededicating its use to slow human traffic, the High Line simultaneously activates yet distances itself from the site's history of acceleration and dislocation. It both extends and restricts the elevated railway's function as a conduit of urban flows.

The implication of my argument regarding the High Line's complicity in New York's culture of speed is that, like the slow living movements (which now stretch to include slow money, slow fashion, slow media, slow design, slow science, slow parenting and more), slow urbanism does not escape the time–space compressions of globalization but instead remains deeply if ambivalently implicated in that condition, even as it interrupts it. In the case of the High Line, the experiment in slow urbanism is one that consciously draws on the perambulatory practices of the sidewalk, including its spatiality and aesthetics, to engineer an otherworldly encounter with the frenetic built environment of the global city. This encounter, in turn, is framed by the revivification of industrial ruins and the re-mobilizing of urban memory. One of the results, I want to suggest, is the nostalgic, reflective and stylistic practice of retro-walking. Another, related result, which I elaborate on later, is an urban pastoral walkway that removes pedestrians from the everyday city while still maintaining a visual connection to the street below. In such a reading, the High Line becomes a site of slowness from which to observe the city of speed.

First opened in 2009, the High Line is an elevated park on Manhattan's West Side that repurposes a 1.4-mile stretch of abandoned railroad track dating from the 1930s (Figure 4.1). The design was inspired by the Promenade Plantée in Paris, where a disused rail viaduct in the city centre was transformed in the 1990s into an

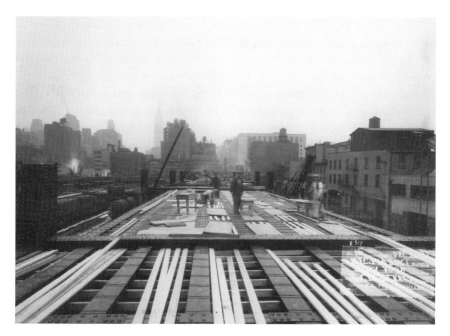

FIGURE 4.1 Future site of the High Line: building the West Side Line, c. 1933. Courtesy Friends of the High Line and New York Department of Parks and Recreation.

extensive green walkway; what Joseph Heathcott describes as a 'classic Parisian bourgeois park, with its carefully crafted landscape and firmly controlled optics – a linear pathway for seeing and being seen' (Heathcott 2013: 289) in the classic mode of the Benjaminian *flâneur*. The High Line shares the Promenade Plantée's concern with bringing nature back into the city, giving new life to a dormant space while blending traditional park elements – such as formal plantings, manicured lawns and delineated paths – into the surviving transport infrastructure. It also shares the Promenade Plantée's emphasis on visibility, not only of the structure itself but also of its users and their practices.

In these respects, the High Line belongs to a broader, global trend in landscape urbanism, in which abandoned, post-industrial sites are creatively remade into eco-friendly, pedestrian spaces designed for conspicuous public leisure. In the New York context I would cite the example of the Fresh Kills garbage dump on Staten Island being transformed into a wildlife preserve and recreation zone (Lindner 2008), which is also a project by Field Operations, the landscape architecture firm behind the design of the High Line. Other examples include the civic reoccupation of Governors Island and its abandoned military base in the form of a giant public park, the transformation of Brooklyn's Navy Yard into a green-tech hipster playground, and Brooklyn Bridge Park's repurposing of defunct cargo-ship piers into playgrounds and sport fields jutting out into the East river.

What makes the High Line remarkable is its staggering popularity. From its initial opening in 2009 onwards, the park has exceeded all expectations in terms of the volume of visitors (attracting upwards of 4.5 million visitors per year at the time of publication), and has quickly established itself as one of New York's must-see destinations and an alternative green space to the more traditional, nineteenth-century landscape design experience of Central Park. This popularity has helped to regenerate, and in some cases re-gentrify, the surrounding neighbourhoods (Loughran 2014; Halle and Tiso 2015), attracting property developers, businesses and even major cultural institutions like the Whitney Museum of American Art, which strategically placed its new building at the Southern entrance to the High Line.

The story of the High Line's success is much more complex, of course, and connects not only to the design of the park, but also to the high level of support and involvement it has received from the local community. In particular, the non-profit organization Friends of the High Line, which led the campaign to build the park, has now assumed both operational responsibility and cultural stewardship over the space in partnership with the New York City Department of Parks and Recreation, as the organization's website explains:

> We seek to preserve the entire historic structure, transforming an essential piece of New York's industrial past. We provide over 90 percent of the High Line's annual operating budget and are responsible for maintenance of the park, pursuant to a license agreement with the New York City Department of Parks and Recreation. Through stewardship, innovative design and programming, and excellence in operations, we cultivate a vibrant community around the High Line.

As this mission statement articulates, the park consciously seeks to activate cultural memory and draw on the city's industrial heritage, but in doing so recasts that memory and heritage into an elaborate, forward-looking experiment with community activism, public art, urban design and cultural programming. All of this, I would argue, hinges on the High Line's former identity as a disused elevated railroad and, in particular, on the way in which that identity shapes the perambulatory experience of the park's linear pathway.

This idea was made visible by Friends of the High Line in an outdoor exhibition of a large-scale photograph displayed on a billboard adjacent to the park in 2011 (Figure 4.2). The work, titled *Landscape with Path: A Railroad Artifact*, comes from a series of photographs by Joel Sternfeld, which was commissioned by Friends of the High Line. Taken in 2000, long before the park construction began, the image shows the tracks of the abandoned elevated railroad. The absence of people, the material neglect, and the resurgence of nature all contribute to giving the deserted railroad a look of wilderness. The scene is reminiscent of an Ansel Adams landscape, only here the landscape is resituated in the post-industrial, urban

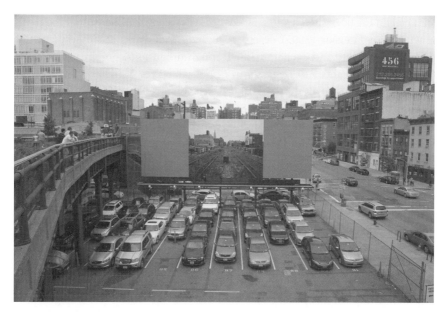

FIGURE 4.2 Billboard next to the High Line: Joel Sternfeld, *Landscape with Path: A Railroad Artifact*, 2011. Commissioned by High Line Art, presented by Friends of the High Line and the New York City Department of Parks and Recreation. On view from 2 to 30 June 2011 on the High Line, New York. Photograph by Brian Rosa.

environment of New York City's West Side. Looking at Sternfeld's photograph, it does not require a large leap of the imagination to envisage a park springing from this space. Indeed, as many commentators have noted (Patrick 2013), most of the finished design of the High Line, particularly in its vegetation and ecology, looks like a more ordered and controlled version of what was already there, which was precisely the intended aim of the park's design.

The placement of the photograph on a billboard next to the High Line and directly above a parking lot is significant too. The relationship between the photograph's image of emptiness and stillness resonates strangely with the congested stasis of the unoccupied vehicles in the parking lot. The more powerful resonance, however, occurs between the billboard and the park located beside it. This juxtaposition of the site's post-industrial history of abandonment next to its present day condition of revival and reoccupation delivers a poignant, visual reminder of the park's status as a transformed urban ruin.

In this respect, the High Line speaks to a wider cultural fascination with ruins. It is a fascination inherited from European romanticism (Hell and Schönle 2010) and the Renaissance turn to classical antiquity (DeSilvey and Edensor 2012), but that has been renewed and intensified in recent decades by the growing spectacularization of post-industrial abandonment, as in the case of ruined cities like Detroit, ghost towns like Japan's Hashima Island (which shot to fame after

featuring in the 007 film *Skyfall*) and toxic disaster sites like Chernobyl. The result is what Tim Edensor (2005) describes in *Industrial Ruins* as an aesthetics of disorder, sensuality and enchantment. Through urban photography projects like Camilo José Vergara's *American Ruins* (1999) and Yves Marchand and Roman Meffre's *The Ruins of Detroit* (2010), as well as museum exhibitions like Tate Britain's *Ruin Lust* (2014), these ruin aesthetics have captured the visual imagination in much the same way as the global slum, which has also been experiencing a new wave of artistic and popular interest for much the same reasons and in much the same way (Jones 2011). What the global slum and the industrial ruin both evoke in their urban aesthetics is a condition that Sudeep Dasgupta, writing about urban poverty in Mumbai, has called 'permanent transiency' (2013: 148).

Crucially, the High Line's status as an industrial ruin (albeit a ruin whose qualities of decay and disorder have been carefully sanitized and contained) allows the park to reference the mobility and visuality contained in the structure's original function as an elevated railway. As Michael Cataldi, David Kelley, Hans Kuzmich, Jens Maier-Rothe and Jeannine Tang argue in their analysis of the High Line's use of public art, Sternfeld's photographs thus 'form a supplement to the High Line's development, evoking its precarious past to regulate its future' (Cataldi et al. 2011: 362). In other words, the positioning of Sternfeld's photograph in the direct view of the park's visitors helps to reinforce the desired public image of the High Line as a defamiliarizing space of memory and mobility, which James Corner, the park's lead designer, once described as 'a postindustrial artifact maintaining a sense of melancholy and other-worldliness in a city context that, by contrast, [is] ever-evolving and modernizing' (in Fehrenbacher 2013).

The sense of melancholy and otherworldliness to which Corner refers is integral to the popularity of the park, which partly functions as a nostalgic memory walk for a bygone era of industrial urbanism and faded promenade culture. The elevated walkway lifts visitors up from the level of the street just enough to provide a different perspective on the city. Yet, unlike the original railroad which moved rapidly across the city, the park offers a decelerated encounter with the surrounding urban landscape. That landscape, in turn, is the product of the accelerated urbanism of globalization and, in the immediate vicinity of the High Line, the result of neoliberal gentrification gone wild – a phenomenon that Loretta Lees, writing about the proliferation of exclusive and expensive enclaves in global cities, calls 'super-gentrification' (Lees 2003: 2487). In the case of the High Line, this process of rapid and chaotic urban renewal is fuelled by the popularity of the site to the extent that the view *from* the park is partly being shaped by both the presence *of* the park and the view *onto* the park.

This is evident, for instance, in the surge of signature architecture projects that have sprung up around the High Line, seeking to boost their visibility through proximity to the park and in the process aiming to become new visual anchors in the cityscape views afforded by the High Line. Key examples include the new

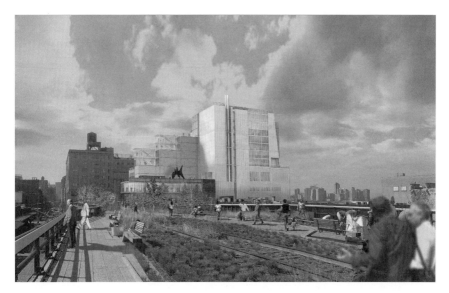

FIGURE 4.3 View from the High Line: rendering of Whitney Museum of American Art at Gansevoort, 2007 – in progress. Renzo Piano Building Workshop in collaboration with Cooper Robertson & Partners (New York). © RPBW, render by Cristiano Zaccaria.

Whitney Museum building by Renzo Piano (Figure 4.3); the Polshek Partnership's Standard Hotel, which straddles the High Line and has become something of a magnet for both performing and watching exhibitionist sex through hotel windows; and the corporate vanity project of the Frank Gehry-designed IAC Building. This dynamic of the High Line producing its own view also registers in the explosion of new luxury condo developments adjacent to the park, which frequently incorporate the High Line into their names and trade on their proximity. These include the much-hyped Soori High Line Condos, which come with private indoor swimming pools; the Zaha Hadid-designed starchitect condos at 520 West 28th Street (Figure 4.4), which boast prices up to $35 million; and Neil Denari's HL23, the first luxury residential complex to be named after the park.

All of these factors give the High Line a strange doubleness. It is both an ageing ruin and an object of newness. It is simultaneously abandoned and occupied. It is populist and accessible, but also exclusive and elite. The park is designed to generate precisely these kinds of tensions and, just as importantly, to provide opportunities to reflect on them under conditions of slowness. In an essay about the influence of landscape historian John Dixon Hunt on his design practice, James Corner is explicit on the deceleratory aims of the park and, in particular, on its insistence on slow walking:

> There can be no immediacy of appreciation, no fast way to consume landscape
> in any meaningful or lasting way. . . . In the case of the High Line, the experience

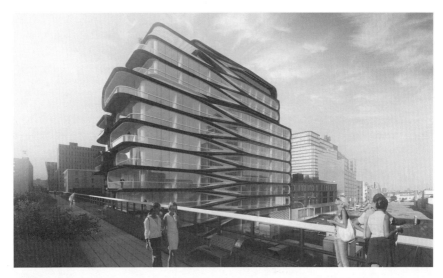

FIGURE 4.4 Luxury living at the High Line: rendering of 520 West 28th Street. Courtesy Zaha Hadid Architects.

of strolling is intentionally slowed down in the otherwise bustling context of Manhattan. Paths meandering in between tall perennial and grass plantings create an experience that can not really be properly captured in a photograph, or even video. Like so many other gardens, the place must be walked, with scenes unfolding in sequence and in juxtaposition.

CORNER 2014: 345

Despite overstating the uniqueness of the High Line experience (after all, no space or landscape can be fully grasped through mediated representation), Corner's comments are revealing for the emphasis they place on the design's resistance to speed. Pause, delay and detour are all possible on the High Line, and are encouraged by the meandering design of the central walkway and the various stopping places and viewing points spread along the way, such as the Sunken Overlook, which provides amphitheatre seating suspended above 10th Avenue, facing a glass window that cinematically frames the street below. In these sorts of ways, the High Line keeps visitors close to the street, immersed in the city, yet released from the everyday.

The High Line effect

As a reinvention of the urban promenade, the High Line speaks to the depth of our cultural investment in streetwalking as an urban practice tied to leisure and embodied pleasure. It is therefore somewhat ironic that Paris's Promenade Plantée,

although popular, has not attracted anything like the public attention of the High Line, since this earlier experiment with repurposing an elevated railroad cuts across the very city where the modern boulevard and its attendant promenade practices were invented. My view is that the High Line's greater public visibility as a landscape architecture project is connected to the cityscape it inhabits as much as to the park's design itself, in the sense that the extreme iconicity of the New York skyline and the opportunity provided by the park to encounter that skyline – even inhabit it – in a defamiliarized, intimate and decelerated way is at the core of the High Line experience.

It is therefore worth noting that, as both an urban park and an engine of urban renewal, the High Line has directly inspired similar projects to repurpose abandoned railroads in cities as diverse as Bangkok, Sydney, Rotterdam, Chicago and Philadelphia, to name just a few. Many of these projects have stalled or collapsed but the trend in seeking to build elevated green walkways has been gathering momentum since the High Line. In New York, for example, a campaign was launched in Queens in 2011, led by the community coalition Friends of the QueensWay, to 'transform the blighted structure that housed the Long Island Railroad and was abandoned over 50 years ago into a public greenway'. Both the QueensWay proposal and its grass-roots community approach consciously seek to replicate the High Line model while connecting to both the geographic and cultural specificities of Queens (Larson, Bachu, Toneato and Jurgena 2013).

Back in Manhattan, another High Line-inspired project was also announced in 2011. Called the Lowline, it takes the design concept behind the elevated railroad park in a new direction: underground. Still in progress at the time of this book's publication, the Lowline is a proposal by designers James Ramsey and Dan Barasch to build an underground park at the site of the abandoned Williamsburg trolley terminal, located under Delancey Street on Manhattan's Lower East Side (Figure 4.5). The project is explicitly conceived as a spatial inversion of the elevated linear walkway comprised by the High Line, and envisages a subterranean space with walkways, trees, plants and abundant natural light made possible by remote skylights using fibre optics. Unlike the High Line, the Lowline specifically places technology at the centre of the park's design, and experiments with how that technology can help to solve urban design problems, such as the lack of available space for public parks in dense urban environments. So although it shares the High Line's concern with repurposing abandoned railroad tracks for eco-friendly public use, the Lowline goes one step further by seeking to conjoin smart city and sustainable city design.

As an inversion of the High Line's spatiality, the Lowline differs in a few significant ways. First, its underground location means that it offers no city views. The project's flipped urbanism thus promises a kind of extreme visual self-reflexivity in which the only view available from the Lowline is the Lowline. Gone are the High Line's sweeping panoramas and any associated experience of inhabiting

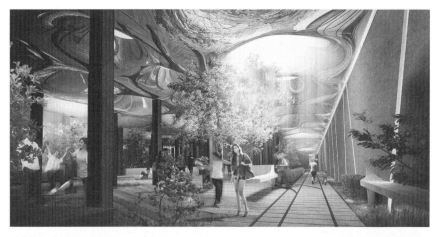

FIGURE 4.5 Rendering of the Lowline at Delancey Street, 2012. Courtesy Raad Studio.

the New York skyline from a floating walkway. Second, the Lowline is not visible from the street, and consequently lacks the conspicuousness and public presence that helps the High Line draw visitors and attract surrounding development. For instance, there is no possibility of building luxury Lowline condos overlooking the park, unless the buildings were similarly subterranean. Although entirely unlikely, such a project is technically feasible and, if realized, would represent another form of inversion: the upside down penthouse, where the lowest floors of the building offer the best park views and become the most expensive and coveted levels. My point is that, because of its inversion, the Lowline is unlikely to have the same gentrifying effects on its surrounding neighbourhood as the High Line and would most likely struggle to achieve a similarly iconic status in the urban imaginary.

Even so, public interest in the concept of an underground linear park has been strong enough for the Lowline to gather substantial community support and financial backing, and even to generate spin-off proposals of its own. In 2012, for example, Fletcher Priest Architects won a green infrastructure design competition in London with a proposal for an underground urban mushroom garden in a disused mail rail tunnel running beneath the congested shopping artery of Oxford Street (Bathurst 2012; Figure 4.6). As illustrated by the transnational migration of the concept of the underground railway park, we can now also speak of a Lowline effect – a subterranean variation on the High Line effect – in which ruin lust meets green-tech fetishism.

Yet if we strip away all the hi-tech solar technologies of the Lowline and set aside the absence of visibility, what remains is remarkably similar to the High Line: a green walkway shaped by the linear spatiality of a railroad and made possible by the abandonment of that infrastructure in a time of post-industrial urban decay. More than that, all of these park projects hinge on producing what Sunny Stalter,

FIGURE 4.6 'Pop Down': proposal for Mail Rail urban mushroom garden in central London, 2012. © Fletcher Priest Architects.

writing about 1950s' artists concerned with the obsolescence of the El, has called a 'nostalgic urban visuality' (Stalter 2006: 871) rooted in the transport history of the space. What makes the Lowline different is that it seeks to achieve its nostalgia and otherworldly transformation by submerging visitors beneath the street, whereas the High Line and the Promenade Plantée achieve these effects by gently elevating visitors above the street. Yet, in both the elevated and underground versions of the railroad park, the aim remains the same: to refigure the street by relocating its sidewalk practices to a decelerated space of reanimated urban mobility – a space where those sidewalk practices do not conventionally belong, but where they can be newly enacted through interruptive, otherworldy transformations of the space.

Slow street

Far from unique to architecture, planning and design, the slow urbanism shaping the High Line (as well as the broader trend of linear railway parks) is widely discernable in the visual culture of global cities. Drawing on another New York example, I want to conclude by considering how similar concerns over aesthetics, mobility and nostalgia converge in a photo-filmic installation that was exhibited at

New York's Metropolitan Museum of Art in 2013. Made in 2011 by British artist James Nares, *Street* is a 61-minute digital film shot in super-Hi-Definition from a moving car cruising around Manhattan. Scored with original music by Thurston Moore, the lead guitarist from Sonic Youth, the edited footage is shown in extreme slow motion. The result is an unbroken flow of radically decelerated, gliding, sliding streetscapes in which intimacies of movement, embodiment and encounter become strangely, newly observable.

Street can be placed within two intersecting visual traditions, which Nares himself has explicitly referenced. One is animal locomotion photography, extending from Eadweard Muybridge's images of galloping horses in the late 1870s to Harold Edgerton's scientific films of hovering hummingbirds in the 1940s, and in which the stop-motion and slow-motion possibilities of visual media are used to understand and analyse physical movement. The other tradition is the urban actuality film, which first emerged at the turn of the twentieth century and took a special interest in everyday scenes of the city.

Nares combines the aesthetics, concerns and techniques of both of these traditions. He pushes the technical capabilities of the medium of film. He slows motion to the radical extent that it reveals new or hidden realities. And he documents scenes and spaces of everyday life at the level of the street. The overall effect of this decelerated New York, aided by the hypnotic, looping melody, is to engineer a contemplative experience of a space that normally defies pause, meditation and delay – much like the High Line does in its own decelerated refiguring of the street.

What *Street* helps to make newly visible are the asynchronous temporalities and mobilities of the sidewalk: each person is on a different track, moving at a different speed, completing a different gesture or movement (Figure 4.7). The film is accordingly an excellent example of what, writing elsewhere about globalization and street photography, I have called slow art: 'aesthetic interventions that emerge from, but also counter, the conditions of speed, mobility, and invisibility (anonymity) that have become so ubiquitous in rapidly globalizing cities' (Lindner and Meissner 2015: 7).

Thus I would argue that, like the High Line and its spin-off projects, *Street* constitutes an interruption of the sidewalk's conditions of speed and movement, which occurs here at an aesthetic and phenomenological level. In doing so, the film offers another articulation of retro-walking. It returns to the visual traditions of animal locomotion photography and urban actualities developed in the late nineteenth century. It revisits their concerns with, respectively, slowing motion and figuring the street. And it presents a stylistic, performative enactment of the contemporary global city, reflecting its generic urbanism.

The important connection between *Street* and the High Line is that both projects produce what I call 'slow spots' (Lindner 2013: 16): creative spaces of decelerated practice and experience developed in response to what Paul Virilio, commenting on the architecture of velocity, describes as the amnesiac 'speed-space' of the

FIGURE 4.7 Stills from James Nares, *Street*, 2011, music by Thurston Moore, sixty-one minutes. Courtesy of the artist and Paul Kasmin Gallery.

contemporary city (Virilio 2001: 69). The projects may promote retro-walking within slow spots as an interruption of the accelerated city, but those interruptions are only temporary and superficial, ultimately reinforcing urban velocity. The reason is that their slow urbanism is also a palliative urbanism. It is designed to alleviate symptoms associated with life in the accelerated city, while simultaneously stimulating surrounding conditions of speed, anonymity, spectacle and amnesia.

Heterotopia and retro-walking

In an article on the poetics and politics of walking, David Pinder (2011) has argued that we need more nuanced, differentiated models for understanding spatial practice as resistance, nomadism and subversion. I agree. One tendency in critical responses to the High Line's perambulatory conditions has been to label the space a heterotopia – a space of radical otherness that disturbs and transforms. For example, in a recent article, Daan Wesselman works through Michel Foucault's various writings on heterotopia and maps the concept onto the High Line, arguing that the elevated park perfectly fits the label, but concludes that 'the alternative offered by the park remains tied to the dominant surroundings, showing the limits to the suspension of the everyday that heterotopia can achieve' (Wesselman 2013: 25). While I think the label of heterotopia can work for the High Line, it is also far too generalizing to reveal much beyond the park's surface experiment with the idea of spatial otherness.

To contribute to a more nuanced, differentiated reading of the High Line – one that is more attuned to what Pinder describes as the potentialities of urban walking 'for experiencing, researching, weaving, re-enchanting, or subverting spaces' (Pinder 2011: 676–7) – I have proposed the concept of retro-walking. This concept does not disregard the heterotopic potential of slow practice and the spaces in which that practice occurs. Instead, the concept of retro-walking connects those qualities to the broader trend of slow urbanism. It is a trend that extends from architecture, landscape design and urban planning, to art, urban heritage and everyday life, and that is paradoxically being absorbed into the very conditions of neoliberal globalization and accelerated living that it seeks to interrupt.

Note

Early versions of this chapter were presented as guest lectures at UCLA's Urban Humanities Initiative and The City Centre at Queen Mary University of London. I would like to thank the organizers and audiences at these events for their questions and comments. Parts of this chapter draw on material revised from Part II, 'Sidewalks', of my book *Imagining New York City* (Oxford University Press, 2015).

5 SOUND, MEMORY AND INTERRUPTION: GHOSTS OF LONDON'S M11 LINK ROAD

David Pinder

The ghost is that which interrupts the presentness of the present and its haunting indicates that, beneath the surface of received history, there lurks another narrative, an untold story that calls into question the veracity of the authorized version of events.

JEFFREY ANDREW WEINSTOCK 2013: 63

And then – listen – there is the way a city comes to us in memory and reverie, its cadences, whispers and sighs . . .

FRAN TONKISS 2003: 303

Traffic streams

Streams of traffic quicken, congeal and block before regaining their pace. The roar modulates but rarely lets up. In the distance rise the new structures of the financial city and the 2012 Olympics. In the other direction the motorway threads out of the city. Standing on a bridge over the six lanes of passing metal, tyres and exhaust, it is hard to imagine the dense neighbourhoods of terrace housing that once filled this part of north-east London, or the struggles twenty years ago to defend them. What had been places to live, sleep, cook, work, play and encounter were cleared for this asphalted channel. Precedents for the M11 Link Road, since renamed the

A12 Eastway, had been mooted for many decades before it was driven forward as part of a massive expansion of road building heralded by the UK Conservative government in its policy document *Roads for Prosperity* (Department of Transport 1989). In the name of smoothing flow and shaving minutes off travel times, the highway destroyed around 400 homes and displaced approximately 1,000 people from the areas of Leyton, Leytonstone, and Wanstead before it opened in 1999. Its 6-kilometre path is now flanked by retaining walls. At points the road rises, at others it dips and tunnels, while footpaths run alongside or arc across.

As with many highways that have been hacked through dense urban areas, the road's construction was fiercely contested. After formal political processes of public enquiries, petitions and demonstrations were exhausted and the construction of the road began in September 1993, many opponents turned to peaceful direct action. They staged one of the country's largest and longest anti-road protests. Environmental activists, including veterans from anti-road actions at Twyford Down and elsewhere, joined longer term residents as well as members of a large community of artists. A primary aim became to interrupt the road, to halt or at least to slow it down by fixing in place and staying put. Protesters barricaded buildings and streets, squatted houses, invaded construction sites, obstructed diggers and bulldozers, and took up residence in trees. They deliberately clogged the urban body whose flows the contractors and the security forces sought to clear. Also important were tactics of 'locking on' to buildings, chimneys, or the street itself with handcuffs or chains as activists placed their bodies 'directly in the cogs of the machine, as a point of resistance in the flow of power' (Jordan 1998: 134).

The most dramatic occupation was at Claremont Road, a short tree-lined street of terraced houses in the predominantly working- and lower middle-class area of Leyton. Sculptures, stages and furniture blocked the way (Figure 5.1). An immobilized car sprouted grass, its wing adorned with the words 'Rust in peace' (Figure 5.2). Another was carved up, its two halves and the road between them painted in black-and-white stripes like a pedestrian crossing. From one of the houses rose a 30-metre-high tower of scaffolding. Movement between houses was enabled by breaching internal walls, and by the installation of a tunnel underneath and of rope-netting overhead. By then recognizing that the houses could not be ultimately saved, the intentions of the activists turned to making the road construction as difficult, time-consuming, expensive and politically unpopular as possible, while also performing other ways of living and using spaces here and now (Jordan 1998; Wall 1999). Barricades became a key symbol and means of interruption. Their rough and improvised composition, from materials torn from their usual contexts, contrasted with the smooth space of the planned highway, while their primary intention was to bring the state forces to a halt. As such they embodied a defiant counter-practice and counter-vision of the street, which connected the opposition to a long history of urban insurrections.[1] The final evictions of Claremont Road in November 1994 took four days and involved 700

FIGURE 5.1 Interrupting the street: protesters prepare for the final evictions at Claremont Road, London, 28 November 1994. Photograph copyright © Andrew Wiard.

FIGURE 5.2 Claremont Road, London, summer 1994. Photograph copyright © Maureen Measure.

police, 200 bailiffs and 400 security guards. By the following June, the last redoubts of the campaigners had cleared and the road opened four years later. A local newspaper headline ran: 'After 2,520 days, £380 million of work and endless delays FINALLY IT OPENS' (Whitlock 1999). Costs had escalated by more than 200 per cent, including security costs estimated at £21.8 million (Donovan 1999).

Now that the motorway has long been part of many people's everyday commutes, it seems ever more difficult to recall what went before. Streams of traffic repel memories of former homes, gardens and streets. More than 20 years on from the struggles and evictions, what has become of those who lived here? What resonances remain? How might the urban fabric, so radically transformed, still speak of their stories, memories, loves and losses? These questions are addressed by Graeme Miller's LINKED, an influential sound walk that has been continuously broadcasting from twenty transmitters along the route between Hackney Marshes and Redbridge since 2003, using technology designed to last at least a hundred years. Miller was one of many artists who had moved to Leyton during the 1980s, due to the availability of cheap housing and studio space on temporary lets through Acme Studios. He was among those displaced by the road construction, although his artistic response came almost a decade later. LINKED was commissioned by the Museum of London and is based on oral histories of people who lived and fought along the route, whose voices are heard by participants equipped with receivers and headphones. In this chapter I set Miller's project against the ongoing flow of the road. Interested in the interruptive capacities of urban art practice and performance, I explore how its use of sound and walking continues to work within and against urban conditions more than a decade further on, while its relationship with the city changes.

Since it opened, LINKED has garnered considerable attention in performance studies, public history, cultural geography and artistic practice. It has been seen as a pioneering mobilization of oral history into everyday spaces (Bradley 2012; Butler and Miller 2005; Butler 2006; Trower 2011). Interest has also centred on its role in 're-framing the theatrical' (Oddey 2007), and as a work of 'civic art' and 'pilgrimage' that offers a means of political performance through walking and witnessing (Lavery 2005; Heddon 2010).[2] In what follows, I reflect on the project's affective qualities as a time-based work that is listened to and walked in place. This connects with wider interest in the potential of artistic practices to address the consequences of urban restructuring and displacement through memory-work that takes seriously the interconnections between memory, bodies, affect and lived space, in opposition to the abstracting logics of capitalist development and state power (Till 2012). More specifically, however, I am interested in how LINKED arrests and re-routes flows of perception and experience, unsettling or haunting the route of the road and enabling it to be seen, heard and experienced differently. Making this argument requires moving away from a view of space and time as pre-given realms into which art is inserted, as is common in conceptions of public

art; instead, it considers how they can be brought into question as socially produced and contested, through a contrasting understanding of art as 'an interruptive activity that keeps things from going on as if they are given and inevitable' (Deutsche 1999: 101).

LINKED: Where are all those people now?

Under Graeme Miller's direction, memories, sounds and snatches of music have been infiltrating spaces alongside the A12 highway for more than a decade. They are carried through radio waves from transmitters mounted on existing lampposts or telegraph poles, and they can be heard above the traffic by participants who walk near the road, and who tune in using a receiver and headphones that may still be freely borrowed.[3] 'If my house was still there,' one former resident states next to the retaining wall of the highway that cleaves Colville Road, 'it would be hanging in space above the inside northbound lane. I can still feel myself in that place, that bit of air, the place where I lay down to go to bed, the place where I had showers, I feel a bit naked suspended in the air there' (Figure 5.3). Another previous resident asks in relation to Claremont Road: 'Where are all those people now?'

Protest scenes are recounted. People wait on rooftops for the bailiffs and police. Schoolchildren, parents and other residents try to stop the uprooting of a

FIGURE 5.3 'If my house was still there': A12 Eastway, London. Photograph by David Pinder.

250-year-old chestnut tree on George Green in Wanstead, a battle that attracted considerable media attention at the time and that did much to galvanize public sympathy for campaigners when they were violently removed. There are vivid accounts of dawn raids, of battered doors, and of swarms of bailiffs and police ransacking homes. Miller himself tells of a terrible sound and glass flying down the hallway early one morning when around thirty riot police stormed his house at 159 Grove Green Road, and he was evicted along with his partner Mary Lemley and his young son after ten years of residence. But most of the broadcasts concern everyday life and spaces: stories of homes, gardens and neighbours, ordinary encounters, tensions, arguments, children playing, flowers, snow, mail deliveries, a cat in the window. These scenes are typically spoken about in the present tense, something that was consciously elicited by Miller's team of interviewers. 'That is how it is now,' runs a refrain from a former resident in Claremont Road as a series of dates are recited.

Homing in on the *now* of everyday experiences and places is something that Miller has long sought to do through working with found physical, psychic and sonic materials from the streets or rural locations. In his own words he 'mines' the everyday and 'turns up the heat' on ordinary practices and codes (cited in Phillips 1998: 104). Drawn to places that are 'charged with people's lives' (Miller 2006a), he finds ways to collate and convey observations, memories, senses of places, as well as events that mark them. It is perhaps not surprising that he sometimes refers to himself as a geographer and a cartographer as well as an artist, theatre maker and composer. His early performances after his departure from the influential Impact Theatre Co-operative, in 1986, often staged journeys and explorations of place. Among them was *Dungeness: The Desert in the Garden* (1987) that combined music, voice and film to inscribe memories of people living on that isolated headland in south-east England. Later *The Sound Observatory* (1992) collaged recordings of voices and sounds from thirty locations in Birmingham, while *The Desire Paths* (1993) gave a central role to walking and political dissent, its construction already marked by anxieties and a sense of loss engendered by the motorway. But his performances soon increasingly went beyond theatre walls through site-specific installations and trails that he regards as 'civic works'. In *Listening Ground, Lost Acres* (1994), a large-scale transmitter and walking project in Wiltshire made with Lemley, walking and listening became means for the audience to become participants 'tied physically and rhythmically into both mythological and the everyday evidence of lives in the area, each individual inscribing his or her body "into the text" of the ground' (Phillips 1998: 112).

While working on that last project, Miller returned home to Leyton periodically to find his own everyday environment in turmoil. The highway was consuming familiar reference points. Holes opened in streets. Streets were cut in half. He recalls walking 'past a corner and everything was suddenly different. Things I knew had vanished'. Following the demolition of his own house only hours after his

eviction, he found himself 'unable to fit the building into the void that was now there' (Miller 2005: 161). Only when the immediate trauma had receded did his thoughts turn to making LINKED, by which time his initial desire for revenge had tempered into a concern also to salvage from the events and communities that had been erased, to 're-appropriate ten years' worth of memories that had been stolen'. He sought to re-place those memories in the landscape and so to reconstruct the environment in the minds of those undertaking the walk, a process that he sees as nurturing the narratives of place against their evisceration by the road, as reclaiming an 'ecology of narrative' by 'sending out seed crop' (Miller 2005: 161). In this regard he highlights the potential usefulness of the work as an action derived from his position as a citizen as much as that as an artist.

In his compositions for LINKED, Miller allows the voices of nameless contributors to float from the locations in which they lived. He does not naturalize or impose order on the experiences but, on the contrary, fragments, interweaves and loops voices while adding sounds and music. A total of 120 hours of interviews, now deposited in the Museum of London along with campaign materials from the Stop the M11 Link Road, have in Miller's own words 'ended up in smithereens' as 'fragments of recollection'. Against the highway that he views as sterilizing history, he intends the broadcast of these fragments to elicit and connect with other memories and stories, including those of participants on the walk, so as to 'renew the narrative tissue of the neighbourhood' (Miller 2003: 1). While participants are provided with a route map, they are invited to find their own ways and pace. Transmitters are not marked but their signals are discovered through walking as voices move in and out of range. Between the transmitters, each of which broadcasts an eight-minute loop, the route falls silent or, rather, there are the sounds of the existing environment to which listeners are newly sensitized. Miller comments on the tension between the museum's concern to ensure a more tightly scripted experience, in keeping with a consumer's expectation for everything to be 'cut and dried', and his own interventionist desire to allow participants to explore and drift such that they might be enticed 'to get lost in a Tesco's car park in Leyton but to discover something wonderful en route' (Butler and Miller 2005: 81).

While LINKED is often described as a memorial and an act of preservation, it is neither of these, at least in a straightforward sense. The fragmented content, gleaned from multiple, overlapping, and sometimes conflicting contributions, resists notions of a singular story or source. The same can be said for its form, which rests on the distributed authority of radio transmitters that must be found by exploring and going off track. Its memories cannot be downloaded and consulted in private but must be activated by people who walk and listen in place, in the midst of everyday activities and sounds. The project depends on what Deirdre Heddon terms 'the performance of the interpolated body committed to listening'. In this sense, not only is its speaking voice 'part of an ensemble' and hence 'plural, fragmented, divergent and intertextual', but the 'auditory community'

is also 'never singular or presumed' (Heddon 2010: 37). As Heddon and other commentators further note, being committed to listening involves time as well as mental and physical effort. Hearing the broadcasts can be a strain, whether that is above the roar of the traffic or through radio signals that drift in and out of range and that get interrupted themselves. Participants become used to manoeuvring to gain clearer reception, including through placing the receiver onto metal objects such as gates, fences and lampposts. This process of walking and conducting the route, Miller suggests, 'invites you to merge your experience, your narrative, with those of the stories you hear on the headset'. As a consequence, 'you start to write your own story'. You become 'no longer a spectator but a witness' (Miller 2005: 162).

As its title implies, LINKED is concerned with making and remaking connections. These include those between participants and residents, between the self and absent others, between memories and place and between varied stories and narratives. Retaining, repairing and retracing links to place are important to its composition. But at the same time Miller's project works interruptively, by dislocating time and space. In the next sections, I explore how it does this. First I address the pace of the work, and specifically its deployment of slowness and arrest in a context profoundly shaped by dominant forms of automobility. Second, I consider how the project conjures past realities in the present, and how it thereby troubles the times of place through forms of haunting. Finally, I draw out some of the implications, also in relation to the material form of the project and its dynamic relations with the area as the city itself changes.

Out of time, out of place

The same year that the struggles against the M11 Link Road reached their height, the UK Pedestrians Association's journal *Walk* published a 'Requiem for the pedestrian'. Signed by W.S. Wake, this warned against the 'systematic and insidious squeezing of the traditional, original user of the highway' and the dangers urban walkers face from all sides. One must be nimble and energetic to survive on the streets, its author contended, and even simple journeys now require frightening dashes across road junctions and circumnavigations of railings, underground passages, 'foul smelling caverns' and 'arched catwalk[s] over the thundering juggernauts' (Wake 1994: 15). The same issue carried on its cover a photograph from Claremont Road taken that August, depicting hundreds of police orchestrating evictions. More photographs from the street appeared in the opening article entitled 'Acts of violence', which began with an account of the brutal earlier eviction of one of the Association's members, Richard Laughton, and his elderly mother from their home on Colville Road. The journal described the action, which involved 168 police officers, 11 bailiffs and 40 security guards, as an expression of

'a car supremacist culture which puts immense value on the speed and convenience of the motorist and which is backed up by all the resources of the State', while anti-roads protesters are made 'enemies of the state' (*Walk* 1994: 4, 10).

Mobility theorists have engaged that 'suprematicist culture' through the more neutral-sounding concept of automobility. The term refers beyond the automobile itself to encompass the socio-technical-political practices, institutions, ideological formations and connected phenomenologies that legitimize and naturalize modes of being and moving through the city based around the car, and that serve to marginalize others, for example those involving walking or cycling (Böhm, Campbell Jones and Paterson 2006). In referring to it as a regime, critics highlight its systemic qualities and the power relations that sustain it, while also arguing that it should not be seen as universal, natural or inevitable and instead needs to be politicized. The reproduction of the mode of automobility centred on the car has required vast resources and political effort. At the same time it has profoundly shaped urban spaces and their rhythms through an emphasis on smooth, rapid and individualized circulation, which has helped to naturalize its forms and processes. The 'squeezing' of the pedestrian has a long history and was, for example, already central to the discourse on *flânerie* in nineteenth-century Paris, where the horse-drawn torrent of the boulevards was perceived as imperilling its well-being and indeed survival. But its endangered status has intensified as automobiles have become 'the dominant and predatory species', and as *flâneurs* 'like tigers or pre-industrial tribes, are cordoned off on reservations, preserved within the artificially created environments of pedestrian streets, parks, and underground passageways' (Buck-Morss 1986: 102).

Participating in LINKED there is certainly a sense of being, if not necessarily threatened, then out of time and out of step. This is most keenly felt walking next to the highway when one is often caged next to its roar (Figure 5.4). Yet in the walker's failure to align with urban speed-up and with associated injunctions against loitering may be found opportunities for critical insight. That at least seems to be Miller's wager, along with that of a number of other artists and writers who similarly explore cities and, specifically, highways through walking. Among the most prominent in London in recent years has been the writer Iain Sinclair whose peregrinations have included journeys along motorways and other major routes around or from the capital – notably the M25 and A13 – conducted with apparent perversity on foot. They involve walking within the 'acoustic footprint' of the roads, slowly drawing out stories from their terrain as he explores '[d]ull fields that travellers never notice' (Sinclair 2003: 16). Another committed walker, John Davies, has recounted a two-month walk along the M62 in North England, from Hull to Liverpool, addressing ordinary spaces typically overlooked or driven through at pace. Using a term I return to later, he describes himself as walking 'in the company of ghosts'. Among the ghosts to which he refers are villages and communities lost to the highway or other forces; the 'dead roads' and desire paths cut through by its

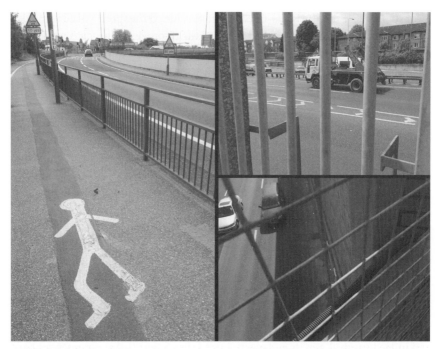

FIGURE 5.4 Walking the motorway. Photographs by David Pinder.

lanes; 'spectral sounds' heard from underneath its path when the vehicles above can no longer be seen; and memories of those who have lived, struggled and died along its route (Davies 2012).

Similarly resisting the haste of automobiles and of pedestrians rushing for buses or trains, LINKED may be understood in terms of what Christoph Lindner and Miriam Meissner (2015) have termed 'slow art', as it works within and against the commonly perceived accelerated mobilities of contemporary urban life. The slowness partly comes from the pace of walking and stopping to hear the broadcasts. But Miller also slows down listening through his deployment of repetition, loops, music, ambient sounds, lulls, stillness and silence. The addition of music bolsters the words and also 'suspends time and place', he suggests, serving to estrange or distance surroundings (Miller 2005: 164). Gaps within the broadcasts and also between them provide space to think and imagine. Sampling zooms in on spoken phrases and words; it takes them out of the temporal flow, arrests them and places them in new compositions that echo and loop. At Dyers Hall Road, words are broken into syllables. Their component parts are dragged out, repeated and gradually reassembled – piece by piece – to designate everyday objects from long eradicated homes: a deco-style ceramic jug; a painted Madonna figure; a blue duvet on the bed. As each word and phrase is haltingly recomposed, at one point

breaking into the repeated conjunction – 'and, and, and, and, and' – traffic streams past. The resulting texture helps to cultivate what Toby Butler terms a 'hyper-aware meditative state' (2005: 83), one that is attentive to what is immediately accessible to the senses as well as to what was once there, that is, to what might be recovered from the recesses of memory or discerned in the cracks and traces of the present.

Slowing down perception so as to attend closely to everyday environments, to experience them afresh in their multifaceted complexity, is a concern that runs through much of Miller's work. His current touring installation *Track*, since 2010, is a device for this purpose, in which participants lie back on platforms and look upwards as they move slowly and individually through environments along dolly tracks of the kind used for filming. The pace is determined by the individual 'grip' who pulls them. When staged in Birmingham, in 2012, the tracks passed underneath the Gravelly Hill Interchange of the M6 motorway, popularly known as Spaghetti Junction. Looking up at the concrete structures rumbling with traffic, participants' senses of time and space were temporarily suspended in ways that afforded new modes and angles of perception on the city and its mobilities. The slowness of such works is not about rejecting or stepping outside contemporary speed culture with its erasure of memory and senses of place, even though Miller intends his performances to work against it (Lavery 2005). Rather, as Lindner and Meissner suggest through their notion of slow art more generally, it is more about engaging with the multiple temporalities, rhythms and velocities of urban everyday life.[4] In the case of Miller's works, this multiplicity is sensed through embodied immersion. Bringing the body back in as a sensual being, against its abstraction and pacification, can be seen as a significant step in urban contexts that have been 'given over to the claims of traffic and rapid individual movement', and that have 'succumbed to the dominant value of circulation' (Sennett 1994: 256). But the critical effectiveness of the move depends on a certain friction or distancing that allows varied temporalities and rhythms to be apprehended as such, in particular those associated with normative inscriptions and modes of subjectification.

In proposing rhythmanalysis as a means of addressing the construction of rhythms through relations of power, as well as their potential appropriation and diversion, Henri Lefebvre notes that rhythm as it is ordinarily lived cannot be analysed unless there is a distancing, an externality. At the same time one needs to be grasped by a rhythm in order to grasp it (2004 [1992]: 88). In LINKED, such a distancing comes especially from tuning into sounds. This partly removes the participant from the situation as it is seen, while she or he remains immersed in it. At times the confluence of sound, situation and moving body might constitute what Leila Dawney terms a 'corporeal moment', which 'halts and disrupts the flow of experience'. Discussing this in relation to subjectification and affect, she suggests that such an interruption 'provides a locus from which to interrogate the body and to ask questions of the various rationalities and regimes that work to produce "natural" responses and modes of experience' (Dawney 2013: 628). The need to

question naturalizing regimes has already been noted above in relation to automobility, the politicization of which is an important step in refusing its inevitability and imagining potential alternatives beyond it. In the next section, I want to consider in more detail the interruptive use of sound and voice in LINKED, and how it productively dislocates participants and their senses of space and time. In particular, I focus on how it conjures past realities in the present, challenging the common privileging of visual apprehension through its use of aural descriptions in the present tense.

Ghosts and the dislocation of time and space

A woman is immersed in her garden. There is a swing, shrubs, trees, pond, cherry blossom, wallflowers, lilacs, bluebells and dappled light. People are laughing. Smoke wafts from a barbeque. Someone spots a tulip that is managing to grow unscathed through the rubble of number 181. These observations are heard through headphones in what is now Linear Park, a thin strip next to the motorway along Grove Green Road whose entrance sign announces: 'No dogs, no cycling, no ball games' (Figure 5.5). The breaks between the realities described through the headphones and those felt and sensed on the walk enhance the feeling of displacement and dislocation, of being out of time and out of place (Read 2003; Lavery 2005: 154). On occasions these disparities are seasonal or diurnal in form. But in more dramatic cases they attest to the violence of the highway construction, to the uprooting of place and neighbourhood where homes and gardens were replaced with a ruin, a void, or a channel of traffic. They leave participants, as they did former residents, struggling to reinsert memories and stories into the changed landscape.

Disjoining sound and sight by dislocating and relocating sounds, for example through broadcasting live or recorded ambient materials from one location to another, has been a strategy in place-based, site-specific sound art to render places strange in provocative and productive ways, and to transform how they are experienced. Brandon LaBelle notes the significance of the dislocative and disjunctive in this field for fostering 'a heightened relation to perception, narrative, and the sense of being somewhere' (2006: 230). The collision of sounds may be uncanny, with 'each interrupting the other's spatio-temporal reality'. He adds that 'such dislocations transform not only our spatial context and awareness of location but our perceptual and cognitive map' (LaBelle 2006: 231, 237). In the case of LINKED, the disjunction comes from hearing broadcasts about places and people that are no longer there but that are typically spoken about as if they were. With the perceptual and cognitive shifts, the motorway and its rushing traffic are viewed

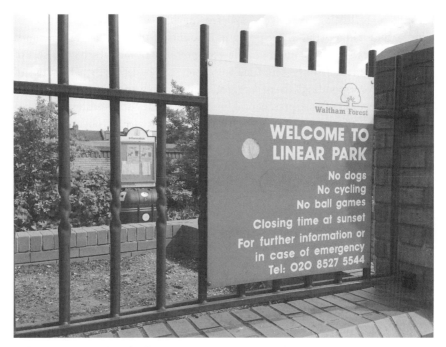

FIGURE 5.5 Linear Park, Grove Green Road, London. Photograph by David Pinder.

anew. Often this is from the visual and aural conflicting, as in the description of the garden while sitting in Linear Park. But also provocative are moments of synchronization within otherwise changed scenes that can have their own uncanny qualities. Once walking the route early one summer morning, I pause in Colville Road to listen to the man telling how his house would now be hanging in space above the northbound lane of the motorway: 'the place where I lay down to go to bed, the place where I had showers'. Intermingled with his voice is a sound coming through an open window above me, from a house that would have been opposite his; it is a sound that I come to recognize as a running shower.[5]

The 'nows' of the walk are multiplied and entangled. They displace linear senses of time and dissolve ideas of the past as a stable reference. Dates are often spoken in the broadcasts but they are not fixed markers within a progressive narrative; rather, they repeat, circle, skip and weave through stories, becoming almost like incantations: 1990, 1986, 1985. The sequences echo and shift, carrying collective as well as personal associations for the speakers: '1947 the weather; 1957 the smog; 1955 my dad bought his first car'. Uncertainty sometimes creeps in: '1985, or something like that'. Besides evoking the workings of individual memories, including their fragility and fallibility, the dates speak to the dense layerings of places whose times are impacted, knotted and cross-cut. 'The time is out of joint', to use Hamlet's line that Jacques Derrida (2006 [1993]) deploys in his influential

account of 'hauntology', which has spurred much recent spectral discussion in cultural and literary studies, including in accounts of trauma, loss and memory. Derrida writes of the 'disjointure in the very presence of the present, this sort of non-contemporaneity of present time with itself' (2006 [1993]: 29). Questions of time have correspondingly been foregrounded through recognition that ghosts unsettle categories of past, present and future, just as they are positioned between dichotomous oppositions such as the visible and invisible, the phenomenal and non-phenomenal, life and death. Ghosts return, they surprise or interrupt the presentness of the present. They are 'the mark or trace of an absence', signalling the potential emergence of a different narrative (Weinstock 2013: 64).

Over the last two decades, haunting has become a common means of figuring cultural engagements with occluded, disavowed and suppressed elements of the past inside the present, and with what has been silenced within dominant histories and geographies. Proposing the ghost as a figure of interruption, in the sense that I am giving that term here, therefore requires elaboration. In an earlier essay entitled 'Ghostly footsteps', I discussed experiences of following another audio walk in East London by the Canadian artist Janet Cardiff, and I considered how the soundtrack, originally heard via CD and headphones, cultivates attention to the multiple layers and narratives of the streets through interweaving the self and city, and the conscious and unconscious (Pinder 2001).[6] Preoccupied with loss and disappearance, the immersive tour's haunting qualities derive from the absent presence of the multiple recorded voices and sounds of the environment as it was walked through earlier, and their melding with the consciousness of participants who consequently have a sense of communing with the lives of those who have previously passed this way. Time and space are unsettled as sounds suddenly interrupt the reality through which one walks, a process that I likened to the flash of involuntary memories triggered by moving through the streets. In the process, linear constructions of time and fixed understandings of space give way; they are multiplied, entwined and enfolded.

The sense of haunting experienced on Cardiff's walk is therefore not only temporal but also inseparably spatial. Following Steve Pile, ghosts can be been to 'destabilise the flow of time of a place' and 'register the dislocation of urban times and spaces', such that it is possible to speak of space as well as time 'out of joint' (Pile 2005: 131, 132; see also Blanco and Peeren 2010). There are similarities with the interruptions of time and space experienced through LINKED for which the language of haunting seems especially apt, as its frequent use by participants attests. Taking up this theme, performance scholar Carl Lavery notes how the work 'haunts the road' and participants 'walk in a city of ghosts', as 'the phantasmic voices broadcast by the transmitters weave a dream blanket of reminiscence over the East End' (2005: 149, 155). Yet the ghostliness takes on distinctive qualities. What is at stake in Miller's project is not a generalized structure of haunting of the kind that has characterized some writings associated with a 'spectral turn', and that is

'symptomatically blind to its generative loci', as one critic has argued in relation to contemporary Gothic apprehensions of London (Luckhurst 2002, 528). Nor does it depend on the divination of obscure and mystical forces by 'visionaries', whose arcane knowledge is then passed down to initiates (cf. Luckhurst 2002: 532). What haunts in LINKED are the evicted and repressed elements of the area now returning, the stories and perspectives of former residents whose voices are carried through radio waves. They originate from specific historical and geographical situations, in relation to the injustices of evictions and erasures brought about by urban development.

Lavery's account of the 'phantasmic voices' of the route revolves around the dislocation he feels when listening to them, and how the experience unhinges and affects him. He highlights Derrida's ethical injunction to learn from spectres not by assimilating them but by living with them and by letting them speak. What is significant from this perspective is the transformative encounter with the spectre as a figure of alterity. Lavery suggests that by placing participants in contact with the ghosts of the highway, and by inviting those participants to pay witness by listening, Miller unsettles reality as it is. In the process his walk raises questions of justice and how to live, and is oriented to the future (opening to the absence of those 'who are not yet *present and living*') as well as to the past (those who are 'no longer' [Derrida 2006: xviii]).[7] For Lavery this leads to more specific questions such as why individuals and communities are sacrificed to ease of access, why the addiction to speed, and why the prominence of the automobile? Lavery therefore underlines the walk's transformative potential as a work of mourning, and he considers ways in which the communities may be remaking themselves and renewing their 'narrative tissue', a futural task to which Miller hopes his 'spectral art' might contribute (Lavery 2005: 156).

In addressing LINKED's haunting qualities, however, I want to build on these insights by considering in further detail its sonic form and technology. This involves taking up Mark Fisher's conjecture that hauntology has 'an intrinsically sonic dimension' and that, in terms of sound, it is a question of 'hearing what is not here, the recorded voice, the voice no longer the guarantor of presence' (2014, 120). Unlike Cardiff's walk, which is conveyed via DVD or now MP3 download, and unlike many other recent sound walks that operate through downloads, internet or GPS triggered signals, LINKED depends upon radio broadcasts that allow the voices to float free from the living bodies of the speakers. The spectral qualities of audio recording as it separates voice from body, and as it allows the reproduction of voices in other times and places, including those of the departed and dead, have preoccupied media and technology theorists, who have also noted the distinctive physical relationship involved in analogue recording. The development of radio broadcast technologies specifically, and their transformative implications for conceptions of the human subject, have often been viewed through ideas of the phantasmic and the ghostly, while also stimulating fantastical modern imaginings

(Sterne 2003; Weiss 1995). Sampling, by making recordings from other recordings of sound and voice, adds additional layers through a 'musical art of ghost co-ordination and ghost arrangement' (Reynolds 2012: 313–14). These and other connotations of LINKED's form are significant for appreciating its haunting power. While they have received surprisingly little discussion to date in relation to Miller's walk, they are becoming more evident over time through technological changes and as the technology he deploys itself comes to materialize memories.[8]

The voices transmitted through LINKED are an absent presence. They are continually there, still in place, and they should remain so for a hundred years. Yet at the same time they repeatedly pass and fade, they are transient traces of the evicted and departed. To be heard they require an animated or spectralized body that is equipped with receiver and headphones, which bring the voices temporarily into range before they fade and disappear. As participants manoeuvre the receiver across surfaces in search for a signal, they at times feel as if they are channelling the spirits of place. The sounds come to pervade objects and structures without an obvious source. In this way, as has been argued in relation to modern auditory experience and the development of radio more generally, the singular perspectival space of vision gives way to 'a plural, permeated space' and the listening self becomes less a point than 'a membrane', a 'channel through which voices, noises and musics travel' (Connor 1997: 207). Voices emerge, dissipate and always return. They cannot be simply summoned or directed, for they must be tuned into, with all the variability that involves. The presentness yet intangibility and ghostliness of sound, registered through the body, has resonances with discussion of memory as present but shifting and impermanent. Musician and author David Toop writes: 'Sound is absence, beguiling; out of sight, out of reach. Who made the sound? Who is there?' He continues: 'Listening, as if to the dead, like a medium who deals only in history and what is lost, the ear attunes itself to distant signals, eavesdropping on ghosts and their chatter' (Toop 2010: vii).

Conclusions

Looking down on the streaming traffic of the A12 today, there might seem few traces of the communities that were displaced by its construction or of the protests that sought to save them. As the area continues to change, including through processes of gentrification that have been fuelled by the nearby Olympics, its ghosts are further expunged and exorcized. Yet circulating unseen and only occasionally heard over the traffic are other cities of memory and reverie, cities that LINKED helps bring forth through eavesdropping, listening and witnessing. That said, LINKED's political significance as a performance work should not be overdrawn. This is especially given the ways in which community-inflected artistic projects are routinely enlisted in place promotion and the aestheticization of urban

development, and in which urban 'slow art' often occupies an ambivalent position in relation to urban restructuring and its socially divisive consequences (Lindner and Meissner 2015: 7–9). Referring to LINKED's incorporation into a festival of London's history organized by the Conservative Mayor of the city, Boris Johnson, Josephine Berry Slater and Anthony Iles remark with regard to its engagement with the anti-road protests: 'The whitened bones of history, now considered safe from the fecundity of decay, are conjured as character-giving heritage in newly sanitized city districts.' They argue more generally that what allows art to be readily integrated into urban regeneration schemes is its perception 'as a social and environmental enhancer rather than destabilising agent or potential cause of blockages within the smooth functioning of the city, its populations and productive flows' (2010: 22). To their critical comments can be added those of many protesters from the Stop the M11 Link Road campaign who have been at best ambivalent towards commemorating the past, if not actively hostile to it as a distraction from moving on to new struggles.[9]

As I have argued, however, Miller's LINKED is not a fixed memorial, nor is it about the anti-road protests as such. It is political less by stance than through what it addresses and the questions it poses. Dispersing the authority of monuments, it involves participants in the everyday geographies of the area and invites their critical reflection on the destruction, as well as construction, of place. Particularly significant is how, as a time-based work with a long view, which reaches back one hundred years and that intends to be broadcasting one hundred years hence, it unsettles linear histories, conjuring elements that have been evicted and repressed. Withholding narrative progression by layering fragmented voices and making them looped, interwoven and discovered through wandering, it engages at a bodily level with the multiple temporalities and rhythms of place. Approaching its form through the language of the spectral, as I have done here, does not necessarily secure a politics, progressive or otherwise. Indeed, discussion of a generalized spectral process can, politically speaking, easily become empty (Luckhurst 2002). But, as I have tried to show, presented in more specific terms it can help elucidate questions about the present and future as well as the past, and to challenge the senses of the given and inevitable. Addressing the spectral qualities of LINKED also directs attention to how its material form is haunted and haunts through its changing relationship with the city. The walk itself becomes an index of urban transformations as the route changes, for example as transmitters disappear – one to the Olympics development – and through the increasing difficulty of accessing the receivers from local libraries due to cuts to public services.[10]

At the start of the catalogue for LINKED, Miller reproduces two photographs of the location of his former house, Grove Green Road. One was taken before the highway and depicts the street lined with houses. The other was taken shortly before the houses were built in the 1890s, and shows a tree-lined path and a young girl who looks at the camera. Later contemplating the latter photograph and its personal

significance, Miller notes that it marks one edge of his project, the period prior to those invoked in the broadcasts. He imagines reversing time towards that moment so that the Link Road fills in, the destroyed houses reappear and renew themselves until, 'in the 1890s, they pour back into their foundations and grow over with rye-grass, hawthorn and elm' (2006b: 111). But he then imagines running time forwards from the present, one hundred years into the future when he is outlived by the work before it erases itself. From a future yet to be made, he looks back on himself standing small on a bridge over the Link Road. If from a personal perspective he finds the view a 'little chilly', he also sees 'living corporeal history growing around the transmitters' and imagines clusters of memory coral 'radiating from the transmissions and strands strung between them' (2006b: 112). Participation in LINKED today is always at street level from a particular perspective and moment, yet the experience of listening to the broadcasts shifts that perspective both temporally and spatially. Walking the route is to be haunted by both past and future. Thoughts are drawn to what was here before the motorway, even before the houses. But what of the view from a future yet to come, a future not yet written? A time after the motorway, perhaps, when the traffic is stilled and the place moves to other rhythms?

Acknowledgements

I would like to thank Shirley Jordan and Christoph Linder for the opportunity to discuss this paper at a symposium on 'Global Cities and Practices of Interruption'; the Museum of London and especially Beverley Cook for assistance; and students at Queen Mary University of London for sharing thoughts on LINKED over a number of years through my MA course on 'Art, performance and the city'.

Notes

1 A comparison may be drawn, for example, with Kristin Ross's (1988) account of the barricades of the Paris Commune of 1871. She contrasts their construction with the isolated monuments of the new boulevards and notes that their primary function was to prevent the enemy forces from circulating.

2 A long-term study of the work from the perspective of its audiences, involving interviews and focus groups with participants, is also being conducted by Sarah Wishart as part of her PhD at the University of Leeds; see http://www.sarahwishart.co.uk/research/

3 For details, see http://www.linkedm11.net

4 That multiplicity includes the tempos of the highway that are of course highly variegated, not least due to the road's frequent congestion: it has recently been labelled the ninth most congested in the UK (ITV News 2014). On commuting by car and 'the multiple capacities of stillness', see Bissell (2014).

5 This was during a walk in May 2014. This chapter draws on my engagements with LINKED over a number of years, including through my MA course on 'Art, performance and the city' at Queen Mary University of London.

6 Cardiff's *The Missing Voice (Case Study B)* was commissioned by Artangel in 1999, and was originally available for free hire from its starting point at Whitechapel Library, in East London. Following the library closure, the starting point is now within the Whitechapel Gallery, although the walk still remains available as a download from: http://www.artangel.org.uk/projects/1999/the_missing_voice_case_study_b

7 Derrida writes: 'No justice … seems possible or thinkable without the principle of some *responsibility*, beyond all living present, within that which disjoins the living present, before the ghosts of those who are not yet born or who are already dead' (2006: xviii).

8 The ways in which technology materializes memory is a concern that runs through recent writings on sonic hauntology, especially as it manifests in contemporary music culture's fascination with the material form of vinyl records, television and audiotape, and with the sounds of them breaking down (Fisher 2014: 21; Reynolds 2012). A recurring case is the reproduction of vinyl record crackle in contemporary music, where it signals to the listener a time 'out of joint'. In the contemporary context of increasing smartphone and mobile GPS-based audio walks, Simon Bradley hints briefly at the significance of Miller's use of 'media technology of a bygone era' in the form of radio waves and transmitters for its 'fractured aesthetic', which depends on the broadcasts being fixed and actually looping, and on them coming in and out of reception. He notes that 'this form of analog glitching remains surprisingly difficult to simulate digitally' (Bradley 2012: 104).

9 'Claremont is done with, over, finished. … There are new campaigns now,' the activist Mick Roberts is quoted as arguing soon after his eviction from the road. Another protester, Bill, concurred that 'we don't want commemoration or monuments', but he saw value in preserving the campaign's archives and stated: 'We don't want to be seen as a case-study but as a working model' (both cited in Butler 1996: 359).

10 One of the transmitters lost to the Olympics, situated at a pub that is said to be haunted, has not yet been recovered, although Graeme Miller and Artsadmin are currently (early 2015) discussing longer-term issues about the future repair and maintenance of the project.

PART TWO

RESISTANCE AND RENEWAL

6 SUBURBIA, INTERRUPTED: STREET ART AND THE POLITICS OF PLACE IN THE PARIS *BANLIEUES*[1]

Gillian Jein

The efficacy of art [. . .] consists above all in a distribution of bodies, in divisions of singular spaces and times that define ways of being together or apart, opposite or amidst, inside or outside, near or far.
JACQUES RANCIÈRE, *Le Spectateur émancipé*[2]

The purpose of this chapter is to examine the interrelation between street art and the politics of urban renewal in reworking imaginaries of place in the Paris suburbs or *banlieues*. Recent French policies of decentralization and urban 'renewal' or 'renovation'[3] present the need to rethink the centre–periphery binary that has defined the *banlieues'* relationship to the capital, and to re-examine the consequences of governmental reorderings of place for the spatialities emergent on the edge of the *intra muros* city. Placing into tension the discursive operations of renewal with the visuality – the 'social fact' of visibility (Foster 1988: ix) – of street art, the argument presented here has a dual purpose: first, to explore critically the conceptualization of the commons in renewal discourses and, second, to problematize the role of art in the 'rehabilitation' of these 'badlands' (Dikeç 2007) of the French capital. The chapter draws on Jacques Rancière's politics of aesthetics to tease apart – before reconnecting – the urbanist and the cultural strands of this argument, here brought together through the concept of interruption. These strands are conceived as the critical agency manifest in modes of politico-aesthetic disturbance or interruption that potentially rework dominant spatialities or

'regimes of sensible intensity' (Rancière 2013: 39). The spaces of interruption discussed here are thus implicated in wider debates of visuality, concerns about what it means to be together in urban space, and the mutual ways in which contesting regimes of visibility engender possibilities for experiencing the 'commons' in the global city.

In the French government's urban policy of the last decade, issues of 'social mixity' and cultural 'rehabilitation' have dominated discourses of renewal in the *banlieues* (Clerval 2013). Locating rehabilitation as a reactionary force emergent from the visuality at work in the governmental and mediatized constructions of the *banlieues*, renewal is conceived here in tension with both the Chiraquien imaginary of 'social fracture' and the Left's and Right's understanding of the *banlieues* as zones apart, separate spaces often designated by the emotionally evocative term 'sensitive urban zone'. Recently, a discourse of renewal emerged at the level of state and departmental politics, which includes discussions of the need to officially reclaim and reorder such places (in response to the global rise of the cultural economy), the adoption of a sustainability agenda and, on a national level, the necessity to maintain the identitarian coherence central to Republicanism's legislative imagination of the citizen. These discourses not only define a model of action for the *banlieues*, they also effectively draft a map of acceptable visuality, repressing contradictions inherent in the *banlieues'* position within the imaginary of the Republic's relationship to the postcolonial and de-industrialized complexities of its socio-cultural space, and defining a mode of architectural and cultural experience that has effectively set into motion the gentrification of these former 'outsider zones' (Fourcaut, Bellanger and Flonneau 2007).

Sociologists and ethnologists of gentrification have emphasized the spatial segregation, economic marginalization and social displacement accompanying processes of gentrification across global cities in the Western hemisphere, identifying different dynamics of mobility within the North American and European contexts, respectively (Lippard 1997; Davidson 2007). This analysis also insists on the importance of displacement and segregation, but does so within a more emphatically cultural, theoretical framework, to examine cultural practices engaged in the reframing of the *banlieues* on the basis of relationality. As such, the chapter focuses less on statistical or sociological studies, but rather concentrates on the politico-aesthetic shift – in Rancièrian terms, the redistribution of the sensible – instigated by gentrifying processes at work in the Parisian urban core since the mid-nineteenth century. This shift requires further problematization, because of the centre's significant neoliberal and nationalist turn in redefining its relationship to the periphery. The foundation of Rancière's philosophical integration of politics and aesthetics consists of a critical resistance to the givenness of place, connecting established orders of governance to questions of visuality, or how governmental discursivity – 'the police order' – normalizes power

distributions, by securing the order of sensible (aesthetic) experience, and delineating lines between what is visible and invisible, sayable and unsayable, central or peripheral. From this perspective, as an operation that installs and conserves the systemic loci filtering power through the organization of space, in accordance with market and administrative agendas, gentrification of the *banlieues* can be seen as a force that re-determines the distribution of roles in these communities and, in so doing, reshapes the forms of exclusion operational within this space.

Within this context, it becomes necessary to explore the agonism at stake in art's participation in the place-making policies of the neoliberal Republic, addressing the issue of art's role in interrupting the sensory fabric of the city. Specifically, this chapter examines the relation between aesthetics and politics in the context of a public art project on the Canal de l'Ourcq that recently formed part of the cultural programme for redevelopment in the commune of Pantin, located on the eastern edge of *intra muros* Paris, in the department of Seine-Saint-Denis (department 93). This exhibition, 'Edifice', consists of what has become known as 'urban art' and involves the re-appropriation of the derelict buildings of the former Chambre de Commerce et d'Industrie de Paris (CCIP), more commonly referred to as the Magasins Généraux, by graffiti and street artists. The theoretical framework for discussing this art form's relation to the politics of urban renewal is Rancière's notion of art as an act of interruption, that reframes material and symbolic space; a practice that, in opening spaces of deviation, potentially reworks dominant distributions of sensibility (Rancière 2000). In this conception, art constitutes a locus of enunciation, that roots 'true' politics as dissensus in aesthetic modalities that make the invisible visible, translate noise into speech, and so contest normative perceptive boundaries (Rancière 2013: 137). This exhibition's appropriation and reinterpretation of the post-industrial landscape of Pantin suggests a confrontation between, on the one hand, discourses of street art and graffiti as art forms that articulate the peripheral voices of the disenfranchised *banlieusards* and, on the other, the problematic, reactionary role art plays in the middle-class reworking of Pantin's industrial past and its ongoing rehabilitation as official 'place of memory' (Nora 1989). Framed by Rancière's notion of politics as a mode of dissensus and of art as a mode of interruption – both modes, therefore, stemming from struggle between the established social order and its excluded 'part which has no part' (Rancière 2013: 70) – this chapter explores the extent to which we might consider such visual forms of sensory disturbance as indications of an emergent form of urban identity politics. Thus, in the contexts of the state-sponsored gentrification and the global commodification of street art, in what sense, if any, can we perceive such local artistic initiatives as potential redistributions of the sensible, that interrupt and challenge dominant distributions of spatial, cultural and class identities?

The image of the *Cité*: building consensus in the *banlieues*

Conceiving the city as a distribution of the sensible, we begin to pick apart the seams of the dominant rationality of the Habermasian bourgeois public sphere, reorienting its vertical dynamic towards political action conceived as aesthetic interruption that, crucially, is without pre-intended destination, assuming no direct correlation between the message of the art form and its efficacy in the public domain. The redistribution of the sensible, emergent from interruption of police consensus, does not replace one hegemony with another, but rather enables the heterogeneous mutation of the visibilities and spatialities of the 'public'. In Rancière's terms, the 'public' does not take shape in space as any singular body or group, nor does it by extension reformulate place in consistency with ideas of stability and rootedness. Rather, following Vito Acconci, it adheres to the assemblage as urban spatiality wherein 'a "real" public space is constituted and experienced as multi-directional and omnifunctional' (Acconci 2009: 135). Public spaces are situated phenomena, and by extension street art – as a mode of articulating public life in public – is never an autonomous arena, but is 'regulated by economies and policies, and constantly in connection with other fields or spheres' (Sheikh 2004: 139), critical, contextual and political. Nor is public space devoted to the contemplation of art; as an arena of everyday life, public space constitutes an inherently politico-aesthetic space where – through a nexus of restrictions, possibilities, governmentalities and cultural codes – spatialities are mobilized (Figure 6.1). It is, as Rosalyn Deutsche (1996) points out, the space of democracy, and art within this public arena is implicated in issues of the 'right to the city' (Lefebvre 1968), in political control of space, and in the issues of identity and voice that are always at stake in the construction of meanings for 'the public'. The recent admission of street art into the white cube means that many of the artists working in Pantin are members of two visibility regimes – the non-commercial public space forum and the coded regime of the art market. This commodification infers that assumptions regarding any innate potential of street art's 'outsider' status to disrupt the coded mechanisms of institutional order are no longer entirely tenable. However, it is precisely for its complicated interconnection with protest traditions in art on the one hand, and with capitalist spectacle on the other hand, that street art calls on a micro-analytical mode, motivated by a materially led interpretive position. Street art, with its deep dependence on – and empathy and haptic intimacy with – the ephemeral flows of the city's everyday life, brings material and historical context to the fore. It materializes the visuality debate, inviting a decelerated look at its embodiment on the wall. With this in mind, let us turn to these walls to examine their recent reconfiguration in political strategies to rehabilitate the *banlieues*.

Architecture has been central to the construction of political and cultural membership in the Republic, both implicitly and explicitly, since the emergence of

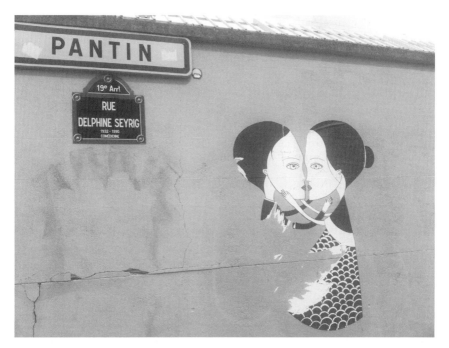

FIGURE 6.1 Pantin sign and Fred le Chevalier, September 2013. © Jeanne Menj.

the nation-state in the eighteenth century, operating to spatialize values of national coherence (Leith 1991). By no means a homogeneous, ahistorical discourse, it is nevertheless possible to identify two relatively consistent strands of thought informing Republicanism's spatializations of citizenship: universalism and assimilationism. Universalism is founded on the ideal that the core values of the Republic – *liberté, égalité, fraternité* – can be applied to all, constituting an idea of univocal singularity and the republic as 'one and indivisible'.[4] This ideal is complicated by the second assimilationist strand, positing the hegemony of 'French' culture, and requiring its citizens' assimilation into this culture, often as a prerequisite to full political membership. In this representational regime, the state is central to promoting visualities of the common, through intervention in the everyday lives of its people, with the result that issues of cultural coherence are spatialized in the *banlieues*. Given its concentration of 'immigrant' residents – largely due to successive colonial and postcolonial policies – urban policy affecting these areas is imbricated in French identity politics, so that the right to the city becomes equivalent to the right to a 'place' in the nation. Since the 1970s, corresponding with the rise of cultural anti-pluralism, we observe the rapid formulation of the *banlieues* as 'non-places', with the *grands ensembles* (high-rise housing blocks) readily dismissed as a vast collective error (Lefebvre, Mouillart and Occhipinti 2003). The ascent of republican nationalism in the 1990s saw the housing estates of the *grands ensembles* represented as the spatial disintegration of

republican coherence, with these areas discursively constructed in the media as deviations in an otherwise coherent society: 'a zone without rights, to be born there meant social death' (Baran 2012). In this regime, the *banlieues* emerge as detritus requiring evacuation, inhabitants designated as 'scum' or filth to be erased,[5] with this governmental rendering of the *banlieues* as 'part without part' defining the lines for those outside the order of the police, and reflexively securing the limits of identities with a stake in the Republic. Therefore, inextricably bound to questions of cultural belonging are issues of spatiality, and the nomination of a specific arena as beyond the realm of the republican commons, consolidated as the 'city apart' (Fourcaut 2004: 198), existing somewhere 'beyond' Paris but not part of it.

This imaginary of the *banlieues* as non-places is a central preliminary discourse to that of renewal, justified in the governmental schema as the re-making of 'place', and newly complicated by the meeting of republican nationalism and neoliberal market agendas to secure Paris's economic competitiveness on the global stage. Against such a background, urban renewal – closely connected to the social mixity designed to encourage the *banlieues*' attractiveness to a middle-class housing market – has managed to secure almost uncontested support on the part of both left- and right-wing parties (Epstein 2012). Founded on mapping the republican ethos onto an image of the commons, smoothing away any contested terrains so that these conform to 'the way of life or *ethos* of a society – the dwelling and lifestyle of a specific group' (Rancière 2013: 72), the discursive operations of architectural renewal in the *banlieues* can be understood as the spatial rendering of governmental consensus, constructed on the plinth of republican nationalism and neoliberal market directives. On 1 August 2003, social mixity was consolidated in the 'Borloo law', which prioritized this concept as a means to reclaim the *banlieues* as republican territory. Finding a solution to the 'problem' of the *banlieues* was framed in an irresistible language of national survival, evident in Jean-Louis Borloo's conceptualization of his legislation as the 'new battle for France' (Bissuel 2002). Mapping spatial coherence onto the desired outcome of social cohesiveness preserves the republican emphasis on notions of social solidarity, and assumes architecture's pedagogical efficacy: if we build coherence, the commons will be coherent. The result is that privatization, and the interest of commercial enterprises in the lower rent and larger spaces that the *banlieues* provide, have begun paving the way for gentrification, particularly in the suburbs bordering the périphérique – *la petite couronne*. While not a uniform operation, transforming the social composition of buildings and public spaces in neighbourhoods traditionally seen as '*populaire*' has visibly affected a number of communes of the Seine-Saint-Denis region – notably neighbourhoods in Montreuil, Lilas, Bagnolet, Romainville and Pantin – with this *embourgeoisement* being strongly linked to state-led renewal projects. In Pantin, for instance, the former mills (Figure 6.2) now house the banking conglomerate BNP (Figure 6.3), while, further along the canal, Chanel has opened its new headquarters and Hermès has purchased entire blocks to install its ateliers, with both fashion conglomerates committed to

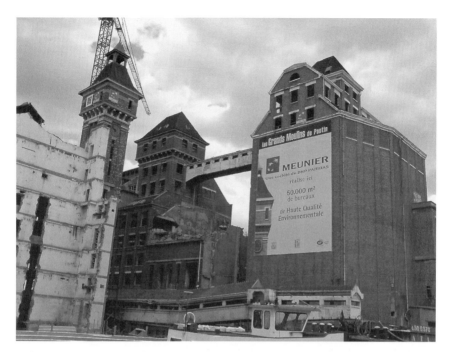

FIGURE 6.2 *Grand Moulins*, July 2004. © Pascal Vuylsteker.

participation in departmental renewal of the immediate vicinities of their buildings (Kamdar 2013).

In addition to the new visibilities engendered by urban policy, culture has become an essential component of government-led renewal in the suburbs. This complicates the ideal of national coherence by the nation's cultural commodification at a global level where, for Paris performing on a world stage, signs of national identity potentially generate a coherent and positive promotional image for easy international consumption. In the *banlieues*, this commodification assumes the form of publicly and privately rehabilitated architectural landscapes and the installation of cultural institutions. Culture-driven strategies promoting festivals, art exhibitions and the instalment of creative quarters in the *banlieues* see culture 'employed as a driver for economic growth' (Miles and Paddison 2005: 833), and strongly bound to a localized rearticulation of the 'popular' as a cultural commodity. Where governmental strategies posit national coherence, local programmes tend to realize redevelopment in terms more akin to global processes of gentrification. The arrival of internationally renowned cultural brands in Pantin – the commune is home to the Centre National de la Danse, the Designer Days annual festival and the renowned jazz club Dynamo, organizing the annual *Banlieues Blues* festival – has contributed to the ongoing reformulation of the commune's popular or working-class inheritance, in terms equivalent to other global cities. This

FIGURE 6.3 BNP buildings, July 2014. © Jeanne Menj.

reformulation was articulated in a recent article in the *Nouvel Observateur,* naming Pantin as the 'new Brooklyn' (Lefebvre 2013). Drawing parallels between the gentrified visualities of the New York and Paris suburbs, the piece documented the opening of a new gallery by international curator Thaddaeus Ropac. Laura Berteaux, the site manager, stated that in persuading such art and architecture celebrities as Norman Foster, Gilbert and George, and Anselm Kiefer to do the

'unbelievable thing' and cross the boulevard périphérique, she had the impression they were 'pioneers, transforming the image of the city' (Lefebvre 2013).

As Berteaux's statement reveals, artistic activity is an economy of the sign, and the presence of the culture industries is bound up in the normative revalorization of spatiality. As Zukin explores throughout her work, implantation of an arts infrastructure to an urban site is more than demand-oriented, it speaks to a governmental will to create new 'urban markets for cultural consumption' (Zukin 1982a: 424). In Pantin, in addition to the creation of an artistic quarter in the run-down neighbourhood of Quatre Chemins, a regular summer arts festival, and the provision of pleasure cruises along the canal de l'Ourcq, the phenomenon of urban walking also forms part of departmental strategy to rehabilitate the negative image of Seine-Saint-Denis, whereby Tourisme93, as part of the *Douce Banlieue* project, maps over 500 suburban walks. The media reports on these events consistently emphasize the discrepancy between such cultural initiatives and the image of the *banlieues* as wasteland, framing its neoliberal coverage as the edgy contradiction of negative stereotypes, and emphasizing the common cultural regime linking centre and periphery. Such revalorization is achieved, however, at the expense of long-term residents living and working in the area; class and cultural barriers are not necessarily broken down by introducing new culture industries; rather the latter tends to reproduce the visibility regime of dominant cultural elites. As Zukin points out, 'symbolically and economically, support for a city's arts infrastructure often undergirds a general attempt to build support for urban revalorization' (Zukin 1982a: 424), suggesting intolerance to difference in cultural and monetary terms. As the *banlieues* are revalorized, it becomes increasingly difficult for working- or lower middle-class families to remain there, and already property prices along the canal de l'Ourcq have reached 5,300 euros per square metre (an increase of 18.9 per cent in the last 5 years) (Zappi 2012). Architecture's and art's roles in reconfiguring suburban space assure the marketability of place, with new spatial arrangements acting to guarantee the compatibility of neoliberal market logic with republican ideas of the social regeneration of place. In this schema, the unmaking of place and its re-making through renewal suggest the *banlieues*' gentrification as the state's most recent civilizing mission. In such an analysis, art can no longer be conceived as innocent or separate from processes of social and political exclusion.

Interrupting art

In the emergent geographies of the *banlieues*, it is apparent that we cannot compartmentalize the art object or separate art from its situatedness. Renewal has established an order of consensus that pins bodies 'to "their" places, allocating the private and the public to distinct "parts"' (Rancière 2013: 139), through the cultural identitarian discourse of nationalist Republicanism, as well as the competitive

intensities of real estate prices in the capitalized environment of the 'rehabilitated' suburb. On this stage, the critical question for art is whether or not it can negotiate – and emerge critically from – its complicity in the new spatial and social arrangements performed by renewal, and what such an art might look like. In what follows, I argue that street art interrupts the aesthetic regime of architectural and experiential coherence, redistributing dominant modes of sense-making, not through any direct engagement with political discursive operations as such, but rather via two main interruptive gestures inherent in the way in which this art's aesthetic identity is rooted in everyday sensory experience: first, by its inseparability from public space, and second through its ephemerality, or tactile accessibility. Both of these interruptions are considered here as the promotion of 'endotic' (Perec 1989) subjectivization. I combine the terms 'endotic' and 'subjectivization' to suggest the incipient, non-rationalizable aspect of the subject's everyday existence, which, when gathered by aesthetic practice, suggests 'a process by which the subject places itself beyond the dominant categories of identification and classification' (Rancière 2004: 92). The endotic subject expresses the means through which everyday life interrupts the discursive seamlessness of governmentality, and in this sense its practices are akin to what Michel de Certeau (1984) describes as 'tactics'. Rancière's aesthetic twist on the political, combined with De Certeau's political twist on everyday life, facilitates a conceptualization of the means through which aesthetic experience at the level of the everyday interrupts orderly space, to represent the commons – for however short a time – as conflictual and contradictory. In this way, the space of democratic debate, dissent and demotic expression – comes back into view. Within this schema, dissensus is understood not as the 'designation of conflict as such', not as overtly political in the sense of an artistic *avant-garde* but, more fundamentally, as a 'conflict between *sense* and *sense*' (Rancière 2013: 139).

The question of where street art belongs, to which sense apparatus it can be designated – the realm of 'art' or that of vandalism? – has been the subject of much contemporary debate on the subject. I do not engage with this debate here, being less concerned with aesthetic merit or lack thereof, and more with the material presence of art in the street. Street art is a hybrid form of visual culture, designated by some as 'post-postmodern' (Irvine 2011) – in reference to how it tends to bypass the national forum to be more explicitly enmeshed in local (situated) and global (virtual) identification platforms – but beyond this general observation, the precise qualities of street art – what makes a work identifiable as street art – suggest an aesthetic response to modernity's separation of art and life (Riggle 2010: 243). Public space is street art's material resource, without which it loses its specificity, a characteristic that displaces the distinction between art and the real as spatially articulated by the gallery and museum, and which implicates art in the everyday of the street. In this way, while everyday life was certainly a concern of art movements such as Ready-mades and Pop art, these artists problematized the seeming meaninglessness of the everyday by displacing it inside the over-coded, auratic arena of the gallery. The operations of

street art are decisively different in their emphasis – with often spectacular and highly accomplished art works being found in the street – so that it is everyday life – with its loose, multiple and mobile networks of meaning – that rearticulates the aesthetic's relation to the everyday (Highmore 2002) as an issue of public space and the public's sensory experience in that space. The specific attributes of street art, its situation in the street and its consequent ephemerality, suggest the significance of its physical placement as paramount, and that its deployment of public surfaces as an artistic resource differs considerably from other commercial art forms (posters, billboards, digital advertisements, for example) and certain forms of public art, which can be removed, sold and interpreted as integral objects without enduring detrimental effects to their meaning. For street artists, the city performs as a working environment and living exhibition site, so that codes for interpreting art are necessarily entwined in the particular dynamics of the urban situation. Certainly street art is enmeshed in the market economies of the art establishment, having recently stepped over institutional thresholds to enter the pre-coded arenas of galleries and museums, but its resonances in the street are subdued in such places; it cannot be transplanted to the museum without amputation of its material substrate, and the severe compromise of its meaning. As a context-dominant mode of expression, street art thus defies common disciplinary categories for thinking through art and its relationship to the social, for the object and location are so inseparable that the materiality and connotations of public space and its users are implicated in its meaning.

Turning to the site, then, the shift in Pantin's identity from a 'ville populaire' to a suburb undergoing gentrification is exemplified by the changing identities of the building where the street art project under discussion, Edifice, took place, in 2012–2014. The buildings of the Magasins Généraux (CCIP) on the right bank of the Canal de L'Ourcq, constructed in 1929, at the height of Pantin's industrial boom, served as a customs warehouse until the late 1990s, after which they were purchased by the commune from the Ville de Paris in 2004, and subsequently sold to global advertising agency BETC and real estate firm Nexity. Nexity are constructing a housing complex of 300 apartments, New Port, in the upper floors of the building, seventy of which will be reserved for social housing. BETC own the lower floors, where they will house their agency, in addition to a shopping mall and a cultural exhibition centre for contemporary art, which will open to the public in 2016. Undergoing refurbishment at the time of writing, this ruin has provided the substratum for the work of local taggers and street artists – where accomplished wild-style tags sit adjacent to amateurish sprayed scrawls – with hundreds of tags patterning its crumbling brick-work and broken windows, presenting the viewer with a palimpsest of anonymous, ephemeral writing. These qualities will be discussed below, but turning to the building first of all, we note that, unlike many other forms of architecture, ruins are ostensibly devoid of intended function, with the effect that their aesthetic qualities come into view more forcefully. In conceptualizations of the ruin, as popularized in eighteenth- and nineteenth-century neoclassical revivals, we

cling to a notion of the monument as a testament to uniqueness, a romantic gesture resonant with temporal singularity. Against this, the architecture of the *industrial ruin*, often prefabricated, spare and monotonous, intimates the monumentality of everyday repetitions inserted within macro-economic forces, a Fordist architecture dominated by functional considerations, where singularity – architecture as *arche* – is of little importance. The industrial ruin fluidly intimates the once highly encoded procession of everyday working lives, and the global processes rendering such networks of identification void. The banality of the industrial wasteland opens towards multiple repetitions, one ruined factory, looking much like another, speaks of its others, suggesting a metonymical geography of correspondences, sameness implicating each building in a flow of larger processes. Thus, the micro-processes of one particular ruin – its conception, construction, functioning, decline, dilapidation and eventual abandonment – suggest the wider macro-processes at stake in the creation and destructions of globalization and its local implications. As the substrate for the Edifice project, the ruin's broader horizons implicate street art in this common ground of experience, and in the temporal flows of everyday life in the global city.

To turn to the first interruptive quality of street art, through its material dependence on its surface, the Edifice project brings the ruin's past–present dialogue into sharp relief by its re-appropriation of the CCIP building's architectural arrangements. The artists blocked off large sections of the ruin, covering it in a brightly coloured mélange of graphics, stencils and image hybrids that could be seen from hundreds of metres away. Through the fluidity of the images across floors, windows and each other, they combine to form a dense tapestry of 'improper' uses, re-coordinating the planar logic of the building's design. As such, these art forms accentuate the monumentality of the ruin, through the reconfiguration of monumentality as public playground. As images curve around corners, ignoring floor separations and using cracks, fissures, bars and shattered cubed widows as canvases, the graphic carnival of images and their cumulative coincidence creates a vivid intersection between the meanings of pre-inscribed architectural elements – their functional lives and abandoned afterlives – and the artists' playful articulation over and amongst them in the present. Out of place in the ordered symmetry of rectangular grey concrete, out of place in their accomplishment and colouring in of the ruin's degraded surface, these images eschew the cultural wall to interrupt normative sensibilities through the materiality of their superficial (playful), surface-driven difference. The forms' inseparability from their architectural substrate and from each other calls into question the categorical borders of art as a discrete sphere of activity, to embed it in contingency. These are unresolved, unrationalizable collections of visual matter, without stated intention and definite physical boundaries, not art objects as such but, rather, processes of art, not discrete entities, but open-ended actions of 'layering and accretion' (Poyner 2013). This ruin's layered graphics attest to the presence of bodies passing through, but they do so 'under the

radar', there is no auratic artistic presence here; playful, angry and intimate, their visual creep over the decaying industrial surface suggests the accumulation of voices, a generation of anonymous urban prowlers scaling the walls of this derelict testimony to former, industrialized orders of experience in the suburbs. This, then, is a dissensual form of critical art in the Rancièrian sense: the cumulative project 'shakes up the distribution of places and competences' (Rancière 2013: 149) through its implication in the flow of the suburb's everyday existence. This is not 'political art' in the sense of an *avant-garde* committed to social change in any transparent sense. In any case, the efficacy of art is doubtful; we cannot assume that because art has a 'cause' it will, *ergo*, effect social change; there is no direct guarantee of art's communicative transmutation to action. Instead, this art effects a clash between the sensory regimes of deindustrialization and renovation on the one hand, and the articulation of micro-level aesthetic interruptions to these processes on the other. Because its aesthetic works to displace the borders that define art's traditional places, it constitutes an 'art that questions its own limits and powers' and 'refuses to anticipate its own effects' (Rancière 2013: 149), establishing itself in the transience of the present, making itself visible as an interruptive gesture that slices a fissure through the macro-political flow of globalization and gentrification and, in so doing, creates multiple vistas where processes of the production and reproduction of space are brought into view simultaneously. Street art's interdependence on the planar surface of the city opens up to a regime of visuality that materializes the different sets of relationships determining public space and, in particular, the spatialities of identities that order and experience it.

That interruption is only a momentary gesture in spaces undergoing renewal is most concretely articulated in the plans for this derelict site. Destined to re-enter the normative semiotic regime of governmental visuality, in early 2014 the wildstyle playground of the ruined depot was covered in scaffolding and netting as it was prepared to be wiped clean of its disorderly murals, tamed and returned to the smoothed-out landscapes of the canal's new marina complex (Figure 6.4). BETC's and Jung Architecture's conversion of the site into a cultural, commercial and housing space reorders the space to conform with the aesthetic encoding of glass, steel and cladding prevalent in the language of renovation, effectively smoothing out this fissured building's presence along the refurbished canal. In response to the popularity of the Edifice project (the building was part of the *journées du patrimoine/heritage days* in November 2013) and high-profile press coverage in the *Nouvel Observateur*, that lamented the building's conversion and lauded it as a 'a graffiti cathedral destined to disappear' (Cabrera and Cerdan 2013), BETC attempted to counteract any negative connotations its appropriation of the building might attract, by launching an interactive website based on the building's architecture, where users can write their own graffiti. On their website the company claim: 'Because the history of this building and the thousands of graffiti constituting its second skin are part of the identity of the Magasins Généraux, we could not

FIGURE 6.4 CCIP building undergoing renovation in 2015. Photograph by Gillian Jein.

envisage beginning its transformation before conserving all of this and making it accessible to everyone' (BETC 2014).

This website, however, fails to capture any of the sensory complexity of the ruined site. Its operation system lags, and users' tags are wiped clean when they log off. The company's concern about 'accessibility' suggests a nod to the 'longing for less regulated spaces' (Edensor 2005: 59) but locates such spaces within a highly regulated site 'of ordered disorder' (Featherstone 1991: 82). In doing so, these transpositions – from the everyday contingency of the street to the policed virtual site – ensure the seamlessness of the city while relegating more disorderly aesthetic forms to the private public sphere of the web.

The networked flows of life in the city, and the tight order of these flows at local level, leads us to the other core quality defining street art: its ephemerality, identified here as the second interruptive gesture in renewal's normative regime for viewing the city, and integrally linked to the form's dependence on the city as material resource, as discussed above. The ephemeral quality of street art is due to its embedding in the volatile constellation of activities that form the 'endless reconstitution of gathering' (Edensor 2005: 64) and dispersal that constitute life in the global city, processes made tangible in suburbs undergoing coordinated renewal such as Pantin. Street art exposes itself to everyday contingencies; during the Edifice project, the building's exterior remained unpoliced, part of the fabric of the public place. While I had to cross an expanse of derelict car park, scramble over bollards

FIGURE 6.5 Da Cruz, CCIP building, September 2013. © Agnès Gautier.

and negotiate a various mixture of plant life, stray dogs, feral cats, swans and men drinking beer from cans wrapped in brown paper bags – the lives that had encroached upon this once delimited site – the building's accessibility meant that I could touch its tags, smell fresh paint, watch as graffiti artists climbed precarious ladders, as boats of tourists sailed by on the canal, hear the crunch of gravel as people moved about the space and draw on the building with my paltry permanent marker. While several of the more well-known artists, such as Da Cruz and Popof, are recognizable by their distinct styles, the building was also awash with anonymous tags, stencils, stickers and posters from long departed and more recent visitors (Figure 6.5). On an obvious

level, this participatory openness defies the panoptic place of the gallery and museum, but in a material sense – rendered more tangible when the building's surface was cocooned in the developer's netting – the transient existence of this art brings the interruptive gesture into view as a temporal slicing through the ruin's past and immanent rehabilitation, with the effect that its forecast disappearance brings the present moment into focus. Street art exists in a visuality of the present, flanked by past and future as conceptual invocations of the lives of its substratum; its materiality testifies to the instability and possibility of everyday life at ground level. There is an embodied and affective urgency to viewing this ruin, which is less a 'viewing' in the aesthetic sense of world, and more akin to the action of visual capture. The urge to photograph, to document and preserve, is tangible here, but the sense of this mechanical insufficiency before the combined sensory experience of this ruin as playground means that visitors stand for long periods at a time, walking the perimeter again and again, as though attempting to form a memory to exceed the frame of re-presentation (Figure 6.6). Bringing the present into focus has other consequences for the viewer, however, because the volatility of this art form, the possibility for its existence, is dependent on the ruin and its inevitable disappearance through architectural renewal. The form comments materially and reflexively on the interwoven and disjunctive flows (Massey 1991; Appadurai 1996) of the suburb's local and global extensions, and, in doing so, renders the intangible transience of everyday life more palpable. A sensory interruption, then, which highlights the potential of disorderly creativity to materialize suburban experience as the

FIGURE 6.6 CCIP building with swans, September 2013. © Agnès Gautier.

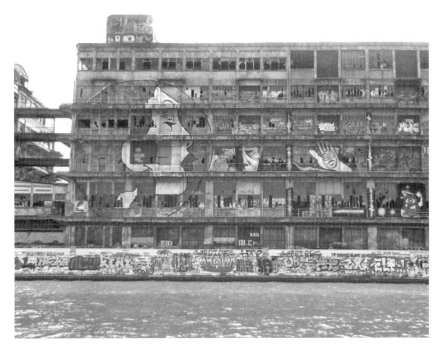

FIGURE 6.7 CCIP building, July 2013. © Gillian Jein.

participatory, playful and conflictual site of communal activity: a transient level of aesthetic experience that brings together the shared contradictory collectivities of the commons in a loose weave (Figure 6.7).

Conclusion

Finally, in this schema the everyday can be understood as a 'dimension of human experience rather than an abstract category' (Sheringham 2006: 16), a structure of human feeling that works at the level of the transient and the insubstantial – a paradoxical mode whose definition is mostly located in the way it escapes definition. The everyday has a collective dimension, but awareness of sharing the rhythms of daily life stands on the precipice of human consciousness: it is a sharing of common banalities, movements, tasks, uses, misuses and expression that are most often ignored by the police order of discursive organization, specialization and, ultimately, social separation. Street art, at its best, interrupts this police order, through its material performance of the ephemeral and aesthetic interruption of the smoothness of public architectures. It calls on the viewer to stop and look, creating pause in the flow of orderly departures and destinations that cause us very often to miss the cumulative presences that make urban space a public place. The

modalities of endotic subjectivization enacted by street art are political in their dissensual engagement of participants in the necessarily conflictual democratic activity of the *polis*, not in the sense of any conventional political ordering or rationalized manifestation, but rather as an aesthetic process understood to interrupt the frameworks of identification and classification for the political subject. This subject is the 'empty operator' that challenges the 'natural order of bodies' (Rancière 2004: 90) as distributed by governmental conceptualization of the *banlieues*, and unhinges the categories of who can enter the public arena, who can be seen there, and in what way, and who can be heard there, and with what voice. Edifice confronts us with the tensions and contradictions inherent in the public use of public space: its aesthetic alterities suggest a ground of multiplicities and possibilities where the meanings of our terms can change, where 'disorder' signals 'difference', where 'outsiders' are 'participants', where 'democracy' means 'dissensus' and where paying attention to the everyday introduces a sensory tangibility and flexibility to the orderly abstractions of grand Paris. In the fight for public space in the French capital, it is in the suburbs that such alternatives remain conceivable.

Notes

1 The primary research for this chapter was kindly funded by the British Academy and the Modern Humanities Research Association.

2 Unless otherwise stated, all translations in the text are mine.

3 The former term being preferred by the Left, with the latter designating much the same policies on the Right.

4 Article 1 of the French constitution.

5 Terms taken from Sarkozy's speeches as Minister of the Interior in 2005 at La Corneuve (cited in Hughes 2009).

7 LOOKING AT DIGITAL VISUALIZATIONS OF URBAN REDEVELOPMENT PROJECTS: DIMMING THE SCINTILLATING GLOW OF UNWORK

Gillian Rose, Monica Degen and Clare Melhuish

The urban fabric of global cities is constantly changing. And in the past few years, a new form of visualizing those changes has become commonplace. On the billboards of almost every building site, a new kind of image is appearing: a digital visualization of what that site will look like when the construction work has finished (see Figure 7.1). In particular, the iconic new buildings that no global city can now be without (Kaika 2011) are always surrounded by such visualizations on the hoardings that encircle them as they gradually rise into the city skyline. In the hustle and bustle of many big city streets, the presence of these high-definition, glossy visualizations is often striking, inviting passing pedestrians, passengers and drivers to pause and experience their high-end design, lovely weather, pretty planting, gorgeous lighting and leisured lifestyle.

Large-scale urban redevelopment projects are pictured in a panoply of visualizations, in fact, which appear in advertising aimed at real estate investors and house-buyers, on the websites of architecture offices and visualizing firms, as part of planning applications and as framed artworks in development companies' offices, as well as on building-site hoardings. To date, these digital visualizations have been given very little scholarly attention. However, it is possible to argue that they exemplify one of the key aspects of contemporary capitalism, and that they do so through their particular visual qualities, qualities that are enabled by the

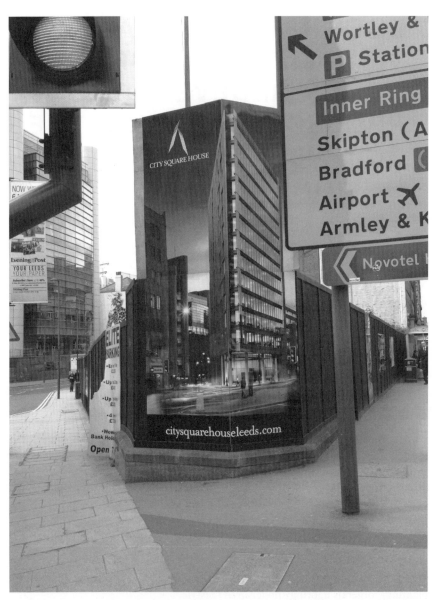

FIGURE 7.1 A billboard showing a digital visualization of a building under construction in Leeds, UK, June 2013.

possibilities of the digital technologies that create them. Several critics have argued that contemporary capitalism should be described as what Böhme (2003) calls an 'aesthetic economy' (Klingmann 2007; Lonsway 2009; Biehl-Missal and Saren 2012). Böhme argues that contemporary capitalism relies more than ever before on the aesthetics of its commodities. It is the 'aesthetics' of an object, argues Böhme,

that makes it attractive to consumers, by which he means the way that the sensory qualities of a commodity reach out and engage the (potential) consumer. Thrift has also written about the importance of such sensory seduction to contemporary capitalism, suggesting that 'everyday life becomes a cavalcade of aesthetically charged moments which can be used for profit' (Thrift 2008: 13), and digital visualizations of buildings-yet-to-be-built can be seen as one way in which everyday urban spaces are becoming 'aesthetically charged'. Böhme (1993: 72) elaborates:

> These aesthetic qualities of the commodity then develop into an autonomous value, because they play a role for the customer not just in the context of exchange but also in that of use ... they form, as it were, a new type of use value, which derives from their exchange value in so far as use is made of their attractiveness, their aura, their atmosphere. They serve to stage, costume and intensify life.

It could be argued, then, that digital visualizations of new urban developments serve to 'stage, costume and intensify' particular, sensorily seductive, atmospheric visions of urban life, in order to sell them.

The first section of this chapter will argue that this is indeed the case. Using a case study of a large urban redevelopment project in Doha, Qatar, we will argue that digital visualizations do emphasize the atmosphere, and by extension the attractiveness, of new buildings and spaces. The redevelopment project in question covers a 31-hectare site in central Doha, and is called Msheireb Downtown. The design of Msheireb Downtown began in 2008; construction started in 2010 and is scheduled to finish in 2016 at a cost of €4.18 billion. The developer is Msheireb Properties, a company owned by the Qatar Foundation. The concept master plan was produced by AECOM, and AECOM, with Arup and London architects Allies and Morrison, drew up the detailed master plan. There is a further range of site-wide and executive consultants with specific responsibilities, coordinated by the Master Development Consultants (MDC) team. Nine design architects were chosen to design the hundred or so buildings on the site. A partner at Allies and Morrison was appointed to the project as the Architectural Language Advisor (ALA), who was a particularly enthusiastic advocate of the project's digital visualizations as a means of cohering the project's different components into 'something one wants on the cover of a magazine'. This was particularly important in the early stages of the project, when the developer insisted that the various schemes proposed by the individual design architects should cohere into an attractive overall design. The visualizations were initially created to do just that; they were a means of integrating the different buildings into a pleasing whole, to persuade Msheireb Properties to invest in the project. The MDC manager summed up the role that the images played when he said that they were intended to show 'how that place will look and feel'. Visualizations, then, were crucial to gaining the necessary investment in Msheireb Downtown, and their atmosphere was key to that achievement.[1]

It is also the case, of course, that in visualizing the buildings in an 'atmospheric' way, the digital visualizations rendered various other aspects of this redevelopment project invisible. The selectivity of place marketing images – which is the genre of visual image these visualizations most resemble – has long been recognized by a wide range of scholars. Digital visualizations have been described as 'a key marketing strategy' (Kaika 2011: 985), whose role, like any other advertising imagery, is to 'affectively allure' investors into buying property (Jackson and della Dora 2011: 295). In the process, any number of omissions are made. Like all place marketing images, digital visualizations never picture the labour associated with urban redevelopment projects, for example, neither the labour that goes into building them, nor the labour that their offices, apartments and shops will house. The visualizations do not show the wider economic processes and relations of the investment in them. Nor do they show a very wide range of social activities going on in the new spaces being built. Nothing much happens in these sunny spaces except the leisured and happy strolling, shopping and sipping of coffee by apparently affluent inhabitants.

There seems to be, then, a need to critique these visualizations. Their proffered interruptions to the fast everyday rhythms of city dwellers – these still and quiet images of beautiful buildings, beautiful weather, beautiful people – need to be interrupted in turn. But how? Well, many, perhaps most, of the pedestrians, passengers and drivers who encounter these visualizations are so used to seeing them, and so familiar with the ploys of advertisers, that they no longer pay them any attention, if they ever did. More interventionist strategies are also possible, though, and this chapter explores several.

Understanding how these interventions – or interruptions – work, requires knowledge of what sort of images digital visualizations are and exactly how they 'stage, costume and intensify' urban life. The first section of the chapter therefore discusses how and why these visualizations are made, and identifies three key characteristics that are complicit with their selling of urban redevelopment: their visual content, their seductive atmosphere and their erasure of any visible signs of labour. The chapter then discusses the ways in which each of these three characteristics has been challenged by a range of different tactics, from art photography to blogging to a sort of graffiti.

What sort of image is a digital visualization?

Digital visualizations are a relatively new form of image, and this is reflected in the diversity of ways of naming them. They can be called 'renders', which is an existing term used by architects to describe any kind of picturing of a building design; they

can be called 'computer-generated images'; they can be called an 'artist's impression'; they were even described as 'photographs' for a long time in the architecture columns of the *Guardian* newspaper, before it settled on 'architectural visualization'. Call them what you like (apart from photographs, which they patently are not); as a new kind of image, it is necessary to spend a little time considering what sort of image they are. One way to do this is to understand how they are made. (This was the basis of the case study on which this chapter draws; the production of Msheireb Downtown's visualizations was observed, and interviews were also undertaken with architects, visualizers, representatives of Msheireb Properties and with the ALA.)

A digital visualization of a new urban development like Msheireb Downtown usually starts life as a file generated by the Computer Aided Design (CAD) software, used by a team of architects to design a building. That file is then sent to a visualizer and imported into a visualization software package such as, in this case, 3DS Max.[2] The architect and the visualizer may be part of the same architectural firm, or the visualizer may work for a separate company specializing in visualization. The visualizer begins work on the CAD file by stripping out a lot of the architect's design details, which leaves something on his screen that looks like a wire-framed model. He then specifies the precise location of the building and a date and time, both of which dictate the direction and angle of sunlight in the eventual visualization, and starts to add layers of colours, materials and textures to the model (which can still be manipulated in three dimensions on the visualizer's screen). To check on the results of this work, the file is sent to be 'rendered': that is, to be converted from a working image to something that looks more like a 'picture'. The file then returns to the visualizer for more work.

Once the building itself is looking good in 3DS Max, the file is imported into another software package, usually Photoshop, to be worked up still further as a 2D image. At this point, the visualizer will insert visually complex elements into the visualization – the sky, perhaps, trees and very often people – by pasting photographs into the visualization (Houdart 2008). The photographs will be sourced either from a library of photos that the architecture or visualizing company will have built up for this purpose, or from a number of online, commercial image banks.

At one level, then, a digital visualization of an urban redevelopment project is highly accurate. The buildings are developed directly from the architect's original design, and many other elements of the visualization have the same realism as a photograph. However, the image nonetheless offers a very particular sensory/aesthetic vision of urban life, as we have already noted: leisured, sunny, attractive. Moreover, as Houdart (2008) notes, the content relies on the photographic images at the visualizer's disposal. This created a problem for the visualizers working to create images of Msheireb Downtown, because neither their own image banks nor the commercial ones carried anywhere near enough photographs of people dressed in Qatari clothing. One solution they deployed was to search the online

photo-sharing website Flickr for holiday snaps taken in Qatar that they could cannibalize. Another was to create their own. Thus one of us found ourselves in a large warehouse in London on a cold November morning in 2012, at a photo-shoot organized by the studio who had been tasked to rework some of the forty-two visualizations to bring them up to date, witnessing a quite literal 'staging and costuming' of urban life. Three photographers were taking shots of individuals who had been recruited through a film extras agency in London and costumed in what the visualizers thought were Qatari-looking clothes (actually bought from Asian stores in Southall, a London suburb). These film extras were photographed doing the kinds of things that constituted the particular sort of urban lifestyle that the visualizers and developer wanted to show in the visualizations: chatting with each other, having fun with their children, carrying lots of shopping bags, sitting down at café tables and strolling around, and the photographs were later pasted into the revised visualizations.

Digital visualizations are thus made to picture a specific range of activities. These particular activities were part of the effort to convey the 'atmosphere' of this redevelopment project. But a great deal of work also went into making the Msheireb Downtown visualizations look atmospheric and glamorous in more affective ways, *pace* Bohme and Thrift (Degen, Melhuish and Rose, forthcoming). In particular, most of the visualizations that were created to persuade Msheireb Properties to invest in the redevelopment, and which then became the first 'marketing' images for the project, used quite striking light effects. Just as a lot of care was taken to ensure that sufficient numbers of the people who appeared in the visualizations looked Qatari, so too care was taken to capture the distinctive quality of light in Qatar: a little dusty, slightly hazy.

But light is in fact the basic element of the 3DS Max visualization software. As we have already noted, one of the very first things a visualizer does when he or she starts to work on a visualization of a new building is to locate the building in physical space using the software's inbuilt Geographical Positioning System, and to specify a date and a time of day. The software then automatically recreates how the sun's rays would fall on the building at that place and time. The visualizer then goes to work with that basic information about how light and shadow will work in the final image, in this case adding a whole range of other light effects too: the flare of the sun high in the sky; the glow of lights at dusk; fireworks at night; shafts of sunlight falling into courtyards, mosques and shopping malls. Light is used to create a jewel-like intensity and add a glow to the colours of the visualizations. All of this is best seen on screens, of course, and many contemporary uses of a range of digital visualization software for a wide range of purposes rely on an extensive visual vocabulary of light effects (Dorrian 2008): dazzle, glint, glow, twinkle, glare, glimmer, haze, shadow . . .

So, in both their content and in their atmosphere, these visualizations use digital methods to intensify the urban spaces they are picturing. The final aspect of their

digitality is what Galloway (2012: 25) calls the 'glow of unwork'. Galloway uses this term in the context of his discussion of digital interfaces. An 'interface' is the 'point of contact at which different bodily or machinic systems meet' (Gane and Beer 2008: 53). In digital studies, use of the term is often restricted to the relation between a human and a digital device. As Galloway (2012) points out, interfaces are designed to be invisible and unremarkable. The best touch screens, for example, are so responsive to fingers that they are no longer noticed when they are used; which means that, if the work done at an interface to make it work is effective, then, paradoxically, it appears as if no work is taking place. This is what he calls 'the glow of unwork'. While digital visualizations on billboards are obviously not digital devices, we have argued elsewhere that there are good reasons for nonetheless conceiving of them as interfaces (Rose, Degen and Melhuish 2014), and that part of their glamorous atmosphere derives from the glow of unwork that permeates them. Like movie special effects and computer games, digital visualizations seem almost magical in their ability to show, in a quasi-realistic visual language, something that does not exist. In their seamless mix of photorealistic elements, the work that has gone into making them disappears entirely.

So, the digital visualizations that litter global cities are complex image forms, and when thinking about interrupting their efforts to sell very specific versions of urban life, we need to consider three components in particular: their visible content, their affective atmosphere and their erasure of their processes of production. All three of these offer different possibilities for interrupting the visions of urban futures that these digital visualizations carry. The next three sections sketch three different kinds of interruption: resisting, deglamourizing and networking.

Interruption 1: resisting

The form of interruption that we call 'resisting' engages very directly with the visual content of digital visualizations of urban redevelopment projects. It takes up their invitation to be looked at, and it looks at them closely; closely enough to ask certain kinds of questions about what is being shown. Let's look at three examples.

On a visit to London in December 2013, one of us noticed a small addition to the visualizations on the hoardings surrounding the Leadenhall Building, one of the new generation of high-rise office blocks currently changing London's skyline (see Figure 7.2). Stuck next to one of the figures strolling through the visualization's foreground space was a speech bubble that asked 'do YOU wish you could skateboard?'. This small and polite question nonetheless very directly challenges the limited range of activities shown in most digital visualizations.

Our second example was reported in the London newspaper the *Evening Standard* in July 2013 and articulated its resistance more directly. Two visualizations had been created to show the finished redevelopment of Narrow Way in Hackney,

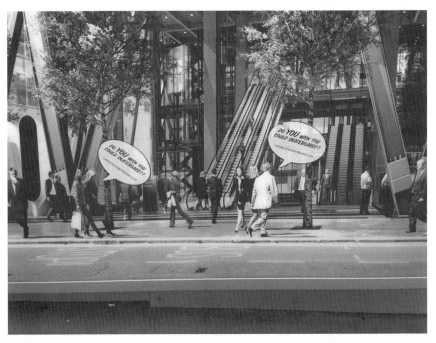

FIGURE 7.2 Stickers on a visualization of the Leadenhall Building in London, December 2013.

a super-diverse area of east London. The first visualization had gone up on the local council's website, and had then been criticized by local black and ethnic minority activists for showing the street 'inhabited almost entirely by young white people'. To the activists, this implied that redevelopment projects were created to attract white gentrifiers rather than for the existing residents, and they concluded that the visualization 'whitewashed' Hackney's future. As a result, the council removed the visualization from its website and replaced it with another, with a more appropriate range of figures Photoshopped in.

The third example is an equally trenchant challenge to a visualization, this time of a much larger redevelopment project called Greenpoint, in New York. In August 2013, the *New York Times* reported that a local pressure group, Save Greenpoint, had created their own digital visualization to counter one produced by the architect's office. 'The [visualizations] presented to us at community meetings were coated in a gloss of trees and leaves and flowers, and translucent towers blending into the sky,' a group member was reported as saying. (Note here the attention given to the particular light effects in this visualization – gloss, translucence – which have the effect of diminishing the presence of the buildings.) The group's visualization, in contrast, showed 'swollen and clearly exaggerated buildings the colour of sickly flamingos loom[ing] over a diminished Manhattan skyline,

threatening to swallow their neighbors in a gluttonous fit', according to the *New York Times*. Exaggerated they may have been, but, according to Save Greenpoint, the point was 'to express the brutality' of the redevelopment plan, not make a more realistic image.

In this form of interruption, then, the efforts to make a digital visualization of an urban redevelopment project atmospheric and attractive work, but with unintended consequences. In all of these examples, careful attention has indeed been given to the content of digital visualizations, but that content has then been challenged. More precisely, what is challenged are the values implicit in that content. This is particularly clear in the second and third examples, where what was important about the visualizations was how they were showing 'whitewashing' and 'brutality'. What is happening here is not a challenge to the visualization's visual accuracy, then, but rather to the social relations implicit in the urbanism it is picturing, and this is true of the inserted question about skateboarding too (Yaneva 2009). And of course, given how digital visualizations are created, demands for more 'accurate' or 'realistic' visualizations are indeed difficult to make: what can be a more accurate basis for a visualization of a building than the architect's plans for it? Instead, this form of interruption resists visualizations by explicitly refusing to agree to the social relations scripted in the images.

Interruption 2: deglamourizing

The second form of interruption focuses less on the visual content of digital visualizations of urban redevelopment projects and what it represents, and more on their affective atmosphere. We have already discussed how important it is to these visualizations that they convey glamour and atmosphere. Another way to interrupt their very particular picturing of new urban spaces, therefore, is to locate visualizations whose glamour is in some way defective, and then to share that deglamourization with various audiences.

This has been the object of at least two artists' projects, both of which explore what happens when digital visualizations are materialized as images on hoardings in city streets. Rut Blees Luxemburg has created large-scale photographs of visualizations of a proposed tower in Bishopsgate, London.[3] Many of her photos play with how various kinds of light fall on their hoarding, thus emphasizing the way the visualizations offer a backdrop to the staging of urban life. The photographs, however, also stare close up at the surface of the visualizations, in order to show how 'dust unmasks the fantasy of the visualization once it is placed in the public territories of the city. The visualization becomes hostage to the materiality of the city, which very quickly covers the images with dust, dirt, pollution. So the visualization's smooth surface becomes stained' (Luxemburg 2014), and Luxemburg's photographs emphasize that staining. Her work thus captures and displays the failure of these visualizations to project their atmosphere in city streets. In similar

fashion, Randa Mirza in her project Beirutopia takes photographs of digital visualizations on billboards and hoardings, but carefully includes signs of their specific urban locations in her photograph – tatty roads and bashed-up cars, real bits of trees and cars and scooters – as well as photographing billboards with their visualizations torn and sagging.[4] The smooth and glossy surfaces of visualizations materialized in urban spaces is interrupted this time by the recording of their physical deterioration and damage. Mirza not only shows these in galleries but has also installed them in Beirut's streets, taking these photographic mementoes of unglamorous visualizations back into urban spaces, extending the reach of her photographs' urban commentary.

A different method for interrupting the smoothness of digital visualizations also focuses on their materiality, but this time on their materiality as Photoshopped images. We earlier noted that the human figures in most digital visualizations are created by inserting photographs of people into the visualization using Photoshop. Digital activist James Bridle has explored some of the consequences of this method in his Flickr album of 'render ghosts'.[5] He creates digital images of visualizations, crops them so that each image contains only individual people or small groups, and then enlarges the image. In that process, what become visible are two things. First, the enlargement process makes visible the often rather inaccurate way in which the human figure was extracted from its original photograph; bits of the original background become visible, as do places where small parts of the figures have been sliced off. Second, the way in which these figures have been cut-and-pasted into a visualization becomes much more visible. It becomes more obvious that they are not pictured by the same light source as the visualization; that they are doing something with something or someone no longer visible; that they are looking intently at, in the visualization, nothing; that their digital resolution is not the same as the visualization; that they have no shadow. These close-up views of the figures in visualizations diminish their glamour considerably, not only by making them look rather less seamless and glossy, but also by infecting their glamour with what can only be described as a rather disconcerting weirdness. 'Ghosts' is a term well-chosen by Bridle; these are figures oddly out of place, precisely not at all at home in the urban space the visualization is attempting to make so desirable.

Crystal Bennes does something similar.[6] She also collects examples of digital visualizations, by photographing them on billboards and hoardings, and collates them on her blog. However, rather than emphasize the oddness of the visualizations, she focuses on the text that accompanies them. That text is there to sell the development, and it often uses a particular form of marketing-speak that, when multiplied on Bennes' blog, moves from the hyperbolic to the absurd.

Although these various examples use different methods, all share a concern to focus on the materiality of the visualizations as they appear in urban spaces, in order to interrupt their glamorous presence there. Their seductive atmospheres are

not always sustained, as hoardings fade and tear, as dust covers them and parked cars obscure them, and as the words that accompany them tip into absurdity. Their glow does not always project into urban spaces, and all these examples identify and record that failure. All also amplify that failure by displaying photographic records of it, whether in galleries, in streets or on online image-sharing platforms.

Interruption 3: networking

A third tactic of interruption focuses on the 'glow of unwork' that surrounds digital visualizations' near-magical picturing of urban scenes not-yet-built. This tactic is about conceptualizing these images precisely as sites of work, and thus attempts to see them differently. Making visible the labour that goes into the making of a digital visualization disrupts its magical quality of somehow showing, in a more or less real-looking way, what does not exist.

This third tactic is one that emerged as we studied the digital visualizations created to picture the Msheireb Downtown project. What we realized very quickly as we observed the production process of those visualizations was that their creation is a highly complex, iterative process that involves a range of actors. At various points in the process of creating a visualization, the visualizer will have sent the file back to the architect for viewing and feedback on their work; this might happen several times. If the design of the building being visualized changes (which it often did in our case study), the visualizer has to incorporate that too. In our case study, the ALA also commented on the visualizations; when he was satisfied, the visualizations were sent to Doha for comments from the developer, the project management team, other consultants and (sometimes) the architects again, as part of the ongoing process of designing the development.

So visualizations are a result of discussion and negotiation between lots of different actors, and here we can start to see how looking at the labour of making them can interrupt their aura of non-work. Because not all of these actors necessarily agree on what the finished visualization should look like. A digital visualization of an urban redevelopment project is the result of discussion and debate between the architect, the visualizer and the developer, in the context of any planning or advertising regulations that the visualizations also have to conform to. Throughout the Msheireb Downtown project, there were tensions between the architects, the MDC, the ALA, the developer and visualizers, who all wanted different kinds of images, which would do different things by looking different. The developer rejected visualizations that did not look adequately Qatari. Neither the architects nor the ALA liked the marketing 'hero shot'; the architects tended to be much more fascinated by what one called 'the backstreet world'. Both the architects and the MDC were also uncomfortable with the sorts of visualizations made for the client, both as part of the pitch and as part of the design process. They were 'one sided', according to a MDC interviewee: good at 'engaging people' but not so useful for

design work because they often show 'things that lead to inappropriate discussions'. Another architect explained, 'people tend not to look at the architecture but at the image and make decisions based on liking or not liking the image'. And a visualizer pointed to another tension, between his desire to produce a beautiful, well-composed image and the architects' desire to show the details of their buildings, which he felt led to his views on how the image should look being 'slightly hijacked'.

This process of production, circulation, comment and revision can be understood, following Actor Network Theory, in terms of a network (Rose et al. 2014). Understanding visualizations as circulating among a network of actors enables several insights into the production of visualizations. For example, it emphasizes the mobility of these images. As image files, they travelled between architects and visualizers in Europe and the USA, the client and ALA in Doha, and render farms in China where they could be processed much faster and more cheaply than by servers elsewhere. Most accounts of such global networks emphasize their flow and their speed. Following Law's (2002) account of networks, however, it is also necessary to emphasize the work that has to be done to maintain that mobility. Using this notion of net*work* thus conceptualizes the work in a network in a double sense: the network both carries the work done by visualizers, and requires work itself, for that carrying to function.

So, given those disagreements about what the visualizations should look like, the MDC eventually had to set up a clear system for ensuring that all the various comments on an individual visualization were both collated and then coordinated, with 'master comments' sent directly to the architects, who, then, could not ignore them. As one architect told us, 'there was a hierarchy to the comments ... [the client's] were the most important ... [the MDC manager's] were kind of the second most important. And, you know, [laughing] then there was sort of [the ALA] was somewhere way up there. And, you know, my comments were sort of, you know, scraping the ground somewhere'. And there were many other examples of work having to be done to enable the circulation of these visualizations through the network of actors involved in the creation of Msheireb Downtown. For instance, the MDC team had to set up a cloud system for storing all the various versions of the visualizations as they were being worked on, as well as protocols for naming files and for their technical specifications (so that, for example, the various CAD models for buildings that had been designed separately could be integrated into single visualizations to evaluate their integration).

What examining the labour of creating these visualizations suggests is that they are far from being near-magical, seamless, pristine images of glossy urban futures. Instead, they are rather more like sites of debate and disagreement, which shift and change as different designs are inputted, different sorts of views desired, and different sorts of audiences anticipated. And if they could be seen like that, the seamless views of urban living that they offer could also be challenged, by being seen as networked.

James Bridle's render ghosts can also be seen as exemplifying this tactic; as well as deglamourizing visualizations by suggesting that their inhabitants are spectrally out of place, his close-ups of the human figures also make visible traces of the digital cut-and-paste operation that inserted them into the visualization by a visualizer toiling at their screen. Our research project tried different methods of revisualizing these images, by placing them in their networks. One was to write about them as networked interfaces rather than as images (Rose et al. 2014). The other was to design an exhibition that, in its layout, attempted to fragment and disperse these visualizations. The exhibition took place at the Building Centre in London in August 2013 (see Figure 7.3).[7] It consisted of a series of frames over which were stretched panels of semi-permeable banner fabric; the panels had various combinations of solid colour, images and text printed on them. The fabric suggested the pixilation through which these visualizations are created and so often seen, thus focusing attention on their digital production. The panels divided the exhibition space into seven linked areas, each of which addressed one aspect of the various kinds of work that are done to create the visualizations. And the visualizations themselves were scattered across these panels, all but one of them either embedded among many other images or printed across – broken up by – two panels. All these design elements were intended to help visitors to the exhibition see the work that is done to make these images, and to embed that work

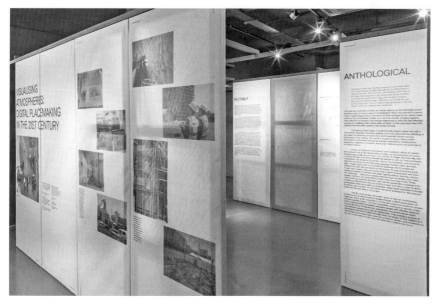

FIGURE 7.3 A view of the exhibition 'Architectural Atmospheres: Digital Placemaking in the Twenty-first Century', held at the Building Centre in London in August 2013. Photograph courtesy of Pete Landers.

within the image itself. We also wrote a booklet to accompany the exhibition that made its intentions explicit.

So this is a final critical tactic, then: challenging digital visualizations of urban redevelopment projects by understanding how these images are produced, and embedding that production into how they are seen. Because these visualizations do not have to be seen as dazzling spectacles. They can also be seen as objects crafted by people labouring to get a job done. And if some people have laboured to visualize an urban future one way, then, at least in principle, it is possible to imagine labour that would make very different visualizations of urban futures.

Conclusion

Digital visualizations of buildings not yet built are highly selective in what they show, and quite particular in how they show it. They show the designs of buildings and urban spaces in, quite literally, their best light: inhabited by relaxed shoppers and strollers, bathed in lovely weather and gorgeous dazzle and glow. This chapter has argued that in order to challenge that selectivity, it is necessary to understand what sort of images these visualizations are and how they work to sell their visions. In that context, the chapter has identified three key characteristics of these images – the selectivity of their content, their atmosphere and their glow of un-work – and has described a range of examples of each of these elements being challenged.

Each of these examples is different from the other, and not only because they interrupt digital visualizations in different ways, by resisting their forms of urban life, by deglamourizing their seductive affects or by seeing the visualizations as networked. In particular, they deploy different strategies to intervene in the complex circuits of contemporary visual culture in order to make their challenges to digital visualizations on building-site hoardings. Several used the space of an exhibition to display versions of visualizations that deglamourized visualizations, or that made visible the network (and its labour) on which their production depends. In resisting, deglamourizing and networking visualization, other means can also be deployed to make and share that critique: academic writing, blogs, Flickr albums, stickers, media coverage. What this suggests is that many of those pedestrians, passengers and drivers who notice digital visualizations in global cities do in fact take up their invitation to pause and enjoy them. It also makes very clear, however, that enjoyment is not necessarily what follows. Critique can also develop, and articulating and sharing that critique can take a wide range of forms.

Finally, though, we should not forget the fear that haunts the visualizations themselves: that they might actually be taken seriously as accurate pictures of what you will get if you buy one of the penthouse views they so love to show, with its dusk-time view over a twinkling global city centre. On many visualizations now,

you will find, in small print in a dark corner, the words 'Computer Generated Image is indicative only'. Quite.

Acknowledgements

Thanks to Keith Harris, Christoph Lindner, Joel McKim and Olga Smith, who suggested some of the examples of interruptions discussed in this chapter. We are grateful to Msheireb Properties for giving us access to their Msheireb Downtown project, and to all the architects, designers and managers who allowed us to observe and interview them; the project was funded by a grant from the UK Economic and Social Research Council RES-062-23-3305.

Notes

1 The Msheireb Downtown visualizations can be viewed on the developer's website: http://mdd.msheireb.com/default.aspx

2 Some CAD packages – Rhino in particular – allow architects to work in 3D from the start of the design process. In this case, there is no transition between the design and visualization software.

3 http://chandelierprojects.com/London-Dust-Rut-Blees-Luxemburg-and-Keef-Winter-March-April-2014 (accessed 1 September 2014).

4 http://randamirza.com/beirutopia.html (accessed 1 September 2014).

5 https://www.flickr.com/photos/stml/sets/72157626849497838/ (accessed 1 September 2014).

6 http://developmentaesthetics.tumblr.com/ (accessed 1 September 2014).

7 The exhibition was designed in collaboration with Studio DA, London.

8 'HERE WE ARE NOW': AMSTERDAM'S NORTH–SOUTH METRO LINE AND THE EMERGENCE OF A NETWORKED PUBLIC

Ginette Verstraete

This chapter can be situated in what has been termed 'the mobility paradigm' in the social sciences and the humanities.[1] This theoretical paradigm has started from the observation that with the increase of global transport and communication technologies since the 1980s, the movement of people, goods, ideas and information has grown exponentially. More people, things and cultural ideas are on the move, and they travel increasingly faster, and across greater distances. This observation has resulted in different ways of thinking about society, culture and identity as mobile, nomadic, displaced and connected, rather than rooted in one nation, place, family, language and so on. Hence the need for studying mobility through a new paradigm that inherently crosses traditional disciplinary boundaries.

What is typical of this 'mobility turn' is that it studies the various movements not in an abstract, disconnected way, but in close relation to the different material and symbolic contexts within which these movements happen: the actual places travelled through; the infrastructures of mobility and communication used; the centres of power and money instigating movement of people and financial flows; the marginalized places and people excluded from mobility; and crucial to the humanities – the images and discourses used to legitimate certain kinds of movement (e.g. tourists) while interrupting others (e.g. migrants). In other words, what has come to be known as 'mobility studies' focuses on the complex dynamics between movement, places, technologies and social subjects and the images,

symbols and words that give them meaning. In the humanities this interdisciplinary approach to mobility has generated exciting connections between cultural and media studies, geography, sociology, anthropology, art and architecture.

This chapter focuses on one highly mediated infrastructure of mobility in particular, the Amsterdam underground, and continues a previous study of the association between the building of the first – very disruptive – metro line in the eastern part of Amsterdam, in the 1970s, and the resistance movements that erupted in opposition to this, including the role that their magazines, posters, photographs, films and monumental art works played in channelling the citizens' protests (Verstraete 2013). The current discussion proceeds deeper into present-day affairs and pays more attention to the role of the Internet and of social media as ways of managing protests and controlling interruptions. Large-scale street-level havoc for the sake of building a new North–South metro line has hit the city of Amsterdam in the last decade, and will continue to do so at least until 2017. In an attempt to counter criticism and make the noisy delays and economic setbacks acceptable to neighbours and passers-by, officials have relied on a whole range of visual interventions. Interestingly, concurrent with the progression of the metro line, the lines of communication and mediation have also changed: not only has digital connectivity appeared at the centre, but portable devices such as laptops, iPhones and tablets have offered non-stop access to Internet and interactive Web 2.0 applications such as Facebook, YouTube and Twitter. In many ways, the recent history of the North–South metro line runs parallel to the growing success of these and other social media platforms, both in the Netherlands and globally. Between 2007 and 2012, the amount of users over 15 years old has grown from 6 to 82 per cent: 'Within less than a decade, a new infrastructure for online sociality and creativity has emerged' (Van Dijck 2013: 4). These social sites have begun to penetrate our everyday lives to such an extent that the worlds of offline and online are hard to separate. Due to the rapid success of social media platforms among all kinds of users, many corporations, governmental agencies and activist groups have incorporated them for communication, networking and product-placement. I will demonstrate that the North–South line also started to integrate these global developments after 2010, in its search to win back trust from the citizens of Amsterdam.

Studying transportation networks side by side with media networks in this way is not particularly new. Ever since Raymond Williams (1974) developed the notion of 'mobile privatization' to describe how the success of mobile television sets in the home grew alongside other technologies of private mobility (notably cars) transporting citizens back and forth between cities (the space of work and commerce) and suburbia (the space of living and home entertainment), several authors have underscored the intersections between mobility, place and media, and the importance of a spatial-materialist understanding of media formations in particular (Hay 2012; Ross 2004; Couldry and McCarthy 2004). While clearly

indebted to the important work done in this field, this chapter will not reference it explicitly. The convergence between media, mobility and space at work in the case of the Amsterdam Metro fits larger developments elsewhere, but also constitutes a particular field of forces with a complex genealogy of its own, which will be addressed in this article.

This is a contribution in three parts. Upon reviewing the history of the building of Amsterdam's North–South metro line until the present day, the chapter discusses the way in which the Dienst Metro (the Municipal Office in charge of all metro lines in the city) has responded cleverly to the recent drawbacks, through the use of visual markers in urban space, as well as the Internet and social media. Two of the officially used spatial metaphors help us to unpack this carefully crafted change in communication: 'From tunnel vision to open house' and 'Here we are now!' I will argue that the post-2010 focus on openness and offline/online friendly visibility in public space has improved the metro line's current reputation, and has enhanced a certain acceptance by the public. In many ways this strategy boils down to repeating age-old problems by newer means of communication: by using a top-down infrastructure-led mindset, the city of Amsterdam has failed to truly engage its citizens. Simple information feedback hosted by the Dienst Metro – using commercial channels such as Google, Twitter and Facebook – and streamlined 'pop up' visibility or entertainment may contribute to impressions of transparency and accessibility, and even garner instant public support, but they do not lead to improving citizen engagement *vis-à-vis* this contested long-term urban disruption. Hence in the closing, third part of this chapter I will show that what is needed is a public support that holds up in times of (permanent) crises. In contrast to the clean superimpositions of real and virtual spaces implemented by officials, I will defend heterogeneous networked publics. In line with the central theme of this book, interruption in this chapter becomes an occasion for a sustained inquiry into the limits of transparent communication and representation in a networked world. Thinking with interruption allows me to draw together a variety of visual interventions in public space that attest as much to connection as to disconnection and discontinuity. As to the topic of globalization, the metro line's narratives of growth and speed, the use of the Internet, the unacknowledged import of Eastern European labour and the impact of the financial-economic crisis of 2008 all attest to the global dimensions of this local story.

Lessons from the past

The plans for building a North–South metro line underneath the historic city of Amsterdam date from the 1950s, when the Municipality of Amsterdam first ordered the installation of a Committee of Transport charged with investigating how the city could be made more hospitable to car traffic and other transportation

modes, thus opening up the poverty-stricken inner city to economic development in the whole region. In 1963, a Bureau for City Rails (Bureau Stadsspoorweg) was set up that specifically investigated the possibility of an underground metro line, and upon the publication of several of its reports a press conference was held in 1966 in which a network of four rails was presented to the public, one of which ran to the east of Amsterdam, from Central Station to Bijlmermeer, and another that ran from northern Amsterdam to Amstelveen in the south. Two years later these plans were officially accepted by the Municipal Council and became a political reality, despite growing citizens' protests against the financial and social costs, and in 1970 the building of the Eastern line took off. By the time the first part of this first line was put into use in 1977, the project had accrued so many social, financial and political disasters – and so much violent resistance against the demolition of neighbourhoods and eviction of people – that the original plans were withdrawn and the other three lines (including the North–South line) were postponed indefinitely. Only the Eastern line was completed. As argued previously, because of the immense publicity given to the social and political unrest on television, in newspapers and through activist urban and media performances, the Amsterdam 'metro' had been made taboo by the late 1970s to the extent that the word itself was banned from public discourse.[2]

Hardly surprising, then, that when alderman Ernst Bakker presented the Municipality's plans for finishing the North–South line to a journalist, twenty years later, his communication with the press staged the role of an underdog explaining that courage is needed to talk about the Amsterdam 'metro' once again (Davids 2000). Rather than firmly presenting a top-down decision taken by the City of Amsterdam, as was the case in the 1960s, a critical public needed to be charmed into accepting a difficult resolution about a building project that supposedly could still develop in different directions but would definitely contain eight new metro stations, and run from north of the harbour to the business district in the south, underneath the IJ harbour, the old Central Station and the beautiful canals with their picturesque seventeenth-century houses and gables. The goals were said to be the relief of traffic jams caused by cars and trams, linking the inner city of Amsterdam to the whole region of North-Holland and Schiphol airport in particular, and transporting a (hopefully) growing population back and forth between their suburban homes and downtown offices and stores smoothly, ten minutes faster than the controversial Eastern line. But as my MA student Eric Rutgrink (2014) has stated:

> Who actually stands to gain most from this new transport link? The Zuidas, as a rapidly developing business district in Amsterdam south, is home to the headquarters of large multinationals such as ING Group, ABN-Amro, and Akzo Nobel, while the north is still very much a working class residential zone; the south has the highest average income per household and the north almost

the lowest, and when assessing employment statistics, the south proves more economically significant for Amsterdam than even its central region. What this suggests, is that the rationale for the scheme, while claiming to support socio-economic development in all regions of Amsterdam, is needing to balance global capitalist interests at one end of the track, with local urban development on the other.

RUTGRINK 2014: 63

From now onwards, the management of this difficult urban infrastructure would first be kept underground, far from public view, and later be integrated in various offline and online communication strategies, including a host of 'pop-up' markers and interventions that led to extreme visibility on the Internet and in the city, but failed to establish urban renewal as a means of empowering public participation, as will be discussed further below.

The first important step in creating public support for the plans was complying with a local referendum in 1997 about the projected 9 kilometres of rail – with 6 kilometres subsurface – which were promised to be finished in 2008, cost 800 million euros (with 95 per cent of all financial risks covered by the State), and would avoid social turbulence and urban disruption during the construction since, in contrast to the 1970s' project, tunnelling would happen 20 to 30 metres below the surface, by means of a superior tunnel-boring technology that reduced safety risks to a minimum.[3] While the claims were optimistic, the people were not, and 65 per cent of the voters said no. Luckily for the politicians and engineers the overall turnout of ballots was exceptionally low, hence the referendum was deemed invalid, and the North–South line was accepted by the City Council soon after. When in April 2003 all the public contracts were finally signed and the work could officially start at last, the costs were already estimated as high as 1.4 billion euros. By then it had also become clear that the national government would finance the project only with a fixed lump sum not covering possible risks and overspending (to be paid by the City government), the early drilling tests delivered questionable results, and the deadline of 2008 was considered unrealistic. Planned date of completion: 2011.

Not only did the enterprise thus start under an exceptionally weak licence to operate due to the failed referendum, the broken promises and a collective memory of the traumatic Eastern line, but the resistance was alive and kicking from the start and increased as the financial, social, political and urban costs totalled up, albeit with little effect. As early as 1995 *Wijkcentrum d'Oude Stadt* published a critical analysis of the plans, in which many of the conditions and reasons for the new metro line were interrogated, and alternative transport networks above ground suggested (*Metropijn*). Similarly, *Platform Metro* – an umbrella group of inhabitants and organizations in Amsterdam contesting the subway and responsible for the referendum above – organized a conference in the RAI Convention Center

in 1996, in which a light rail system in the streets of the city modelled after Manchester, Milan and other European mid-size cities was proposed (Van Den Berg 1995). One year later, *Stichting de Bovengrondse* tried to prevent the plans for underground digging on legal grounds, but their lawsuit never succeeded. A crucial role in the debate prior to and during the construction was played by the local Amsterdam newspaper *Het Parool*, publishing many critical articles and columns pro and contra by a variety of intellectuals, politicians and activists. One of its journalists, Bas Soetenhorst, analysed the internal political bickering in the City Council, the financial and organizational mismanagement of the first phases of the project and the pressures exerted on the actual routes of the metro line by particular civil servants, enterprises and wealthy citizens whose interests were deemed more important than the ideals of accessible public transportation. His findings were gathered in the award-winning book *Het wonder van de Noord/ Zuidlijn* (Soetenhorst 2011). As a final example of how the projected North–South line generated – an increasingly broadly organized and slowly successful – contestation across various social levels, as its accompanying tunnel visions were realized underneath the urban fabric of the historic city, consider the success of the left-wing political party *Red Amsterdam* (*Save Amsterdam*) during the local elections of 2010: the party was officially presented a couple of months before the deadline and immediately gained one seat, mostly through campaigns against the disaster that the underground railway had by then become. How was this instant success of an anti-metro political party in 2010 finally possible?

To most people in the Netherlands the North–South line 'became a national symbol representing everything that can go wrong for underground construction' (Van Wijck 2012) in 2008 when, due to leakages in the soft soil of Amsterdam, various buildings around Rokin and especially Vijzelgracht cracked, and inhabitants had to be evacuated. The danger of collapse had already manifested itself during the drilling tests prior to 2003 and in early 2008, but in their communication about the problems, engineers and managers had minimized the dangers and said that from a technological point of view nothing serious could happen as long as the subsidence of buildings did not exceed 2.5 centimetres. In June and again in September 2008 the subsidence exceeded 15 and 23 centimetres at two areas on the Vijzelgracht as 'large volumes of ground had been lost through failures in the slurry diaphragm support walls. Several seriously damaged buildings adjacent to the station box failures had to be evacuated' (Van Wijck 2012). Inhabitants of the Vijzelgracht heavily protested as fourteen families were removed from their seventeenth-century houses in front of the cameras. What had been kept away from public scrutiny so far – 30 metres beneath the surface – suddenly erupted into the open air with far-reaching effects. The physical cracks in the houses shattered the metro's dream world and realized what the protest movements so far had failed to do.

Dienst Metro still hoped to call the first dip in June 2008 an unhappy 'incident' due to unforeseen circumstances, but the second one in September culminated in

a national disgrace for all the parties involved in the metro line. Construction work at the trouble-hit stations was put on hold for almost a year in order to investigate how to proceed; national television and press reported widely on this calamitous state of affairs under social-democratic mayor Job Cohen and his colleague Herrema; and the inhabitants of the Vijzelgracht filed yet another lawsuit against the city for yet another transgression of the original contract between citizens and project-management. After 5 years of excessive noise, smell, physical hindrance and danger, bankruptcy and closure of local shops, and drilling hours late into the night, citizens now also risked losing their homes. Add to this the fact that in the meantime the metro line's total budget had tripled at the expense of the City Government and the delivery date had to be extended once again due to technical problems – the deadline by then was 2015 – and we can understand why one question resounded louder and louder: All these costs to what end? The old answer – to speed up mobility through Amsterdam, enabling passengers to travel from the northern to southern ends 10 minutes faster than current public transport – no longer sufficed.

In 2008, the past years of heavy urban disruptions, together with the recent damage to houses and the decision to stop the work became hot items widely reported on in local and national newspapers, television and on a multitude of online platforms and blogs such as Nufoto.nl, Marokko.nl, elsevier.nl and ruimtevolk.nl (Baetens 2012: 95). A deep political crisis ensued. As always in the Netherlands, the answer to such a potentially explosive dossier was the installation of independent audits: one about the past (what went wrong?); the other about the future (what to do next?). The question that was most widely reported on in the media could be summarized thus: Should Amsterdam stop the construction work altogether and, if not, how could the building process run more smoothly – and to citizens more acceptably – in the future? One year later two harsh reports totalling 700 pages appeared about all that had gone wrong,[4] but not unexpectedly a firm positive conclusion was put forward: reorganize the management of the process, reconsider the contracts and time-plan, improve the social communication and networking, but keep building. Upon the resignation of Alderman for Transport Tjeerd Herrema and the Director of Projectbureau Noord/Zuidlijn Henk van Veldhuizen, and Job Cohen's move back to the Hague to become leader of the Social Democratic Party, a complete reshuffle of managers, employees and contractors took place. This is the context in which *Red Amsterdam* gained a seat in the local elections of 2010, as stated above.

As to the afflicted inhabitants at the Vijzelgracht, they organized themselves into an official *Stichting Gijzelgracht* (http://www.gijzelgracht.nl) to better monitor future developments, orchestrate consultations or legal procedures and improve the communication with the metro management. Interestingly, in 2012 the neighbourhood also founded *Stichting Culturele Activiteiten Vijzelgrachtbuurt Amsterdam* (SCAVA), which was co-sponsored by Dienst Metro, Advisory Project

Bureau Witteveen+Bos and the metro's major building contractors. The final part of the chapter will demonstrate the role that public–private cultural initiatives such as SCAVA played as part of the comprehensive offline and online communication strategy through which the Dienst Metro improved its reputation after 2010, managed conflict, and incentivized particular local stakeholders in the discredited transportation project. Central to the new direction in public relations was no longer the question of how to join the city to the region through fast metro lines but how to connect the metro to the city through excessive visibility, social networking and short-term art projects in real and virtual space, above ground as well as underground. This leads us to the final question of this chapter: What role did the Internet and social media platforms play in profiling the North–South line in a particular way across a multitude of imagery and channels, thereby creating a viral visibility in urban space and a certain amount of online followers at a click-through rate?

Here we are now: from tunnel vision to open house

Anyone who has visited Amsterdam in the past 4 years may have come across big arrows in the physical space of the city, pointing out to the public at large exactly where underground workers were drilling in the tunnels at that moment (Figure 8.1). The arrows above ground highlighted the place of the boring machines underground and moved through the streets as the tunnelling activities proceeded. They were red, about two metres high, and inscribed on them in white were the words: *hier zijn wij nu*! ('here we are now!'). The arrows themselves were removed two year ago but their pictures are still widely available on the Internet. Interestingly, http://www.hierzijnwij.nu was, and still is, also the name of the official website of the North–South line offering more information on all the activities in and around the construction sites. An earlier version of the metro's web portal showed a virtual map of Amsterdam with red arrows moving in relation to their mobile presence in the real world. The arrows in the streets of Amsterdam thus not only referred to particular places of construction underground, they also pointed visitors to the metro's digital environment overlaying the whole length of the North–South axis with more icons, information, images and tweets. Integrating offline and online presence in this way, the arrows functioned as portals to a building project extending vertically and horizontally in a real and virtual world. They located the visitor *vis-à-vis* the work underground and the information on the Internet.

The *hier zijn wij nu* campaign, developed by Alex Sheerazi, Head of Communications at the North–South line since 2009, is clearly an extension of the *I Amsterdam* marketing campaign that started in 2004, and which is now being

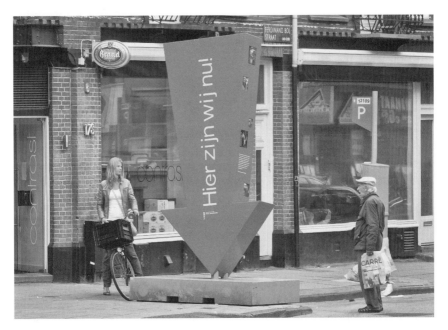

FIGURE 8.1 *Arrow on Street. North–South line.* Photograph by R. Vincken.

extended through the red carpeting of the city.[5] *I Amsterdam* is the name of a particular slogan launched 10 years ago to brand Amsterdam as performative (a verb), a personality (the I), a playful pun, the friendly city where you want to *be and with which you want to identify* (Birdsall 2013). The phrase sounds like a statement identifying individuals with the city and carries associations of pride, intimacy and inclusiveness. The red-and-white phrase – letter and image in one – has expanded beyond its initial campaign with public posters, T-shirts, souvenirs, an official website (the commercial portal to the city), an organization and an umbrella term for booking and sponsoring activities in Amsterdam. But the most famous spin-offs are the outdoor, tangible, red-and-white sculptured letters travelling around the city as they are photographed, hugged, sat on, climbed through, by tourists.

Conceived in the lineage of the *I Amsterdam* project, *hier zijn wij nu* emphasizes performance and activity, collective pride and current presence in the city. The vision behind the new communication project has also been summarized as 'from tunnel vision to open house' (Detmar 2013). Staged as a narrative of rupture with the (evil) past that emerged out of the Vijzelgracht crisis of 2008, Sheerazi's communication strategy is about openness, realism and acceptance in the present: instead of the secrecy of the past we offer complete openness in the present; instead of top-down decisions we share bottom-up information; instead of managers' grand tunnel visions we present professional experiences of local surroundings;

instead of long-term inertia we offer short-term projects and instant feedback; instead of conflicts we seek connections. Transparency and visibility are emphasized in most of the mission statements widely circulating online:

> Sheerazi saw transparency as key. The project and its construction had appeared secretive; journalists would wait endlessly for answers that did not satisfy their questions. 'I wanted to show the media everything. Let them come!' said Sheerazi. 'My strategy was, and still is, to be as realistic as possible and first of all admit that the project had turned out badly on a lot of levels. But positive and interesting things are worth showing to the media, and to the public as well. By placing these positive images next to the negative ones, you create more balance.
>
> **VAN WIJCK** 2012

Like *I Amsterdam*, the red arrows in the urban fabric have spilled over to other visibility projects developed around the metro line. Along with the material sculptures other 'open house' projects were developed, such as the posters of the builders and engineers pasted on building site hoardings around Amsterdam. Ninety-five per cent of them are male, white and Dutch, which is surprising given the Slovaki labour force hired by one of the contractors. The billboards contain pictures of these men, a brief CV, their function in the building process, and an autobiographical reflection or personal mission statement concerning the North–South line. In various magazines distributed by Dienst Metro,[6] in online briefs, and on the North–South line's YouTube channel, the pictures of and stories by the proud professionals circulate as they are shown at work, interviewed or lovingly talk about their female drilling machines called Molly, Noortje, Gravin and Victoria. This overly white male transmedia poster campaign entitled 'May I present myself' was meant to present a certain public with identifiable protagonists – particular men and machines – in the never ending story that the North–South line had become. Sheerazi describes it thus:

> One of the most successful projects of the communication team was a campaign highlighting the underground construction workers. 'As a concerned citizen, who do you need to trust most: the engineer who designed the metro line or the man operating the TBM [tunnel boring machine]?' asked Sheerazi. 'We placed the workers in front of their machines. Who, and where are they? What and how are they doing?' By placing huge poster images of the underground workers around town, on the website and on YouTube, the public got to identify itself with the workers and empathise even more with the project. It did not take long before national newspapers printed the headline 'Underground Heroes' on their front pages.
>
> **VAN WIJCK** 2012

Citizens and tourists have also literally been invited into the 'open house' to come and admire the sublime technological feats through a series of underground lookout posts, open days and underground tours offering impressive views of the magnitude of the project (Figures 8.2 and 8.3). On such occasions looking, looking through, and looking at are seamlessly integrated into an illusory feeling of nearness and immediacy:

'Those who visit the lookout point get a feeling for the enormous underground space and the complexity of the environment we are working in,' said Sheerazi. 'Everything is very sensory. You don't have to communicate with words anymore. The subliminal message we want to get across is of course that we have nothing to hide. People can watch us work there 24/7.' The lookout point became a quick success. Since opening two years ago, it has had almost 200,000 visitors.

VAN WIJCK 2012

The ideal of transparency and visibility functions as an attraction during the evenings, when the underground work spaces regularly host theatrical and dance performances, film screenings, artistic events, light festivals, design exhibitions,

FIGURE 8.2 *Station Rokin*, research and documentation, 2014. Photograph by Krien Clevis.

FIGURE 8.3 *Tunnel Rokin*, research and documentation, 2014. Photograph by Krien Clevis.

photo shoots for celebrities, music video clips, Super Mario Nintendo launches, and so on. Equally, outside and around the many building sites several street artists have been asked to add their visual signatures through sculptures (Natwerk's *Saunaman*), canvases (Ilonka Ruiter and Hugo Kaagman), photographs or painted murals (Maarten Berkers and Wout Schildermans).[7] However, spontaneous artistic interventions in and around the space of the metro, such as graffiti and street music, have been banned (Parool 2013; Van Bers 2013), which shows how far the distance between the official art-in-the-metro and 'the people' really is.

In many ways these metro-led cultural projects of temporary vacant space reuse fit the global proliferation of 'creative city' initiatives analysed by Mara Ferreri in this volume. They are also perfect examples of what she describes as 'a mimicry of histories and aesthetics of subcultural and political urban movements' for other ends (Ferreri, Chapter 9 of this volume). In this case we can see certain connections between the short-term spatial appropriations of construction sites mentioned in the previous paragraph and the squatting activities by the anti-metro protest movements of the 1970s, including their urban and media performances and their graffiti and posters on the buildings destined for demolition. But whereas the squatting activities were part of a long-term political contestation, today's

momentary occupation strategies serve the purpose of promoting a controversial infrastructural building plan in the present.

The strategic profiling of the North–South line as a friendly host to a multitude of cultural, commercial and community events plays a crucial role in the 'open house' initiative. But it also helps to brand the discredited infrastructure as an accepted part of daily life in Amsterdam and even as a platform through which to 'connect' to each other on a regular basis. Intricately interlinked with the ideals of transparency are those of familiarity, connectedness and (public–private) partnerships, as witnessed by the Ramses Shaffy Art project at Vijzelgracht. Consider also the 2013 community opera, *Günther en Julia*, performed by the inhabitants of the Vijzelgracht, produced by SCAVA, and sponsored by local enterprises, national cultural foundations and various business partners involved in the North–South line, including Max Bögl Construction and Dienst Metro itself. Modelled after Shakespeare's classic as well as the 2008 events, the opera, carried out on site, deals with the tumultuous love affair between a German foreman Günther, employee at Max Bögl, and Julia, a teacher at a local primary school – obviously symbols of the Vijzelgracht as a highly gendered 'problem space'. The stereotypically coded musical was presented as a means to transform the conflicts of the past into a community-based performance and to reclaim the afflicted neighbourhood as an entrepreneurial collective taking the situation into their own hands. Along with the auditioning, weekly repetitions and the actual three performances on location came a wide coverage in national and local newspapers, on television and radio, and on various websites and YouTube channels – including those of the North–South line – long before, during and after the event. One year later the community opera was released on CD and DVD, which, in addition to a recording of the performance, also contained a 'making of' documentary.[8]

Of course, the most important means for opening up to the public what was previously kept secretive and underground, being visibly present 24 hours a day, and presenting the messy transport infrastructure as a magical meeting place for citizens and fans, have been the Internet and various social media platforms. The website http://www.hierzijnwij.nu was first launched in 2010 and has been updated and redesigned several times since, but from the start it contained a series of links to the eight stations being built along the line, several builders appearing in shifts across the city and the various 'events' hosted at particular sites. It also included the official use of Facebook, Twitter and YouTube. Unlike its predecessor http://www. noordzuidlijn.nl, the new web 2.0 wanted to operate like a decentralized, 'viral' system to cater to the aspirations of a growing community of social media users. Actually Dienst Metro was also forced to integrate these platforms and be more visibly active online, due to the growing pressures of a wide variety of – very critical – media channels mentioned earlier in the chapter: among them the digital environments of AT5, Parool, Skyscrapercity.com, nu.nl, *Stichting Gijzelgracht*,

Wijkcentrum d'Oude Stadt, *Red Amsterdam* and many others. Under the motto 'If you want to control your reputation, start sharing your information', Sheerazi collaborated with these networks while opening the metro's own official Facebook sites (called de Pijp, Rokin, Vijzelgracht), YouTube channels and Twitter accounts, to which followers of the metro could react or pose questions.

Along with the digital environment, a series of urban markers were installed, such as the red arrows, the posters and street art projects discussed above. These offline initiatives had to stage visible connections between the city and the web. Even more important in this respect were the teams of on-site communicators, official photographers and film makers filling the various pages with locally embedded announcements, invitations, interviews, tweets, photos, video clips and even live footage generated by a web camera around the IJ harbour and, recently, high-definition films of the tunnels shot by a drone. At this very moment of writing, the North–South network has expanded to LinkedIn, Google+, flickr, Vimeo and Instagram as well – all of them offering a massive amount of online attention to the progress of the construction or the ('good as well as bad') happenings in and around the various building sites. Although often unique and spectacular in their formal qualities, the pictures circulating on these sites are part of an identical cultural logic – lots of men in boots, big machines, heavy sand, grand walls and other support structures, beautiful tunnels – and reinforce very similar meanings: Here we are! Look at how spectacular the work we are doing is, even (or especially) when things go wrong.

Not only has the North–South line thus remapped Amsterdam as a space to profile its proud presence 24 hours a day, in real time and on various locations, we, citizens, have been asked to follow the fantastic voyage in real and virtual space and to 'connect' through physical visits and by posting comments and tweets, likes and dislikes. All of them are immediately responded to by the various web hosts surveying and, if necessary, moderating the digital traffic. In this way the linear infrastructure running from north to south has been overlaid by an expansive digital network of information, communication, connection, co-creation and personal profiling. Streamlined social media platforms of following and posting have been implemented to complement the brick and mortar, the cables and tunnels, the posters and arrows. This has helped to brand the enterprise in a particular way, while channelling opinions and individual self-promotion on the part of certain hard-core fans and users.

Conclusion: in defence of crisis

Although Sheerazi has won the 2013 Welcom Amsterdam Communication Award for his vision of combining transparency, decentralization and local embeddedness with an aura of collective pride within the organization, two questions remain:

would the pride uphold and the public support remain during the next disaster? How deep does the actual engagement with/of the broader public online go? A quick glance at the quality and quantity of exchange on the platforms tells us that the communication is mostly one way – steered by the various hosts of the sites – while the possibility of user-generated content is kept minimal: one can add comments, likes or tweets; send emails; upload photographs as part of a competition on Flickr; vote for one's favourite art project in the metro. But not much more than that. As to the content of the posts, most of it concerns friendly questions for (technical) clarifications or expressions of admiration, besides an occasional irritation about noise or the fact that the projected date of completion has been moved to 2017. As mentioned in Baetens (2012), the circle of fans has been a small one and the followers seem to be in the construction business or may be retired employees of the metro line. This is hardly surprising given the multitude of representations of white men and machines delineated above.

One could predict that in case something serious were to happen again, many more people – men as well as women, Dutch or not so Dutch – would start to tweet and it would not be all that nice. The reason is that so far the North–South line has been communicating about, displaying and aestheticizing particular parts of itself to a particular audience in a particular way: the stations, professionals, infrastructures, technologies, hard work, open days, the nightly dance performances, are all tied into a linear narrative of 'before and after 2008', complete transparency, collective pride and a spectacular conquest of difficult situations, while leaving out the messy bigger context within which this is happening. More specifically, the metaphors and images used are producing homogenizing views of the project that are distanced from everyday life in the city and from the daily concerns of a wider – critical – public. Thus, while the underground work space is the centre of excessive attention, it is also completely marginalized or detached *vis-à-vis* the complexities of the urban fabric and human interaction. If the way in which Dienst Metro has presented the North–South line through its official digital channels reflects the way it sees and involves – in their own words 'connects to' – the city that shapes it, then there is reason for concern. The base is small. The vision infrastructure-led. The feedback formatted and controlled.

The communication strategy may well have been intended as a way of moving 'from classical mast to spider in the web' (Beatens 2012), but the web here is kept under tight control. It is not seen as the network that it could be if only connectedness in times of crisis were taken seriously. And here we are reminded of Latour's notion of the network (2010) as a heterogeneous assemblage of unexpected elements that appears most visibly at moments of crisis:

> In its simplest but also in its deepest sense, the notion of network is of use whenever action is to be redistributed. ... Take any object: at first, it looks contained within itself with well delineated edges and limits; then something

happens, a strike, an accident, a catastrophe, and suddenly you discover swarms of entities that seem to have been there all along but were not visible before and that appear in retrospect necessary for its sustenance.

LATOUR 2012: 2

Thus, defined networks consist of irresolvable tensions between presence and absence, visibility and invisibility, order and chaos while they permanently contest decisions as to where to draw the line, how to frame things or what/who to include. Here success is seldom determined in the eyes of the beholder (producer) only and definitions of what counts as good or bad are up for debate. Networks are ways of organizing trial, friction and crisis:

You see that I take the word network not simply to designate things in the world that have the shape of a net (in contrast, let's say, to juxtaposed domains, to surfaces delineated by borders, to impenetrable volumes), but mainly to designate a mode of inquiry that learns to list, at the occasion of a trial, the unexpected beings necessary for any entity to exist. A network, in this second meaning of the word, is more like what you record through a Geiger counter that clicks every time a new element invisible before has been made visible to the inquirer.

LATOUR 2012: 5

Latour has not ceased to remind us that in his vision of the network agency lies beyond human activity and many things – often invisible to the human eye – shape the world we live in. When these things manifest themselves out of joint, we speak of crisis or failure and the urgency for further networking emerges.

So what does this mean for our case at hand? Let's go back to the fall of 2008, when the leakage in the soil and the damage to the houses caused the invisible tunnelling below the surface to become visible in public space with detrimental effects, the work was put on hold and the whole project was hotly debated by a multitude of agents on a wide variety of platforms, from newspapers to TV channels, online groups, council meetings, improvised information campaigns on location. Also the two critical audits were crucial in shaping the public opinion around that time, as was Soetenhorst's detailed analyses first in *het Parool* and then in the book *Het Wonder van de Noord/Zuidlijn* (2011). Instigated by the Vijzelgracht, crisis research into the whole process of decision-making, contracting, spending and building revealed a web of conflicting interests and missed opportunities with no room for debate, neither among the engineers, managers and their advisors, nor in the City Council itself. With the Council's lack of political control over the infrastructure, the possibility of public knowledge and the citizens' right to intervene also evaporated. Thus what emerged in the crisis of 2008 was nothing less than a sustained inquiry into a network of secretive messy details attesting as much to a crisis of technology as to a crisis of local democracy. A technical failure was shown

to be a political one. And immediately proved to be an economic one too, as a global financial crisis at that time suddenly hit most cities in the Netherlands and beyond. To speak with Latour, in the unexpected moment of involuntary 'interruption' – the cracks in the diaphragm support walls – appeared the complex entanglements of engineers, managers, civil servants, politicians, bankers and investors shaping their technologies and support infrastructures, while also shaping each other and the contexts in which things went wrong on different levels and with large-scale effects.

One year later Sheerazi's communication strategies were formulated as immediate solutions for well-identified problems: secrecy, lack of transparency, loss of trust and so on. The result has been described at length above. But isn't this campaign about openness repeating the same problem all over again? This chapter has claimed that the central issue was, and still is, a question of disconnection: Who represents which actors in the city, through what media channels, images, urban arrows and lookout posts? What is excessively made visible and what is left out? What places, citizens and stories are worth a massive amount of attention and what is kept out of the picture, and why? In short, what kind of public space does the metro line produce and who are its publics exactly? Enabling more people and things to connect to the North–South line and opening other platforms for collective co-creation of knowledge and vision result in more articulations of different problems and possible solutions. Latour has a name for this process: networked redistribution of knowledge, power and agency on a larger scale.

There are plenty of initiatives in Amsterdam in which alternative – networked – tools for citizens' participation and engagement have been developed that could be of use in this context. A complete survey lies beyond the scope of this conclusion, but one could think of the work done by *The Institute of Network Cultures*, *The Mobile City* and particularly *Waag Society, Institute for Art, Science, and Technology*. The latter is a non-profit research lab for social innovation that has developed out of *The Digital City* (1994), which was the first online community made possible by free access to the Internet in Amsterdam. From the start, *Waag Society* has experimented with open data, user-generated content, chat rooms, urban digital games and so on, to address social problems rather than technology-driven ones. One if its most cited projects in the field of mobile mapping is Esther Polak and Jeroen Kee's *Amsterdam RealTime* (2002), which tracked citizens' movements through Amsterdam by means of GPS-devices and sent the visualized data live to the exhibition *Maps of Amsterdam 1866–2000*. 'In doing so, the piece forced visitors to contrast the traditional maps of the city with the digital maps plotted with the mobility of people' (Gordon and de Souza e Silva 2011: 45). The cultural foundation has repeatedly worked with the Municipality of Amsterdam and three of its latest enterprises explicitly concern user-friendly mobility and sustainable transport in a collaboration with other European partners. Cooperation with citizens and public collectives, exchange of knowledge on a larger scale, and addressing complexity and diversity rather than simplicity have been the hallmarks of the institute. Thus it

recently hosted the Russian-based collective *Metro4all* to collect and analyse data on the accessibility of the Amsterdam metro network for different people with limited mobility and to translate the data into the free mobile app NextGIS, showing all the potential obstacles concerning entrance and exit, elevators, stairs and so on (Waag Society 2014). Another of their recent initiatives is the European (*Smart*) *City Service Development Kit* in which citizens, data providers in the fields of public transport or city services, and app developers collaborate in the production and maintenance of a harmonized public toolkit for various urban services in eight European cities, enabling users to report problems in the city, plan their journeys and improve access to cultural sites (City Service Development Kit 2014). A final example is the experimental *Smart Citizen Kit* meant to enable users to measure air and noise pollution inside and outside, upload the information to a site and share knowledge and experience with other citizens, scientists and policy makers.

Let me end this plea for a broader civic engagement and redistribution of action on a larger scale with a quote by Anthony Townsend, previous Research Director of *the Institute for the Future* at Palo Alto. Talking about the challenge of identifying the intersections of technological and social trends (beyond the use of Facebook in times of crisis) while opening up the government of complex city infrastructures such as transport to the impact of the post-2008 economic crisis on the unemployed, the elderly and the poor, he asks what opportunities urban technologies will provide to excluded groups:

> Solutions will combine the scale of big platforms with citizen-driven innovations. To a degree, this integration is well under way, but urban leaders need to educate themselves and frame an agenda of openness, transparency, and inclusiveness. Without this catalyst for cooperation, we may repeat the devastating urban conflicts of the 20th century that pitted central planners like Robert Moses against community activists like Jane Jacobs.
>
> **TOWNSEND** 2011

The civic acceptance of the North–South line and similar grand infrastructures in the future will depend on the extent to which city governments stop oversimplifying urban problems and are willing to embrace complexity, collaboration and disconnection across a wide spectrum of users, activists and less visible actors under a common management that goes beyond the fixed borders of a professional white, male, machine-driven world.

Notes

1 All my sincere thanks to the editors of this volume for the invitation to join their research group, the congenial atmosphere of the discussions, and the feedback on this

contribution. I am also grateful to the artist-researcher Krien Clevis for our collaboration in preparation of this article, our joint presentation in London, the underground tour with my students and for providing me with two of her most beautiful photographs of the North–South line.

2 This brief post-war history of the Amsterdam metro line has been described at greater length in Verstraete (2013).

3 The technical details are widely available online. For a good survey, see *North-South-Line: The Connection with Tomorrow*, accessed at http://www.dftu.dk/Faelles/ Modereferater/am_ns-maj03%20.pdf on 15 September 2014.

4 *Rapport van de Enquêtecommissie Noord/Zuidlijn*, headed by Limmen, was ordered by the City Council; *Bouwen aan verbinding*, headed by Veerman, was ordered by the Amsterdam Board of Mayor and Aldermen.

5 'The Red Carpet traces the overground route of the North/South Line, which runs from Amsterdam-North to the South of Amsterdam, proceeding from the Central Station via the Damrak, Rokin, Vijzelstraat, Vijzelgracht and Ferdinand Bolstraat to the Ceintuurbaan. This line will eventually extend as far as the Europaplein and Zuidas. When a section of the route of the North/South Line, namely the Damrak and the Rokin, was reprofiled in the early 1990s, the pavement on the west side was widened, giving pedestrians more space. One of the road carriageways was removed, so that motor traffic could no longer travel via the Damrak and Rokin in a southbound direction. The old pavement was replaced by hexagonal red/grey paving stones on the Damrak and by red brick clinkers on the Rokin. This intervention was meant to give pedestrians the feeling that the "red carpet" had been rolled out for them, and this has been the popular name for this route ever since.' http://www.amsterdam.nl/gemeente/ organisatie-diensten/dienst-ruimtelijke/making-amsterdam/planamsterdam-magazi/2009/5-_2009_rolling_out/ (accessed on 10 November 2014).

6 http://www.hierzijnwij.nu/wp-content/uploads/2012/07/NoordZuidkrant-juli-2012. pdf (accessed on 1 October 2014); http://www.amsterdam.nl/noordzuidlijn/ informatie/downloads/ (accessed on 1 October 2014).

7 Krien Clevis was invited to present part of her artistic PhD project *Locus: Memory and Transience in the Representation of Place* at the underground Rokin Station under construction in the Fall of 2013 but due to time constraints and financial pressures at the North–South line, she was forced to find another venue for the installation at the time of her defence. Interestingly she developed an app for iPhone and Android to remedy the interruption and keep a virtual link to the metro station, called *The Once and Future House*, available at: https://play.google.com/store/apps/details?id=nl. twocoolmonkeys.artapps.gapp&hl=nl and https://itunes.apple.com/nl/app/gapp-the-once-and-future-house/id718288967?l=en&mt=8 (both accessed on 15 November 2014).

8 See http://www.scava.net/in-de-media. Again I refer the reader to my article on the Eastern Line, my discussion of van Waveren's making of the film *Groeten uit de Nieuwmarkt* (1980) in particular, to see how SCAVA's public–private community project evokes the subcultural aesthetic interventions of the late 1970s to counter the negative perceptions of the Vijzelgracht crisis.

9 POP-UP SHOPS AS INTERRUPTIONS IN (POST-)RECESSIONAL LONDON

Mara Ferreri

Temporary projects in vacant shops, commonly known as 'pop-up shops', have become a common sight on many high streets in cities in the global north. The adjective 'pop-up', from its onomatopoeic origin in a light explosive sound, refers to something that appears or occurs suddenly and unexpectedly. Transposed into visual terms, the word conjures images of folded cut-out pictures standing out from the flat page of a book and of windows superimposing on a computer screen: unrequested visual events that distract and interrupt an existing activity. By extension, pop-up spaces have become the epitome of urban interruptions: short-term spatial appropriations that appear unexpected and unsolicited, visually and spatially occupying a site with something different and eye-catching. In interrupting the everyday of the city, 'pop-ups' are expected to produce both visual and experiential urban encounters that stand out against a backdrop of alleged urban sameness.

In the emerging interdisciplinary body of literature analysing temporary uses, pop-up practices in cities have been associated with forms of 'insurgent' (Hou 2010) and temporary (Haydn and Temel 2006) urbanism characterized by 'unplanned' approaches to the production of space (Oswalt, Overmeyer and Misselwitz 2013). Pitted against the alleged rigidity of top-down interventions by private and public agents of urban development, temporary and 'pop-up' spaces appear to embody a progressive critique that appeals to 'tactical', as opposed to strategic (De Certeau 1984), or spontaneous and amateurish (Deslandes 2013) approaches to transforming cities. Whether such a 'tactical' urbanism, encompassing a range of 'small-scale, unsanctioned, community-led urban interventionist activities' (Mould 2014: 530), interrupts or reproduces existing global dynamics of

interurban competition and place branding, is an open debate. In this chapter, I contribute to this critical discussion by analysing the recent proliferation of community-oriented 'creative' pop-up shops in the context of the recent global recession in London.

From 'limited time' retail to community-oriented pop-up shops

A little studied 'mainstream' genealogy of pop-up shops situates their appearance in the cultural urban vocabulary of the early 2000s, when media and marketing agents began to use the term to designate 'new' spaces of consumption. 'Pop-up retail' described limited time stores promoting particular brands or new product ranges, particularly in Western global shopping capitals such as London and New York. The commercial success of 'pop-ups' as a form of marketing lay in 'surprising consumers with temporary "performances", guaranteeing exclusivity because of the limited time span. It's about buzz, and about new try-out and testing techniques' (Trendwatching 2004/2010). The temporariness of the space is promoted as an opportunity to generate micro-tourism since 'the draw of pop-ups is the sense of urgency they create, to get there "now" before it disappears, as well as to have been one of the few who were there to have had the experience' (Cambie 2010).

Alongside commercial uses as an explicit marketing strategy, temporary uses of vacant shops have also gained currency and visibility in association with the cultural and third sectors. Practitioners across a broad spectrum of 'creative' professions have taken upon themselves or have been tasked by private and public urban agencies with producing visual and performative fillings of urban shops that have become vacant subsequent to the global financial crisis of 2008. As with commercial pop-ups, this visual response to the recessional urban landscape of high street closures and stalled redevelopments rapidly spread across cities from New York and London (Bishop and Williams 2012) to less known urban centres in the global north. These pop-ups often displayed explicit visual references to the communities of the neighbourhood where they took place, as is visible in the use of traditional Mexican *papel picado* (Figure 9.1) in an Art In Store Fronts shop in San Francisco's Mission District (San Francisco Arts Commissions 2010).

In the United Kingdom, since the global recession, pop-up shops have grafted themselves onto a longer history of social and artistic projects in contexts of urban regeneration. Practitioners and organizations appropriated empty shops for non-profit, social and artistic uses (Meanwhile Project 2010; Berry-Slater and Iles 2010) to produce visual interventions in urban vacancy combined with a more explicit coordination of programmes of local community uses, often framed through a

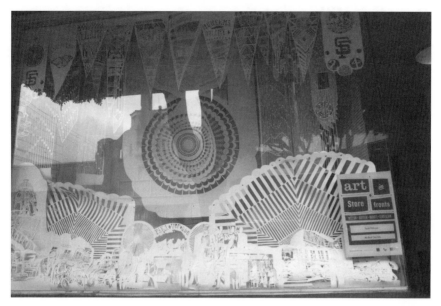

FIGURE 9.1 *Art in Store Fronts,* Mission District, San Francisco (April 2010). Photograph by the author.

do-it-yourself aesthetics evoking urban countercultural imaginaries (Iveson 2013). In this context, a blurring of distinctions between political and promotional temporary appropriations of urban spaces has led to ideas of 'temporary autonomous zones' (Bey 1985/2003) being discussed side by side with site-specific theatre productions and architectural festivals (Bishop and Williams 2012).

Drawing on self-representations, interviews and ethnographic observations collected between 2010 and 2012 in London, this chapter aims to offer a critical analysis of the ways in which community-oriented practices in vacant shops articulate and project distinct urban imaginaries. In the first part I will explore the connection between temporary spaces and discourses of urban regeneration that inform the framing of pop-up shops for both artistic and social uses. The second part will address how this framing is made visible in forms of self-representation of pop-up experiences in inner London and their shared aesthetics. Finally, I will shift the focus to the performative dimension of such aesthetics as co-constitutive of the experience of the spaces by visitors and passers-by. By engaging with the processes of meaning-making that accompany moments of encounter and interaction, I argue that the aesthetics of community-oriented pop-up shops can generate frictions and unintended readings, which throw into relief important tensions about their position in relation to wider urban cultural dynamics. In attending to these interactions I will develop a set of reflections around the cultural politics of imaginaries of temporary urban uses as interruptions.

Creative fillers at times of recession

These days [...] art is not only enlisted to drive regeneration but to quite literally fill the shop fronts of its empty high street.

BERRY SLATER AND ILES 2012: 49

In the Western cultural imaginary, artistic uses of vacant urban spaces often self-identify in relation to established genealogies around the flourishing of artistic *avant-garde* practices in contexts of urban decay caused by processes of de-industrialization and depopulation. Greenberg has identified late-1970s' New York as an important reference point for the mythology of creative re-appropriation of derelict buildings, later promoted through policy interventions, marketing campaigns and the newly established urban lifestyle magazine industry (2008; 2011). Ever since, the imaginary of 'creativity amid urban decay' (Zukin 2008: 729) has become something of an urban cultural trope and a focal point of symbolic identification between art practices and marginalized urban areas.

With the development of global dynamics of place marketing and interurban competition (McCann and Ward 2011) and with cultural activities becoming 'increasingly valued in terms of their ability to foster a new image for the city' (Edensor et al. 2010: 2), since the 1990s cultural spaces have been considered indispensable ancillaries of plans of urban intervention and neighbourhood renewal. In the United Kingdom since the mid-1990s, government departments and councils, such as the Department for Culture, Media and Sport and the Arts Councils, have promoted community-oriented cultural activities as part of the multiple discourse of culture-led regeneration (Miles and Paddison 2005; Pratt 2009). In that context, culture and creativity have increasingly been understood as means to engender and accompany processes of social as much as economic 'reconstruction' of urban spaces (Vickery 2007; see also Böhm and Land 2007).

In the context of the global proliferation of 'creative cities' discourse (Peck 2009) and the quest for distinctive urban marketing elements, Claire Colomb's analysis of public projects of vacant space reuse in Berlin has indicated temporary spaces as a new fertile ground for public and private city promoters (Colomb 2012). Both Colomb (2012) and Peck (2011) have noted how the urban imaginaries promoted through temporary uses in Berlin and Amsterdam respectively explicitly drew on a mimicry of histories and aesthetics of subcultural and political urban movements, taking 'processes of cultural commodification and artistically inflected place promotion, which have existed since the 1970s, one step further' (Colomb 2012: 142).

Historically, temporary uses of vacant spaces have also come to play an important role in the re-invention of the symbolic economies of cities in recessional times. During the 1991 to 1993 recession, Zukin (1995) observed the temporary uses of unfinished vacant shop fronts for contemporary art exhibitions in mid-town

Manhattan. For Zukin, they exemplified her thesis that in times of economic recession the symbolic economy performs a takeover of productive economies, enrolling cultural practices to 'produce and promote imaginative reconstructions of the city' (1995: 17) to be projected onto abandoned scenarios and to serve the purpose of 'selling' urban growth. In the UK, ideas of creative and community-oriented 'pop-up shops' have become ever more popular with local authorities struggling to counter perceptions of urban decay in the aftermath of the global credit crisis of 2008. National urban and cultural policies combined with specific funding for the arts to promote artistic and community uses of vacant shop fronts in struggling cities and inner-city neighbourhoods (DCLG and DCMS 2009; ACE 2010).

Vacant high streets, perceived as the most visible symptom of the recession, became a crucial site of policy intervention. A key part of the rationale of community-oriented creative pop-up shop schemes lay in the promise to dispel negative urban perceptions of social and economic decline, and 'to attract and retain visitors' (DCLG and DMCS 2009: 2). In conjunction with public policy, since 2010, a range of third sector organizations stepped into the breach to act as intermediaries and promote, administer and manage temporary uses on the ground. Organizations such as Meanwhile Space CIC, for instance, have been directly involved in setting up temporary shop front reuse in London and advising other organizations and practitioners through reports based on best practice (Meanwhile Project 2010). Their argument for temporary and 'meanwhile' uses identifies vacant shops as wasted resources to be put to use – 'activated' – through community and creative activities 'while something else is waiting to happen', that is, in that in-between space between vacancy and redevelopment or demolition (Ferreri forthcoming). In order to analyse the kind of 'imaginative reconstruction of the city' promoted by these practices at times of recession, I will begin by focusing on the performative ways in which they fulfil their task of countering negative perceptions through a do-it-yourself, 'creative' and community-oriented aesthetics.

A shared pop-up aesthetics

Self-representations of community-oriented pop-up shops share a fairly established common aesthetics (Deslandes 2013; Mould 2014), which can be observed in their online as well as offline presence. As temporary events in the city, there is a practical reason why many pop-up shops have a highly visible online profile: the lifespan of a pop-up shop ranges from a few days to a few months, and the use of social media to constitute audiences and participants at short notice is absolutely crucial. In this sense, pop-up shops live an interconnected double existence in the online space of mailing lists and forum discussions promoting their activities, including websites that visually document their practice, and in the offline spaces of the streets where the project physically takes place. As the former often leads to the latter, self-representations

circulating through online platforms should not be understood as secondary to the experience of encountering the space, but as co-constitutive of the production of expectations around the pop-up shop itself, at least for a certain section of the population, as will be discussed later.

A significant first visual element in the aesthetics of pop-up shops is constituted by the colourful bunting line stretched across the shop window, which becomes the clearest demarcation of a space of difference. The use of bunting arises from a shared sense that pop-up shops should signal their temporariness by a visual affiliation with the cultural temporary space *par excellence*: the festival. As explained by Lucia, the organizers of a community-oriented temporary shop called Make:Do (Figure 9.2), a pop-up shop 'is supposed to be an interruption, a disturbance, and shake up the timings and the rhythm of the place. [. . .] It's like a festival. The whole point of a festival or a holiday is that you are breaking from your rituals and your everyday life, to interrupt it, to do something else' (Interview 17 August 2011).

The bunting frames the reclaimed shop as a site of festive celebration, literally flagging the space as different from the rest of the street. In the case of Make:Do, it signalled the re-opening of the former local dry cleaning shop, whose name was still visible on the frontage, as something else that clearly interrupted the 'rhythm of the place', a small road within a residential area. Accompanying the bunting, the pop-up shop also displayed wooden A-boards, signalling that the site was open, with handwritten signs drawn in chalk on black board, which conjured an

FIGURE 9.2 Images of the open shop as appeared on the Make:Do blog (November 2010), courtesy of Make:Do.

aesthetics of makeshift spontaneity and informality, borrowed from shared imaginaries of self-organized urban spaces such as independent community cafes, squats and do-it-yourself cultural venues.

A second element that often appears in the self-representations of pop-up shops, and that indeed informs the aesthetic of the space as experienced by passers-by and visitors, is the presence inside the shop and in adjacent spaces, of recycled, reused or up-cycled objects and furniture. The seating inside, and at times outside, is often constituted by untreated wood planks, donated second-hand furniture and repurposed objects. The diversity of uses within the space ensures a degree of casualness and slight disorganization of the everyday appearance of the shops. The study of the material organization of many of these temporary spaces revealed that the limits of low or inexistent budgets pushed practitioners to make use of personal as well as more formal networks to obtain the basic furnishing of the shops, from discarded chairs to borrowed equipment. In the analysis of Deslandes, this DIY aspect of the 'meanwhile aesthetics' in recessional times can be seen as a response to conditions of financial poverty through the recourse to cultural capital (2013: 223). The makeshift aesthetics of these spaces is not only accepted, but also, importantly, celebrated within the discourse of temporary use as re-using wasted spaces and materials and 'making do' with whatever is available.

A third and final element in the shared aesthetics of pop-up shops is the visual articulation of the argument of 'place activation' through the contrast between photographs of the vacant site before the project, and of the same site in use. Such photographs are usually posted on an online forum as well as in online reports addressed at funders and prospective pop-up shop participants and coordinators (Meanwhile Space CIC 2010). Besides documenting the process of reuse, these images serve the double function of evidencing the project's positive impact on negative perceptions of vacancy, as well as performing a call for participants and visitors to be involved.

The 'before' and 'after' visual narrative device was present, for instance, in Space Makers Agency's online documentation and promotion of its pop-up activities in the Granville Arcade in Brixton Market, which comprises a street market and a series of early twentieth-century covered shopping arcades, in the inner London borough of Lambeth. The arcade presented many vacancies, partly also due to the recession, and was threatened with demolition. In 2009, Space Makers Agency coordinated a programme of performances, pop-up galleries and designers' temporary shops, many of which were leased rent-free on a temporary basis, The project was initially intended to last three months, but was extended to one year (November 2009 to November 2010) and led to the rebranding of the place as 'Brixton Village' (Space Makers Agency 2010). In 2010, a 'before and after' image composition appeared on the Agency's webpage, and was circulated and reposted on several blogs[1] as an illustration of the positive impact of pop-up projects in urban spaces. The image combined two images side-by-side. On the left-hand side,

the 'before' image (Figure 9.3, black and white in the original), was used to convey a sense of dereliction and abandonment increased by a lone figure in the background walking away from the viewer. This functioned as an element of visual contrast to the 'after' image, on the right-hand side, the colour photograph of a

FIGURE 9.3 Granville Arcade 'before'. Photograph © Sara Haq. http://www.sarahaq. com, formerly on Space Makers Agency's Brixton Market webpage (2010).

crowd watching a performance in the arcade, under a colourful bunting, in a festival-like atmosphere of informal sociability.

The three elements outlined so far, the festive, the repurposing and the 'place-activation', blend together to conjure an imaginary of hand-made, amateurish, artisanal and localized urban uses and encounters. The idea of activation and repopulation of 'empty' spaces, with all its neo-colonial implications that can only be briefly mentioned in this chapter, is informed by a nostalgic vision of 'authentic' urban spaces of face-to-face interaction, which presents pop-up shops as oases in which to reconnect to an imagined local community in a world dominated by mass-produced goods, fast global flows and impersonal encounters (Zukin 2008; see also Moses 2013). Against a backdrop of recessional vacancy, community-oriented pop-up spaces project an imaginary of decelerated urban life, the idea of urban 'village', as well creativity or 'slow art' (Lindner and Meissner 2015) that appears to resist and interrupt London's hectic everyday rhythms and promote a more localized and personal approach to space.

Beyond their self-representation, these imaginative reconstructions operate by enrolling visitors into the space through 'drop in' hours and programmes of events. Under the bunting and across the open door past the A-board on the pavement: people are drawn in to visit, interact and make use of the space. Returning to the two meanings of the term 'pop-up', unexpected appearance and unexpected occurrence, it is time to attend to the performative encounters taking place within such a highly choreographed stage, and to the experiences, expected or unintended, that they give rise to.

Expected and unintended experiences

The claim of pop-up shops to 'activate' urban vacancy involves a promise to generate different urban experiences that attract and intrigue visitors into using the space. If pop-ups are to be understood as interruptions simultaneously of urban vacancy and of the everyday experience of high streets, associated as they are with festivals and fairs, the second meaning of 'happening' or 'occurrence' points more specifically in the direction of an embodied and relational dimension of encounter and interaction. As observed earlier in relation to Lucia's explanation, pop-up shops are to be interpreted as interruptions, as a breaking from everyday life's rhythms and rituals. Visitors to the spaces are meant to understand this exceptionality, suspend their everyday activities and embrace the temporary space as an urban event. By extension, they are expected to approach the space as something radically different from its surroundings, and to experience of it through a suspension of daily frameworks of interpretation.

In practice, however, visitors encountering pop-up spaces draw on situated frameworks of reference, and on the complex histories of specific urban sites that are

far from the inert backdrops that pop-ups are meant to interrupt and 'activate'. The issue of the legibility of pop-up spaces and the different social encounters they aim to generate cannot be addressed without an analysis of the ways in which people experience such spaces and their performance of interruption. As argued by Degen, Desilvey and Rose in their study of everyday experiences of designed spaces, it is necessary not to presume that 'inhabitants of urban spaces are a submissive audience of the spectacle, anesthetized by aestheticization and dulled by design' (2008: 1908). Drawing on two examples of encountering community-oriented pop-up shops that generated unintended readings, I analyse the performative dimension of pop-up spaces through an embodied and situated understanding of the cultural, social and political dynamics informing the processes of meaning-making.

Waste and gleaning in Whitechapel

The first example of unintended reading refers to a pop-up shop opened by Meanwhile Space in Aldgate, Tower Hamlets, for 3 months (January to April 2011). The shop consisted of two large rooms with floor to ceiling front windows, located on Whitechapel High Street, by a busy crossing and on the corner of the popular nightlife destination of Brick Lane. The front windows were adorned with bunting, an A-board on the pavement announced upcoming events and the right-hand side of the room had been converted for a short while, among other activities, into a carpentry workshop (Figure 9.4).

The space was presented as 'dedicated to making the most of unused spaces for the benefit of local communities' (Meanwhile Space CIC n.d.) and rapidly attracted a wide range of people, from passers-by to artisans and arts practitioners seeking a space to exhibit their work locally or to start a practice. The response to the pop-up shop was quite exceptional and proved to be one of the most popular meanwhile spaces; in the words of a Meanwhile Space organizer, 'at Whitechapel certainly we were bombarded with people coming through the door wanting to do stuff [...] everyone wanted to have a go' (Interview 1 July 2011).

The shop also caught the attention of members of the East London activist scene, for whom the neighbourhood and broader area were an established site of political activity and spaces, including nearby Freedom Bookstore, on Angel Alley, and the London Action Resource Centre (LARC) on Fieldgate Street. A recent history of squatted activist sites was also fresh in the collective imaginary. In particular, within a short distance had been located the recently evicted RampArt Social Centre (2004 to 2009), on Rampart Street, and Non-Commercial House (2009 to 2010), on Commercial Street, a squatted shop front used for meetings, film screenings, a bicycle repair workshop and a 'freeshop' to swap clothes and other donated objects.

A member of this scene, Ann, came across the Meanwhile Whitechapel pop-up shop in early 2011. As a young activist involved in a squatted shop front turned

FIGURE 9.4 Photograph of Meanwhile Whitechapel pop-up shop taken by the author on 26 February 2011.

social centre called Well Furnished (February to June 2011), in the nearby borough of Hackney, her experience is indicative of the imaginaries evoked by the site and its potential unintended readings. In March 2011, she decided to visit the shop to attend an event that combined a screening of the documentary by French independent filmmaker Agnes Varda, *The Gleaners and I* (French: *Les Glaneurs et la Glaneuse* 2000), with the book launch of *FREE: Adventures on the Margins of a Wasteful Society* (Hibbert 2010). Both film and book are explicit investigations of practices of re-appropriation of waste in contemporary Western societies. Varda's film is a journey through practices and histories of gleaning both in urban and rural France. Similarly, *FREE* is a critique of food and space waste in London based on the author's first-hand experiences of practices of 'skipping', i.e. salvaging food from bins, and squatting.

Thematically, the topic of reclaiming food and space going to waste perfectly befitted the frame of a vacant shop temporarily reclaimed for social and creative activities, and presented political overlap with Ann's own experience and interests as a squatter organizing a reclaimed shop front. The aesthetics and declared intentions of the pop-up shop, in combination with this particular cultural event and the wider frame of a neighbourhood, were easily associated by the activist with reclaimed urban counter-cultural spaces and their 'freeconomy' of recycling, reusing and redistributing wasted resources for free. She was therefore extremely surprised to discover that the event was ticketed and that the entrance would cost

five pounds. Reflecting on her disappointed expectation that the event be free, she described the way the project was presented as 'ambiguous' (Conversation 12 March 2011).

The incorporation of visual elements borrowed from DIY urban countercultures, combined with a localized recent history of temporary appropriations, raised expectations of a radical political space that were frustrated by the material arrangements of the meanwhile space. While Varda's documentary explores the legal, social and economic dimensions of gleaning as a pre-capitalist form of rural commoning (Linebaugh 2004), the space where it was screened celebrated ideas of appropriating urban 'waste' while remaining firmly within the sanctioned boundaries of event organizing and legalized spatial use. Ann's reaction to the ambiguity of the situation and her unintended reading thus signal an important tension between the aesthetics and the economic and legal conditions of the pop-up. Underneath a veneer of countercultural re-appropriation, lie a watertight 'meanwhile' legal agreement and a social enterprise economic model that are antipode to the radical critique of capitalist dynamics of enforced scarcity, and its subversion through direct re-appropriation, upon which squatted spaces are constituted.

Popping up in the Elephant

The second example of unintended reading of community-oriented pop-up shops refers to a series of temporary shop front projects that took place in the Elephant and Castle Shopping Centre, in Southwark. If in Whitechapel the interpretative reference point for activists was constituted by squatted pop-up shops and other radical political spaces, in Elephant and Castle the reading of the temporary shops was framed by the long-term local history of urban regeneration plans.

The Shopping Centre is a remarkably understated place on a very busy roundabout in the middle of the Elephant and Castle Opportunity Area, a zone designated by the London Plan for intensified redevelopment, which included the site of the now demolished Heygate Estate (London Borough of Southwark 2010). In the early 2000s, after years of semi-abandonment and lack of refurbishment, the centre was acquired by a real estate management and development company, with the aim to redevelop it as part of the comprehensive regeneration plans for the area. With the financial and credit crisis of 2008, however, the regeneration plans were stalled, and the Centre was showing a high presence of vacant units. As part of an attempt from management to counter negative perceptions of inactivity and danger, partly linked to the presence of the nearly vacant Heygate Estate, a string of vacant shops were leased rent-free on a temporary basis for practitioners and cultural organizations to deliver a range of public cultural and artistic projects.

Between 2008 and 2012, vacant spaces in the Centre were used for a variety of art and community projects ranging from pop-up theatre to temporary cinemas,

to community mosaics workshops and art exhibitions, alongside more institutional uses of the corridors to display visual materials as part of the various local authorities' public consultations around the proposed redevelopment plans. The visual appearance of many of these temporary shops reproduced the makeshift and 'slow art' aesthetics discussed earlier, and many projects used recycled and borrowed furniture such as benches, bean bags and second-hand sofas to create welcoming spaces.

Engaging with local residents was seen as a crucial component for many projects and artists, and organizers attempted to physically transform the shops into more open and accessible spaces. Yet, physical accessibility did not necessarily translate into openness, as was discovered by Kay, a visual artist who ran a short-term art project in one of the empty units in the summer of 2011. After noticing that many visitors would stand outside the windows and look in but would not enter her space, she explained: 'I opened up the big doors, and I opened all the doors so that it was, literally, people could just walk in' (Conversation 15 February 2012). Despite her action, 'what was really interesting was that people were then standing on the thresholds but they wouldn't . . . they wouldn't cross that. If I left them alone, they might, they might just cross over, and if I went talking to them they would just go away' (Conversation 15 February 2012). The gesture of opening all the doors and the active attempts to engage with 'the people who stand on the threshold' did not translate into people crossing the invisible boundary of the space and becoming the kind of audience that she expected. Commenting on what she perceived as a disengagement, she speculated on the ability of the audience to 'read' the space: 'There are some people who go "oh, it's an art show in a pop-up shop" and come in and have a look, and know what they are doing, know what to expect, that's fine. And then there're other people who just . . . don't know what to make of that at all, and so won't come in' (Conversation 15 February 2012).

In her interpretation, the likelihood of people crossing the threshold is based on different degrees of familiarity with the format of an art exhibition in a pop-up shop, which presupposes a certain familiarity with the discourses of temporary reuse. The people who 'know what they are doing' and who 'know what to expect', and engage with the space without any need for an explanation, are those who possessed the cultural capital to relate with the space and 'read' its intended role of temporary interruption. In fact, she even wondered whether to those who 'don't know what to make of' a pop-up, many of whom she identified as 'locals', 'having these spaces, these pop-ups . . . means anything' (Conversation 15 February 2012).

A different interpretation, however, was offered through the encounter with a long-term resident who voiced a different reason for the withdrawal from entering and participating in the staged experience of the pop-up. Rather than an inability to read the purpose of the temporary use, his response indicated a more complex reflection on the space in relation to the controversial regeneration plans and their private and public promoters. Of particular significance in this context was the

slow process of displacement and rehousing of the over 3,000 Heygate Estate residents. In Kay's recounting of her conversation with the man in the shop, she explained her frustration: '[H]e would not believe that I didn't have the plans for the Heygate [Estate] redevelopment. He wouldn't really . . . and I was saying, no, I am not part of the Council, you know, and this isn't the consultation xyz, this is an art project. I was a bit hurt that he couldn't tell!' (Conversation 15 February 2012).

Although she was aware of the uncertainties surrounding the plans for regenerating the centre and the area more broadly, and the perceived lack of a forum to confront and question the local council and developers, she felt that it was 'very odd' that local visitors would assume that she was 'part of the council' and that she must know about the recent development on the regeneration plans. By challenging the performative frame of the pop-up, the unintended reading produced by the local visitor and his questioning of the artist's position made visible the political implications of pop-up shops in the centre. In place of a performance of frictionless dialogue, it voiced the anxieties of local residents and traders affected by processes of displacement and redevelopment, as well as by the sense of uncertainty and lack of transparency that surrounded the regeneration plans. In relation to the plans to demolish or at least entirely redevelop the Centre, and contrary to expectations of exceptionality, the pop-up shop appeared as part of a strategy of temporary cosmetic interventions 'in the meanwhile'.

As critically argued by Vickery, community-oriented participatory practices in the context of regeneration are often enrolled to perform 'an act of symbolic integration' (2007: 77) against a backdrop of perceived or real social and economic exclusion. By not crossing the threshold and by questioning the practitioner about her relationship to the development plans, the visitors enacted a critical repositioning and withdrawal from the expected behaviour in the pop-up space as well as from its use as a device for the symbolic integration of a 'community' about to be displaced. Reading beyond the artists' intentions, the visitors' response pointed at the wider frame of the on-going agenda to reshape, with the redevelopment of the built environment, the social and cultural imaginary of the neighbourhood. In the context of the Elephant and Castle Shopping Centre, the temporary occupations of empty shops, with their ambiguous and carefully choreographed makeshift aesthetics and their affable attempts at engaging with the community, became easily aligned with the imaginaries of the coming redeveloped neighbourhood, and the activities of its 'consulting' promoters, as yet another sign of the gentrification to come.

Conclusions

Over the last two decades the relationship between community-oriented artistic practices and urban vacancy has become commonplace, partially thanks to the circulation of ideas of 'creative cities' and culture-led regeneration; tactical

urbanism, to which pop-up shops belong, has become the new vernacular of creative city discourse (Mould 2014). This vernacular of urban activities and associated sanctioned meanings has been spreading simultaneously at the level of practitioners and at that of policy makers and city promoters. Its success derives from its character of mobile paradigm for urban interventions that are easy to translate and apply to cities at many different scales across the globe.

Pop-up shops and their 'imaginative reconstruction of the city' rely in their performance on a similarly mobile gaze. From private to public and public–private sector schemes, from self-initiated to policy-backed initiatives, the narrative of DIY appropriation of 'wasted spaces' presupposes a familiarity both with established global cultural tropes and with newly promoted urban trends. Such an informed gaze, in turn, is expected to produce a codified approach to the pop-up shop, which is predicated on a shared understanding of the rules of participation in a temporary urban cultural event. Practitioners across London have internalized such expectations, and in the reproduction of a shared pop-up aesthetics presume an unquestioned legibility of narratives of urban interruptions and alternative city experiences.

In the course of this chapter, I have focused on embodied encounters and interactions across the reclaimed shop front in order to challenge expected readings by re-territorializing temporary interventions within localized processes of meaning-making. While there are significant differences between the social, cultural and economic positions from which the two unintended readings were produced, both unveiled the normalization at work in pop-up urban performance, and offered an entry point to expose a projected urban imaginary that attempted to sideline the conflicts and power relations inherent in the production of urban vacancy and its sanctioned temporary occupation. In the eye of the squatting community, emptied of its political and antagonistic elements the 'alterity' of the intermediary-led pop-up shop reclaiming of 'wasted' spaces revealed itself as one of appearances, but not of substance. Conversely, the community-orientation of the pop-up exhibition in Elephant and Castle was suspected of being complicit with processes of consultation, and of being aligned with the powers producing vacancy and preparing its re-occupation in the context of contested regeneration plans.

To conclude, the pop-up shop vernacular has become a recognizable visual and performative 'filler' of urban vacancy, at times of recession and beyond. The urban imaginary it projects is now familiar to a global urban cultural audience that is expected to question neither the power dynamics at play in the production of vacancy, nor the future uses of the site after the 'meanwhile' interaction. Yet, the analysis of everyday encounters through the space can reveal perceptive challenges to the role of pop-ups in situations of heightened urban transformation. Beyond the spectacle for the global gaze, a critical and situated analysis of local dynamics and histories enables to extricate the often contested thick cultural politics of spatial interventions and offer insights into processes and practices of informed

critique by those very communities and urban subcultures that temporary use practitioners gesture towards, but may be involuntarily complicit in displacing. Disappointment, withdrawal from participation, active questioning: the unintended responses to urban interruptions present a focal point that highlights the surfacing of conflicts generated by the double move of appropriating and emptying practices of unsanctioned and community-based spatial uses, within a framework and at the service of a continuous reconstruction of the built environment and imaginary of the city.

Note

1 Including the online *Art and Architecture Journal*, in the post Compendium for the Civic Economy, 13 May 2011.

PART THREE

BODIES AND SPACE

10 INTERRUPTION EXPANDED: URBAN PHOTOGRAPHY'S PERSPICACIOUS VIEW

Hugh Campbell

I

In his 1972 essay 'Understanding a Photograph', John Berger characterizes the instant in which a photograph is taken as a momentary disruption of time's flow. For Berger, it is precisely by virtue of this continuous flow that events develop in time and ultimately allow for their meaning and significance to be perceived and felt. By this reading, therefore, the photograph's act of disruption serves simply to confuse or confound meaning. In order to overcome this inbuilt limitation, and in order to achieve some success as an image, Berger suggests that the photograph must move beyond the specificity of its moment of making, and in so doing point to the larger significance of that moment.

'A photograph which achieves expressiveness thus works dialectically' concludes Berger: 'it preserves the particularity of the event recorded, and it chooses an instant when the correspondences of those particular appearances articulate a general idea' (2013: 13). For the prospective photographer, added to this burden of choosing the right instant is the challenge of framing that instant in such a way that its larger significance emerges. It all comes down to how and where you point the camera, and when you close the shutter.

If, by one reading, Berger's interpretation seems overly narrow and proscriptive, looked at differently it can actually be taken as a validation of the photograph as image. If isolated instants can indeed be made to resonate, to blossom into significant life, then this surely argues for the value, or even the necessity, of

capturing such instants in the first place. It can be argued that the techniques and equipment of photography are in fact predicated upon the ability to expand upon an interruption. There is a particular set of spaces, thresholds, apertures and distances built into the making of a photograph, and there is an equally rich combination of parameters at play in viewing that photograph. Even though all these layers can be collapsed into the instant the shot is taken, they are still present and active within the finished image. And even though the move to digital has further obviated many of the material dimensions of the practice, their trace persists both in the making and the viewing of photographs. Time and space are built in.

As if in response to the manner in which the frictionless instantaneity of digital photography makes this interruptive character less apparent, there has been much revisiting of analogue methods and technologies in recent photographic practice. And in many cases, the interest is precisely in exposing and experimenting with those spatial and temporal dimensions of the photographic image. The rediscovery of this spatio-temporal capacity of the camera apparatus can be seen as a critique of instantaneity, as manifest in the contemporary urban condition. If the global city of today is understood as the site of confluence of numerous varieties of flow, from the abstract to the physical and corporeal – a reading that, for all the critiques and qualifications that have built up around it since it was first proposed by Manuel Castells, has become almost unavoidable – then photography can be seen as cutting across, or 'brushing against the grain' of these flows. It might seem surprising, even counter-intuitive, to define as interruptive a medium so closely associated with instantaneity. And it is certainly possible to trace a history of photography that 'goes with the flow' rather than cutting across it, a history that would encompass Lartigue's early embrace of the giddying speed of sports cars and the social whirl and Garry Winogrand's immersion in the torrent of New York street-life. But what is explored in this essay is a photography that is more perspicacious, that cuts into the flow and then steps back to observe what has been revealed.

What also comes to the fore in this essay is the way in which the photographic process allies itself with individual conscious experience. An equivalence is established between the formation of the image within the camera and the registering of experience upon the mind. Thus, simply by virtue of its mode of operation, the camera acts to instantiate within the public realm moments of private experience. The interruption that photography performs might best be thought of as a kind of fold or pocket in what is often seen as a continuous, seamless fabric. Sometimes this sequestering of time and space happens within the making of the image, as is the case with Thomas Struth, sometimes it is more explicitly evident in the finished image, as in the work of the Cuban-American photographer Abelardo Morell.

II

In his practice and in his teaching, Morell has consciously revisited the roots of photography. The construction of a camera obscura has long served as his first assignment to photography students because, as he explains, although the effect is achieved by the simplest of means, and has been known for centuries, its capacity to induce wonder, even in the most knowing, sophisticated viewer, remains as powerful as ever. It is effortlessly disarming. And of course, it connects the students back to the physical principles of photography – the controlled introduction of light through a lens into a closed chamber in order to produce an image – while at the same time suggesting that the tools and techniques of photography, and by extension the discourse around it, might ultimately represent a kind of falling away from the richness and potency of this first iteration of the type.

In parallel, Morell has been working on his *Camera Obscura* series for the past 20 years. His *modus operandi* is first to transform a room into a camera obscura by blacking out all apertures for light save a small hole into which he inserts a lens. Then he sets up his camera and photographs the result, capturing, through long exposures of up to eight hours, the inverted image of the outside world projected

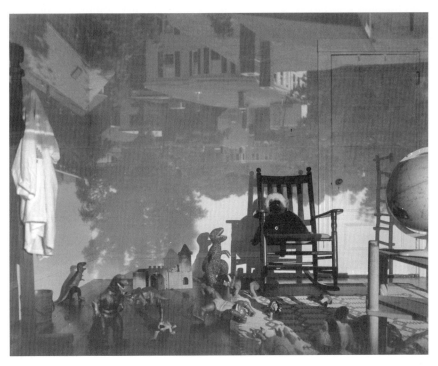

FIGURE 10.1 Abelardo Morell, *Brookline View in Brady's Room*, 1993. © Abelardo Morell, Boston/Courtesy Edwynn Houk Gallery, New York & Zürich.

through the lens onto the surfaces of the darkened room. The resulting photographs are both instantly enchanting and endlessly fascinating.

Among the earliest in the series, and the opening image in the 2004 publication *Camera Obscura*, is a picture taken in the bedroom of Morell's son, Brady (Morell 2004). Dropping from the ceiling down the walls, the presence of the suburban world immediately beyond – the neighbouring houses, the mature trees – is registered on the unassuming white surfaces of the room. The fact that this flood of visual data is inverted and seemingly uncontained contributes to its disorienting effect (interestingly, the impact is lessened if the photo is viewed upside-down). Two realms, one private and fixed in dimensions, the other untrammelled and expansive, are abruptly and completely conjoined. To this might be added a third: the imagined realm of play, established by the dinosaurs and castle distributed across the floor of the room, and enhanced by the play of images on the walls.

Watching the way in which his son interacted with the world, and constructed worlds within his head made Morell, as he puts it, 'look at things longer, with more love and tenderness' (Casper 2014). Whereas previously his work had pursued 'the decisive moment', as proposed by Henri Cartier-Bresson, now he became more interested in 'longer looking'. 'I started paying attention in a way I hadn't done before', he explains, 'living with the things in front of me' (Casper 2014). Even as the photographs in the series become less tentative in their technique and more spectacular in their execution, and even as the conjunction between interior and exterior becomes more extreme and dramatic, this underlying attentiveness to the given, and a related desire to dwell within the image, remains a constant.

A recurring trope in Morell's series finds a city panorama emblazoned on the walls and ceiling of a hotel bedroom. The camera obscura's long association with making available the grand urban view is well known (Patrick Geddes' Outlook Tower in Edinburgh is among the best-known examples). This urge to encompass and possess the city has often been taken as a natural extension of the camera's capacity to order and rationalize, but Morell's pictures speak of a different kind of relationship – not of ownership or command but of wonderment and awe on the one hand, confusion and bewilderment on the other. The sheer profusion of visual data, its lack of frame or focal point prohibits comprehension: submission and surrender seem the only options. What a strange thing it is to walk into a still space and find it suddenly and completely animated by traces of the world just left behind.

A useful point of reference here is Umberto Boccioni's famous painting, *The Street Invades the House* (1911), which depicts a dynamic scene in which the vast, unknowable urban realm presses right up against the private chamber. This image was made at a period of tumultuous urban growth, its very ungovernability a source variously of anxiety or exhilaration. For the Futurists it was more the latter than the former, and although it is not entirely clear which of these emotions the woman with her back to the viewer, facing into the urban tumult, is feeling, the

relationship to the city is clearly of a different order from that presented by, for instance, Gustave Caillebotte in his well-known painting *Young Man at His Window* (1875) from 40 years previously.

In the twentieth century, the urban room as a site of loneliness and alienation is a recurring theme, and the hotel bedroom, Morell's favoured location, could be taken to epitomize this set of associations. The grand hotel was a product of the age of rapid urbanization and has thus found itself pressed into service as an emblem of the new urban relationships and identities being produced. Sigfried Kracauer memorably described the Hotel Lobby as the modern antithesis of the temple, a place of anonymity and superficiality, betokening loss of identity (Kracauer 1995). More recently, the hotel has been presented by Maureen Montgomery and Douglas Tallack, among others, as a female, quasi-domestic space inscribed within the predominantly male world of the city (Montgomery 1998; Tallack 2005). The focus of such interpretations is almost invariably the hotel's reception rooms, but the same intimations both of anonymity and of private intimacy might equally be ascribed to the hotel bedroom (Avermaete and Massey 2013). In fact, the bedroom might be seen as the ultimate locus of this ambiguous character – a space possessing all the trappings of domesticity – the bed, the soft furnishings, the low light – but only ever transiently occupied.

In suggesting this essential equivalence between the room, the camera and the conscious subject, Morell's images act to enlarge our sense of how the city is constituted. Most often, the urban realm is taken to encompass only the space between buildings, but these pictures draw attention to the inhabited edge that surrounds and overlooks that space and is, on occasion, visible from it. Incorporating that one-room-deep layer into our understanding of the public realm draws attention to the private selves who ultimately populate it. As such, Morell's images act as an interruption to the view of public space as being the preserve of the undifferentiated urban multitude. They overlay one realm of experience – the public spectacle – upon another – private interiority – and point to their inextricable co-existence in the city.

Of course there are very practical reasons for which Morell has so often chosen hotel rooms as his location – they are hireable by the day, they guarantee privacy, they offer removal and elevation from one's surroundings. And in fact these same qualities all lend a deeper resonance to the resulting images.

Implicit in the use of such private rooms is the suggestion that they house a single occupant and a single viewer. With their juxtapositions of beds and larger landscapes, many of Morell's images seem to suggest that they are offering visual access to the world of imagination or of dreams, reinforcing the feeling that what is being presented is a single subject, a single consciousness. And yet, there are no people present in these pictures: they are merely records by one kind of viewing mechanism of the products of another. The conscious subject is absent. The camera acts as a surrogate recording device. No individual volition or agency is necessary;

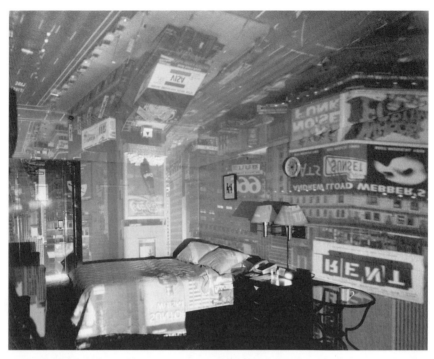

FIGURE 10.2 Abelardo Morell, *Times Square in Hotel Room*, 1997. © Abelardo Morell, Boston/Courtesy Edwynn Houk Gallery, New York & Zürich.

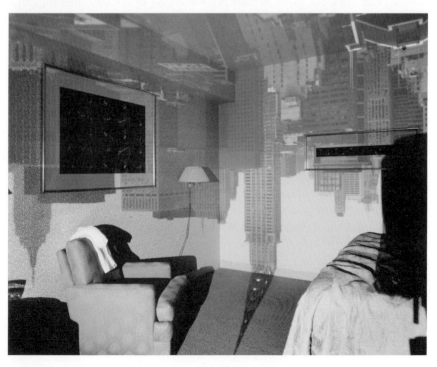

FIGURE 10.3 Abelardo Morell, *The Chrysler Building in Hotel Room, NY*, 1999. © Abelardo Morell, Boston/Courtesy Edwynn Houk Gallery, New York & Zürich.

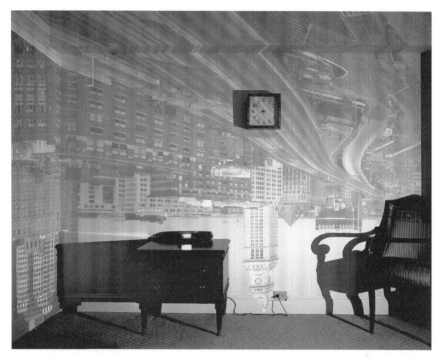

FIGURE 10.4 Abelardo Morell, *Boston's Old Custom House in Hotel Room, Boston MA,* 1999. © Abelardo Morell, Boston/Courtesy Edwynn Houk Gallery, New York & Zürich.

nobody bears witness and yet witness is borne. (Morell himself does not remain in the room during what is typically an 8-hour exposure. He tried it once, he recalls, but found it a near-hallucinatory experience.) What is portrayed is an automatic, recursive loop in which one camera sits inside another, seeing it in the act of seeing. This might be seen as a bleak, mechanistic view of subjectivity, but in fact it accords much more closely with some more recent interpretations of consciousness, which see it as something endlessly, automatically produced rather than something rationally constructed.

Morell has spoken of how these pictures represent for him a conscious 'turn inwards, towards private experience'. But perhaps what is really being set forth in these images is a more fundamental affinity between the room with its view folded back in upon it, and the experience of consciousness. The camera obscura has repeatedly been invoked as a metaphor to describe how the conscious subject perceives and experiences the world. When its use as an aid in painting became more widespread during the seventeenth and eighteenth centuries, so the parallel was more commonly asserted. John Locke, for instance, felt that human understanding was 'not much unlike a closet wholly shut from light, with only some little opening left . . . to let in external visible resemblances, or some idea of

things without'. '[W]ould the pictures coming into such a dark room but stay there and lie so orderly as to be found upon occasion,' continued Locke, 'it would very much resemble the understanding of a man' (Locke 1690). Rene Descartes famously made extensive use of the camera obscura in his elaboration of the relationship between the *res extensa* (the world out there) and the *res cogitans* (the inner world of the mind). The camera obscura became for Descartes an abstracted, ideal figure, establishing a clear distance between sensation and its perception. For Richard Rorty, Descartes and Locke shared 'the conception of the human mind as an inner space in which both pains and clear and distinct ideas passed in review before an Inner Eye. . . . The novelty was the notion of a single inner space in which bodily and perceptual sensations . . . were objects of quasi-observation' (Rorty 1979: 49–50).

This inner space was where the self was constituted as a sovereign subject – its point of reference not the world at large, but the world as it appeared in what Locke termed 'the mind's presence-room' (Locke 1690). Even as it made that world available, the camera obscura affected a break between exterior and interior. For Jonathan Crary, who provides an extensive critique of this tendency in his study *Techniques of the Observer*, the camera

> impels a kind of *askesis*, or withdrawal from the world, in order to regulate and purify one's relation to the manifold contents of the now 'exterior' world. Thus the camera obscura is inseparable from a certain metaphysic of interiority: it is a figure for both the observer who is nominally a free sovereign individual and a privatized subject confined in a quasi-domestic space.
>
> **CRARY** 1992: 39

Hence the camera became 'a model simultaneously for the observation of empirical phenomena *and* for reflective introspection and self-observation'. Crary offers Vermeer's paintings of *The Astronomer* and *The Geographer* as exemplars of a kind of ideal equilibrium between these two species of interior – that which is directed outward and that which is directed inward. However he notes how the model can also acquire 'a more self-legislative and authoritative function: the camera obscura allows the subject to guarantee and police the correspondence between exterior world and interior representation and to exclude anything disorderly and unruly' (Crary 1992: 81).

While it is not quite clear how this kind of editing might take place, it is nonetheless possible to understand how authority might be assumed over everything seen from the vantage point of the interior. Yet how closely does this kind of idealized viewing relationship, as adumbrated by Descartes and as achieved in such finely tuned spaces, accord with the altogether more giddying and disorienting experience of the camera obscura? Far from inducing sensations of calmness and equilibrium – of things being in balance – they seem rather to

disrupt the perceived order, literally to turn things on their head. In Morell's images the commingling of the world outside and the world inside appears far less susceptible to easy analysis, hardly fit to serve as an emblem for rational thought.

Locke may have had the shifting, immersive nature of the camera obscura experience in mind when he wished that 'the pictures coming into such a dark room [would] but stay there and lie so orderly' (Locke 1690). Crary duly interprets the camera as offering precisely that possibility. It would finally allow images to be fixed and contained and stands therefore as the logical endpoint of the development of perspective vision – a kind of seeing in which everything keeps its distance. In his iconoclastic history of modernist vision, *A Fine Disregard*, Kirk Varnedoe referred to the early cameras as 'little Brunelleschi boxes' (Varnedoe 1990: 65). Of course, the inherently perspectival nature of the camera has been mitigated by a myriad of technical advancements and practical innovations since, but nonetheless, the camera obscura, as witnessed by Morell, does seem to offer a more comprehensive breaching of that distance created by the technology that it inaugurated. Vastness is overlaid directly upon intimacy with no regard for where it lands. Images imprint themselves upon the space. But here the word 'images' does not feel appropriate – this is an impression of the world outside, in real and continuous time, being relayed within. It has not yet been framed and made available as an image.

To this extent at least, Morell's series might seem an affirmation of Berger's idea of the significant photograph as an expanded moment. The strategy of expansion clearly applies to the making of the image, in which a second camera sits inside the original and registers its working. The parallel layers of the process and the time involved remain present in the final image: these are understood by the viewer as photographs which required the manipulation of space and time to produce.

III

If the advent of the photograph seems to tame within a frame the unruly immediacy of the camera obscura experience, it does so primarily through collapsing the image on to the two-dimensional surface on which it will be affixed. The nascent image no longer occupies the entire darkened chamber – it is flattened. In the large-format camera, direct descendant of the camera obscura, this effect was made available to the photographer via the ground-glass viewfinder. To move between the scene as it presented itself to the eye and what appeared – inverted, framed, but still in motion – on the gridded screen was to witness an image coming into being. In this process, Berger's instant of disruption is extended to become a kind of contemplation of interruption. The photographer has time to consider every aspect of the scene and to observe the precise effect of the momentary break that will be caused by the shutter's closing.

The photographer Stephen Shore, who, at a critical moment in his career, moved from using cheap 35 mm cameras to medium- and large-format devices has spoken eloquently about the impact of the change in practice on his understanding of the built environment:

> In the field, outside the controlled confines of a studio, a photographer is confronted with a complex web of visual juxtapositions that realign themselves with each step the photographer takes. Take one step and something hidden comes into view; take another and an object in the front now presses up against one in the distance. Take one step and the description of deep space is clarified; take another and it is obscured. In bringing order to this situation, a photographer solves a picture more than composes one.
>
> **SHORE** 2004: 9

Shore was among the first to rediscover the potential of what had come to be seen as unnecessarily cumbersome and laborious technology. (In fact, it was its very cumbersomeness that he enjoyed.) *Uncommon Places*, the publication that resulted from his use of the large-format camera in documenting the North American built landscape, proved to be enormously influential, particularly in Germany, where it informed the practice of many of those studying under Bernd and Hille Becher at the Dusseldorf Academy.

One of the Bechers' most renowned pupils, Thomas Struth, certainly acknowledged this debt by echoing Shore's title in his first exhibition and publication, *Unconscious Places*. This series of scrupulous, contemplative studies of urban streets and spaces has since extended over 30 years and across a vast range of cities and settlements, and in so doing has gradually embraced colour film, digital technology and larger printing, but in its initial phase, the format was quite strict – black and white, single-point perspective, with an absence of people and a close attention to the built fabric. This rigorous, almost scientific method bears obvious comparison to the work of his teachers, the Bechers, but Struth's motivations were somewhat different, and his methods already more open-ended (Struth 2012).

In an early and typically perceptive review of Struth's photographs of New York streets, Peter Schjeldahl describes how

> as with most of Struth's cityscapes, there is an initial disorientation, a compound of absolute specificity of place and seeming arbitrariness in point of view. It is as if we were walking with a companion who abruptly stopped at a spot with nothing obviously special about it, facing ostensibly nothing much. Following his gaze, we slowly register that we are seeing, for lack of a better word, everything.
>
> **SCHJELDAHL** 1994: 84

To something previously overlooked, untoward attention was being paid.

Beyond noticing how the images bestow significance upon the seemingly unremarkable, Schjeldahl's particular insight is to connect the experience of viewing the pictures with the witnessing of their creation. For Struth, each photograph would involve repeated visits to the chosen location to understand the

FIGURE 10.5 Thomas Struth, *6th Avenue at 50th Street, New York, Midtown*, 1978.

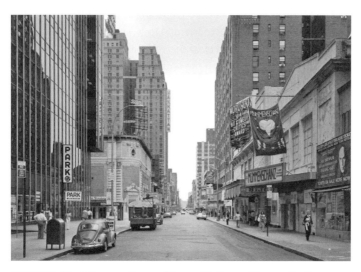

FIGURE 10.6 Thomas Struth, *West 44th Street, Theater D, New York*, 1978.

logistical challenges and plan the shot. Each would involve the mounting of the large-format camera in the middle of the street, most often in the early morning. And from that very exposed vantage point, Struth would duck beneath the cloth, to find the scene, in all its specificity and density of life floating, silently inverted upon the ground glass. There would follow the painstaking adjustments and calibrations, deciding ultimately what slice of time and space to freeze and print. This process, as much as the finished picture, is what endures for Struth. Thirty years after his image of West 44th Street was made, he remembers dwelling on how much of Yul Brynner's face on a billboard to keep within the frame.

Rather than interpret the strongly symmetrical, perspectival nature of this and other images from the series as analogous to the Bechers' documentary work, the term used by Armin Zwiene in his analysis, 'lateral inclusion', might be more persuasive and relevant (Zwiene 2010: 147). The finished image offers a slightly disembodied and yet generic viewpoint from which the scene in all the particularities of its form can be revealed, both sides of the street extending deep into the distance, detail intact. Struth's interest was in revealing the coherence within a given urban location, and then allowing that discovered coherence to assume a psychological and socio-historical significance. He has cited Wolfgang Kohler's *Gestalt Psychology* as one of his key reference points. In that now-classic volume, Kohler develops at length his theory of sensory organization, taking issue with William James's assertion that 'original sensory experience is uniformly continuous, and that all cuts and boundaries are later introduced into the field for pragmatic reasons', arguing instead that the sensory field is composed of sensory units (constellations in a starry sky is the example he gives) that are immediately identified in relation to each other (Kohler 1929: 80). Thus the parts are, and remain, distinct within the whole they come together to form. Fritz Perls called this coherent whole the 'ultimate experiential unit', and focused his Gestalt therapy on assisting patients in attaining a clear view of this 'ultimate unit'.

Perls was equally concerned with the temporality of consciousness:

Nothing exists except in the here and now. The now is present, is the phenomenon, is what you are aware of, is that moment in which you carry your so-called memories and your so-called anticipation with you. Whether you remember or anticipate, you do it *now*. The past is no more. The future is not yet. . . . Nothing can possibly exist except the now.

<div align="right">**PERLS** 1969: 41; emphasis in original</div>

The challenge, for Struth, is to somehow abstract this 'now' from the continuum of time and assert its significance.

The resonance with Berger's definition of the significant photograph is clear. Struth seems to be aiming precisely for the kind of expanded instant which Berger adumbrated. Added to what might be thought of as the socio-historical register is

a psychological dimension, which posits these pictures, just as surely as Morell's, as analogues of individual subjective experience. Morell's room is a camera which transposes and traps the urban flow. Struth's camera constructs a contemplative frame within the flow itself.

IV

Returning, finally, to the theme of interruption, what might be said of both Morell's and Struth's images is that they disrupt the continuous flow of the contemporary urban condition by drawing renewed attention to the status of sovereign subjectivity. Whether setting up a view in the midst of the urban scene or absorbing it from a chamber at its edge, both involve stepping out of the scene in order fully to register it. Paradoxically, this stepping out actually facilitates a deeper engagement. In the case of Struth, the interiority of private experience is transposed into the public realm, whereas in Morell's images, the public experience is impressed upon the private realm. The effect is to remind us that the often undifferentiated flow of city life continuously sustains, both at its edges and in its midst, a myriad of miniature interruptions. Just as the material world can be demonstrated to consist mostly of empty space, at every scale from the microscopic to the cosmic (the point is made most eloquently in the Eames' film *Powers of Ten*), so even the most open and frenetic of urban milieus is in fact composed chiefly of private pockets of experience. And if John Berger's emphasis was on the capacity of the photography to convey the larger significance of events, what this essay has tried to elucidate is the camera's continued allegiance to private experience, as played out in the contemporary global city.

11 BUILDERING, URBAN INTERVENTIONS AND PUBLIC SCULPTURE

Bill Marshall

In John Boorman's 1985 film *The Emerald Forest*, his son Charley plays blond Tommy, abducted as a young child by an Amazon Amerindian tribe, and in the end remaining with them. In many ways the film fits into a pattern becoming visible in the 1980s and 1990s, when the waning of credible alternatives to capitalism in the popular imagination of western film audiences was accompanied by forays into a would-be dissident 'eco' genre often associated with indigenous peoples, be they in art cinema (*Where the Green Ants Dream*, dir. Werner Herzog, 1984; *Until the End of the World*, dir. Wim Wenders, 1992), or in liberal Hollywood (*Dances with Wolves*, dir. Kevin Costner, 1991; even the later *Avatar*, dir. James Cameron, 2009). What these films have in common is to bind narratives of dispossessed or threatened native communities with spectacle, of the natural scene and often of an individual bodily accomplishment involving modern westerners learning or re-learning sensory, cognitive and imaginative relationships with territory and planet. In all these texts, flows associated with globalization, conquest and rapid transformative upheaval – exemplified by mining companies in Australia, the proliferation of digital images, westward American expansion, extra-terrestrial dispossession and exploitation – are interrupted in favour of local and indigenous agency, and by alternative belief systems and ways of seeing.

Towards the end of *The Emerald Forest*, the now teenage Tommy travels to Manaus to enlist the help of his American biological parents to intervene, in order to protect the forest territory where he had been brought up by the Amazonian tribe from rapacious economic development. In the city, he is faced by the tower block in which they live, and promptly starts to climb the exterior, having tied his lower legs with torn fern branches, after carefully touching and assessing the

FIGURE 11.1 Still from *The Emerald Forest* (dir. John Boorman, 1985).

concrete surface (Figure 11.1). The scene is photographed in a developing sequence of point of view shots, angles and camera distance, beginning with a mobile camera reproducing Tommy's view as he approaches the flats, continuing with shots from below the back of Tommy's body as he ascends, the camera moving to encompass the building's complete vertical sweep. A transition shot halfway up puts the viewer in the same plane as Tommy as he looks around, with cityscape and river in the background, and the sequence ends with a shot of him from above as he climbs over the balcony of the parents' apartment, an arrival anticipated by the shot of the father (Powers Boothe) awakening.

The sequence forms a nexus of issues that inform what follows in this chapter. One is thematic, in that the act of unauthorized climbing without ropes, harnesses or other 'modern' support – what is now known as 'buildering' (combining 'bouldering' and 'building') – is made to coincide with non-habitual perceptions of the city, including indeed interruption (Tommy's climb takes place at daybreak, amid silence and empty streets, no doubt for narrative purposes – no distraction involving the public's or authorities' reaction to the event – but also to maximize the contrast with the urban scene and the frenetic chase and fantasy sequences that precede it). But the other is formal, as the question is raised of how to film and photograph this activity. The dominant image is that of the – momentarily anonymized – figure of Tommy from below and behind, strikingly human in the context of the extraordinary ascent and the contrast with the inert skyscraper, but also blurring the human/animal/nature distinction in the prevailing absence of 'face' and the extreme long shot that has him clambering like a monkey, lizard or insect. In this shot (Figure 11.2, the like of which is very common in buildering photography, see Alex Hartley's Figure 11.3 for an explicit zoological but still urban parallel), the framing trees both summarize the nature/city contrast and fold the former ambiguously into the latter, a movement anticipated by Tommy's earlier messy traversal of balcony pot plants. It is only in the sequence's moments of

FIGURE 11.2 Still from *The Emerald Forest* (dir. John Boorman, 1985).

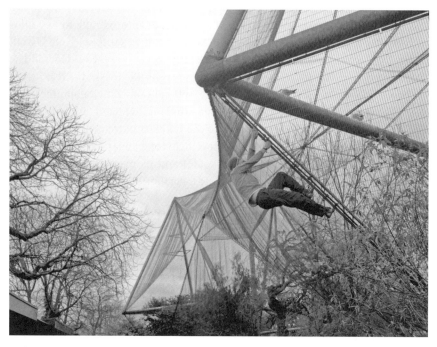

FIGURE 11.3 Nature/city contrast in buildering. Photograph by Alex Hartley, courtesy of the artist.

identification – the film spectator with Tommy's expressive reaction, the (re-)entry into the birth family space – that 'face' returns to play its customary role, in Tommy/Charley Boorman's case a dominant one in this film.

If this sequence from *The Emerald Forest* is an example of buildering *avant* (or rather *sans*) *la lettre*, the term (the *Oxford English Dictionary*'s first entry for it is

from 1977) is very much part of a contemporary, self-conscious exploration and practice: 'Building, [*sic*] now pursues the purity of movement, surface, texture and line in the context of the built environment. It now focuses purely on the phenomenal characteristics of the architecture, on its composition of planes, surfaces, textures and their relationship and accessibility to the physical form of the urban climber' (Hartley 2003: 7).

Historically, its origins lie in two sources: the privileged undergraduate youth of Cambridge colleges (Geoffrey Winthrop Young, *The Roof-Climber's Guide to Trinity* ([1900] 2011); Whipplesnaith, *The Night Climbers of Cambridge* ([1937] 2007) – university campuses are still favourite sites for this activity); and the vogue for climbing the new skyscrapers of New York and Chicago between 1915 and 1920 and later. Figures such as Harry Gardiner ('The Human Fly') attracted huge crowds and notoriety in this period of the reshaping in modernity of urban landscapes, a reshaping coextensive with the moving image and its sites of consumption, mapping the experience of urban life in key films such as *The Crowd* (dir. King Vidor, 1928) and *Safety Last!* starring Harold Lloyd (dir. Newmeyer/Taylor, 1923). With city ordinances and federal law restricting the activity (even if one of its points was its illicitness), the resurgence of buildering as a now well-established sub-cultural activity, proliferating on websites such as buildering.net, urban-climbing.com and also of course YouTube, is partly linked to the spread of the parkour movement in the 2000s. Questions we need to ask include the specificity of buildering within this, in terms both of the practice (vertical parkour?) and its manifestations in visual urban culture; to what extent the term can be metaphorically prolonged to include other interruptive modes of placing the human body in the built environment; and what is at stake culturally and visually when the climbing takes place not on the sides of buildings but on, for example, urban sculpture. How, then, does the contemporary practice of buildering, and its visual representations, navigate that tension between, on the one hand, partaking of global flows, spectacle, and an urban vertical environment generated by capital's surpluses and, on the other, offering a pause that is creative in terms of both spatial and temporal perceptions?

Charms and perils of verticality

The second visual example that forms a starting point for this discussion, Figure 11.4, by the London-based photographer Andy Day, summarizes the risks, contradictions and beauty of one form of the representation of buildering, taken to its apex: namely, the end of the climb.

In previous work on parkour, which looked at Day's and other photographic artists' exploration of *traceurs* in preparation, flight and landing, I argued for the

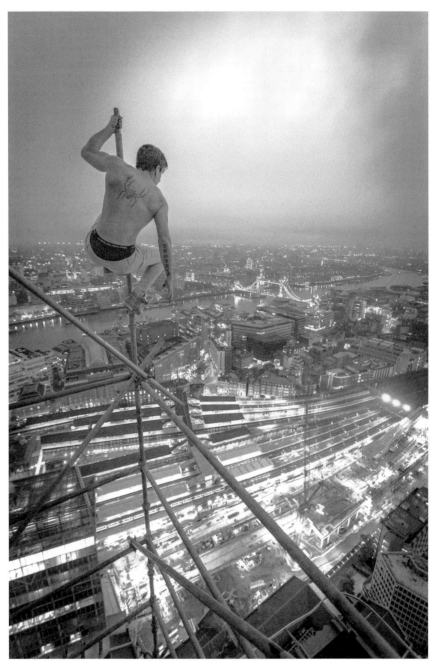

FIGURE 11.4 Ashley Holland, Guy's Hospital. Photograph by Andrew Day, courtesy of the artist.

symbiosis of parkour and photography in their alertness to new ways of looking at, and probing, the possibilities of the urban landscape, and their complicity in a paradoxical stillness and stilling created by the image and the decelerated and contemplative aspects of the action (Marshall 2014). Such still images have the overwhelming tendency to be shot from below, in a refusal of readings of the city that are either alienating/disorientating or panoptic, in favour of playfulness and rediscovery. Figure 11.4, however, would seem to draw us to two related aspects: the view, and the triumphant, posed shot of the climber looking out that partly mediates it. Let us juxtapose this image first with Michel de Certeau's famous counter-example or foil to his celebration of narrative, text, *parcours*, tactics and poaching, in the view from the World Trade Center in Manhattan, which implies domination and the world of abstract (administrative, financial) grids and strategies:

> The 1370m high tower that serves as a prow for Manhattan continues to construct the fiction that creates readers, makes the complexity of the city readable, and immobilizes its opaque mobility in a transparent text. . . . Is the immense texturology spread out before one's eyes anything more than a representation, an optical artefact? It is the analogue of the facsimile produced, through a projection that is a way of keeping aloof, by the space planner urbanist, planner or cartographer. . . . The voyeur-god created by this fiction (. . .) must disentangle himself from the murky intertwining daily behaviors and make himself alien to them.
>
> **DE CERTEAU** 1984: 92–3

We would add for Figure 11.4 those elements of carefully staged male narcissism and indeed auto-eroticism – the shirtless body, the crouching pose in the manner of Spider-Man.[1] Indeed, for the person classed perhaps as the world's most famous builderer, or free solo climber, Alain Robert, all these aspects combine with a cult of spectacle, a to-be-looked-at (including the constant presence of his personal photographer, Emmanuel Aguirre) that accompanies the sense of conquest. Recounting how he hesitated to go the whole hog and mount the spheres that top Petronas Tower 2 in Kuala Lumpur, he writes:

> I suddenly have the conviction that the world belongs to me and I go for this last hanging obstacle (. . .). Two minutes later, I'm standing at the top, arms aloft, looking over (*dominant*) Kuala Lumpur.
>
> 452 metres above the ground, I have won my bet against death.
>
> I am still alive and I am happy.
>
> Happy to have once again conquered fear.
>
> **ROBERT** 2014: 3[2]

Needless to say, the spectacularization and helicopter-led media coverage, and the complicity with global and global-urban flows that marks Robert's sponsorships (and also, to be fair, his anti-globalization interventions), mean that the crowds gathered to watch his feats can only with difficulty be absorbed into narratives of interruption. An Alain Robert event is rather an extension of fairground and the cinematic traditions of spectacle and narrative (suspense in all senses), and hence is consistent with one of those origins of the buildering phenomenon in American cities as the modern age dawned.

The highly gendered nature of our Figure 11.4 also recalls a whole literary anthology, one that might be formed on the basis of 'the young man contemplating the city', even projecting himself into the city, from above and/or from a distance. The most famous of these, consistent with analyses of nineteenth-century modernity requiring 'an uncertain exploration of social space' (Moretti 1987: 4) through narratives of unexpected hopes and restlessness mediated by the figure of the 'youth', is perhaps that of the upwardly mobile student, Rastignac, in Balzac's *Old* [or *Father*] *Goriot* (1835):

> He went a few paces further, to the highest point of the cemetery, and looked out over Paris and the windings of the Seine; the lamps were beginning to shine on either side of the river. His eyes turned almost eagerly to the space between the column of the Place Vendome and the cupola of the Invalides; there lay the shining world that he had wished to reach. He glanced over that humming hive, seeming to draw a foretaste of its honey, and said magniloquently:
>
> 'Henceforth there is war between us.' ['A nous deux maintenant!'/'It's between you and me now!'].
>
> **BALZAC** 2013

To which we might add Thom Gunn's 1961 poem, 'A Map of the City', with its gaze upon London:

> I hold the city here, complete;
> And every shape defined by light
> Is mine, or corresponds to mine,
> Some flickering or some steady shine.
>
> **GUNN** 1994: 103

Or even Wordsworth's, 'Composed upon Westminster Bridge, September 3, 1802', written at the age of 32.

I invoke this *memory of looking*, as Figure 11.4 lends itself to a much more complex understanding than simply a reiteration of the panoptic, of the spectacular, and of masculine preening or self-*mise en scène*. For one thing, the gaze upon the

city does not directly reproduce a panoptic look down, for the cityscape is mediated by the look of the builderer, shot in roughly the same plane as the photographer, so that the lens and the viewer are looking at the climber looking. The ascent of the Guy's Hospital scaffolding has taken place surreptitiously, at night, with no other witnesses. The young climber is posing, but the slightly comic position of the pole between his legs, coupled with the low-slung jeans and the spider tattoo, confirms, this time in contemporary playful form, the motifs we noted in the shots of Tommy in *The Emerald Forest*: the human body seen from behind, the blurring of animal and human. Moreover, the view of the Thames also raises questions in relation to time.

The beauty of parkour is that, sidestepping the official itineraries of the city and defamiliarizing the objects and obstacles of its fabric, it both suggests new pathways and in doing so asks questions of that landscape from the point of view of the past as well as the future. This is achieved in several ways: the rediscovery of pathways and perceptions associated with 'the murky intertwining daily behaviors' at ground level, of, in Deleuze and Guattari's (1988) terms, 'smooth' (open, without fixed associations, nomadic, even pre-modern) rather than 'striated' (administrated, measured) space; the exploration of bodily abilities and powers supposedly left behind by modern life. The question for buildering is whether the charms and perils of its spectacular verticality, as we have seen, do in fact co-exist with the *delving down* that Walter Benjamin deemed crucial to the task of re-entering and exploring the dreams of the past – especially, but now not only, the nineteenth-century urban – and thus to awaken ourselves into history. In Hannah Arendt's terms:

> Like the pearl diver who descends to the bottom of the sea, not to excavate the bottom and bring it to light but to pry loose the rich and the strange, the pearls and the coral in the depths and to carry them to the surface, [Benjamin's] thinking delves into the depths of the past – but not in order to resuscitate it the way it was and to contribute to the renewal of extinct ages. What guides this thinking is the conviction that although the living is subject to the ruin of time, the process of decay is at the same time a process of crystallization ... [and that] some things 'suffer a sea-change' and survive in new crystallized forms and shapes that remain immune to the elements, as though they waited only for the pearl diver who one day will come down to them and bring them up into the world of the living – as 'thought fragments', as something 'rich and strange'.
>
> **ARENDT** 1968: 205

My argument is that buildering and its attendant visual representations are candidates for this process, first in the forms of the chronotope and of the haptic and, as we shall see later, in that of public sculpture.

The chronotope, according to Mikhail Bakhtin (1981), is a compressed understanding of space–time that becomes manifest in art and literature. Certain motifs and places can be saturated with specific senses of time and history, such as the road, the castle, the salon, the provincial town, the threshold and the public square. 'The young man gazing at the city' is another, so that Figure 11.4 not only maps the strata of history that are inevitably here juxtaposed (the medieval Tower, the bend in the river that was the crucible of imperial trade and power, the triumphalist Victorian engineering of Tower Bridge, 1980s' Docklands, the contemporary reconstruction of London Bridge station). *The photograph is enabled to do so* in such memorable fashion by the chronotope it shares with other representations and texts, thus unifying those juxtapositions. By making time and space fuse in the geography of a community (London, Britain, western culture, and why not that of builderers) at this point, 'Time takes on flesh and becomes visible for human contemplation; likewise, space becomes charged and responsive to the movements of time and history and the enduring character of a people. (…) Chronotopes thus stand as monuments to the community itself, as symbols of it, as forces operating to shape its members' images of themselves' (Bakhtin 1981: 84).

The builderer might thus be seen, paradoxically, as a pearl *climber*, analogous to the diver but finding those 'rich and strange' 'thought fragments' in a poaching from a *vertical* margin that reawakens past histories. Unlike Balzac's Rastignac, for whom the city view is a mere prelude to diving back into its spatial, social and economic dynamism, for the builderer the living in the moment of the climb itself, as we shall see, is literally capped by a contemplative condensation of time. To this is added the power of the photograph to represent the past of 'that which was' ('*le ça a été*') and will not be again, and even 'that which will be and has been', a future anterior, as the future of its past is encountered in the gaze of the viewer (Barthes 1980: 28), all to form a multi-layered temporal event.

The second form of delving down from the vertical (apart from the – literal – descent that climbing usually requires) is, more simply, that of the haptic. We saw its importance in the *Emerald Forest* sequence, and more widely the shot of the bandaged and chalked fingers of a builderer is now a favourite motif in photographic representation of the practice (see Figures 11.5 and 11.6, respectively by Cornelia Sick and Sebastian Wahlhuetter). Not only do these shots literally 'delve down' from a summit or higher position, thus re-marginalizing the viewing position as a point in the city rather than its strategic 'prow', they also invoke earlier and wider human histories of the body and the senses. Indeed, one of the founding texts of modern buildering, *The Night Climbers of Cambridge* (1937/2007), written by Noël Howard Symington under the pseudonym 'Whipplesnaith', in its function as guide to the practice of undergraduates illicitly climbing the edifices of Cambridge colleges, is literally gripping in its accounts, here involving the scaling of King's College Chapel:

As you pass round each pillar, the whole of your body except your hands and feet are over black emptiness. Your feet are on slabs of stone sloping downwards and outwards at an angle of about thirty-five degrees to the horizontal, your fingers and elbows making the most of a friction-hold against a vertical pillar, and the ground is precisely one hundred feet directly below you.

WHIPPLESNAITH [1937] 2007: 212

In fact, much of the buildering practice that occurs in cities takes place at modest heights, with groups of mostly young people gathering to support each other in taking time to explore techniques for scaling vertical surfaces.[3]

To summarize thus far: buildering, with roots older than parkour but closely connected with it, makes bodily reconnections with 'the natural' while interrupting the familiar and regulated rhythms and planes of the city. Its photographic representations do not break down the components of the activity, as in parkour, but are characterized by certain motifs: images shot from behind the climber, the tracking and recording of innovative body postures, visual animal metaphors, close-ups of hands and fingers, 'summit' and viewpoint shots. Despite the risks associated with a culminating viewpoint, the movement and its representations also offer renewed relationships with architecture and memory.

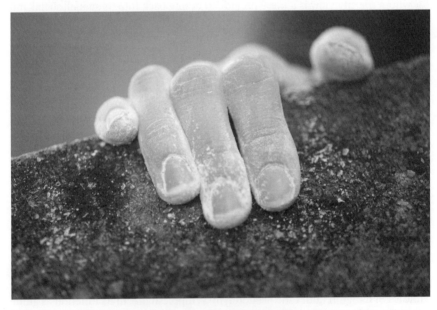

FIGURE 11.5 Builderer's grip. Photograph by Cornelia Slick, courtesy of the artist.

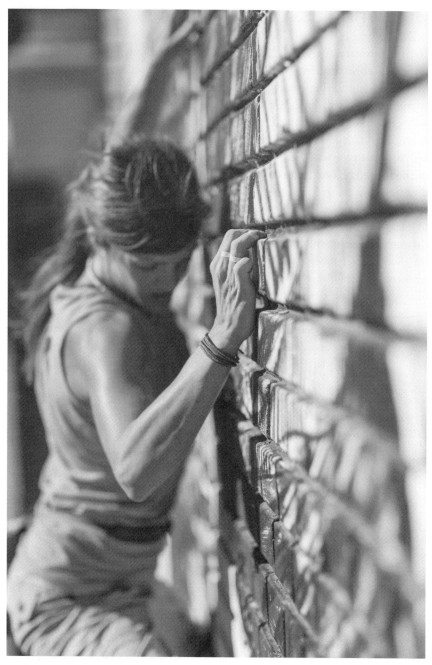

FIGURE 11.6 Scaling a wall. Photograph by Sebastian Wahlhuetter, courtesy of the artist.

Buildering as metaphor

During February to August 2014, the Cincinnati Contemporary Arts Center organized an exhibition, 'Buildering: Misbehaving the City', curated by Steven Matijcio and displaying work by twenty-two artists (or teams of). As the exhibition's pamphlet explained, the theme was 'the invigorating paradox of being an outsider on the inside – finding richness, inspiration and renewed optimism in surroundings made surreal' (a rather loose usage of the latter term), resulting in 'a romantic activism that re-asserts the strange, unwieldy, thoroughly *inefficient* presence of the human body (back) into built space' (Matijcio 2014). The show's elongation of the term 'buildering' can be roughly divided into three approaches. The first looks at the relationship between the human and the built environment from the premise of building material, form and liveability. The Cuban artistic duo Los Carpinteros (Marco Antonio Castillo Valdés and Dagoberto Rodríguez Sánchez) present an installation, *El barrio*, a tumble of cardboard sheds rising to the ceiling that perform the idea of a crisis-ridden urban *un*structure. The work of Alex Hartley here surfaces as a series of images, from his *Built Photographs* collection, of remote landscapes onto which he attaches low-relief scale model dwellings.

The second approach places the human body at its centre, in some cases mimicking the postures, shapes and representations of the urban climber in different architectural contexts. The French artist Etienne Boulanger maps in *Mesures* an aspect of his two-year experiment of living in Berlin rent-free, and consists of images of him using his body to identify cavities and crevices in which he might dwell, in what amounts to a 're-scaling' of the city; *Interstices* documents the fleeting dwellings he set up there. (Indeed, his activity parallels the alternative maps and *topoi* produced online by networks of builderers in cities and on campuses.) The German artist Sebastian Stumpf presents a series of exhibits in which his body, photographed or filmed from behind, takes its surprising place in the urban fabric. *Sukima* has him insert his body in narrow spaces in facades of buildings in Tokyo, a comment on urban overcrowding and the increasing incongruity of the human body in such spaces. The video series *Underground Garages* has him running towards descending garage doors, rolling under them just as they are about to close. In another video series, *Bridges*, Stumpf 'detours from the prescribed paths and normative behavior of the city' (exhibition notes) by leaping into water, in similar deadpan fashion. The American Lee Walton, in *Getting a Feel for the Place* and *Making Changes*, uses video to show, in turn, a project of touching surfaces and persons in a host city (in this case Belfast), and that of subtly altering the urban fabric by moving everyday props, 'interrupting the given order of his urban surroundings one playful violation at a time' (exhibition notes). The Hungarian Antal Lakman's fantasy line of Passive Working Devices, such as the haptic training machine in the guise of an ATM, or the moving walkway 'glider', 'resurrect[s] postures and actions that technological advance has rendered obsolete. (. . .) Taken

as a whole, his devices re-position an active, working body into the public sphere where process can be celebrated without being tied to a product' (exhibition notes). In all these cases, representations of the human body are involved in challenging re-assessments of scale, deviation and agency that plausibly mirror those procedures of buildering that re-place humans in urban space and architecture and renew perceptions of it. A technological realm of flows and ordered urban space that posits the human body as inefficient is here interrupted in favour of a celebration of the latter's incongruity and indeed subversive potential, just as the practice of buildering is able radically to recontextualize the body and reconnect with its abilities even within that given architectural fabric.

On urban sculpture

I wish to concentrate, however, on the third strand, which involves the relation between climbing and the role of public sculpture in public space. In London's Hyde Park, *Rock on Top of Another Rock* (2010/13), by the Swiss sculptors Peter Fischli and David Weiss, consists of two granite boulders seemingly precariously balanced on top of one another, measuring 5.5 metres in height (Figure 11.7). It is forbidden to climb on it (this does not deter builderers), but the contradictions of the licit and illicit are plain to see around this site. The Peter Pan statue in nearby Kensington Gardens is regularly festooned with climbing children and, to take another example, Sou Fujimoto's 2013 Serpentine Pavilion, consisting of a grid of white poles ascending upwards to form layered terraces, positively invited climbers, not only on the circles of transparent polycarbonate inserted to shelter from rain and reflect sunlight, and that rose upwards with the rest of the edifice, but in its resemblance to a gymnasium frame. Buildering photographs and videos frequently display acts of climbing on public sculpture, from Rotterdam to San Francisco.[4]

A striking example of this is of builderers on the pop art painted steel sculpture *Mistos* (*Matchcover*) by Claes Oldenburg and Coosje van Bruggen, inaugurated in 1992 in the run-up to the Barcelona Olympics (Figure 11.8). Located in the Vall d'Hebron district of the city, *Mistos* depicts, in striking yellow, red and a solitary 'lit' blue flame, a giant discarded match cover and its contents, with detached matches, some spent, some unspent, surrounding the central scene. As with the Olympic project overall and previous urban initiatives, the installation forms part of a (re)valorising of public space in the city in the post-Franco era, with an emphasis on abstract rather than figurative art, consistent with both a break with the politically unacceptable monumental past, and a contemporary re-branding of the city as a modernist mecca. In that respect, the site is part of a conscious, civic, even top-down strategy of creating a coherent visual image of the city, which pleasingly encourages and invites the visitor and stroller. Malcolm Miles, tracing the take-off of public art (as opposed to monuments and statuary) in national, regional and

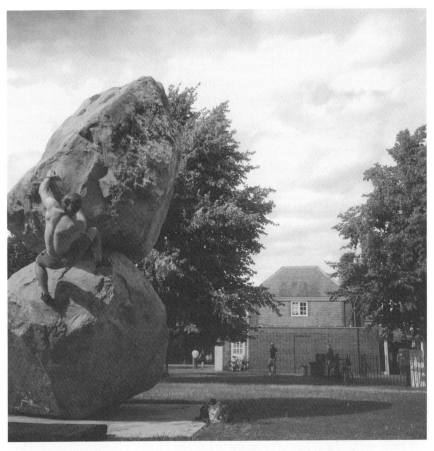

FIGURE 11.7 Bobby Gordon-Smith, Rock On Top of Another Rock. Photograph by Andrew Day, courtesy of the artist.

local policy to a decision by the USA's National Endowment for the Arts in 1967, asks about the implicit power relations:

> if public art represents to its defined or undefined publics a certain aesthetic order (the codes of which are determined by art's establishment), this aestheticizes but does not alter a power relation in which other codes of behavior and value are conveyed by public representation. The blandness of most public art advocacy conceals this, art being seen as noncontentious and of universal benefit, but the design brief will be as much an interpretation of the world for others (whom it assumes can make no such interpretation themselves, or must be prevented from doing so) as the selectivity of a national collection or – again – the decision as to which individuals and virtues are represented in public space.
>
> **MILES** 2008: 73

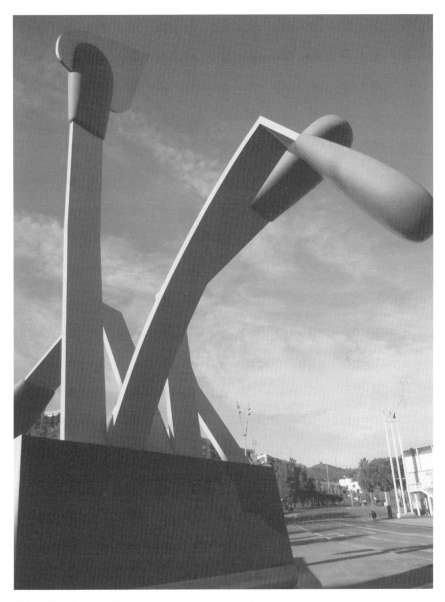

FIGURE 11.8 *Els Mistos*. Photograph by the author.

'Interpretation' of *Mistos* is fortunately plural: civic modernist rebranding via a well-established style by the artists that is non-site specific; a reference to Catalan national recovery via the erect flame and the flag colours, a reading enhanced by the contiguity of the recreated Spanish Republican pavilion at the 1937 Exposition universelle in Paris; references to Cervantes.[5] However, what confirms the site's place

in 'lived' (everyday, mental and practical) rather than or as well as 'conceived' (top-down, strategic) space, in Henri Lefebvre's (1991) terms, is the appropriation by the builderers. Exploring and matching body shapes to the contours, dimensions and surfaces of the site, and even, in the photographic image, contributing to and subtly altering its colour palette, the builderers launch new readings and new dynamics.

At the Cincinnati exhibition, two artists in particular produced radical interventions involving the ascent of public monuments that are otherwise unambiguously associated with order and control. The Colombian Ivan Argote in *Turistas* iconoclastically clothes with Andean ponchos monumental statues in Bogota depicting Columbus and Queen Isabella of Spain. Polish artist Kamila Szejnoch has a multi-part project, *Carousel Slide Swing*, in which she proposes 'counter-monuments' for the post-Soviet era in Warsaw. Here she draws on innovative work on German anti-fascist memorials in the 1980s and 1990s, including a column designed by Jochen and Esther Gerz in Hamburg that gradually disappeared into the ground as people added their names, with the idea of producing an internalized vigilance in everyone. This sense of the counter-monument worked 'against the traditionally didactic function of monuments, against their tendency to displace the past they would have us contemplate – and finally, against the authoritarian propensity in all art that reduces viewers to passive spectators' (Young 1992: 274). Extending this, we can see that any counter-monument is one that overturns conventions of memory that rely on fixity, and that demands interaction from the passer-by by becoming violable. Rather than interrupting the accelerating flows of the present, these projects interrupt an official regulation of the past and a community's relationship to it, i.e. memory, by promoting an active contemplation and engagement rather than a habitual and passive gaze.

Szejnoch conceived three projects in relation to Soviet war memorials in Warsaw: a children's slide forming an integral part of the Memorial to the Red Army Heroes in Skaryszewki Park; the redesign as a carousel of the Memorial to Brotherhood in Arms in Wilenski Square; and the attachment of a swing on the giant hand of the Memorial to the Berling Army soldiers in Okrzei Street (named after the Polish general Zygmunt Berling who commanded the First Polish Army, recruited from former deportees to the USSR, in its westward progress to Berlin during 1944 to 1945). Of these, only *Swing* came to fruition (Figure 11.9). Rather than erasing the respect for these sacrifices, it aims for a new interaction that renders more conspicuous the ambiguities of the object, partly allegorically (the big hand of history and the small individual; collective and individual memory in different layers and in different periods), and partly to comment on the potential that lies in all monuments that these artistic practices, and even interactions such as buildering, might bring out. Monument and counter-monument are not in opposition but

> are rather 'contained' within each other (...) a monument almost equals a counter-monument, as if they were mirror-images (...) they are engaged in an

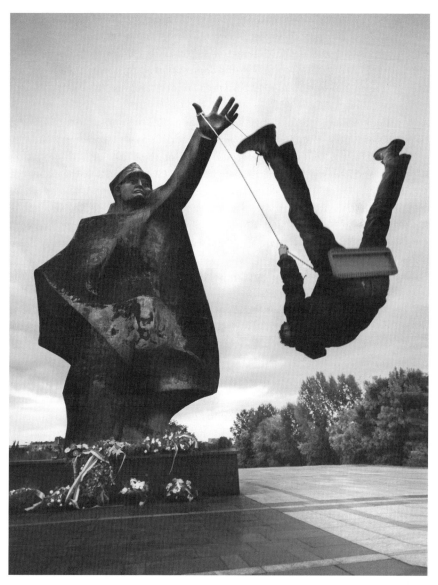

FIGURE 11.9 Kamila Szejnoch, *Swing*, installation, memorial to the Berling Army Soldiers, Warsaw, 2008. Courtesy of the artist.

'illicit' relationship. The counter-monument's validity lies not simply in its status as a new category, but also in the way it is 'exploiting' the monument. Besides (. . .) another theoretical question arises from the concept of the counter-monument, namely that a monument's meaning is not necessarily related to its form, but can be assigned (. . .) by 'us'.

VAN DER MEULEN 2004: 130

Szejnoch's practice can be and has been, therefore, understood as belonging to the generalized category of 'urban interventions' (Klanten and Hubner 2010), in which activist art and design interact with the built environment, locales and public spaces 'to question, refunction and contest prevailing norms and ideologies, and to create new meanings, experiences, understandings, relationships and situations' (Pinder 2008: 730).

My final example brings together questions of memory, monument and counter-monument, climbing, intervention, production of new memory and city branding. It is the traffic cone-adorned statue of the Duke of Wellington, on horseback and pedestal, in Royal Exchange Square, Glasgow, outside the Gallery of Modern Art (Figure 11.10). Located in the grand heart of the Victorian city where statuary of nineteenth-century worthies abounds, particularly in nearby George Square, since the 1980s the Duke's head has almost constantly been adorned with a traffic cone, the result of night-time and even day-time revelries. This is not a protest, nor a comment on the way in which eighteenth-century and then Napoleonic wars soldered British identity against the French, and it certainly has nothing to do with Wellington's other most famous historical contribution, the Catholic Emancipation Act of 1829. Rather, this artefact from 1844 demonstrates that

> the actual consequence of a memorial's unyielding fixedness in space is also its death over time: a fixed image created in one time and carried over into a new time suddenly appears archaic, strange, or irrelevant altogether. For in its linear progression, time drags old meaning into new contexts, estranging a monument's memory from both past and present, holding past truths up to ridicule in present moments. Time mocks the rigidity of monuments, the presumptuous claim that in its materiality, a monument can be regarded as eternally true, a fixed star in the constellation of collective memory.
>
> **YOUNG** 1992: 294

What has changed here is the nineteenth-century urban's attempt to produce orderly behaviour, and the contemporary city's to re-enact this and then adopt it for a branding strategy. When it was proposed in 2013 to heighten the plinth, as part of a restoration project but also ostensibly to discourage climbing and the now time-honoured adornment, not only did the city authorities withdraw the proposal in the face of a campaign of protest, several months later they integrated the artefact into the Commonwealth Games opening ceremony.

The saga of Wellington's traffic cone inserts itself obliquely, but I think meaningfully, into the account given in this chapter of the meaning of buildering and the extensions of its reach into artistic practice and urban intervention. The climbing needed to place the cone is largely completely anonymous, and even the snippets on YouTube display a lack of self-regard and often of individuality.[6]

FIGURE 11.10 Statue of the Duke of Wellington, outside Gallery of Modern Art, Glasgow. Photograph by the author.

The act of climbing and adornment is a bottom-up democratization of the artefact and the space, in which, indeed, it is 'brought back into the world of the living', with this significant 'sea-change', for what? Perhaps the clue lies in Sjoukje van der Meulen's hope that the meaning of a monument (and its counter-monument

shadow) can be 'assigned by "us"', and the unanswered question of who that – constantly to be elaborated – 'us' actually is. In this case, the meaning assigned is that, produced by irreverence towards the artefact, the past, and the urban coherence of the site and the monumental city centre, of *belonging*. Time will tell how the now habitual rather than defamiliarizing practice, with its invention of a new tradition ('It's a Glasgow tradition!', the cry is heard), will enter the future beyond its now all too coherent iconicity.

Even more than parkour, with its striking combination of contemplation and movement, self-improvement and a to-be-looked-at, the contemporary practice of buildering is an open text that resists a totalizing reading and, as we have seen, uses of the term are often elastic. Although possessing its ambiguities in relation to questions of privilege, collusion with spectacle, and institutionalization, it nonetheless offers a creative response – through the distinct, non-habitual mental and physical skills it demands – to regulated movement and to the limits imposed on the human body in modern environments. The other striking element of the instances here examined is that their interruptive practices, harnessing aesthetics, memory and space, all involve the production and reproduction or re-elaboration of communities – tribal, urban, national, sub-cultural – making deliberate interventions in their environments.

Notes

1 See, for instance, the fourth image at: http://www.positivegamereviews.com/2012/07/the-amazing-spider-man-review-is-spidey.html and the toy figure at: http://www.collectiondx.com/news_item/41408/kotobukiya_marvel_spiderman_3_artfx_statues

2 See also: 'Robert compares the feeling of completing a challenging climb to sex. "This is something pleasurable," he said. "I can't tell you it's exactly the same as having an orgasm, but, O.K., I did some stuff that has put me so close to my limit, it's a bit similar to a climax"' (Collins 2009).

3 As this video of such an encounter (part of a competition, in fact) in Vienna demonstrates: http://www.epictv.com/content/how-go-bouldering-city-epictv [accessed 6 September 2014].

4 For examples, see: http://pkazil.free.fr/heath_buildering.html and http://neverstopexploring.com/2014/08/07/alex-honnold-buildering-san-francisco/ [accessed 8 September 2014].

5 Most notably the lance and pen: http://oldenburgvanbruggen.com/largescaleprojects/mistos.htm [accessed 8 September 2014].

6 As, for instance, in: https://www.youtube.com/watch?v=-HkphzL5clM [accessed 9 September 2014].

12 INTERRUPTING THE STREET

Shirley Jordan

This chapter examines some recent investigations of the street in lens-based art. Its starting point is the connection between the street and the still image: photography has been bound to the dense minutiae of the street as firmly as the moving image has been bound to the open vista of the road, and the street – interrupted – has long constituted one of our key takes on the city. Pause to consider the incongruous notion of 'road photography' or 'street movie', and the deep-rootedness of the visual convention at once leaps out. Most of us have a fairly refined sense of what street photography 'is': a category of candid image, key to photography from its nineteenth-century beginnings, that freezes the flow of urban life, seizes fragments of it in public locations, captures the particularity of place, and seems to comment on the intermeshing of private and public experience in busy cities. We think of street photography as random and serendipitous, of the photographer as 'bystander' (Westerbeck and Meyerowitz 1994) lying in wait and capturing unexpected scenes dense with implied narrative, the kind that are famously referred to by Henri Cartier-Bresson as 'decisive moments'. Street photography helps to make cities legible. It documents, it tells us something about what it means to be an individual in a specific city, or sometimes about what it means to live in *any* city: that is, it encompasses the highly particular and at the same time generic matter pertaining to what we might call the urban condition.

In a recent study of young photographers, Nathalie Herschdorfer contends that 'the tradition of "street photography" seems to hold little attraction for [them]' (Ewing and Herschdorfer 2010: 26), yet the last two decades have seen renewed experimentation in the genre and a clear desire to tease out its evolving possibilities (see for example Baird 2011; Eskildsen 2008; Fried 2012; Howarth and McLaren 2010). New sub-categories and practices have been emerging that depict individuals on city streets in order, increasingly, to speak to our sense of rapidly shifting global

realities. Consider for instance how current experiments with staged or performed photography in works by photographers such as Isaac Cordal, Mina Tabizuran, Valerie Jouve or Denis Darzacq re-connect us more awkwardly and uncomfortably to the city, alluding in new ways to escalating perceptions of a generalized precariousness. The tiny concrete figures that Cordal implants in London streets for what he calls not photographs but 'interventions' could well belong in any city (Cordal 2011); his carefully choreographed scenarios are not about London *per se*, but are comments on alienation and enactments of our common fragility. As is the case in other recent artistic experiments with miniature human figures (Valli and Dessanay 2011), their frequently apocalyptic connotations militate against any suggestion of playfulness. Tabizuran's jarring images performed by individuals affected by the 2008 financial crash (Demos and Issa 2008), the disquieting and unnatural poses of Jouve's exaggeratedly frozen *personnages* ('*characters*' in English) (Jouve 2011), or Darzacq's now iconic photographs of French youths in peri-urban areas thrillingly suspended in mid-air (Darzacq 2007, 2009) are also staged images that reach beyond their context, and beyond documentary naturalism, to comment more broadly on conditions – such as anxiety, displacement or privation – that are widely shared at the start of the new millennium. In such images, the temporal interruption that street photography habitually enacts seems enhanced, redoubled, and draws attention to itself with a newly critical purpose (Jordan 2014). Street photography today, then, is sharply alert to the ideas, discourses and experiences of globalization and seems to interrogate these in a range of inventive ways.

This chapter critically evaluates some of the innovations associated with the street-based work of two key practitioners: Swiss photographer and visual artist Beat Streuli, and German photographer and visual artist Michael Wolf. The projects on which I focus destabilize traditional conceptions of street photography through their practices, technologies and aesthetics, as well as through the devices and formats devised by their creators to fold images from the street back into the street and display them there, re-implanting or looping them back into their place of origin. How are streets interrupted by permanent or semi-permanent outdoor installation projects, and to what effect? Does the election of a display context that is potentially more interruptive, and perhaps more democratic than the classic gallery environment, engender new models of spectatorship, new kinds of scrutiny of street photography as not *just* art to be gazed at on a white wall? And how do the street projects explored in this chapter demonstrate their self-consciousness of the global context in which they are made and exhibited?

Beat Streuli: reconfiguring the street

How does Beat Streuli reconfigure the street? My purpose here is to situate his work in terms of continuity and rupture in the evolving idiom of street photography,

to analyse the global consciousness of his corpus, and to speculate on the interruptive potential of his often surprising devices of curation and display. Like all good street photographs, Streuli's are arresting. He makes portraits of individual subjects, often young people, absorbed in their inner thoughts as they go about their business in densely populated city streets. Each is picked out sharply against the blurred urban surroundings and shallow depth of field that results from using a telephoto lens. This is not the kind of street photography that values the physical environment: urban architecture, signage, vehicles and street furniture are incidental; all that counts are the anonymous individuals momentarily revealed amidst the human flow. While there is certainly sufficient 'iconic noise' in, for example, Streuli's New York project (Streuli 2003) to make the city legible *as* New York, it is only the people on the sidewalk that are of interest, and it is they who are magnified, each one writ large in monumental portraits whose scale – several metres high and wide – is astonishing considering their quietly intimate feel. The staple street themes of the Baudelairean *bain de multitude* (the nineteenth-century city poet's notion of 'crowd-bathing' seems peculiarly apt to Streuli) and of the individual detached from the mass are re-articulated here with particular intensity. Streuli's innumerable untitled photographs of strangers take us aback not only by their sharpness and size but by their unusual quality of interiority. Randomly snatched they may be, but these are photographs that dialogue with fine art portraiture, harbouring the same inward-turning complexity and redolent with the same care and insight that derives from a slowly considered rather than a snatched relationship with the subject.

The second thing that strikes us is that Streuli works in series: he is less interested in the single image than in combinations, streams and flows. Curiously, as Raymond Bellour has observed, notwithstanding the large format that he favours and the tender regard for each individual that his camera invites us to share, none of Streuli's images ever really becomes an autonomous photograph (Bellour 2012: 316): the singularity of portraiture is less important than, and offset against, the question of number. In this regard, his art replicates conceptually the rapidly shifting private/public tension that fascinates us in the street. It is also determinedly egalitarian: each of Streuli's subjects is held at a similar distance, picked out with equal sharpness, writ as large as its neighbour, confirming that the photographer thinks very deliberately of the democratization of art, the image, and the gaze. Finally, Streuli's serialization also sets him in dialogue with Walter Benjamin's idea of mechanical reproduction: the photograph in his installations is a visual element or 'unit' that recurs, migrates, and is disseminated between different works, the overall organizing principle being a kind of pulsation between interruption and flow. Streuli's street photography, then, generates a distinctive aesthetic that sits somewhere between the documentary and the conceptual, and that is linked with the ideas of globalization that are an overarching preoccupation in his work.

FIGURE 12.1 Beat Streuli, *Bruxelles 05/06 11*, courtesy of the artist and Galerie Eva Presenhuber, Zurich.

If, as Streuli often tells us, he consciously sets out to explore and engage with the complexities of global reality, what are the manifestations and the terms of this engagement? First, the range of his images is manifestly global. They are taken in – and returned to – city streets from around the world, from Birmingham's New Street (the name of a real street in this British Midlands city that provided the felicitous title of a 2001 exhibition) to streets in Brussels, Tokyo, Krakow, Sydney, New York, London and elsewhere. Second, the images produced in each city typically allude to geographic mobility and migration: Streuli purposefully gravitates to conspicuously multicultural streets where he can make image sets that capture racial and ethnic diversity. This is clear, for instance, in his *Oxford Street* and *New Street* installations and in several series originating in Brussels, a favoured location thanks to the presence of immigrant communities in the city's centre, rather than their concentration on the periphery as in a number of other European cities. He takes pleasure in weaving images back into the spaces where they originated, inviting the dwellers of a particular city to an encounter with themselves. Streuli occasionally also engineers migrations of his own, inserting portraits of individuals taken in one locale into installations curated in the streets of far flung cities. The *New Street* exhibition, for instance, interspersed portraits from Birmingham with some from the streets of Castellón in Spain, the rationale for this intermingling being the parallels in the cities' size, the fact that both were deeply affected by the financial crisis and, a critical point, that both were

unspectacular and un-photogenic when compared with a Paris or a New York. And third, Streuli is patently fascinated by hubs of mobility and international travel, such as stations and airports. Indeed, his work is often installed at such locations, including the major global crossroads of the Schiphol, Frankfurt, Zurich and Dallas/Fort Worth airports, all of which have housed exhibitions of his urban portraits. The idea of a global photographic practice, then, involves in Streuli's case not just the subject matter, but the idiosyncratic and, I shall now argue, sometimes ambivalent spaces of exhibition.

Often Streuli's photographs are exhibited in gallery spaces, either as stills or rendered suggestively dynamic in massive multi-screen projection installations where successive images dissolve into one another. *Oxford Street*, for example, which ran at Tate Britain in 1997, consisted of a slow, soundless sliding between projected images of absolutely overwhelming scale, covering one long wall from floor to ceiling. Such syncopated exhibitions create interest in tempo, choreography and rhythm, unfolding the street somewhere between the still and the moving image, jostling the limits of each category and calling into question the complex correlation between photography, time and flow. Such installations within the dedicated context of art institutions are clearly instrumental in interrupting or renewing ideas of what street photography is. Even more interesting is the potential for interruption that emerges when Streuli's images are, as is his preference, worked back into city space and exhibited not in the hermetic environments of the art world, but out in the street itself. Here they generate new kinds of proposition that map much less neatly onto the encounter with the photograph as art work and that engage with other global systems of image production and display.

The idiom of Streuli's urban installations is the monumental and the commercial. His gentle photographs occupy vast billboards, light boxes and illuminated hoardings, pop up in everyday places such as bus shelters, or form wallpaper or window installations writ large on the facades of corporate or public buildings, sometimes covering entire structures. Typically, image sets are arranged into densely populated patterns, either linear or vertically stacked, declaring the photographer's interest in multiplicity and mutability and, as Jean-François Chevrier nicely puts it, disrupting 'the pathos of the fragment' (Chevrier 1993). Here their status becomes fluid: neither titled nor signed by the artist, they are unmoored, floating between categories, rubbing shoulders and competing with advertisements, and contributing to the seemingly endless proliferation of photographs *outside* the art institution. In this regard they appear to address the current status of photography in a digital world, its omnipresence and the problem of looking. It will be useful here briefly to enlist Walter Benjamin's distinction between 'concentration' and 'distracted consciousness', whose interest for considering urban space – and more specifically street photography – has been noted elsewhere (Baird 2011: 42–53). For Benjamin, 'distracted consciousness' refers to a necessary urban state, 'a mechanism for inhabitants of the metropolis to

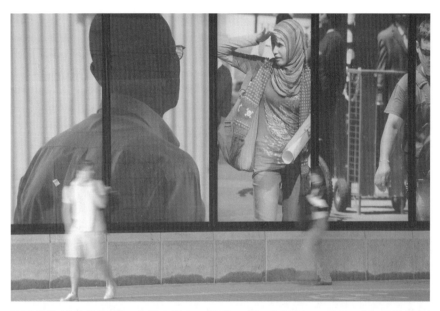

FIGURE 12.2 Beat Streuli, *Sint-Pieters Station, Ghent*, 2011, courtesy of the artist and Galerie Eva Presenhuber, Zurich.

deal with the oppressive intensity of modern life' (Baird 2011: 47). It is precisely this consciousness that is captured in many of Streuli's urban subjects. As far as the viewer is concerned, while the conditions for 'concentration' on his images are produced by their presentation as art in gallery settings, these conditions are deliberately jeopardized when the images are folded back into public space via familiar devices of urban display. The permanent street installation *La Voie publique* [*The Public Way*], which opened in 2011, is a good example to juggle with.

Part of the recent transformation of the Sint-Pieters railway station in Ghent, Belgium, *La Voie publique* is a 100-metre-long work running along the entire length of a tunnel wall, and made up of a vast stream of 58 juxtaposed lightboxes, each over 3 metres tall. Raymond Bellour, who spent time trying to look at the work, speaks of three ways of attempting to view it: as a pedestrian, as a cyclist, or from a motorized vehicle (Bellour 2012: 315). All are subject to constraints: the would-be spectator is either moving too fast, or is too close; the view of the work in this busy public way is disturbed, too immersive, of necessity interrupted. Such prohibition on adequate distance produces a kind of merging, a sense of co-existence or heightened enactment, rather than straight spectatorship. This installation is less a representation of street experience than a redoubling of it, achieved by threading through the street images of its own matter. Accordingly the title of the work is a kind of tautology, for the specificity of *La Voie publique* is that it *is* in fact a public way. We fly past or rub up uncomfortably close to the montage,

barely apprehending its individuals *as* individuals, just as we readily do with other pedestrians as we weave our way through urban spaces. Our own movement through the tunnel, where we glance momentarily at these people partially contained in frames, replicates our apprehension of a strip of film images or individuals in the windows of a passing train. The places and devices of installation are, then, important parts of the meaning of Streuli's work. Not only do his portraits, if we stop to look, reveal the condition of distraction as conceived by Benjamin, they also *reduplicate* it. Here, street photography (both of and on the street) is deliberately held in tension between the remarkable and, paradoxically, the invisible, as it morphs with the saturated visual culture of the city more generally. It challenges wilfully its own capacity to interrupt, to comment, to stop us in our tracks and, conceding its potential failure in that regard, is prepared to risk sinking back unremarked into the flow from whence it originated. This is consistent with Graham Clarke's comment that 'in a world dominated by visual images the photograph has become almost invisible' (Clarke 1997: 11).

A further dynamic contributing to the interlocking or embedding of Streuli's installations in their environment is their strategic use of gaps, transparency and light. These open, porous elements constitute an integral part of the photographer's language, and ensure that the street is not so much a backdrop or support, but rather a context that folds back visibly into the work. Thus the stream of lightboxes in *La Voie publique* is punctuated with clear glass so that the city's movements thread fluidly through it. Elsewhere Streuli makes frequent use of plate glass, applying to its surface massive images on transparent film that make ingenious use of its properties – notably of changing light conditions so that at night, when the interior of the building concerned is illuminated, these sharp images are brightly back-lit and vibrantly clear. The facades of the Chicago Museum of Contemporary Art (1999), the Wolfsburg Art Museum (2007), the Kiasma Museum of Contemporary Art in Helsinki (2008) and many others have been filmed-over by such see-through images, as if proposing that we attend to the very question of looking. Streuli's formats ask us what looking in the street means, how it is different from looking in other environments, and foreground the tension between looking 'through' and looking 'at' that is part of any act of looking in our super-semantically charged urban environments. These windows encourage us to do both simultaneously, while remaining aware of the condition of 'distracted consciousness' that I have already mentioned. They constitute one of the devices the artist uses to create space for looking, while at the same time reminding us of how our everyday environment is so dominated by the image that we sometimes fail to notice it. Despite the implied complexity of their inner lives, the tender regard for them that Streuli's portraits seem to solicit, and the vast scale to which they are magnified, the subjects of these installations teeter vulnerably on the brink of invisibility.

One particular photograph by Streuli sets up a wonderfully casual visual joke, which seems to me to allude to the difference between his very distinctive practice

and that of much other street photography. I have dubbed this the 'shocking evidence' photograph and I will conclude the current section of this chapter with discussion of the ideas it generates. Taken in New York in 2009, the image shows a man of oriental origin clutching a folded newspaper whose legible headline, 'Shocking Evidence', is literally and figuratively central to the photograph, irresistibly inflecting its meaning in a way that reaches out to the whole of Streuli's practice. The image and its ready-made caption challenge us to ask what it is that Streuli is showing us. If photographs have routinely been thought of as evidentiary documents (Streuli's 2010 *Lucid Evidence* exhibition at Frankfurt's Museum of Modern Art engaged with this idea), then what kind of evidence do Streuli's portraits provide? Certainly not evidence of anything shocking, but rather an affirmation of the pulse of place and period, of ordinariness, of who we are now, of the way we look to ourselves. They are clearly evidence of the sustained emphasis in contemporary culture and theory on the immersive experience of the everyday (Highmore 2001; Sheringham 2009). Exhibited in urban installations they are also evidence of the status of photography as both art and marketing device (Smith 1999) since their formats and modes of display straddle disconcertingly both image types. Streuli has reported that people often respond to the paradoxically quiet merging of his photographs with advertising images by thinking that they are in fact just that: uncaptioned advertisements for some global brand or product so universally known that it need not be named or shown (Coca Cola perhaps, or Benetton). Instead, this 'empathetic voyeur' (Katz 2003: 205) seems intent on advertising city dwellers to themselves. Nonetheless, perhaps Streuli's work reminds us of how photographs, now so readily launched into global circulation, are always involved in commerce; how, for instance, our data is being mined as we use Facebook to share our own pictures of the everyday.

Streuli's work stands in ambivalent relation to this volume's core idea of interruption. The brief analysis that I have presented here began by asking how he reconfigures the street. The answer is complex. He certainly reconfigures the language of street photography. He also materially transforms the street by re-entering it and physically changing its make-up. Yet, as I have argued, we may question whether the presence of his images as they loop back into the street really reconfigures it at all. The street perhaps becomes more self-referential, its existing idiom reduplicated, magnified, perhaps somewhat disturbed, but rather than the hiatus that makes us pause and reflect, Streuli's appealing images readily meld with their environment in a mutually supportive excess of smoothness. At a 2013 seminar on vernacular photography in London's Tate Modern, the eminent scholar of photography history Geoffrey Batchen commented provocatively that most of the photographs produced today are not meant to be *looked* at. He asked: 'Why do we photograph when the image is no longer relevant?' It could indeed be argued that in Streuli's street installations, photography seems almost wilfully to undermine its own capacity to interrupt. While the trouble provoked in gallery

contexts by his extraordinary portraits is very real, out in the streets his installations appear to demonstrate uncritical collusion with the global urban condition. They are like the vast billboards presiding over flyovers that we see yet do not see. Paradoxically, the larger and more monumental his images are writ, the less noticeable they become and the more they seem un-obstructive of the ways in which global cities are being reshaped. In the last analysis, Streuli's often seamless redistribution of street photography back into the street might be read as an allusion to, and perhaps a demonstration of, art's current impotence as interruptive force and its inevitable complicity with neoliberal agents of globalization. As Fried acknowledges, the artist seems to proffer 'an anodyne version of universalist globalism' (Fried 2012: 245), which is entirely un-barbed. In the world's airports, his images speak to and are of a piece with the multicultural, mobile, commercialized and sanitized sleekness of the environment. If any irony is intended in such installations it is undeclared, and ultimately Streuli's global installations trouble us precisely inasmuch as they seem so little designed to trouble.

There are several important links between Streuli's work and the next project I discuss in this chapter, by the photographer Michael Wolf. These include a blurring between categories of photograph, an interest in the overwhelmingly indigestible torrent of everyday images by which we are routinely assailed, a fascination with the constantly re-calibrated tension between the acts of taking and looking at images, and a (necessary) engagement with rapidly shifting debates, technological and ethical, about the making, dissemination and uses of lens-based images as an integral part of the global condition. Both projects make us particularly mindful of the apparatus and technology involved in their making and dissemination.

Michael Wolf: *Street Views*

The global reach of Michael Wolf's city photography is clear, as is his eloquent charting of key phenomena that shape contemporary urban experience. From snatches of intimate lives glimpsed within Chicago's monumental glass-based towers in his *Transparent City* project (2008), to the haunting *Tokyo Compressions* series (2010) whose studies of suffocating entrapment in underground trains expand the idiom of subway photography (Campbell 2014), his urban photographs typically record a preoccupation with privacy and with density. Of particular interest for the current chapter is his fascination, shared with a number of other contemporary street photographers such as American Doug Rickard, Canadian Jon Rafman and Brussels-born Mishka Henner, with the potential for a new kind of street photography derived from exploring the city via the virtual world of the Google Street View mapping system.

The workings of Google Street View, which was launched in 2007, are common knowledge: the multiple 'eyes' of a remote nine-lens ocular camera fixed to a car or

other moving vehicle capture a continual stream of still images as they scour the world's cities. The rolling shutters produce images that are then stitched into panoramic views, and are available to navigate on-line. Although the project's image capture is mechanical and devoid of aesthetic purpose, Google has nonetheless been recognized as 'the most prolific street photographer today' (Howarth and McLaren 2010: 10); indeed Wolf's somewhat ironic suggestion that Google should be awarded a documentary photography prize came to paradoxical fruition when it was recognized in the Daily Life category of the 2011 *World Press Photo Awards*. But what more precisely is it about Google Street View that excites photographers like Rickard, Rafman, Henner and Wolf? There are a number of factors: the sheer potential of its immense archive of candid images; its ubiquity and unquestioned access to everything on the street; its genuinely global potential; the obscure and vaguely threatening dimension of its image-making and image-storing processes; and the fact that much of its content is consistent with the preoccupation in a significant part of photographic production in the last 40 or so years with the unremarkable, the slight, the deadpan, the 'nothing to see'. Street View also offers a unique opportunity for re-inventing *flânerie*. Wolf records his awareness of becoming a new breed of virtual *flâneur*, engaged in a twenty-first-century, indoor version of voyeuristic wandering with distinct phenomenological and political implications. Here, issues of the photographer's volition, skill, trademark style and special personal relationship with the city (very often with a particular city), as well as with the camera and with a sense of what street photography might be *as an art*, are inflected by sustained dialogue with this infinite, impersonal, mechanical and resolutely global resource. Rather curiously, fine-art engagements with Street View allude to the discovery of a new sense of freedom: Rickard speaks of finding it as a kind of epiphany (Hoby 2012; Rickard 2012); Rafman discovers in it what he calls 'the new sublime' (Hoby 2012), an idea related to the sheer vastness of its enterprise, to the uncanny, disquieting or outstandingly beautiful character of the images he derives from the data bank, as well as to the idea that he might be the first to gaze upon a given scene. Both are aware that in browsing they become part of a major project that connects the world. Henner meanwhile enjoys defying the conventions of traditional documentary photography in his Street-View-captured images of sex workers on rural roadside locations (a project shortlisted for the 2013 Deutsche Börse photography prize). These photographers also inevitably engage with the visual politics of what is referred to by many as a post-photographic age: issues of the status, ownership, appropriation, circulation and display of such digital images are raised in all of their projects.

Wolf's use of the Google database is interesting for two reasons, both of them connected to the way in which his *Paris Street View* project, begun in 2008, marks its own relationship to street photography as a genre. First, his procedure is to extract individual frames that show candid human moments, implicitly testing

their potential to exercise a similarly powerful attraction to that of classic street photography; second, he focuses on one single city, a global capital that not only has a particularly long and complex relationship with street photography, but that is often thought of as the genre's birthplace (Scott 2007). In so doing, he seeks to interrupt or reconfigure the relationship between the French capital and the photographic image. Wolf's relationship with Paris as photographic city is, we should note, conflicted: he settled there only reluctantly in 2008 for family reasons, and once *in situ* needed to find a way of working in a city whose visual fabric he considered to be exhausted. Precisely because central Paris has been so intent on beautifying and gentrifying itself, it has become too obviously photogenic, choked with clichés, devoid of the unruly, teeming and inventive fabric of Hong Kong (where Wolf also lives) and of what he sees as the visually inspiring unpredictability of Asia. In fact the copious visual heritage of Paris has become something of a deterrent for many of today's city photographers, who find themselves at every turn haunted by the memorable framings of an Atget or a Brassaï, a Cartier-Bresson or a Doisneau. This may be one factor inducing so many of the newer generation to explore the peri-urban rather than *intra-muros* areas.

Through Google, Wolf arguably re-invents Paris as photographic subject, shedding new light on the super-photographed city and shaking off altogether the dominant sense of it as heritage space. The very title, *Paris Street View*, in which 'Paris' replaces 'Google', pits the whole history of the City of Light as photographic spectacle against Google's un-aestheticized, un-differentiated recording of its streets, so that the word 'Paris' is emptied of its historic resonance. Google is indifferent to urban specificity; the very idea is muted if not evacuated in its project, and Paris is just one more place for the global Street View apparatus to chart. Indeed, although Wolf's images occasionally contain indicators of their context, such as street names, relatively few of them are recognizably in Paris. The subjects captured stand in relation to no architecturally identifiable backdrop; some of them could be anywhere in continental Europe, or sometimes anywhere at all. It is in part this interruptive, anonymized reading of the city *without* its immediately recognizable iconography that Wolf considers to be a kind of breakthrough.

I referred earlier to '*Wolf's* images', which begs two questions. One is that of ownership, of whether these interruptive images are borrowed, co-authored, or his alone (Wolf uses the word 'appropriated'). The other is that of how he actually works with Street View's raw material. To take pictures from the platform, he fixes his camera with a macro lens and focuses-in very closely – sometimes up to 2 inches away from the screen – to pick out tiny, specific details. Methodically, he has paced every street of this parallel Paris, combing the city centre in search of his own intriguing and ambivalent images in which narrative is suggested and invited. The crop here is critical: as Marc Feustel observes in a short article on Wolf, '[t]he crop and choice of angle have replaced the camera' (Feustel 2010: 53). The scale of

the final product is a further key factor making the pictures interesting and individual: the prints are disproportionately big – for instance, 1 by 1.5 metres (we see a connection with Streuli here inasmuch as intimate detail is blown up by both experimenters to a massive format). Unlike certain of the photographers who trawl this vast databank of raw material, Wolf is not just looking for an interesting scene to fit a particular category (Henner's street prostitution series, for instance): he is not merely lifting but interacting with and interpreting the visual material. It is acknowledged, in fact, that with *Paris Street View*, Wolf became 'the first street photographer of the online world' (Feustel 2010: 53), his screenshots receiving an Honourable Mention at the prestigious World Press Photo contest in 2011.

It will be useful to linger for a moment on one particular image. In an extraordinary example of serendipity, Wolf's trawl throws up an uncanny contemporary echo of Robert Doisneau's iconic Parisian photograph *Le Baiser de l'Hôtel de Ville* (*Kiss by the Hotel de Ville*) of 1950, a connection well worthy of a place in Jeff Dyer's wonderfully fertile exploration of the intertextual afterlives of

FIGURE 12.3 Michael Wolf, *Paris Street View No. 28*, 2009.

photographs, *The Ongoing Moment* (2005). Just as there is wry commentary about street photography embedded in Streuli's 'shocking evidence' photograph, so too there is wry commentary here; and just as Streuli sets up a contrast between the unrelenting stream of images by which we are assailed on the street and the quietness of classic portraits that are made to be singled out and reflected upon, so Wolf asks us to settle on this image. It is by now over-familiar and somewhat tired. Taken for a photo-spread about Paris lovers in *Life Magazine*, and featuring on calendars, posters and postcards the world over, it has become emblematic of Paris being branded as 'city of romance' and of a particular kind of street photography. As the rest of the street obligingly hurries past at various speeds, framing the moment of the kiss *as* a still moment and promoting at the same time the impressive architecture of the city, the idea of the serendipitous urban epiphany that we associate so strongly with the genre is re-confirmed, complete with the tension in street photography between public and private and the undeniable pleasures of voyeurism. As is now widely known, this, along with other of Doisneau's photographs, was in fact very precisely staged, a harbinger of the emphasis on conspicuous performance in much photography today.

The cropping of Wolf's un-aestheticized, untitled re-make of Doisneau's image is brilliant – a powerful geometry momentarily brings together three totally separate, private worlds: that of the man smoking a cigarette in the foreground; that of the lovers in the centre; and that of a faceless man in a suit carrying what looks like a bit of screwed up paper, every bit as enigmatic as the man in André Kertséz's famous 1928 image *Meudon*. Life traverses this photograph, spilling diagonally into and out of the frame, with the still centre of the turning world, the private/public kiss, in the middle. The sheer arbitrariness of this Doisneauesque composition amazes: who would have thought it? This couple, this man, this cigarette . . . In that regard the image does brilliantly what classic street photography has always done, but this should not blind us to the more powerfully critical dimension available in Wolf's super-pixellated picture. A series of jarring mis-matches between image types calls us to a new awareness. Notably, the image's poor visual quality ironically undercuts its aesthetic value, distinguishing it from the sharpness and detail not only of its forerunner but of that increasingly produced in contemporary urban photography by, for example, large format cameras. The quality renders the image somehow furtive. The scale to which Wolf blows up his adaptations is also jarring given their habitual slightness of motif and poor visual quality. Core to the meaning of the kiss photograph, as to the meaning of all the images in Wolf's series, is the staggering ambition of Google's mapping project and, linked to this, the rapidly evolving regime of digital image-making and circulation in which we are increasingly bound up. All the digital noise in the *Street View* pictures forcefully reminds us of their origin, as does Wolf's deliberate retention in many of them of the globally transferrable, homogenizing language of symbols devised by the Google Street View interface (see Figure 12.4). The

FIGURE 12.4 Michael Wolf, *Paris Street View No. 9*, 2009.

superimposed lines, arrows or other geometric shapes that add a further layer to the city's already semantically charged environment, superseding all other co-ordinates and levelling all cities, call for fresh approaches to reading the image. These new co-ordinates that interrupt our view of the street seem to fix, target or circumscribe subjects, underscoring their fragility not simply by virtue of their presence in the anonymizing urban mass, but by evidence of their enmeshing within a powerful global system that is beyond their control. In terms of the retention of what we might call 'Google noise' in his photographs, Wolf also occasionally enjoys incorporating the copyright notices that punctuate Google Street View at regular intervals, including in one instance, alarmingly, the inscription 'Google copyright 2009' on the Paris sky!

If the making of these photographs may be seen as an interruption of photographic regimes, their display is sometimes also deliberately interruptive. The *Paris Street View* project takes on further resonance as Wolf's images of ordinariness writ large find their way back into the street in outdoor installations, for instance in Amsterdam's Zuidas business district in spring 2010. The overlaying of everyday urban matter with more of the same has rather different effects from that operated by Streuli. The latter's sleek aesthetic, related as I have shown to both fine-art and the language of advertising, is far removed from Wolf's blurry, low-resolution pictures; and Wolf's massive boards, mounted on crude concrete plinths, break up urban space rather than smoothly slipping into spaces already ordinarily

allocated to photographs, such as hoardings. The massive scale of Wolf's work has a quite other set of meanings from that of Streuli: if both photographers build on the idea of a global image bank, the *Street View* project is nonetheless more clearly and overtly political. Encountering a monumental Google-produced image on display in the Amsterdam Zuidas, the passer-by might more readily have been jolted into considerations less about aesthetics than about the ethics of photography in the digital age. It is not only the candid nature of these images that raises such questions but, for example, crucial issues such as face-recognition technology. Wolf purposely foregrounds in many images the results of Street View's algorithm that automatically blurs human faces in a gesture towards safeguarding privacy, but which is far from fool-proof. His photographs sometimes capture places where it fails to operate, such as the kiss photograph, or conversely places where something in the image – in one instance the head of a dog – is blurred needlessly. The viewer in the Zuidas would also have seen evidence of a special sub-category of street photograph that was uncovered by Wolf's trawl: what have been dubbed the 'FY' pictures (see Figure 12.5). This cluster of photographs shows individuals who have taken cognisance of the Google cameras and who offer aggressive one-finger salutes in response (Wolf 2011). Concerns about privacy and about the massive might of Google's global image-making system are communicated

FIGURE 12.5 Michael Wolf, *Paris Street View No. 27*, 2009.

by these small, ineffectual gestures, which Wolf's project reveals to be a sign of our times. In retaining all the hallmarks of Google's Street View imagery, then, Wolf deliberately draws attention to (dare one say 'interrupts'?) its redoubtable potency.

Coda: from still to slow

This chapter began by underscoring traditional associations of the still image with the street and the moving image with the road. Contemporary lens-based art has however begun to interrogate the street not only by putting it 'on hold' in the photograph but also, driven by the search for newly revelatory devices and idioms that stand in keener relation to momentum, mobility and flow, by seeking to create works that operate in spaces of slippage between the still and the moving image. Streuli's animation of his monumental photographs in slideshow projections that favour multiplicity and syncopation over the value of the single image has already been mentioned. Reaching further in this direction, he began in the early 2000s to create digital videos of moving crowds in a range of global cities. Instead of excising individuals from the urban environment, this footage, once again taken with a telephoto lens, reveals them plunged within it, and allows Streuli to experiment still more conspicuously with rhythm and pulsation. This final brief coda explores in particular the effects of the slow-motion digital videos in which he decelerates the street's powerful surge, rather than freezing it altogether.

The installation on which I briefly focus here is Streuli's *Four Two Screen Projections* (2001 to 2002), a truly global immersive piece incorporating looped videos made in Sydney, Birmingham (UK), New York and Bangkok, the first three of these being shown at 33 per cent of the film's original speed. For the Birmingham and New York films a camera is placed at a fixed point, capturing randomly the upper body and head of whomever passes; for the Sydney and Bangkok films it moves slowly and erratically to focus in close-up on given individuals waiting, for example, at a bus stop. Streuli's mesmerizing footage is projected simultaneously on several walls, producing an all-round environment, the disorientating effect of which is compounded by the dislocation of soundtrack and image: his pedestrians go about their business in uncanny silence or accompanied by unsynchronized voices, chanting, music or sounds of traffic that have no apparent connection to what we see on screen. The net effect is one of powerful defamiliarization, but what more precisely are the revelatory virtues of Streuli's insistence on slowness as a form of interruption? Arguably, the strangeness and dislocation of temporality, spatiality, movement and sound produce a new sense of tension between the individual and the mass that is simply not available in the still image. The street's rhythm and mobility are made newly compelling. Slow-motion footage in, for example, the Birmingham film *The Pallasades* (see Figure 12.6) produces an impression that the

FIGURE 12.6 Beat Streuli, *The Pallasades*, 2001, courtesy of the artist and Galerie Eva Presenhuber, Zurich.

dense mass of walkers are gliding, or carried along on a liquid current, their head bobbing on its surface (Fried, for one, returns irrepressibly to metaphors of flows, streams and waves in discussing Streuli's videos (Fried 2012: 240–8)).

The powerful combination of detachment and dramatic intensity that surfaces when we view Streuli's still images in a gallery context is here redoubled: urban bodies engaged in ordinary patterns of movement become not just formally interesting, but, as familiar gestures are unaccountably endowed with grace, newly redolent with feeling. It is striking that few faces are impassive. Most are almost troublingly eloquent, the slow-motion films suggestively revealing a quality of interiority and intimacy that is habitually inaccessible on frenetic streetscapes: it is as if Streuli had set out to intensify, extend and modulate the sense of deep absorption in some inner world that photographers such as Walker Evans, or later Luc Delahaye, seek to make available in their studies of passengers on the underground. His slow-motion studies confirm with particular pathos the urban condition of anonymity, as they focus almost tenderly on specific individuals making their way towards the camera, their expressions beginning to create narratives often of concern, anxiety, or apprehension. In so doing, they achieve on the level of affect a similar feat to that brought about on a purely mechanical level by Eadweard Muybridge's pioneering stop-motion studies of human and animal

locomotion, whose revelatory force was intricately connected to the snagging of the image between stillness and motion. What they reveal of both the individual and the mass is, as Fried so rightly observes, 'literally inaccessible to normal vision' (Fried 2012: 245). Their genius lies in the tension they perform between an omnivorous desire to record everything as it streams indiscriminately by, and a nascent selectivity. The camera allows us to strike up relationships of intense curiosity with individuals who are briefly brought into startlingly sharp focus, rather like selecting partners in a dance (indeed, notwithstanding the randomness of what the camera captures, one is tempted to talk about choreography). The film *begins* to show an instinct to coalesce into still compositions, as if we were engaged with the photographer in 'seeking pictures in the flow of daily life' (Cotton 2004: 123), but these are never allowed to settle. Nonetheless, the still image inhabits Streuli's videos insistently; they are films that absorb and contemplate street photography precisely in order to interrupt its habitual regime and expand its expressive reach.

What is the net effect of the bravura experiments with street photography discussed in this chapter? Both Streuli and Wolf provide evidence of a new restlessness in this branch of lens-based art, as it repositions itself in an ever more conspicuously global world. Both are driven by a sense that something new needs to be done with the conventions of the genre in order to make it more relevant to, and revelatory of, life in twenty-first-century global cities. But beyond the baseline fact of photography's inherent putting the world on hold, what can be said of their respective capacity for interruption? Streuli's particularity, I have argued, is precisely that his art slides in and out of the gallery, in and out of other spaces of local and global transit, in and out of the devices and formats favoured by global brands as they market themselves in hugely seductive visual displays. I have suggested that such dialogue or interfolding with the aesthetics of corporatism gives pause for thought, not least when its absorption into the urban environment threatens its very visibility. Wolf's fleeting anti-Google gestures direct our attention very deliberately to the apparatus and technology involved in their making, and are by contrast conspicuously subversive. Their blurry, pixelated raw material is the very stuff recorded by the global giant, while the cluster of so-called 'FY' protest photographs are at the opposite end of the spectrum from Streuli's gently pensive, interiorized portraits. Both projects deliberately set out to explore what can result from artistic engagement with the broader spectrum of visual practices that currently prevail on the street. Both affirm the revelatory potential of the still and the slow, and both aspire to generate minor pauses for thought about what it means to live in global cities. In the last analysis we might indeed, however modestly, consider such pauses as interruptions.

REFERENCES

Acconci, V. (2009) 'Leaving Home: Notes on Insertions into the Public', in C. Doherty (ed.), *Situation: Documents of Contemporary Art*, London and Cambridge, MA: Whitechapel Press and The MIT Press, 135–6.

Agamben, G. (1998) *Homo Sacer: Sovereign Power and Bare Life*, Palo Alto: Stanford University Press.

Appadurai, A. (1996) *Modernity at Large: Cultural Dimensions of Globalization*, London: University of Minnesota Press.

Arendt, H. (1968) 'Walter Benjamin 1982–1940', in *Men in Dark Times*, New York: Harvest, 153–206.

Arendt, H. (2005) *The Promise of Politics*, New York: Schocken Books.

Arts Council England (ACE) (2009) *Art in Empty Spaces: Turning Empty Spaces into Creative Spaces*, London: Arts Council England.

Avermaete, T. and A. Massey (eds) (2013) *Hotel Lobbies and Lounges: The Architecture of Professional Hospitality*, London: Routledge.

Baetens, T. (2012) 'Casus Noord/Zuidlijn: van Klassieke Zendmast naar Spin in het Web', *Sociale Vraagstukken*, 14 December 2012, available at: http://www.socialevraagstukken. nl/site/2012/12/14/casus-noordzuidlijn-van-klassieke-zendmast-naar-spin-in-het-web/ (accessed 1 October 2014).

Baetens, T. (2012) *De Ingenieur en de Buurman: Communicatie Rondom de Aanleg van de Noord/Zuidlijn*, in opdracht van de Raad voor Maatschappelijke Ontwikkeling, The Hague.

Baird, G. (2011) *Public Space: Cultural/Political Theory; Street Photography*, Amsterdam: SUN.

Bakhtin, M. (1981) *The Dialogic Imagination*, translated by C. Emerson and M. Holquist, Austin: University of Texas Press.

Balzac, H. de. (2013) *Father Goriot*, translated by E. Marriage, available at: http://www. gutenberg.org/files/1237/1237-h/1237-h.htm (accessed 25 August 2015).

Baran, C. (2012) 'Rénovation Urbaine, la Success Story', *Le Figaro Magazine*, 24 March, 13.

Barthes, R. (1980) *La Chambre Claire: Note sur la Photographie*, Paris: Cahiers du cinéma/ Seuil.

Barthes, R. (2000) *Camera Lucida*, translated by R. Howard, London: Vintage.

Bathurst, M. (2012) 'A "Low Line" for London?', *Design Week*, 9 October, available at: http:// www.designweek.co.uk/news/a-low-line-for-london/3035377.article (accessed 27 December 2014).

Baudrillard, J. (2010) *America*, London: Verso.

Bauman, Z. (2000) *Liquid Modernity*, Cambridge: Polity.

Bellour, R. (2012) 'Mouvements, Glissements, Démocratie', in *La Querelle des dispositifs: Cinéma – Installations, Expositions*, Paris: POL, 314–21.

Benjamin, W. (2003) 'On the Concept of History', in *Selected Writings Volume 4, 1938–1940*, Cambridge, MA: Harvard University Press, 389–400.

Berger, J. (2001) *The Shape of a Pocket*, London: Bloomsbury.

Berger, J. (2013) *Understanding a Photograph*, London: Penguin.

Berry Slater, J. and A. Iles (2010) *No Room to Move: Radical Art and the Regenerate City*, London: Mute Books.

Berry, C., X. Lu, and L. Rofel (2010) *The New Chinese Documentary Film Movement: For the Public Record*, Hong Kong: Hong Kong University Press.

BETC (2014) Magasins Généraux in Pantin, *BETC LIFE* [blog], available at: http://www.betc-life.com/#/fr-inside/graffiti-general-est-arrive/ (accessed 2 August 2014).

Bey, H. (1985/2003) *T.A.Z.: The Temporary Autonomous Zone, Ontological Anarchy, Poetic Terrorism*, New York: Autonomedia.

Biehl-Missal, B. and M. Saren (2012) 'Atmospheres of Seduction: A Critique of Aesthetic Marketing Practices', *Journal of Macromarketing* 32 (2): 168–80.

Birdsall, C. (2013) '(In)audible Frequencies: Sounding Out the Contemporary Branded City', in C. Lindner and A. Hussey (eds), *Paris–Amsterdam Underground: Essays on Cultural Resistance, Subversion, and Diversion*, Amsterdam: Amsterdam University Press, 115–31.

Bishop, P. and L. Williams (2012) *The Temporary City*, London: Routledge.

Bissell, D. (2014) 'Commuting and the Multiple Capacities of Stillness', in S. Hemelryk Donald and C. Lindner (eds), *Inert Cities: Globalization, Mobility and Suspension in Visual Culture*, London and New York: I.B. Tauris, 77–97.

Bissuel, B. (2002) 'Jean-Louis Borloo Esquisse Son Plan Pour Une "Nouvelle Bataille de France"', *Le Monde* [online], 28 May 2002, available at: http://abonnes.lemonde.fr/cgi-bin/ACHATS/ARCHIVES/archives.cgi?ID=9498f770e524628e05abe62233498d391d8b73ae3ac73c8e (accessed 10 July 2013).

Blanco, M. del Pilar and E. Peeren (2010) 'Introduction', in M. del Pilar Blanco and E. Peeren (eds), *Popular Ghosts: The Haunted Spaces of Everyday Culture*, London: Bloomsbury, ix–xxiv.

Böhm, S. and C. Land (2007) 'No Accounting for Culture? Value in the New Economy', *Working paper No. WP 07/08, November 2007*, Colchester: School of Accounting, Finance and Management, University of Essex.

Böhm, S., C.L. Campbell Jones, and M. Paterson (2006) 'Introduction: Impossibilities of Automobility', in S. Böhm, C.L. Campbell Jones, and M. Paterson (eds), *Against Automobility*, Oxford: Blackwell, 3–16.

Böhme, G. (1993) 'Atmosphere as the Fundamental Concept of a New Aesthetics', *Thesis Eleven* 36: 113–26.

Böhme, G. (2003) 'Contribution to the Critique of the Aesthetic Economy', *Thesis Eleven* 73 (1): 71–82.

Bradley, S. (2012) 'History To Go: Oral History, Audiowalks and Mobile Media', *Oral History* 40 (1): 99–110.

Braester, Y. (2013) 'The Architecture of Utopia: From Rem Koolhaas' Scale Models to RMB City', in *Spectacle and the City – Chinese Urbanities in Art and Popular Culture*, Amsterdam: Amsterdam University Press, 61–76.

Brayer, M.A. (2008) 'Anarchy-architecton', catalogue *Fuegogratis*.

Brockling, U., S. Krasmann, and T. Lemke (2010) 'From Foucault's Lectures at the Collège de France to Studies of Governmentality', in U. Brockling, S. Krasmann, and T. Lemke

(eds), *Governmentality: Current Issues and Future Challenges: 1*, London: Routledge, 1–33.

Broudehoux, A. (2007) 'Spectacular Beijing: the Conspicuous Construction of an Olympic Metropolis', *Journal of Urban Affairs* 29 (4): 383–99, available at: http://onlinelibrary. wiley.com/doi/10.1111/j.1467-9906.2007.00352.x/full (accessed 25 November 2014).

Buck-Morss, S. (1986) 'The Flaneur, the Sandwichman and the Whore: The Politics of Loitering', *New German Critique* 39: 99–140.

Butler, B. (1996) 'The Tree, the Tower and the Shaman: The Material Culture of Resistance of the No M11 Link Roads Protest of Wanstead and Leytonstone, London', *Journal of Material Culture* 1 (3): 337–63.

Butler, T. (2006) 'A Walk of Art: the Potential of the Sound Walk as Practice in Cultural Geography', *Social and Cultural Geography* 7 (6): 889–908.

Butler, T. and G. Miller (2005) 'Linked: A Landmark in Sound, a Public Walk of Art', *Cultural Geographies* 12: 77–88.

Cabrera, E. and A. Cerdan (2013) 'Street Art à Pantin: Une Cathédrale du Graff Qui va Disparître', *Le Nouvel Observateur* [online], 14 September 2013, available at: http:// rue89.nouvelobs.com/rue89-culture/2013/09/14/street-art-a-pantin-cathedrale-graff-va-disparaitre-245641 (accessed 25 September 2013).

Cambie, S. (2010) 'Pop-ups. Part 1: Creating Micro-Tourism', *Tourism Insights*, available at: http://www.insights.org.uk, website archived in April 2010 (accessed online 15 March 2010).

Campbell, H. (2014) 'At the Still Point of the Turning World: The Power of the Urban Portrait', in S. Hemelryk Donald and C. Lindner (eds), *Inert Cities: Globalization, Mobility and Suspension in Visual Culture*, London: I.B.Tauris.

Casper, J. (2014) 'Outside-in, Upside-down – and Now in Color!', *Lens Culture*, available at: https://www.lensculture.com/articles/abelardo-morell-outside-in-upside-down-and-now-in-color (accessed 24 August 2015).

Castells, M. (1996) *The Rise of the Network Society*, Oxford: Blackwell.

Cataldi, M., D. Kelley, H. Kuzmich, J. Maier-Rothe and J. Tang (2011) 'Residues of a Dream World: The High Line, 2011', *Theory, Culture & Society* 28 (7/8): 358–89.

Chef (2014) [Film] dir. Jon Favreau, Open Road Films.

Chevrier, J.F. (1993) 'Physiologie de l'image', in *Beat Streuli, Projektionen und Fotografien, NYC 1991/93*, Kunstmuseum Luzern, Verlag Lars Müller.

Chomsky, N. (2012) *Occupy*, New York: Penguin.

Chow, Y.F. and J. de Kloet (2013) 'Flânerie and Acrophilia in the Postmetropolis: Rooftops in Hong Kong Cinema', *Journal of Chinese Cinemas* 7 (2): 139–55, available at: http:// www.tandfonline.com/doi/abs/10.1386/jcc.7.2.139_1 (accessed 25 November 2014).

City Service Development Kit (2014) 'CitySDK Cookbook', *City Service Development Kit*, available at: http://www.citysdk.eu/wp-content/uploads/2014/11/CitySDK-Cookbook. pdf (accessed online 1 October 2014).

Clarke, G. (1997) *The Photograph*, Oxford: Oxford University Press.

Clerval, A. (2013) *Paris sans le Peuple: la Gentrification de la Capitale*, Paris: Éditions La Découverte.

Collins, L. (2009) 'The Vertical Tourist. Alain Robert's Obsession with Skyscrapers', *The New Yorker*, 20 April 2009 (accessed 6 September 2014).

Colomb, C. (2012) 'Pushing the Urban Frontier: Temporary Uses of Space, City Marketing, and the Creative City Discourse in 2000s Berlin', *Journal of Urban Affairs* 34: 131–52.

Connor, S. (1997) 'The Modern Auditory I', in R. Porter (ed.), *Rewriting the Self: Histories From the Renaissance to the Present*, London and New York: Routledge, 203–23.

Cordal, I. (2011) *Cement Eclipses: Small Interventions in the Big City*, London: Carpet Bombing Culture.

Corner, J. (2014) 'Hunt's Haunts', in J. Corner and A. Bick Hirsch (eds), *The Landscape Imagination: The Collected Essays of James Corner, 1990–2010*, New York: Princeton Architectural Press, 341–8.

Cotton, C. (2004) *The Photograph as Contemporary Art*, London: Thames and Hudson.

Couldry, N. and A. McCarthy (eds) (2004) *Mediaspace: Place, Scale and Culture in a Media Age*, London and New York: Routledge.

Crary, J. (1992) *Techniques of the Observer*, Cambridge: MIT Press.

Crary, J. (2013) *24/7: Late Capitalism and the Ends of Sleep*, New York: Verso.

Cresswell, T. (2006) *On the Move: Mobility in the Modern Western World*, London: Routledge.

Crinson, M. (ed.) (2005) *Urban Memory: History and Amnesia in the Modern City*, London: Routledge.

Darzacq, D. (2007) *La Chute,* Paris: Éditions Filigranes.

Darzacq, D. (2009) *Hyper,* Paris: Éditions Filigranes.

Dasgupta, S. (2013) 'Permanent Transiency, Tele-visual Spectacle, and the Slum at Postcolonial Monument', *South Asian Studies* 29 (1): 147–57.

Davids, K. (2000) 'Sporen in de Stad. De Metro en de Strijd om de Ruimtelijke Ordening in Amsterdam', *Historisch Tijdschrift Holland. Werken Aan een Open Amsterdam*, 32 (3/4): 157–82.

Davidson, A. (2013) 'The Food-Truck Business Stinks', *New York Times*, 7 May 2013, available at: http://www.nytimes.com/2013/05/12/magazine/the-food-truck-business-stinks.html?pagewanted=all&_r=0 (accessed 25 August 2014).

Davidson, M. (2007) 'Gentrification as Global Habitat: A Process of Class Formation or Corporate Creation?', *Transactions of the Institute of British Geographers* 35 (4): 490–506.

Davies, J. (2012) 'M62 – in the Company of Ghosts', in A. Corkish, with E. Chell and A. Taylor (eds), *In the Company of Ghosts: The Poetics of the Motorway*, Liverpool: erbbace-press, 19–24.

Davis, M. (1998) *Ecology of Fear: Los Angeles and the Imagination of Disaster*, London: Vintage.

Davis, M. (2006) *Planet of Slums*, London: Verso.

Dawney, L. (2013) 'The Interruption: Investigating Subjectivation and Affect', *Environment and Planning D: Society and Space* 31 (4): 628–44.

De Botton, A. (2006) *The Architecture of Happiness*, London: Hamish Hamilton.

De Certeau, M. (1984) *The Practice of Everyday Life*, translated by S. Rendell, Berkeley, CA: University of California Press.

Debord, G. (2008) 'Introduction to a Critique of Urban Geography', in H. Bauder and S. Engel-Di Mauro (eds), *Critical Geographies: A Collection of Readings*, Kelowna: Praxis (e)Press, 23–7.

Degen, M., C. Melhuish, and G. Rose (forthcoming) 'Producing Place Atmospheres Digitally: Architecture, Digital Visualization Practices and the Experience Economy', *Journal of Consumer Culture*.

Degen, M., C. Desilvey, and G. Rose (2008) 'Experiencing Visualities in Designed Urban Environments: Learning from Milton Keynes', *Environment and Planning A* 40 (8): 1901–20.

Deleuze, G. and F. Guattari (1988) *A Thousand Plateaus: Capitalism and Schizophrenia*, translated by B. Massumi, London: Athlone Press.

Demos, T. J. and R. Issa (2008) *Mitra Tabrizian: This is That Place*, London: Tate Publishing.

Department for Communities and Local Government (DCLG) (2009) *£3 Million Empty Shop Revival Fund for Most Deprived and Hardest Hit High Streets*, London: Department for Communities and Local Government.

Department for Communities and Local Government (DCLG) and Department for Media, Culture and Sport (DMCS) (2009) *Looking After Our Town Centres*, London: Department for Communities and Local Government and Department for Media, Culture and Sport.

Department of Transport (1989) *Roads for Prosperity*, available at: http://bettertransport. org.uk/sites/default/files/research-files/Roads_to_Nowhere_October2012_web_ spreads_0.pdf

Derrida, J. (2006 [1993]) *Spectres of Marx: The State of Debt, the Work of Mourning, and the New International*, translated by Peggy Kamuf, New York: Routledge Classics.

DeSilvey, C. and T. Edensor (2012) 'Reckoning with Ruins', *Progress in Human Geography* 37 (4): 465–85.

Deslandes, A. (2013) 'Exemplary Amateurism Thoughts on DIY Urbanism', *Cultural Studies Review* 19 (1): 216–27.

Detmar, H. (2013) 'Van Tunnelvisie naar Glazen Huis', *Noordzuidlijnkennis.net*, 10 June 2013, Amsterdam: Gemeente Amsterdam Dienst Metro, available at: http://www. noordzuidlijnkennis.net/noordzuidlijn-van-tunnelvisie-naar-glazen-huis/ (accessed on 1 October 2014).

Deutsche, R. (1996) *Evictions: Art and Spatial Politics,* London and Cambridge, MA: The MIT Press.

Deutsche, R. (1999) 'The Threshold of Democracy', in J.A. Farmer (ed.), *Urban Mythologies: The Bronx Represented Since the 1960s*, New York: The Bronx Museum of the Arts, 94–101.

Dikeç, M. (2007) *Badlands of the Republic: Space, Politics and Urban Policy*, Oxford: Blackwell Publishing.

Donald, S.H. and C. Lindner (eds) (2014) *Inert Cities: Globalization, Mobility, and Suspension in Visual Culture*, London: I.B. Tauris.

Donovan, P. (1999) 'Are New Roads the Right Road?', *Contract Journal*, 18 August: 16–17.

Dorrian, M. (2008) '"The Way the World Sees London": Thoughts on a Millennial Urban Spectacle', in A. Vidler (ed.), *Architecture Between Spectacle and Use*, London: Yale University Press and Clark Art Institute, 41–57.

Duara, P. (1995) *Rescuing History from the Nation: Questioning Narratives of Modern China*, Chicago, IL: The University of Chicago Press.

Dyer, J. (2005) *The Ongoing Moment*, London: Little, Brown, and Company.

Economist (2012) 'The City Roars Back', *Economist*, 21 July 2012, available at: http://www. economist.com/node/21559338 (accessed 21 August 2015).

Edensor, T. (2005) *Industrial Ruins: Space, Aesthetics and Materiality*, Oxford: Berg.

Edensor, T., D. Leslie, S. Millington, and N. Rantisi (eds) (2010) *Spaces of Vernacular Creativity: Rethinking the Cultural Economy*, London: Routledge.

Ehrenhalt, A. (2013) *The Great Inversion and the Future of the American City*, New York: Vintage Books.

Epstein, R. (2012) 'ANRU: Mission Accomplie?', in J. Donzelot (ed.), *À Quoi Sert la Rénovation Urbaine?* Paris: PUF, 51–97.

Erie, M.S. (2012) 'Property Rights, Legal Consciousness and the New Media in China: The Hard Case of the "Toughest Nail-House in History"', *China Information* 26 (1): 35–59,

available at: http://cin.sagepub.com/cgi/doi/10.1177/0920203X11436164 (accessed 25 November 2014).

Eskildsen, U. (ed.) (2008) *Street and Studio. An Urban History of Photography*, London: Tate Publishing.

Evans, H. (2014) 'Neglect of a Neighbourhood: Oral Accounts of Life in "Old Beijing" Since the Eve of the People's Republic', *Urban History* 41 (4): 686–704.

Evening Standard (2013) 'Hackney Council Replaces Drawing of Street Because it's "Too White"', available at: http://www.standard.co.uk/news/london/hackney-council-replaces-drawing-of-street-because-its-too-white-8726764.html (accessed 24 August 2015).

Ewing, W. A. and N. Herschdorfer (2010) *reGeneration2: Tomorrow's Photographers Today*, London: Thames and Hudson.

Featherstone, M. (1991) *Consumer Culture and Postmodernism*, London: Sage.

Fehrenbacher, J. (2013) 'Interview: Architect James Corner on NYC's High Line Park', *Inhabit*, available at: http://inhabitat.com/interview-architect-james-corner-on-the-design-of-high-line (accessed 4 October, 2013).

Fer, B., A. Hudek, M. Nixon, A. Potts, and J. Stallabrass (2001) *October*, 98: 3–26.

Ferreri, M. (forthcoming) 'The Seductions of Temporary Urbanism', special issue '*Saving the city*', *Ephemera: Theory and Politics in Organization*.

Feustel, M. (2010) 'Towards a New Street Photography', *Foam Magazine* 22, *Peeping* (Spring): 52–4.

Fisher, M. (2014) *Ghosts of My Life: Writings on Depression, Hauntology and Lost Futures*, London: Zero Books.

Florida, R. (2005) 'The World is Spiky', *Atlantic*, October: 48–51.

Foster, H. (ed.) (1988) *Vision and Visuality*, Seattle, WA: Bay Press.

Foucault, M. (1978) *The History of Sexuality: An Introduction*, New York: Vintage Books.

Foucault, M. (1996) 'Of Other Spaces: Utopias and Heterotopias', in N. Leach (ed.), *Rethinking Architecture: A Reader in Cultural Theory*, London: Routledge, 350–5.

Fourcaut, A. (2004) 'Les Premiers Grands Ensembles en Région Parisienne: Ne Pas Refaire la Banlieue?', *French Historical Studies* 27 (1): 195–218.

Fourcaut, A., E. Bellanger, and M. Flonneau (eds) (2007) *Paris/Banlieues: Conflits et Solidarités*, Paris: Éditions Créaphis.

Fried, M. (2012) 'Street Photography Revisited: Jeff Wall, Beat Streuli, Philip-Lorca diCorcia', in *Why Photography Matters as Art as Never Before*, New Haven and London: Yale University Press, 234–59.

Friends of the Highline (n.d.) 'About Friends of the High Line', available at: http://www.thehighline.org/about/friends-of-the-high-line (accessed 4 October, 2014).

Friends of the Queensway (n.d.) 'About Us', available at: http://www.thequeensway.org/about-us (accessed 6 October 2013).

Frisby, D. (2001) *Cityscapes of Modernity*, Cambridge: Polity Press.

Galloway, A.R. (2012) *The Interface Effect*, Cambridge: Polity Press.

Gane, N. and D. Beer (2008) *New Media: Key Concepts*, Oxford: Berg.

Gapper, J. (2013) 'America's Heart is in the City Once Again', *Financial Times*, 8 September 2013.

Glaeser, E. (2012) *The Triumph of the City*, London: Pan Books.

Gordon, E. and A. de Souza e Silva (2011) *Net Locality: Why Location Matters in a Networked World*, Oxford: Wiley-Blackwell.

Green, J. and K. Naughton (2014) 'Woes of Megacity Driving Signal Dawn of "Peak Car" Era', *Bloomberg.com*, 24 February 2014, available at: http://www.bloomberg.com/news/2014-02-24/woes-of-megacity-driving-signals-dawn-of-peak-car-era.html (accessed 7 September 2014).

Greenberg, M. (2008) *Branding New York: How a City in Crisis Was Sold to the World*, London: Routledge.

Greenberg, M. (2011) 'The Abandoned Movie Set: Art, Space, and the Politics of Crisis in 1970s-Era New York City', Talk given for workshop 'Cultural Landscapes of Boom and Bust' of conference *Creative City Limits: Urban Cultural Economy in a New Era of Austerity*, Urban Laboratory, University College London, 1 June 2011.

Gunn, T. (1994) *Collected Poems*, London: Faber & Faber.

Guo, L. (2012) 'Collaborative Efforts: An Exploratory Study of Citizen Media in China', *Global Media and Communication* 8 (2): 135–55, available at: http://gmc.sagepub.com/cgi/doi/10.1177/1742766512444341 (accessed 25 November 2014).

Hall, P. (1996) *Cities of Tomorrow*, Oxford: Blackwell.

Halle, D. and E. Tiso (2015) *New York's New Edge: Contemporary Art, The High Line, and Urban Megaprojects on the Far West Side*, Chicago, IL: University of Chicago Press.

Harbison, R. (1977) *Eccentric Spaces*, London: Andre Deutsch.

Hartley, A. (2003) *LA Climbs: Alternative Uses of Architecture*, London: Black Dog Publishing.

Harvey, D. (1989) *The Condition of Postmodernity: An Enquiry into the Origins of Cultural Change*, Oxford: Blackwell.

Harvey, D. (2000) *Spaces of Hope*, Edinburgh: Edinburgh University Press.

Hay, J. (2012) 'The Birth of the "Neoliberal" City and Its Media', in J. Packer and S.B. Crofts (eds), *Communication Matters: Materialist Approaches to Media, Mobility, and Networks*, ,Wiley London and New York: Routledge, 121–40.

Haydn, F. and R. Temel (2006) *Temporary Urban Spaces: Concepts for the Use of City Spaces*, Basel: Birkhäuser.

Heathcott, J. (2013) 'The Promenade Plantée: Politics, Planning, and Urban Design in Postindustrial Paris', *Journal of Planning Education and Research* 33 (3): 280–91.

Heddon, D. (2010) 'The Horizon of Sound: Soliciting the Earwitness', *Performance Research* 15 (3): 36–42.

Hell, J. and A. Schönle (eds) (2010) *Ruins of Modernity*, Durham, NC: Duke University Press.

Hibbert, K. (2010) *FREE: Adventures on the Margins of a Wasteful Society*, London: Ebury Press.

Highmore, B. (2001) *The Everyday Life Reader*, London: Routledge.

Highmore, B. (2002) 'Everyday Life and Cultural Theory', in S. Johnstone (ed.), *The Everyday: Documents of Contemporary Art*, Cambridge, MA: The MIT Press, 79–87.

Hoby, H. (2012) 'Google Muse: The New Breed of Street Photographer', *The Guardian*, Saturday 14 July 2012, available at: www.theguardian.com/artanddesign/2012/jul/14/google-muse-street-photographers-interviews (accessed 4 December 2013).

Hollis, L. (2013) *Cities are Good for You*, London: Bloomsbury.

Honoré, C. (2004) *In Praise of Slow: How a Worldwide Movement is Challenging the Cult of Speed*, New York: Harper Collins.

Hou, J. (ed.) (2010) *Insurgent Public Space: Guerrilla Urbanism and the Remaking of Contemporary Cities*, London and New York: Routledge.

Houdart, S. (2008) 'Copying, Cutting and Pasting Social Spheres: Computer Designers' Participation in Architectural Projects', *Science Studies* 21 (1): 47–63.

Howarth, S. and S. McLaren (2010) *Street Photography Now*, London: Thames & Hudson.

Hughes, B. (2009) 'D'Argenteuil à Bobigny, les Visites de Sarkozy en Banlieue', *Le Figaro* [online], 24 November, available at: http://www.lefigaro.fr/politique/2009/11/24/01002-20091124ARTFIG00435-d-argenteuil-a-bobigny-les-visites-de-sarkozy-en-banlieue-.php (accessed 23 July 2013).

Irvine, M. (2011) 'The Work on the Street: Street Art and Visual Culture', in I. Heywood and B. Sandywell (eds), *The Handbook of Visual Culture*, London: Bloomsbury, 235–79.

ITV News (2014) 'Traffic Jams are Getting Worse Despite the Congestion Charge', 14 March, available at: http://www.itv.com/news/london/update/2014-03-04/britains-ten-most-congested-roads-are-all-in-london/ (accessed 25 August 2015).

Iveson, K. (2013) 'Cities within the City: Do-It-Yourself Urbanism and the Right to the City', *International Journal of Urban and Regional Research*, 37 (3): 941–56.

Jackson, J.B. (1980) 'The Necessity for Ruins', in *The Necessity for Ruins and Other Topics*, Amherst: The University of Massachusetts Press.

Jackson, M.S. and V. Della Dora (2011) 'Spectacular Enclosures of Hope: Artificial Islands in the Gulf and the Urban Present', in R. Shields, O. Park, and T. Davidson (eds), *Ecologies of Affect: Placing Nostalgia, Desire and Hope*, Waterloo, ON: Wilfred Laurier University Press, 293–316.

Jameson, F. (1991) *Postmodernism, or the Cultural Logic of Late Capitalism*, Durham, NC: Duke University Press.

Jones, G.A. (2011) 'Slumming About', *City: Analysis of Urban Trends, Culture, Theory, Policy, Action* 16 (6): 696–708.

Jordan, J. (1998) 'The Art of Necessity: The Subversive Imagination of Anti-Road Protest and Reclaim the Streets', in G. McKay (ed.), *DiY Culture: Party and Protest in Nineties Britain,* London: Verso, 129–51.

Jordan, S. (2014) 'On Hold: Urban Photography as Interruption', in C. Lindner and S. Hemelryk Donald (eds), *Globalization, Mobility and Suspension in Visual Culture,* London: I.B. Tauris, 17–39.

Jouve, V. (2011) *Résonances*, Göttingen: Steidl Publishers.

Kaika, M. (2011) 'Autistic Architecture: The Fall of the Icon and the Rise of the Serial Object of Architecture', *Environment and Planning D: Society and Space* 29 (6): 968–92.

Kamdar, M. (2013) 'The Other Paris, Beyond the Boulevards', *The New York Times* [online], 9 November 2013, available at: http://www.nytimes.com/2013/11/10/opinion/sunday/the-other-paris-beyond-the-boulevards.html?module=Search&mabReward=relbias%3Ar&_r=1& (accessed 13 January 2014).

Katz, B. (2013) *The Metropolitan Revolution*, Washington, DC: Brookings Institute.

Katz, V. (2003) 'The New York Photographs of Beat Streuli', in *Beat Streuli: New York City 2000–02,* Ostfildern-Ruit: Hatje Cantz Publishers, 204–7.

Kay, J. (2014) 'Innovation Disrupted by Warring Gurus', *Financial Times*, 19 August 2014, available at: http://www.ft.com/cms/s/0/0f599a20-26d0-11e4-bc19-00144feabdc0.html#axzz3B7i1cBxe (accessed 21 August 2014).

Kim, J. (2012) 'Embodying the Evictees of Asian Olympic Cities: Video Documentaries of Demolition and Relocation in Seoul and Beijing', *Asian Cinema* 23 (2): 183–97, available at: http://openurl.ingenta.com/content/xref?genre=article&issn=1059-440X&volume=23&issue=2&spage=183 (accessed 25 November 2014).

Klanten, R. and M. Hubner (2010) *Urban Interventions. Personal Projects in Public Places*, Berlin: Gestalten.

Klingmann, A. (2007) *Brandscapes: Architecture in the Experience Economy*, Cambridge, MA: MIT Press.

Koepnick, L. (2014) *On Slowness: Towards an Aesthetic of the Contemporary*, New York: Columbia University Press.

Kohler, W. (1929) *Gestalt Psychology*, Oxford: Liveright.

Kracauer, S. (1995) 'The Hotel Lobby', in *The Mass Ornament: Weimar Essays*, translated and edited by T.Y. Levin, Cambridge, MA: Harvard University Press, 175–6.

LaBelle, B. (2006) *Background Noise: Perspectives on Sound Art*, London: Continuum.

Lane, A. (2014) 'Movies', *New Yorker* (9 May–17 June 2014), available at: http://www.newyorker.com/goings-on-about-town/movies/chef-2 (accessed 25 August 2014).

Larson, S., C. Bachu, M. Toneato, and S. Jurgena (2013) *QueensWay Diversity Study*, Urban Studies at Queens College, available at: http://qcurban.org/office-ofcommunity-studies/our-work/ (accessed 27 December 2014).

Latour, B. (2010) 'Networks, Societies, Spheres: Reflections of an Actor-Network Theorist', Keynote Speech for the *International Seminar on Network Theory: Network Multidimensionality in the Digital Age*, 19 February, available at: http://www.bruno-latour.fr/sites/default/files/121-CASTELLS-GB.pdf.

Lavery, C. (2005) 'The Pepys of London E11: Graeme Miller and the Politics of *Linked*', *New Theatre Quarterly* 21 (2): 148–60.

Law, J. (2002) 'Objects and Spaces', *Theory, Culture & Society* 19 (5/6): 91–155.

Lees, L. (2003) 'Super-Gentrification: The Case of Brooklyn Heights, New York City', *Urban Studies* 40 (12): 2487–509.

Lefebvre, B., M. Mouillart, and S. Occhipinti (2003) *Politique du logement: 50 ans pour un échec*, Paris: Harmattan.

Lefebvre, H. (1968) *Le Droit à la Ville*, Paris: Anthropos.

Lefebvre, H. (1991) *The Production of Space*, translated by Donald Nicholson-Smith, Oxford: Blackwell.

Lefebvre, H. (2004 [1992]) *Rhythmanalysis: Space, Time and Everyday Life*, translated by S. Elden and G. Moore, London: Continuum.

Lefebvre, C. (2013) 'Pantin, Nouveau Brooklyn?', *Le Nouvel Observateur* [online], 18 November 2013, available at: http://obsession.nouvelobs.com/pop-life/20131115.OBS5673/pantin-nouveau-brooklyn.html (accessed 10 December 2013).

Leith, J. A. (1991) *Space and Revolution: Projects for Monuments, Squares and Public Buildings in France, 1789–1799*, Montreal: McGill-Queen's University Press.

Les glaneurs et la glaneuse (2000) [Film] dir. A. Varda, France: Ciné Tamaris.

Lindner, C. (2008) 'New York Undead: Globalization, Landscape Urbanism, and the Afterlife of the Twin Towers', *Journal of American Culture* 31 (3): 302–14.

Lindner, C. (ed.) (2009) *Globalization, Violence, and the Visual Culture of Cities*, London: Routledge.

Lindner, C. (2013) 'Smart Cities and Slowness', *Urban Pamphleteer* 1: 14–16.

Lindner, C. (2015) *Imagining New York City: Literature, Urbanism, and the Visual Arts, 1890–1940*, New York: Oxford University Press.

Lindner, C. and M. Meissner (2015) 'Slow Art in the Creative City: Amsterdam, Street Creativity and Urban Renewal', *Space and Culture* 18 (1): 4–24.

Linebaugh, P. (2008) *The Magna Carta Manifesto: Liberties and Commons for All*, Berkeley and Los Angeles: University of California Press.

Lippard, L. (1997) 'Home in the Weeds', in M. Miles, T. Hall, with I. Borden (eds) (2004) *The City Cultures Reader*, 2nd ed., London: Routledge, 269–76.

Lippard, L. (1997) *Six Years: The Dematerialization of the Art Object from 1966–1972*, Berkeley and Los Angeles: University of California Press.

Locke, J. (1690) *An Essay Concerning Human Understanding*, London.

London Borough of Southwark (2010) 'Elephant & Castle Supplementary Planning Document/Opportunity Area Planning Framework', London: London Borough of Southwark.

Lonsway, B. (2009) *Making Leisure Work: Architecture and the Experience Economy*, London: Routledge.

Loughran, K. (2014) 'Parks for Profit: The High Line, Growth Machines and the Uneven Development of Urban Public Spaces', *City & Community* 13 (1): 46–68.

Luckhurst, R. (2002) 'The Contemporary London Gothic and the Limits of the "Spectral Turn"', *Textual Practice* 16 (3): 527–46.

Luxemburg, R.B. (2014) 'Interview with Rut Blees Luxemburg by Olga Smith', available at: http://www.photomonitor.co.uk/2014/06/london-dust/ (accessed 24 August 2015).

Marchand, Y. and R. Meffre (2010) *The Ruins of Detroit*, Gottingen: Steidl.

Marshall, B. (2014) 'Parkour and the Still Image', in S. Hemelryk Donald and C. Lindner (eds), *Inert Cities: Globalization, Mobility and Suspension in Visual Culture*, London: I.B. Tauris.

Massey, D. (1991) 'A Global Sense of Place', *Marxism Today* 38: 24–9.

Massey, D. (1994) *Space, Place, and Gender*, Minneapolis: University of Minnesota Press.

Matijcio, S. (2014) *Buildering: Misbehaving the City*, Cincinnati: Contemporary Arts Center.

McCann, E. and K. Ward (eds) (2011) *Mobile Urbanism: Cities and Policymaking in the Global Age*, Minneapolis: University of Minnesota Press.

Meanwhile Project (2010) 'No Time to Waste . . . The Meanwhile Use of Assets for Community Benefit', London: Meanwhile Project.

Meanwhile Space CIC (2010) *Meanwhile Hoxton Centre Evaluation*, London. Available at http://www.meanwhilespace.com

Meanwhile Space CIC (n.d.) *Meanwhile in Whitechapel Report*, London. Available at http://www.meanwhilespace.com

Mehta, S. (2004) *Maximum City: Bombay Lost and Found*, New York: Knopf.

Metropijn (1995) *Kritisch Onderzoek naar de Geplande Noord-Zuid-Metro van Amsterdam*, Amsterdam: Wijkcentrum d'Oude Stadt.

Miles, M. (2008) 'Critical Spaces: Memorials and Reparations, Memories and Changes', in C. Cartiere and S. Willis (eds), *The Practice of Public Art*, London: Routledge.

Miles, S. and R. Paddison (2005) 'Introduction: the Rise and Rise of Culture-led Urban Regeneration', *Urban Studies* 42 (5/6): 833–9.

Miller, G. (2003) *LINKED: A Landmark in Sound, An Invisible Artwork, A Walk*, London: Arts Admin.

Miller, G. (2005) 'Walking the Walk, Talking the Talk: Re-imagining the Urban Landscape. Interview with Carl Lavery', *New Theatre Quarterly* 21 (2): 161–5.

Miller, G. (2006a) 'Interview', *Time Out*, 2 June, available at: http://www.timeout.com/london/art/graeme-miller-interview (accessed 25 August 2015).

Miller, G. (2006b) 'Through the Wrong End of the Telescope', in L. Hill and H. Paris (eds), *Performance and Place*, Basingstoke: Palgrave Macmillan, 104–12.

Montgomery, M. (1998) *Displaying Women: Spectacles of Leisure in Edith Wharton's New York*, London: Routledge.

Morell, A. (2004) *Camera Obscura*, New York: Bullfinch Press.

Moretti, F. (1987) *The Bildungsroman in European Culture*, London: Verso.

Moses, J. (2013) 'Byron, Brewdog, and the Recuperation of Radical Aesthetics', *openDemocracy*, 10 May, available at: http://www.opendemocracy.net (accessed 10 May 2014).

Mould, O. (2014) 'Tactical Urbanism: The New Vernacular of the Creative City', *Geography Compass* 8 (8): 529–39.

Mumford, L. (1947) *City Development: Studies in Disintegration and Renewal*, London: Secker and Warburg.

New Street, Birmingham: Ikon Gallery Exhibition Guide, 21 November 2012 to 3 February 2013, available at: www.ikon-gallery-Co.uk/programme/current/event/673/new_street/ (accessed 27 September 2013).

New York City Department of Parks and Recreation, available at: http://www.thehighline. org/about (accessed 20 August 2015).

New York Times (2013) 'Idealized or Caricature, Architectural Renderings are Weapons in Real Estate', available at: http://www.nytimes.com/2013/08/27/nyregion/architects-renderings-as-a-weapon-in-real-estate.html (accessed 25 August 2015).

Nora, P. (1989) 'Between Memory and History: Les Lieux de Memoire', *Representations* 26 (Spring): 7–24.

Noss, A. (2013) 'Household Income: 2012', US Census Bureau, available at: http://www. census.gov/prod/2013pubs/acsbr12-02.pdf (accessed 25 August 2014).

Nye, J. S. (2004) *Soft Power: The Means to Success in World Politics*, New York: Public Affairs.

Oakland First Fridays (2014) available at: http://oaklandfirstfridays.org (accessed 27 August 2014).

Oddey, A. (2007) *Re-Framing the Theatrical: Interdisciplinary Landscapes for Performance*, Basingstoke: Palgrave Macmillan.

Oswalt, P., K. Overmeyer, and P. Misselwitz (2013) *Urban Catalyst*, Berlin: Dom Publishers.

Ouellette, L. and J. Hay (2008) 'Makeover Television, Governmentality and the Good Citizen', *Continuum: Journal of Media & Cultural Studies*, 22 (4): 471–84.

Parool (2013) 'Straatartiesten Niet Langer Welkom Rondom Centraal Station', *Parool*, 11 July 2013, available at: http://www.parool.nl/parool/nl/4024/AMSTERDAM-CENTRUM/article/detail/3474001/2013/07/11/Straatartiesten-niet-langer-welkom-rondom-Centraal-Station.dhtml (accessed 1 October 2014).

Patrick, D.J. (2013) 'The Matter of Displacement: A Queer Urban Ecology of New York City's High Line', *Social and Cultural Critique* 15 (8): 920–41.

Peck, J. (2009) 'The Creativity Fix', *Variant*, 34: 5–9.

Peck, J. (2011) 'Recreative City: Amsterdam, Vehicular Ideas and the Adaptive Spaces of Creativity Policy', *International Journal of Urban and Regional Research* 36 (3): 462–85.

Perec, G. (1989) *L'Infra-ordinaire*, Paris: Seuil.

Perls, F.S. (1969) *Gestalt Therapy Verbatim*, Lafayette, CA: Real People Press.

Phillips, A. (1998) 'Borderland Practice: The Work of Graeme Miller', in N. Childs and J. Walwin (eds), *A Split Second of Paradise: Live Art, Installation and Performance*, London: Rivers Oram Press, 102–16.

Piketty, T. (2014) *Capital in the Twenty-First Century*, Cambridge, MA: Harvard University Press.

Pile, S. (2005) *Real Cities: Modernity, Space and the Phantasmagorias of City Life*, London: Sage.

Pinder, D. (2001) 'Ghostly Footsteps: Voices, Memories and Walks in the City', *Cultural Geographies* 8 (1): 1–19.

Pinder, D. (2008) 'Urban Interventions: Art, Politics and Pedagogy', *International Journal of Urban and Regional Research* 32 (3): 730–6.

Pinder, D. (2011) 'Errant Paths: The Poetics and Politics of Walking', *Environment and Planning D: Society and Space* 29 (4): 672–92.

Poyner, R. (2013) 'The Incidental Pleasure of Street Art', *Design Observer* [online], available at: http://designobserver.com/article.php?id=37992 (accessed 3 January 2014).

Pratt, A.C. (2009) 'Urban Regeneration: From the Arts "Feel Good" Factor to the Cultural Economy: A Case Study of Hoxton, London', *Urban Studies*, 46 (5/6): 1041–61.

Rancière, J. (2004) *The Politics of Aesthetics*, translated and introduced by G. Rockhill, afterword by S. Žižek, London: Continuum.

Rancière, J. (2008) *Le Spectateur émancipé*, Paris: La Fabrique Éditions.

Rancière, J. (2013) *Dissensus: On Politics and Aesthetics,* edited and translated by S. Corcoran, London: Bloomsbury.

Read, A. (2003) 'The Arithmetic of Belief', in G. Miller, *LINKED: A Landmark in Sound, An Invisible Artwork, A Walk,* London: Arts Admin.

Reynolds, S. (2012) *Retromania: Pop's Addiction to its Own Past,* London: Faber.

Rickard, D. (2012) *A New American Picture,* New York: Aperture Foundation.

Riggle, N.A. (2010) 'Street Art: The Transfiguration of the Commonplaces', *Journal of Aesthetics and Art Criticism* 68 (3): 243–57.

Robert, A. (2014) *Haute tension: l'homme-araignée se raconte,* Paris: le Cherche-Midi.

Roberts, J. (1998) *The Art of Interruption: Realism, Photography and the Everyday,* Manchester and New York: Manchester University Press.

Robinson, L. (2012) 'Alternative Archives and Individual Subjectivities: Ou Ning's Meishi Street', *Senses of Cinema* 63, available at: http://sensesofcinema.com/2012/miff2012/ alternative-archives-and-individual-subjectivities-ou-nings-meishi-street/ (accessed 21 August, 2015).

Robinson, L. (2013) *Independent Chinese Documentary: From the Studio to the Street,* Hampshire: Palgrave Macmillan.

Rogers, R. (1996) *Cities for a Small Planet,* London: Faber and Faber.

Rorty, R. (1979) *Philosophy and the Mirror of Nature,* Princeton: Princeton University Press.

Rose, G., M. Degen, and C. Melhuish (2014) 'Networks, Interfaces, and Computer-Generated Images: Learning from Digital Visualizations of Urban Redevelopment Projects', *Environment and Planning D: Society and Space* 32 (3): 386–403.

Rose, N., P. O'Malley, and M. Valverde (2006) 'Governmentality', *Annual Review of Law and Social Science* 2: 83–104.

Ross, A. (2004) 'Dot.Com Urbanism', in N. Couldry and A. McCarthy (eds), *Mediaspace: Place, Scale and Culture in a Media Age,* London and New York: Routledge, 145–62.

Ross, K. (1988) *The Emergence of Social Space: Rimbaud and the Paris Commune,* Basingstoke: Macmillan.

Rossi, A. (1982) *The Architecture of the City,* Cambridge, MA and London: MIT Press.

Runciman, D. (2012) 'Stiffed', *London Review of Books,* 34 (20): 7–9.

Rutgrink, E. (2014) *Mind the Gap: How Representations of Space Affect the Production of Social Space,* MA Thesis Comparative Arts and Media Studies, VU University, 2014.

Sá, L. (2007) *Life in the Megalopolis: Mexico City and São Paulo,* London: Routledge.

San Francisco Arts Commissions (2010) *Art in Store Fronts,* online: http://www. sfartscommission.org/storefronts (accessed 5 February 2011, no longer available).

Sassen, S. (1991) *The Global City: New York, London, Tokyo,* Princeton: Princeton University Press.

Schjeldahl, P. (1994) 'Thomas Struth', *Columns and Catalogues,* Great Barrington, MA: The Figures.

Scobey, D. (1992) 'Anatomy of the Promenade: The Politics of Bourgeois Sociability in Nineteenth-Century New York', *Social History* 17 (2): 203–27.

Scott, C. (2007) *Street Photography from Atget to Cartier-Bresson,* London: I.B. Tauris.

Sennett, R. (1994) *Flesh and Stone: The Body and the City in Western Civilisation,* London: Faber.

Sheikh, S. (2004) 'In the Place of the Public Sphere? Or, The World in Fragments', in C. Doherty (ed.) (2009), *Situation: Documents of Contemporary Art,* London and Cambridge, MA: Whitechapel Press and The MIT Press, 137–41.

Shen, S. (2014) 'From Deconstruction to Activism: The Chinese Independent Documentary and the Crowd', *Modern China*, available at: http://mcx.sagepub.com/cgi/doi/10.1177/0097700414555476 (accessed 25 November 2014).

Sheringham, M. (2006) *Everyday Life: Theories and Practices from Surrealism to the Present*, Oxford: Oxford University Press.

Sheringham, M. (2009) *Everyday Life: Theories and Practices from Surrealism to the Present*, Oxford: Oxford University Press.

Shore, S. (2004) 'Interview with Lynn Tillmann', in S. Shore, *Uncommon Places*, New York: Aperture.

Shuelvitz, J. (2013) 'Don't You Dare Say Disruptive', *New Republic*, 15 August, available at: http://www.newrepublic.com/article/114125/disruption-silicon-valleys-worst-buzzword (accessed 25 August 2014).

Sinclair, I. (2003) *London Orbital: A Walk Around the M25*, London: Penguin.

Sinha, A. (2013) 'Slow Landscapes of Elevated Linear Parks: Bloomingdale Trail in Chicago', *Studies in the History of Gardens and Designed Landscapes* 34 (2): 113–22.

Skonieczny, A. (2010) 'Interrupting Inevitability: Globalization and Resistance', *Alternatives: Global, Local, Political*, 35 (1): 1–28.

Smith, T. (1999) 'Everyday Arcadias', in *About the World: Beat Streuli, Bondi Beach-Parramatta Road, 1998*, Hanover: Sprengel Museum Hanover.

Soetenhorst, B. (2011) *Het Wonder van de Noord/Zuidlijn: Het Drama van de Amsterdamse Metro*, Amsterdam: Bert Bakker.

Soja, E. (2014) *My Los Angeles,* Berkeley and Los Angeles: University of California Press.

Soja, E. (2000) *Postmetropolis: Critical Studies of Cities and Regions*, Oxford: Blackwell.

Space Makers Agency (2010) Brixton Village, available at: http://www.spacemakers.info/projects/brixton-village (accessed 15 March 2014).

Stallabrass, J. (2002) *Paris Pictured: Street Photography 1900–1968*, London: Royal Academy.

Stalter, S. (2006) 'Farewell to the El: Nostalgic Urban Visuality on the Third Avenue Elevated Train', *American Quarterly* 58 (2): 869–90.

Sterne, J. (2003) *The Audible Past: Cultural Origins of Sound Reproduction*, Durham, NC: Duke University Press.

Streuli, B. (2003) *New York City 2000–02,* Ostfildern-Ruit: Hatje Cantz Publishers.

Struth, T. (2012) *Unconscious Places*, Munich: Schirmer Mosel.

Szejnoch, K. and A. Żechowska (2008) *Carousel Slide Swing,* Arnhem: Dutch Art Institute, available at: http://www.kamilaszejnoch.com/images/stories/pdf/CarouselSlideSwing.pdf.

Talen, E. (1999) *The Charter of the New Urbanism*, New York: McGraw-Hill.

Tallack, D. (2005) *New York Sights: Visualizing Old and New New York*, London: Berg.

The Emerald Forest (1985) [Film] Dir. John Boorman, USA: Embassy Pictures.

The Wire (2002–8) [TV programme] created by David Simon, HBO.

Thrift, N. (2008) 'The Material Practices of Glamour', *Journal of Cultural Economy* 1 (1): 9–23.

Till, K. (2012) 'Wounded Cities: Memory-Work and a Placed-Based Ethics of Care', *Political Geography* 31: 3–14.

Tonkiss, F. (2003) 'Aural Postcards: Sound, Memory and the City', in M. Bull and L. Back (eds), *The Auditory Culture Reader*, Oxford: Berg, 303–10.

Toop, D. (2010) *Sinister Resonance: The Mediumship of the Listener*, London: Bloomsbury.

Townsend, A. (2011) *A Planet of Civic Laboratories*, Palo Alto: The Institute for the Future, available at: http://www.iftf.org/uploads/media/IFTF_Rockefeller_CivicLaboratoriesMap_01.pdf (accessed 1 October 2014).

Trendwatching (2004/2010) 'Pop-up Retail', available at: http://www.Trendwatching.com (accessed 13 October 2010).

Trower, S. (2011) 'Introduction', in S. Tower (ed.), *Place, Writing, and Voice in Oral History*, Basingstoke: Palgrave, 1–24.

Un-Habitat (2013) 'Financing Urban Shelter: Global Report on Human Settlements 2005', London: Routledge.

Urry, J. (2007) *Mobilities*, Cambridge: Polity.

Valli, M. and M. Dessanay (2011) *Microworlds*, London: Laurence King Publishing Ltd.

Van Bers, R. (2013) 'Graffiti in de Oostlijn: "We Halen het Altijd Weg"', *hierzijnwij.nu*, 10 May 2013, Amsterdam: Gemeente Amsterdam Dienst Metro, available at: http://www. hierzijnwij.nu/nieuws/graffiti-in-de-oostlijn-we-halen-het-altijd-weg/ (accessed 1 October 2014).

Van Den Berg, P. (1995) 'Platform Metro Wil Stadsvervoer Bovengronds Houden', *Volkskrant*, 19 December 1995, available at: http://www.volkskrant.nl/dossier-archief/ platform-metro-wil-stadsvervoer-bovengronds-houden~a408848/ (accessed 1 October 2014).

Van Der Meulen, S. (2004) 'Monuments in the Expanded Field', in B. Kempers et al. (eds), *Stiff: Hans van Houwelingen Vs. Public Art*, Amsterdam: Artimo, 112–48.

Van Dijck, J. (2013) *The Culture of Connectivity: A Critical History of Social Media*, New York: Oxford University Press.

Van Wijck, A. (2012) 'Winning Back Trust in Amsterdam Metro.' Discussion Forum of *TunnelTalk*, September.

Varnedoe, K. (1990) *A Fine Disregard: What Makes Modern Art Modern*, New York: MOMA.

Vergara, C.J. (1999) *American Ruins*, New York: The Monacelli Press.

Verstraete, G. (2013) 'Underground Visions: Strategies of Resistance along the Amsterdam Metro Lines', in C. Lindner and A. Hussey (eds), *Paris–Amsterdam Underground: Essays on Cultural Resistance, Subversion, and Diversion*, Amsterdam: Amsterdam University Press, 77–95.

Vickery, J. (2007) *The Emergence of Culture-led Regeneration: a Policy Concept and its Discontents*, Working Paper, Coventry: University of Warwick, Centre for Cultural Policy Studies (Research papers).

Vidler, A. (1994) *The Architectural Uncanny: Essays in the Modern Unhomely*, Cambridge, MA: The MIT Press.

Virilio, P. (2001) 'Speed-Space', in J. Armitage (ed.), *Virilio Live: Selected Interviews*, London: Sage, 69–80.

Virilio, P. (1997) 'The Overexposed City', in N. Leach (ed.), *Rethinking Architecture: A Reader in Cultural Theory*, London: Routledge, 381–9.

Virilio, P. (2007) *City of Panic*, Oxford: Berg.

Vitali, V. (2010) 'Film Historiography as Theory of the Film Subject: A Case Study', *Cinema Journal* 50 (1): 141–6.

Waag Society (2014) 'Amsterdam Joins Metro4All', *Waag Society*, 27 November 2014, available at: https://www.waag.org/nl/news/amsterdam-joins-metro4all (accessed 1 October 2014).

Wake, W.S. (1994) 'Requiem for the Pedestrian', *Walk: The Journal of the Pedestrians' Association* 7 (9): 15–17.

Walk (1994) 'Acts of Violence', *Walk: The Journal of the Pedestrians' Association*, 7 (9): 3–10.

Wall, D. (1999) *Earth First! and the Anti-Roads Movement: Radical Environmentalism and Comparative Social Movements*, Abingdon: Routledge.

Webber, M. (2005) 'The Post City Age', in R. LeGates and F. Stout (eds), *The City Reader*, London: Routledge, 470–4.

Weinstock, J.A. (2013) 'Introduction: The Spectral Turn', in M. del Pilar Blanco and E. Peeren (eds), *The Spectralities Reader: Ghosts and Haunting in Contemporary Cultural Theory*, London: Bloomsbury, 61–8.

Weiss, A.S. (1995) *Phantasmic Radio*, Durham, NC: Duke University Press.

Wesselman, D. (2013) 'The High Line, "The Balloon" and Heterotopia', *Space and Culture* 16 (1): 16–27.

Westerbeck, C. and J. Meyerowitz (1994) *Bystander: A History of Street Photography*, London: Thames and Hudson.

Whipplesnaith ([1937] 2007) *The Night Climbers of Cambridge*, Cambridge: Oleander Press.

Whitlock, L. (1999) 'After 2,520 Days, £380 Million of Work and Endless Delays FINALLY IT OPENS', *Wanstead and Woodford Guardian*, 5 August.

Williams, R. (1973) *The Country and the City*, Oxford: Oxford University Press.

Williams, R. (1974) *Television: Technology and Cultural Form*, London: Fontana.

Williams, R.J. (2004) *The Anxious City*, London: Routledge.

Williams, R.J. (2014) 'Unpublished interview with Alan Ehrenhalt', 24 June 2014.

Wolf, M. (2011) *FY*, Berlin: Peperoni Books.

Winthrop Young, G. ([1900] 2011) *The Roof-Climbers' Guide to Trinity*, Cambridge: Oleander Press.

Xing, D. (2009) 'Work Statement', *Urban Fiction*, available at: http://www.danwen.com/web/works/uf/statement.html (accessed 25 November 2014).

Yaneva, A. (2009). 'Making the Social Hold: Towards an Actor-Network Theory of Design', *Design and Culture* 1 (3): 273–88.

Young, J.E. (1992) 'The Counter-Monument: Memory against Itself in Germany Today', *Critical Inquiry* 18 (2): 267–96.

Zappi, S. (2012) 'Fini le Tourisme Plan-plan, Direction le "9-3"!', *Le Monde* [online], 6 October 2012, available at: http://abonnes.lemonde.fr/societe/article/2012/10/06/fini-le-tourisme-plan-plan-direction-le-9-3_1771172_3224.html (accessed 10 November 2013).

Zukin, S. (1982a) 'Art in the Arms of Power: Market Relations and Collective Patronage in the Capitalist State', *Theory and Society* 11 (4): 423–51.

Zukin, S. (1982b) *Loft Living*, Baltimore and London: Johns Hopkins University Press.

Zukin, S. (1995) *The Cultures of Cities*, Cambridge, MA and Oxford: Blackwell.

Zukin, S. (2008) 'Consuming Authenticity', *Cultural Studies* 22 (5): 724–48.

Zukin, S. (2009) *Naked City: the Death and Life of Authentic Urban Places*, New York: Oxford University Press.

Zwiene, A. (2010) '". . . A Certain Sense of Placelessness . . ." Thomas Struth Between Seoul, Cape Canaveral, Garching and Greifswald', in *Thomas Struth Photographs 1978–2010*, Munich: Schirmer Mosel, 147–60.

INDEX

9/11 2, 23
24 City (Zhangke) 37

Acconci, V. 90
activism 66, 150–2, 190
Actor Network Theory 116
advertising 5, 108, 200
aesthetic economy 106–7
affect 47, 68, 75, 102, 110, 113–15
Agamben, G. 20
Aguirre, E. 178
Ai Weiwei 45
Allies and Morrison architects 107
Amsterdam 121–39, 144, 205–6
Amsterdam RealTime (2002) 137
Anarchitekton (Colomer 2002–2004) 4–6
animal locomotion photography 62,
 209–10
anti-road protests 81
antitopianism 37–8
apartment blocks 57, 97
Appadurai, A. 1, 102
Archer, N. 29 n.8
architectural uncanny, the 52
Arendt, H. 31, 32, 36, 180
Argote, I. 188
Armando (artist) 48 n.4
Arte Povera 26
artist's impressions 109
assimilationist cultures 91
audio walks 68–83
Augé, M. 19
austerity 26
authenticity 19, 27, 149
autobiographical posters 130

automobility 73, 79
avant-garde practices 96, 99, 144
Avermaete, T. 163

Baetens, T. 127, 135
Baird, G. 198
Baiser de l'Hôtel de Ville (Doisneau, 1950)
 204–5
Bakhtin, M. 181
Bakker, E. 124
Baltimore 19
Balzac, H. de 179, 181
Bangkok 208
Baran, C. 92
Barasch, D. 59
Barcelona 4, 185
barricades 66–7
Barthes, R. 9, 181
Batchen, G. 200
Bathurst, M. 60
Baudrillard, J. 8
Beer, D. 111
'before and after' imagery 147–8
Beijing 3, 19, 31–48
Beirutopia 114
Belfast 21, 184
Bellanger, E. 88
Bellour, R. 195, 198
Benjamin, W. 34–5, 48, 180, 195, 197, 199
Bennes, C. 114–15
Berger, J. 3, 159, 167, 170–1
Berlin 144
Berry, C. 43, 46
Berry Slater, J. 81, 142, 144
Berteaux, L. 94–5

Bey, H. 143
Biehl-Missal, B. 106
billboards 105–19, 128–31
Birdsall, C. 129
Birmingham (UK) 70, 75, 196, 208–10
Bishop, P. 142, 143
Bishopsgate tower (London) 113–14
Bissuel, B. 92
Blanco, M. del Pilar 78
Boccioni, U. 162–3
Böhm, S. 73, 144
Böhme, G. 106–7, 110
Bonaventure Hotel (Los Angeles) 8
Boorman, J. 173–5
Boulanger, E. 184
boundaries 153, 163
bourgeoisie 5, 53, 90, 92
Bradley, S. 68, 83 n.8
Braester, Y. 37–8
Brazil 6–9
Brindle, J. 114, 117
Brockling, U. 32
Broudehoux, A.-M. 42
Brussels 196
Buck-Morss, S. 73
'buildering' 10, 174–92
Butler, B. 68
Butler, T. 68, 75

Cabrera, E. 99
Caillebotte, G. 163
Cambie, S. 142
Camera Obscura (Morell 2004) 161–7
Campbell, H. 201
Campbell Jones, C.L. 73
Canal de l'Ourcq public art project (Paris) 89
Capital (Piketty 2014) 28
capitalism 18, 24, 34, 43, 105–7, 173
Cardiff, J. 78
Carousel Slide Swing (Szejnoch) 188–9
cars and driving 22, 23, 73, 79
Cartier-Bresson, H. 162, 193, 203
Casper, J. 162
Castells, M. 1, 18, 21, 160
Cataldi, M. 56
Celant, G. 26
censorship 46
Cerdan, A. 99

Chef (Favreau 2014) 26–7
Chernobyl 56
Chevrier, J.-F. 197
Chicago 22, 51, 59, 176, 199, 201
Chomsky, N. 28 n.1
Chow, Y. F. 38
chronotopes 181
Cincinnati 188
Cingapura housing development (São Paulo) 8
Cities of Hope (Harvey 2000) 19
Clarke, G. 199
Clerval, A. 88
Clevis, K. 131, 132, 139 n.7
Cohen, J. 127
Collins, L. 192 n.2
Colomb, C. 144
Colomer, J. 4–6
Computer Aided Design (CAD) 109
condo/apartment blocks 57, 97
congestion 21
Connor, S. 80
consumerism 25, 37
contagion 4–5
contemporary art 18, 97, 144–5, 184, 199
contingency 37, 43, 47
Cordal, I. 10–11, 54–6, 194
Corner, J. 56, 57–8
Cotton, C. 210
Couldry, N. 122
counterculture 27, 51, 152
counter-monuments 188–92
Crary, J. 1, 166, 167
creative city discourses 132, 144, 154–5
Cresswell, T. 1
crime rates 22
Crowd, The (King Vidor, 1928) 176
cultural capital 153
cultural rehabilitation 19, 88, 93–5, 131–3, 144
cultural resistance 25–6

Darzacq, D. 194
Dasgupta, S. 56
Davids, K. 124
Davidson, M. 88
Davies, J. 73–4
Davis, M. 7, 19, 24
Dawney, L. 75

Day, A. 176–7
Dazhalan Project 43–4, 46
Debord, G. 51
De Botton, A. 21
deceleration, *see* slowness
decentralization 87
De Certeau, M. 96, 141, 178
defamiliarization 33, 56, 59
Degen, M. 110, 111, 116, 117, 150
deglamourization 113–15, 117, 118
Delahaye, L. 209
Deleuze, G. 180
Della Dora, V. 108
Demos, T.J. 194
Denari, N. 57
Derrida, J. 77–8, 79
Descartes, R. 166
DeSilvey, C. 55, 150
Desire Paths, The (Miller, 1993) 70
Deslandes, A. 141, 145, 147
De Souza e Silva, A. 137
Dessenay, M. 194
Detmar, H. 129
Detroit 18, 51, 55, 56
Deutsche, R. 69, 90
Digital City, The (1994) 137
digital favela 6–9
digital visualizations (architectural)
 105–19
Dikeç, M. 87
Dillon, B. 18
disorientation 8, 168, 178, 208
displacement 37, 66, 68, 76–7, 80, 88, 121,
 154, 194
documentary 43–6
Doha 107, 109–10, 115–18
Doisneau, R. 203, 204–5
Donald, S.H. 2
Dorrian, M. 110
Duara, P. 48 n.1
Dungeness: The Desert in the Garden
 (Miller, 1987) 70
Dyer, J. 204–5
dystopia 17, 20, 22

Eccentric Spaces (Harbison 1977) 19
eco-projects 49–61, 173
Edensor, T. 55, 56, 100, 144
Edgerton, H. 62

Edifice Project 97–8, 104
Edinburgh 162
Ehrenhalt, A. 22–3
El barrio (Los Caprinteros) 184
Elephant and Castle (London) 152–4
Emerald Forest, The (Boorman 1985)
 173–4, 180, 181
endotic subjectivization 96, 104
Engels, F. 19
ephemerality 90, 96, 97, 100–1, 103–4,
 145–7, 149
Epstein, R. 92
Erie, M. 44
Evans, H. 46
Evans, W. 209
everyday, the 27, 58, 64, 70, 96–7,
 102, 103, 150
Ewing, W.A. 193

favela 6–9
Favreau, J. 26–7
Featherstone, M. 100
Fei, C. 37, 43
Fer, B. 18
festivals 93–4, 146
Feustel, M. 203
Field Operations 53
Fischli, P. 185
Fisher, M. 79
flânerie 53, 73, 202
flash-mobbing 17
Fletcher Priest Architects 60
Flonneau, M. 88
Florida, R. 25
flow 2, 18–19, 159–60, 195,
 197, 199
food trucks 18, 24–7
Foster, H. 87
Foucault, M. 20, 32, 64
Fourcaut, A. 88, 92
Four Two Screen Projections (Streuli
 2001–2) 208–10
*FREE: Adventures on the Margins
 of a Wasteful Society* (Hibbert 2010)
 151
Fresh Kills garbage dump 53
Fried, M. 201, 210
Frisby, D. 50
Fujimoto, S. 185

Galloway, A.R. 111
Gane, N. 111
garden cities 21
Gardiner, H. 176
Gautier, A. 101, 102
Geddes, P. 162
Gehry, F. 57
gender 179
gentrification 22–3, 53, 56, 60, 88–9,
 92–3, 94–5, 97
Gerz, J. and E. 188
Gestalt Psychology (Kohler, 1929) 170
Ghent 198–9
'ghost' communities 73–4
ghosts 77–9, 114, 117
Gilge, C. 25
Glaeser, E. 21, 22, 23, 24
Glasgow 190–1
Gleaners and I, The (Varda 2000) 151
global financial crisis (2008) 3, 20, 27–8,
 137, 142, 152
globalization 1–2, 5–6, 37, 50–1, 52,
 173, 201
glow of unwork 111, 115–18
González, D. 6–9
Gordon, E. 137
Gordon-Smith, B. 186
governmentality 32
GPS technology 79, 137–8
graffiti 5, *see also* street art
*Great Inversion and the Future of the
 American City, The* (Ehrenhalt 2013)
 22–3
Green, J. 23
Greenberg, M. 144
Greenpoint (New York) 112–13
growth, urban 22–4, 27, 145
Guattari, F. 180
guerrilla gardening 18
'guilty landscapes' 48 n.4
Gunn, T. 179
Guo, L. 43

Hadid, Z. 57
Hall, P. 21
Halle, D. 54
'happiness' 21
haptic experiences 181–2, 184–5
Haq, S. 148

Harbison, R. 19
Hartley, A. 175, 176, 184
Harvey, D. 1, 19
Hashima Island 55–6
hauntology 78–80
Hay, J. 32, 122
Haydn, F. 141
Heathcott, J. 53
Heddon, D. 68, 71–2
Hell, J. 55
Henner, M. 201, 202, 203
Herrema, T. 127
Herschdorfer, N. 193
'heterotopia' 20, 64
Het wonder van de Noord/Zuidlijn
 (Soetenhorst 2011) 126, 136
Heygate estate regeneration (London)
 152–4
Hibbert, K. 151
hier zijn wij nu! ('here we are now!')
 128–9, 133–9
High Line (New York) 18, 49–61
Highmore, B. 97, 200
historicism 34–5
history, reworking 31–2, 33–7, 71, 81
hoardings 105–19, 128–31
Hoby, H. 202
Holland, A. 177
Hollis, L. 21
Hong Kong 203
Honoré, C. 10
hotels 8, 163–5
Hou, J. 141
Houdart, S. 109
Houston 23
Howarth, S. 202
Hubner, M. 10, 190
hutong neighbourhoods 33, 36, 42–7
hyper-aware meditative states 75
hyperspace 8

IAC Building (New York) 57
identity politics 89
Idroj Sanicne 4
Iles, A. 81, 142, 144
immigration 91, 196
indigenous people 173
Industrial Ruins (Edensor 2005) 56
industrial sites 18–19, 51, 53–4, 56, 98–9

inequality 7, 25, 28
inertia 2
information technology, *see* social
 media; technology
inner cities 22–3, 53, 56, 145
inner space 166
Interdictory Spaces (González 2008) 9
interfaces 111
interruption, defined 2–3, 17–18,
 33, 47
interurban competition 144
inversions 21–4, 59–60
Irvine, M. 96
Issa, R. 194
Iveson, K. 143

Jackson, M.S. 108
Jameson, F. 8
Japan 55–6
Jein, G. 103
Jones, G.A. 56
Jordan, J. 66
Jordan, S. 17, 194
Jouve, V. 194

Kaika, M. 105, 108
Kamdar, M. 93
Kangjun, Z. 37
Katz, B. 21, 22
Katz, V. 200
Kee, J. 137
Kelley, D. 56
Kertséz, A. 205
Kiasma Museum 199
Kim, J. 43
Klanten, R. 10, 190
Klingmann, A. 106
Kloet, J. de 38
Koepnick, L. 10
Kohler, W. 170
Kracauer, S. 19, 163
Krasmann, S. 32
Kuzmich, H. 56

LaBelle, B. 76
labour 11, 27, 108, 117–18
Lakman, A. 184
Land, C. 144
Landers, P. 117

Landscape with Path: A Railroad Artifact
 (Sternfeld 2000) 54–5
Larson, S. 59
Lartigue, J.H. 160
Latour, B. 135–6
Lavery, C. 68, 75, 76, 78–9
La Voie publique (Streuli) 198–9
Law, J. 116
layering 98–9
Leadenhall Building (London) 111
Lees, L. 56
Lefebvre, B. 91
Lefebvre, C. 90, 94
Lefebvre, H. 75, 188
left-wing politics 23, 126, 127
Leith, J.A. 91
Lemke, T. 32
Lemley, M. 70
light rail 21, 23, 121–39
liminal spaces 38
Lindner, C. 2, 17, 50, 53, 62, 74, 81, 149
Linebaugh, P. 152
LINKED (sound walk, Miller) 68–83
Lippard, L. 26, 88
Listening Ground, Lost Acres
 (Miller 1994) 70
Liverpool 21, 23–4
Locke, J. 165–6, 167
loft living 18–19
London 21, 60, 65–83, 111–14, 117,
 141–56, 181, 185
London Review of Books 17
Lonsway, B. 106
Los Angeles 21, 24
Los Carpinteros 184
Loughran, K. 54
low culture (vs. high) 26
Lowline (New York) 59–60
Lu, X. 43
Luckhurst, R. 79, 81
Luxemburg, R.B. 113–14

M11 link road 65–83
Maier-Rothe, J. 56
Make:Do 146
Manchester (UK) 21, 22, 23–4
maquettes 4–5, 11, 31–42
Marchand, Y. 18, 56
marginalized people 44, 46, 88

market cultures 11, 44, 92, 95, 97, 142–4, 200
marketing 108, 110, 114–15, 142, 200
Marshall, B. 178
Marx, K. 19
Massey, A. 163
Massey, D. 1, 102
Maximum City (Mehta, 2004) 24
McCann, E. 144
McCarthy, A. 122
McLaren, S. 202
Meanwhile Space CIC 142, 145, 147, 150–2
Measure, M. 67
media 22
Meffre, R. 18, 56
megacities 24
Mehta, S. 24
Meishi Street (Ou Ning 2007) 33, 43, 45–7
Meissner, M. 62, 74, 81, 149
melancholy nature of interrupted spaces 19, 56
Melhuish, C. 110, 111, 116, 117
memory 28 n.4, 52, 54, 56, 68, 76, 77–8, 89, 179–80, 188–92, *see also* oral histories
Menj, J. 91, 94
Metropolitan Museum of Art (New York) 62–4
Metropolitan Revolution (Katz 2013) 21
Meudon (Kertséz 1928) 205
Meyerowitz, J. 193
middle-classes 40, 92, 95, *see also* gentrification
migration 91, 196
Miles, M. 185–6
Miles, S. 93, 144
Millennium Development Goals (MDGs) 9
Miller, G. 68–83
miniature figurines 11, 194
Mirza, R. 114
Misselwitz, P. 141
Mistos (Oldenburg and van Bruggen 1992) 185–8
mobile restaurants (food trucks) 24–7
mobility 1–2, 12, 49, 56, 61–2, 72–3, 76, 88, 121–3, 137–8, 196–7, 208
Montgomery, M. 163
monument and counter-monument 188–92

Moore, T. 62
Morell, A. 160–7, 171
Moretti, F. 179
Moses, J. 149
Mouillart, M. 91
Mould, O. 141, 145, 155
Msheireb Downtown (Doha) 107, 109–10, 115–18
multiculturalism 196, 201
Museum of London 68, 71
mushroom garden park 60–1
Muybridge, E. 62, 209–10

Naked City (Zukin, 2009) 26
Nares, J. 50, 62–4
narrative tissue (of communities) 79
nationalism 88, 91–2, 95
naturalization 71, 75–6
nature in the city 51
Naughton, K. 23
neocolonialism 149
neoliberalism 5, 37, 50, 56, 64, 88, 89, 92, 95, 201
networking 115–18, 135–6
New Street (Streuli) 196
New Urbanism 21
New York 18, 23, 49–64, 112–13, 142, 144, 168–70, 194, 200, 208
Night-Climbers of Cambridge, The (Whipplesnaith 2007) 176, 181–2
Ning, O. 33, 43, 45–7, 48
Nora, P. 89
nostalgia 49, 52, 56, 61, 149
Novaacqua-Gasosa II (González 2004) 6
Nye, J. S. 32

'Oakland First Fridays' (2014) 19
Occhipinti, S. 91
Occupy movement 17–18, 27
Oddey, A. 68
Off The Grid 27
Oldenburg, C. 185
Olsen, D. 23
Olympics 32, 42, 44, 65, 80, 81, 185
Ongoing Moment (Dyer 2005) 204–5
On the Concept of History (Benjamin 1940) 34–5
open house projects 128–39
oral histories 68–83

Oswalt, P. 141
otherworldliness 56
Ouellette, L. 32
Ou Ning 33, 43, 45–7, 48
Overmeyer, K. 141
Oxford Street (Streuli) 196–7

Paddison, R. 93, 144
Paraisópolis (Vieira, 2005) 7
Paris 52–3, 58–9, 73, 87–104, 202–5
Paris Street View (Wolf) 202–7
parkour 176–80, 182, 192
parks 49–61
participation in art 26, 82, 101–2, 152–4, 155
Paterson, M. 73
Patrick, D.J. 55
Peck, J. 144
pedestrians 72–3
Peeren, E. 78
Perec, G. 96
performativity 26, 49, 62, 129, 142, 145, 149–50, 154, 155
Perls, F. 170
perspective 46, 56, 75, 79, 82, 159–71
Phillips, A. 70
Phoenix 23
photography 44–5, 54–6, 102, 109–10, 113–15, 122, 134–5, 147, 159–71, 193–210
Photoshopping 109, 112, 114
Piano, R. 57
Pile, S. 78
Pinder, D. 64, 69, 74, 77, 78, 190
place activation 147
place marketing images 108, 144
Polak, E. 137
'police order' 89, 103
political art 89, 99
pop art 96, 185
population growth 21
pop-up shops 5, 18, 141–56
postcolonialism 37, 91
post-postmodernism 96
poverty 6–9, *see also* inequality
Powers of Ten (Eames 1977) 171
Poyner, R. 98
Pratt, A.C. 144
progress, discourses of 11, 32–7, 44, 47–8

protest 5, 43, 66, 90, 122, 124–6, 132–3, 207, 210
pro-urbanism 21–2, 24
public art 54, 56, 68, 89, 97, 186–8, 195–8, *see also* street art
public–private initiatives 127, 133, 155

Qatar 107, 109–10, 115–18
Qianmen *hutong* 33, 42–7
QueensWay (New York) 59

race 22, 112, 130
Rafman, J. 201
railways 21, 23, 121–39, *see also* High Line (New York)
RampArt Social Center 150–1
Ramsey, J. 59
Rancière, J. 87, 88–9, 90, 92, 95, 96, 99, 104
Read, A. 76
real estate 19, 23, 33, 36–7, 40, 96–7, 105
realism 43
reclamation projects 51, 151–2, *see also* industrial sites
relationality 88–9
'render ghosts' 114, 117
renders 108–9
Republicanism 91, 95
'resisting' 111–13
retro-walking 49–50, 52, 58–61, 62–4
Reynolds, S. 80
rhythmanalysis 75–6
Rickard, D. 201, 202
Riggle, N.A. 96
road systems 65–83, *see also* cars and driving
Robert, A. 178–9
Roberts, J. 2
Robinson, L. 43, 44, 45, 46–7
Rock on Top of Another Rock (Fischli and Weiss 2010/13) 185, 186
Rofel, L. 43, 46
Rogers, R. 21
Roof-Climber's Guide to Trinity, The (Winthrop Young 2011) 176
Ropac, T. 94
Rorty, R. 166
Rosa, B. 55
Rose, G. 110, 111, 116, 117, 150
Ross, A. 122

Ross, K. 82 n.1
Rossi, A. 21
Ruin Lust (Dillon 2014) 18
ruins 18, 24, 52–6, 60, 97–9
Runciman, D. 28 n.1
Rutgrink, E. 124–5

Sá, L. 7
Safety Last! (Newmeyer/Taylor 1923) 176
San Francisco 23, 142
sanitization of history 33–7, 71, 81
São Paulo 8
Saren, M. 106
Sassen, S. 1
scale models 32–42
Schejldahl, P. 168–70
Schönler, A. 55
scientism 36
Scobey, D. 50
Scott, C. 203
sculpture, urban 185–92
Sennett, R. 75
Sheerazi, A. 128, 129–30, 131, 134, 137
Sheikh, S. 90
Shen, S. 46
Sheringham, M. 103, 200
shopping centres 33, 42, 44, 46, 97, 142, 147, 152–4
Shore, S. 168
signature architecture projects 56–7
Silicon Valley 18, 25
Simmel, G. 19
Simon, D. 19
Sinclair, I. 73
Sinha, A. 51
Situationist psychogeography 50–1
Six Years (Lippard 1997) 26
Skonieczny, A. 37, 47
Slick, C. 181
slow food 51
slow-motion video 50, 62, 208–10
slowness 10, 49–64, 74–5, 81, 149, 153, 208–10
slums 6–9, 24, 56
Smart Citizen Kit 138
(*Smart*) *City Service Development Kit* 138
social housing 97
social media 21–2, 44, 122–3, 128, 133–9, 145–6, 200

social mixity 88, 92
Soetenhorst, B. 126, 136
soft power 31–3
Soja, E. 1, 19, 21
So Sorry (Ai Weiwei) 45
Sound Observatory, The (Miller 1992) 70
sound walks 68–83
'space of flows' 1, 18–19
spectral turn 78–9
squatting 132, 150
Stalter, S. 60–1
Sterne, J. 80
Sternfeld, J. 54–5, 56
Street (Nares 2011) 50, 62–4
street art 96–104, 132, 134
Street Invades the House, The (Boccioni 1911) 162–3
street photography 5, 193–210
street running 4–6
Street View (Google) 201–8
Streuli, B. 194–201, 205–6, 208–10
Struth, T. 160, 168–70
Stumpf, S. 184
suburbs 22, 87–104, 124–5
super-gentrification 56
Sydney 208–10
Szejnoch, K. 188–90

Tabizuran, M. 194
tactical urbanism 141–2, 154–5
tagging 97, 101–2
Talen, E. 21
Tallack, D. 163
Tang, J. 56
Tate Modern (London) 18, 200
Techniques of the Observer (Crary 1992) 166
technology 21–2, 44, 59, 79–80, 122, 133–9, 145–6, 160
Temel, R. 141
temporary nature of interruption 5–6, *see also* ephemerality
terrorism 2–3
The Wire (Simon 2002–8) 19
The World (Zhangke) 37
Thrift, N. 107, 110
Till, K. 68
Tiso, E. 54
Tokyo Compressions (Wolf 2010) 201
Tonkiss, F. 65

Toop, D. 80
Townsend, A. 138
Track (Miller, 2010–) 75
Transparent City (Wolf 2008) 201
transport systems 52, 58–9, 65–83,
 121–39, 197
Triumph of the City (Glaeser 2012) 21
Trower, S. 68
Turistas (Argote) 188

Uncommon Places (Shore 2004) 168
Unconscious Places (Struth, 2012) 168–70
underground railways 59–60, 121–39
unwork 111, 115–18
urban actuality film 62
'urban art' 89, *see also* street art
'urban interventions' 10, 190
Urban Museum, Beijing 31–2, 33–42
urban planning 8, 33–4, 52
urban renewal 44, 50, 56, 87–104, 124–5,
 142–3, 144
Urry, J. 1
utopianism 37

Valli, M. 194
Van Bers, R. 132
Van Bruggen, C. 185
Vancouver 22
Van Den Berg, P. 126
Van der Meulen, S. 188–9, 191–2
Van Dijck, J. 122
Van Wijck, A. 126, 130, 131
Varda, A. 151, 152
Varnedoe, K. 167
Vergara, C.J. 56
Vermeer, J. 166
Verstraete, G. 122
verticality 7, 181
Vickery, J. 144, 154
video 208–10
Vidler, A. 52
Vieira, T. 7
violence 2, 40–1, 44, 72–3, 76
Virilio, P. 1, 62
Vitali, V. 48
Vuylsteker, P. 93

Waag Society (Amsterdam) 137
Wahlhuetter, S. 181, 183
Wake, W.S. 72
walking, urban 72–4, 95
Wall, D. 66
Walton, L. 184
Ward, K. 144
Warsaw 188
Webber, M. 21–2
Weinstock, J.A. 65, 78
Weiss, D. 185
Wellington Statue, Glasgow 190–1
Wells, H.G. 23
Wesselmann, D. 64
Westerbeck, C. 193
Whipplesnaith (Noël Howard Symington)
 176, 181–2
Whitechapel (London) 150–2
Whitney Museum (New York) 54, 57
Wiard, A. 67
Williams, L. 142, 143
Williams, R. 23, 122
Williams, R.J. 20, 23, 50
Winogrand, G. 160
Wire, The (Simon 2002–8) 19
Wishart, S. 82 n.2
Wolf, M. 194, 201–10
Wolfsburg Art Museum 199
Wordsworth, W. 179

xianchang (on-the-spot realism) 43
Xing, D. 31, 33, 37–42, 47, 48

Yaneva, A. 113
Young, J.E. 188, 190
Young Man at His Window (Caillebotte
 1875) 163

Zaccaria, C. 57
Zappi, S. 95
Zhangke, J. 37, 42
zhongduan vs. *ganyu* 33, 47
Zukin, S. 19, 26, 95, 144–5, 149
Zwiene, A. 170